Made in Italy

Rethinking a Century of Italian Design

Made in Italy

Rethinking a Century of Italian Design

Edited by

Grace Lees-Maffei and Kjetil Fallan

BLOOMSBURY

LONDON · NEW DELHI · NEW YORK · SYDNEY

Bloomsbury Academic

An imprint of Bloomsbury Publishing Plc

50 Bedford Square	1385 Broadway
London	New York
WC1B 3DP	NY 10018
UK	USA

www.bloomsbury.com

Bloomsbury is a registered trade mark of Bloomsbury Publishing Plc

First published 2014
Reprinted 2014

British Library Cataloguing-in-Publication Data
A catalogue record for this book is available from the British Library.

ISBN: HB: 978-0-8578-5388-2
PB: 978-0-8578-5389-9
ePDF: 978-1-4725-5842-8
ePUB: 978-0-8578-5390-5

Library of Congress Cataloging-in-Publication Data
Made in Italy (2014)
Made in Italy : rethinking a century of Italian design / edited by Grace Lees-Maffei
and Kjetil Fallan.
p. cm.
ISBN 978-0-85785-389-9 (pbk.) — ISBN 978-0-85785-389-9 (hardback) —
ISBN 978-0-85785-390-5 (epub)
1. Design—Social aspects—Italy. 2. Design—Italy—History—20th century.
3. Design—Italy—History—21st century. I. Lees-Maffei, Grace, editor of
compilation. II. Fallan, Kjetil, editor of compilation. III. Title.
NK1452.A1M33 2014
745.20945'09051—dc23 2013031068

Typeset by Apex CoVantage, LLC, Madison, WI, USA
Printed and bound in Great Britain

CONTENTS

ILLUSTRATIONS

INTRODUCTION: THE HISTORY OF ITALIAN DESIGN

KJETIL FALLAN AND GRACE LEES-MAFFEI

This general introduction is divided into three sections. It begins with a critical reflection on the place of national histories in an increasingly globalised design environment, highlighting the key methodological issues for design historians. The second section provides historical context for understanding Italian design during the period covered by the book as a whole—the early twentieth century to the present. The final section explains the book's structure and contents. The historiography of Italian design is addressed in chapter one.

I. NATIONAL HISTORIES

Why conduct a national study of Italian design here and now, in this increasingly global age? What is the place of national and regional histories when digital technologies have enabled the routine international collaboration of designers, manufacturers, marketers and retailers and the development of a large and non-elite global group of consumers who use the Web to access visual culture regardless of, as well as due to, its geographical origins? Does it make sense to speak of Italian design, for example, at a time when 'Italian' cars may be designed by Britons and Brazilians and manufactured in Poland and Pakistan for consumption in Switzerland and Swaziland (Figure 0.1)?[1] The quest to move beyond the Western bias of modernist histories has informed intellectual endeavours such as 'world history' and 'global history', aimed at expanding the purview of historical scholarship, empirically and methodologically. As a corollary to this development, the tried-and-tested framework of national histories has been increasingly criticised as unsuited to a new 'global gaze' within which neither contemporary society nor historical narratives are to be confined to the geopolitical straightjacket of nations.

Questioning the existence of nations as a conceptual category, Benedict Anderson considered them to be 'imagined communities', whereas Ernest Gellner deemed them a modern myth.[2] Arjun Appadurai has gone so far as to claim that 'the nation state has become obsolete', at least in terms of identity construction in contemporary society.[3] And, based on the complex workings of contemporary high-end architecture, where globetrotting 'starchitects', multinational organisations and transnational construction processes form intricate networks that decidedly complicate the notion of national architectures, Jilly Traganou asserts 'the need to perform a shift from the orthodox focus on the nation-state as a conflated political and cultural unit' to global narratives.[4] But while the latter approach may be better suited to frame the design practice with which

Traganou is concerned—a highly visible but quantitatively marginal part of our material culture—national, regional and local contexts remain significant for much design practice, both contemporary and historical. In the words of John Walker: 'In spite of the mythical nature of the concept of nation, it does have material consequences'.[5]

Whereas it is certainly true that the nation state is no longer the only sociocultural or political-economic unit forming our identities and experiences—if it ever was—we argue that a move to discard national frameworks in writing history is both premature and unwise. As Kjetil Fallan noted in introducing a recent regional study, *Scandinavian Design*:

> Regions and nations are complex and contested units but nonetheless make viable arenas for studying design history. The mesh of cultural, social, political and economic configurations and codes that makes up our society clearly contributes to maintaining the regional and the national as valid categories of demarcation and identity.[6]

From medieval artisans to today's design students, from the coins of antiquity to our smartphones, people and things have always been mobile. Nevertheless, there is a reason why we do not speak of the Armenian system of manufacture;[7] Coca-Cola is not the same in Trinidad as it is in Texas, and electricity generators in Senegal are not used as prescribed by their French designers.[8] In short, the 'global village' long ago heralded by Marshall McLuhan, where geocultural contexts become insignificant, remains a utopia.[9] Furthermore, we believe that the growth of global cultures makes the examination of national and regional cultures even more important; indeed, we perceive a *mandate* for national studies of design at this point in global economic and cultural development. These same economic, cultural and intellectual conditions provide, of course, a need for comparative studies as well as national and regional ones. However, the national studies we advocate do not respond to geopolitical borders as absolutes; rather, we propose national studies that are attentive to cultural exchange and international trade and influence.

National histories are a tried-and-tested unit of analysis in a range of fields from history and area studies to design history. In the latter context, these include the works of Jeffrey L. Meikle on the United States, Tony Fry on Australia, Lasse Brunnström on Sweden, Pekka Korvenmaa on Finland, Cheryl Buckley on Britain, Mienke Simon Thomas on the Netherlands, Penny Sparke on Japan and Italy, David Crowley on Poland and Paul Betts on Germany.[10] The national design history is an established genre that has successfully communicated the distinctive stories and contributions of a number of mainly Western industrialised nations. This bias towards the industrial West derives from design history's concern for design understood as a product of mass manufacture and mass consumption.[11] However, recent developments mean that the design histories of a raft of countries beyond the Euro-American nexus need to be written and made available to an international audience in order to allow recognition of the distinctive nature of these national design cultures and to aid understanding the interaction of these countries with the rest of the world. In the case of East Asia, where design history is emerging, it has

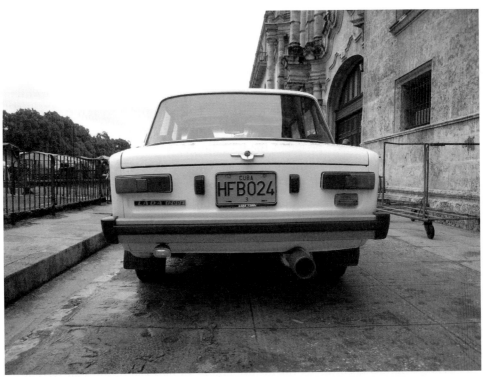

Fig. 0.1 Is this car Italian, Russian or Cuban? A Lada 1200s—a Russian modification of the 1966 Fiat 124—on the streets of Havana, Cuba, where it is a staple of everyday life. Photo by Brian Beaver.

been argued that national histories are not only a natural focus at this stage but, in fact, a prerequisite for the region's contribution to the globalisation of the field.[12]

But where does this leave the national histories of countries whose design cultures have already been charted? Should the continued writing of national histories be confined to those countries that have to date been neglected in the English-language literature of design history? Are national histories to be justified *only* by the extent to which they address nations and regions previously unfamiliar to an international readership? Clearly, those nations that have received disproportionate design historical attention may also warrant new national histories in order to reflect novel approaches and innovative scholarship.

HISTORIES OF ITALIAN DESIGN

Italy provides a rich example through which to demonstrate the continued relevance of national studies. Even though, in terms of global manufacturing, Italy's output is relatively modest, the country's celebrated design heritage and reputation for innovation mean that goods 'made in Italy', and/or designed in Italy, carry added value. Since 1945 the history of Italian design has been widely celebrated. Design 'made in Italy' has generated a disproportionate amount of column inches in professional design journals and mass-market consumer magazines, as well as book-length studies.

The historiography of Italian design is the subject of chapter one of this volume, so here we simply mention a few notable surveys. *Italy: The New Domestic Landscape: Achievements and Problems of Italian Design* (1972), edited by Emilio Ambasz to accompany the now-famous exhibition of the same name at the Museum of Modern Art (MoMA), has exerted a towering influence on the course of Italian design history. As well as providing today's historians of Italian design with a snapshot of design thinking at the start of the 1970s, it includes 'historical articles' on 'Art Nouveau in Italy', futurism, modernism and the post–Second World War period.[13] The following decade, designer and design critic Andrea Branzi celebrated an avant-garde design boom in *The Hot House: Italian New Wave Design.*[14] In 1990 Nally Bellati's *New Italian Design* provided a primarily pictorial survey of the network of Italian designers in the late 1980s, while Penny Sparke's *Design in Italy: 1870 to the Present* offers a classic linear national history explaining the development and character of Italian design.[15] More recent studies to have focused on one area of design practice include Alberto Bassi's *Italian Lighting Design, 1945–2000* and Michelle Galindo's *Italian Interior Design.*[16] Italian design history is told through a series of objects in both Silvana Annicchiarico's *100 Objects of Italian Design* and Giampiero Bosoni and Irene de Guttry's *Il Modo Italiano: Italian Design and Avant-Garde in the 20th Century.*[17] In 2008 daab published *Italian Design*, a sourcebook of designers and architects, and Giampiero Bosoni's *Italian Design* was published by MoMA, using examples from the museum's collection and bringing the historiography of national histories of Italian design full circle.[18] While each of these national studies functions as an argument for the utility of understanding design at a national level, there are additional structural reasons for analysing Italian design as a discrete category,[19] and these are introduced below.

But is Italian design well served by the steady stream of magazine features and coffee-table books through which it is celebrated? Italian design is, to some extent, the victim of its own celebrity in that hagiographic public relations and marketing-driven treatments fail to reward its innovative, delightful and confounding output with proper analysis. National histories can all too easily fall into the trap of functioning as tools of canonisation, providing readers with lists of celebrated designers. Histories of Italian design are sometimes perceived as promoting the excellence of Italian design at the expense of the thoroughgoing analysis it deserves, although a small, but growing, body of scholarly journal articles forms an exception.[20] Italian design is indeed often excellent, and often rich in associative meaning; it therefore warrants a *critical* approach. A national history of Italian design should therefore function, at least partly, as a corrective to the hagiographic tendency displayed by some book-length works on the subject.

IDENTIFYING NATIONAL DESIGN

Clearly, national design history is not beyond censure. A common criticism points to the essentialist attitude to national identity prevalent in many such accounts. As Viviana Narotzky has written, 'Not surprisingly, many of the studies that have looked for formal national characteristics have failed to find an ultimately defining "local style" in

the goods produced by any particular country'.[21] The pigeonholing of a nation's design culture by means of a few idiosyncratic traits is reductive. Such a tendency is particularly constraining when imposed by outsiders, as Lise Skov has shown in the case of Japanese fashion.[22] Therefore, in order to function as a valuable analytic concept, national identity must be understood as subtle and nuanced.

How do we decide if a designed object is Italian or Irish, or whether a designed image is Nigerian or Nicaraguan? First, we might determine nationality in design by starting with the designer: her or his birthplace, parental and wider familial heritage, place of upbringing, place of training, site of professional practice and location of group practice, as well as the location of manufacturers she or he works with and her or his sites for commissions—all of these can influence the assignment of nationality, and as this list makes clear the nationality of a designer is not easy to identify, as it is more likely to be mixed than confined to one region.

Second, design is rarely the product of one individual, so, potentially, a mix of nationalities is at play not just in an individual named designer's possibly mixed cultural heritage but also in the team that brings a product to market. In this age of multinational corporations, outsourced manufacture and the increased separation of brand from product, not even manufacturers, products or brands are readily identifiable with one specific nation. Also relevant is the fascinating process of transculturation, whereby a product gathers different meanings as it moves from its country of origin to other countries in which it is consumed.[23] (See Figure 0.2.)

Finally, we can seek to determine nationality in design by looking at nations or regions themselves as sites for design, for manufacture and for the mediation and consumption of design. Nations and regions have specific natural resources as well as centres of design and manufacturing specialisation—take, for example, the porcelain centre of Jingdezhen in the Jiangxhi province of China, or the furniture manufacture at Grand Rapids in the US state of Michigan. In each of these cases, the availability of natural resources—clay on the one hand and timber on the other—prompted the development of centres of specialist manufacturing know-how and associated networks of mediation and transportation. As these two examples make clear, regionality is crucial in understanding design through a geographically embedded historical and cultural lens. In Italy, regions and city states have been key, developmentally, from Milan's network of designers to Turin's manufacturing base (see, for example, Simona Segre Reinach's discussion of regionality in her account of Italian fashion in this volume).

So identifying a design, or a designer, as a product of one country is not simple. Nationality is a complex, multiple phenomenon, and where a design or designer is particularly associated with one nation state, it is usually because one of the above factors has taken precedence over the others. The reason might be economic: pitching a product as Danish can be considered smart in marketing terms, even though it might have been designed by an Argentine and manufactured in Taiwan. The consequence, though, according to Stina Teilmann-Lock, is that 'today, the term "Danish Design" is self-referential. It

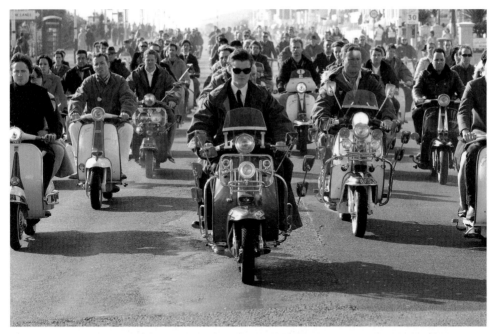

Fig. 0.2 Transculturation in transit: mod-ified Lambrettas and Vespas on the streets of Brighton, United Kingdom. Screenshot from the film *Brighton Rock* (2010), where mods and rockers fight it out in 1964. Image courtesy of STUDIOCANAL Films Ltd.

is a "post-modern" simulacrum, a signifier with itself as the signified. Danish Design has a name because there *was* Danish Design'.[24] But less orthodox understandings of national identity may also be fruitful in design history.

THE CASE OF ITALY

There are structural reasons why it is useful to produce a new book about the specific case of Italian design. Italy is a relatively young country formed as part of a process encompassing unification (1871 is one date given for the achievement of unification) and the constitution of the Italian Republic in 1948. This relative youth is significant for the understanding of Italian design as distinct for several reasons. First, it means that Italians maintain strong local identities; city states still exercise a cultural hold and since 1970, when Italy instituted regional governments, a political one, too.[25] These local town, city and regional contexts and networks, further entrenched by the centrality of family within this Catholic culture, mean that a designer might identify as Neapolitan rather than Italian in the first instance and might favour local methods, personnel and manufacturers for the realisation of her or his work. All too often, Italian design is said to centre on a relatively small network in Milan, but Italy as a whole enjoys numerous regional centres of specialisation in craft and manufacturing, such as the metalworking area in the northern Italian lakes region, which is home to Bialetti and Alessi, to name but two internationally

recognised Italian manufacturers.[26] The centrality of local culture is exemplified beyond design in the development, for example, of the Cittaslow movement (1999–)[27] and its culinary corollary, the Slow Food movement; Italian cuisine is distinctly regional.

Second, notwithstanding the local and regional identification, the relative youth of the Italian Republic means that Italian national identity is observed in a similarly self-conscious way. Venetians and Romans are also Italians. However, Italians are also acutely conscious of the ancient civilisation on which their contemporary lives are based—much of the built environment is ancient or at least hundreds of years old, and these more-or-less crumbling edifices are respected so that contemporary life is woven around them and into them with more pride than resignation. In fact, a combination of two of the factors we have already identified as particularly relevant to understanding the case of Italian design—the local networks and built environment of the city states—contributes to a third, and crucial, distinguishing feature of Italian design: the architectural training experienced by most Italian designers.

Italian architects and designers agree that it is hard to build in Italy, meaning that contracts are sewn up in family and local networks, rather than being offered for competitive open tender, and the spaces in which it is possible to build are constrained by similarly entrenched politics and the need to accommodate existing historical structures. Year after year, alongside the graduates of industrial design programmes, new architects graduate and turn to designing objects, rather than buildings, as a matter of economic necessity. It is perhaps the heavily theorised architectural education they have received, as opposed to the practice-based studio education encountered by design graduates outside of Italy, that informs a lateral, subversive, innovative, poetic and playful approach to design that is upheld as epitomising design 'made in Italy'. Indeed, the 'made in Italy' tag is perhaps justification enough for a national study of Italian design that probes the stereotypes on which that banner relies. Maddalena Dalla Mura and Carlo Vinti's historiographical chapter in this volume begins the project taken up by the rest of the book.

We do not wish to overstate the homogeneity of Italian design: it is indeed 'constituted of a multiplicity of subjects, making it difficult to define as a uniform, centralized, organized system'.[28] Furthermore, the success of Italian design and the unofficial 'made in Italy' brand has meant that Italian manufacturers and design groups alike are able to recruit designers from around the world to work, either in Italy or remotely, on furthering the project and excellence of Italian design. In such cases, the nationalities of the designers recruited to Italy from abroad are subsumed into the identity of Italian design. Sardinian-born curator Paola Antonelli has argued that 'when designers move to Italy—some for long periods, others permanently—and begin to truly enjoy the work experience and be inspired by it, their design passport becomes Italian'.[29] Her comment prefaces a book on Italian design told through objects from New York's MoMA collection, which includes Japanese Toshiyuki Kita's Wink lounge chair 111 of 1980 for Cassina, Australian Marc Newson's Wood chair for Cappellini (1988) and Brazilians Fernando and Humberto Campana's Corallo armchair of 2004 for Edra.

Evidence of the international nature of Italian design is ubiquitous. For example, the design group King and Miranda was set up in 1975 by Briton Perry King and Spaniard Santiago Miranda, yet King and Miranda is based in Italy and its output is regarded as contributing to that of Italian design.[30] The same can be said of Japanese designers Isao Hosoe and Makio Hasuike, who have both lived and worked in Italy since the mid-1960s, being virtually instantly Italianised (Figure 0.3; for a detailed discussion of coffee machines, see Jonathan Morris' chapter in this book). Even Italy's most influential design theoretician is an immigrant: the Argentine Tomás Maldonado, who came to Italy from Germany in the late 1960s (see Raimonda Riccini's chapter). As the closing chapter of this book explores, Alessi's household goods are always Italian, whether the designer is American, Japanese or Romanian/German, because Alessi promotes itself as an Italian design factory or, rather, a manufacturer in which the innovative, culturally embedded and deeply engaged design-management skills of the co–general manager Alberto Alessi subsume the national identities of its itinerant and international designers. So extensive is Italian dominance in the design industry that Alessi has boasted that 'even today those who look for the most interesting examples of French or British or Brazilian design will often have to consult the catalogues of the Italian Design Factories'.[31] How did this situation of Italian prominence, if not dominance, arise? It is necessary to consider the history of Italian design to understand the ways in which Italian design is perceived today.

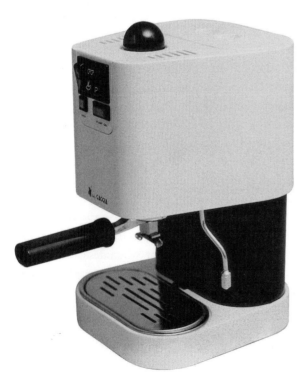

Fig. 0.3 An Italian design icon by a Japanese designer: the 1977 Baby Gaggia domestic espresso machine designed by Makio Hasuike. Image courtesy of Makio Hasuike & Co s.r.l.

II. A BRIEF HISTORY OF ITALIAN DESIGN

This book is not a genealogy; it does not set out to trace the genesis of Italian design. With an emphasis on the nation and the national in an international context, our history of Italian design is a history of modern design. This is corroborated by our dedication to a broad definition of design: with few exceptions, a wider range of design practices beyond traditional craft and decorative art emerged in Italy only with the turn of the twentieth century. The onset of a more diversified design culture is intimately linked with changes in the manufacturing base and Italy's late industrialisation, as well as with altered societal structures and cultural practices, reformed educational systems and new patterns of consumption. Therefore, our 'made in Italy' is a history of the last century or so.

In *The Age of Extremes*, Eric Hobsbawm defined 'the short twentieth century' as starting with the outbreak of the First World War in 1914.[32] As for modern Italian design, we might argue that its 'age of extremes' began a few years earlier, with the publication of Tommaso Marinetti's *Futurist Manifesto* in 1909.[33] Despite Reyner Banham's early and surprising inclusion of futurism in his *Theory and Design in the First Machine Age*,[34] this rampant Italian avant-garde movement is rarely given much design historical attention. This omission has recently been addressed by Ara Merjian, who has argued that not only did the futurists depict the material culture of industrial society in their work, but many of them designed—and made—artefacts easily categorised as design, from clothes, domestic objects and furniture to advertisements and packaging.[35] Fortunato Depero's Campari Soda bottle is one such design (of admittedly few) that has been manufactured in series (Figure 0.4). As Gillo Dorfles has remarked, the historical avant-gardes—including futurism—may have been essential in the development of the visual arts, but they have had little direct influence on the course of industrial design.[36] On the other hand, in the words of Merjian, 'rather than use design as a (subjectivist) bulwark against (coldly objectifying) industry, the Futurists were the first avant-gardists to collapse such distinctions so radically, or at least to call for their collapse'.[37] Befitting, perhaps, a movement glorifying war, futurism can be said to have inaugurated Italian design's 'age of extremes' by bringing together modernist aesthetics and the material culture of industrial society.

IDEOLOGY AND INDUSTRY

With a shared interest in nationalism, modernisation, industrialisation, violence, war and antidemocratic ideas, futurism eagerly joined forces with Fascism as it gained prominence following the First World War. This move from art to politics leads us to a crucial episode in Italian design history, namely, its isolation during the Fascist regime, which strongly influenced Italian manufacturing. Mussolini's attack on Ethiopia in 1935 led to severe trade sanctions being imposed on Italy by the League of Nations. Much can be said of the autarkic policy implemented as a countermeasure, but in terms of industrial infrastructure it only furthered the existing diversity, such as the designs from ' "autarkic" materials' on display at the V Triennale di Milano in 1933.[38]

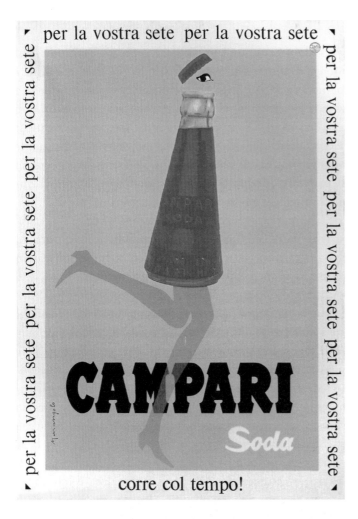

Fig. 0.4 A futurist foray into industrial design: in 1932 Fortunato Depero designed the characteristic Campari Soda bottle still used today—here featured in a 1950 advertisement poster designed by Franz Marangolo. Image courtesy of Davide Campari—Milano S.p.A.

The Italian Fascist movement's attitudes towards the aesthetics of material culture were no less schizophrenic than those of its ally, the German Nazi state: in architecture, the government espoused both the stylistic mélange of Ulisse Stacchini's Stazione Centrale in Milan and the delicate avant-garde modernism of Giuseppe Terragni's Casa del Fascio in Como. Although modernist design has been revealed to be ideologically promiscuous,[39] it seems to have been less influenced by socialism in Italy than elsewhere. This may very well have to do with the heritage of futurism.

Italy's industrialisation was late, slow and piecemeal—hence the fascination it held for the futurists. Mass production of consumer goods on a significant scale would be a long time in coming, so the incentives for consolidating the industrial design profession were few. Still, some Italian architects, artists and theoreticians were concerned with the material culture of serial production, although their interest was mainly aesthetic, skating over the social implications so hotly debated in central and northern Europe at this time. The

Biennali and Triennali in Monza (moved to Milan from 1933 onwards) were important laboratories for what was called the *cultura materiale* and the interaction between the arts, but in this early period they mostly functioned as showcases for the *borghese.*

The pioneers of this new, bourgeois modernism included Gio Ponti, Luigi Figini, Gino Pollini, Giuseppe Pagano and Pietro Chiesa, working for companies such as Fontana, Olivetti and Columbus (Figure 0.5). In this early period, they were more concerned with creating a style or expression that reflected the characteristics of industrial production and differed from artisan tradition than with providing a public with affordable and rational products.[40] The aim was 'to unify the different artistic operations in a single fundamental experience, able to transform the face of the environment in which we live, to create a new style'.[41]

However, seeing what the Second World War did to the production system and the life of ordinary people, Gio Ponti became interested in the social responsibility of industrial design. In 1943 he wrote:

> Only in rare cases has the production of domestic equipment reached forms suitable for our lives, but these sporadic examples, which are reserved for a limited category of persons due to their exclusivity, cannot satisfy the needs of common people.[42]

Ponti's social awakening was symptomatic of a shift from interwar bourgeois formalism to the 'proletarian' idealism of the early post-war period, which significantly altered the rhetoric of design reform.

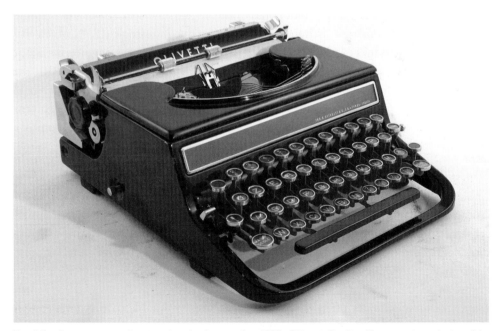

Fig. 0.5 Bourgeois modernism by the letter: the 1935 Olivetti Studio 42 typewriter designed by Aleksander Schawinsky, Luigi Figini and Gino Pollini. © Museo Nazionale della Scienza e della Tecnologia Leonardo da Vinci.

THE REPUBLIC AND PUBLIC ENTERPRISE

The period after the Second World War witnessed the consolidation of the Italian Republic as we know it today, as well as the founding of the main political balance of power and the new state structure. The Christian Democrats (Democrazia Cristiana [DC]) gained and retained power through the first post-war legislature, from 1948 to 1953. Although many Italians soon became dissatisfied with the government, the DC remained the largest single party by far, receiving 40.1 per cent of the vote in the 1953 general election when Giuseppe Pella formed a minority government relying on the support of the small centre and right-wing parties.[43] The 1953 election heralded a long period of 'stable instability' in which the DC and minority coalition governments rapidly exchanged power so that their freedom of action was severely curtailed. Italy became a non-socialist democracy, despite the strong presence of socialist and communist groups (the Communist Party received 22.6 per cent of the vote in the 1953 election).

In the world of industrial design, the socialist and communist influence surfaced in the VIII Triennale di Milano, for example, which was instantly dubbed the 'proletarian Triennale'. If the left-wing parties had succeeded in gaining government influence, the development of Italian design might have taken a different path. Instead, the Italian nation and the history of Italian design alike were formed under the rule of the DC.

Another prominent feature of the Italian state was the *enti pubblici*—government special agencies, of which there were 841 national examples in 1947. The most important of these were the autonomous state agencies administrating the railways, telephone system, postal services and state monopolies.[44] The largest state agency was the Institute for Industrial Reconstruction (Istituto per la Ricostruzione Industriale [IRI]), which employed 216,000 staff by 1948, working across key industries like steel, engineering, shipbuilding, shipping, electricity and communications (telephony). Through the IRI, the state controlled a large number of companies, alongside private investors who often held shares in these joint-stock enterprises. The IRI rendered the state and the DC government less dependent on the private industrial elite, as well as enabling the state to play a very important part in the impending 'economic miracle' (Figure 0.6).[45]

MANUFACTURING STRUCTURE

Unlike Britain, Germany and France, Italy did not participate in the first wave of industrialisation in the nineteenth century. This relatively late engagement with industry, combined with government policies, contributed to Italy's particular industrial structure, dominated by small, often family-owned companies. While some large corporations made indispensable contributions to Italian industry, in comparison with Italy's European neighbours that had industrialised early, smaller firms dominated the Italian context. This situation is often claimed to have been favourable to the development of design: less tradition meant fewer obstacles and less baggage from the past, more freedom in innovation and, possibly, more daring experimentation. A young, diversified and flexible industrial structure could, without the burdens and restrictions of past

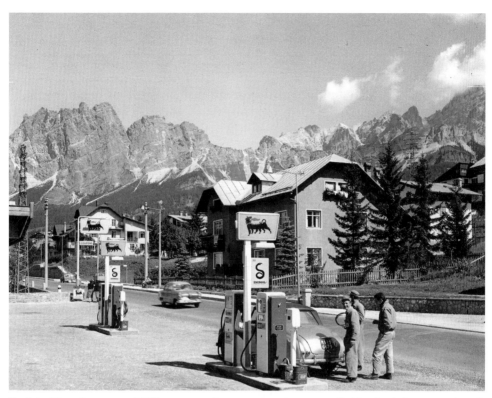

Fig. 0.6 The oil company AGIP was one of many enterprises controlled by the Italian state through the Institute for Industrial Reconstruction (Istituto per la Ricostruzione Industriale). AGIP became an important design commissioner with high visibility in Italian material culture, for example through its ubiquitous gas stations. From Cortina d'Ampezzo in 1954. Image courtesy of Archivio Storico ENI.

traditions, meet the new conditions created by technological innovations. In fact, in new companies, start-up difficulties were often solved through experimentation with new manufacturing methods, while embracing creativity in the loosest sense promised success in formal terms. Similarly, Renzo Zorzi has noted that Italian industry was characterised by an elastic internal structure, which enabled it to respond more easily in case of failed projects, while being less hidebound by habit and tradition.[46]

However, larger companies, too, showed an increasing interest in industrial design. In the Olivetti corporation, one of the world's largest producers of office machines, the company's president and founder's son, Adriano Olivetti, had worked since before the war to create a unifying corporate identity. His pioneering project included engaging young and talented architects and designers such as Marcello Nizzoli, Ignazio Gardella and Ettore Sottsass to overhaul everything from the architecture of company buildings, graphic design and advertising to product design. Adriano Olivetti's devotion to the *cultura materiale* extended beyond his own firm; he contributed to the diffusion of industrial design by, for example, participating in the public discourse on

design and joining the Associazione per il Disegno Industriale (ADI). Olivetti's design programme achieved international recognition: in 1952 New York's MoMA formally included graphic and industrial design in its remit and chose Olivetti for its very first monographic exhibition.[47]

The fact that Italy's industrial structure, from small family firms to the few bigger ones, showed such dedication to design and innovation was based on a number of factors that favoured inventive design: many firms had to start from scratch; the industrial sector was varied so that small, flexible companies and large corporations existed in a fruitful symbiosis; and, furthermore, governmental support secured through the IRI assisted many firms during the difficult start-up stage.

CONSUMPTION GROWTH

The Italian economy grew considerably in the period after the Second World War. The economic boom increased public wealth and private consumption. The rise of the consumer goods industry, especially electric appliances, radios and televisions (official television broadcasts started in 1954), and the evolution of mass production mirrored the increasing standard of living.[48]

The scooter clearly illustrates the increased importance of consumer goods during the post-war period of economic growth. Piaggio's Vespa, designed by Corradino D'Ascanio in 1946, and Innocenti's Lambretta, designed by Cesare Pallavicino in 1947, dominated the market. They were the first individual means of motorised transport available to a larger part of the population; in the years directly following the Second World War, the scooter was enjoyed by the middle classes, but it was not long before it became accessible to working-class consumers (see Thomas Brandt's chapter in this volume for a detailed account of Vespa user cultures). The next step in the development of a consumption culture surrounding personal transport, illustrating the increased wealth of the middle classes, was the much-desired 'Italian Volkswagen', the Fiat 500, designed by Dante Giacosa in 1956. The increasing desire and need for individual, private transport was certainly not diminished by the building of the *autostrade*, a huge government project with enormous spin-off effects in terms of employment. Federico Paolini's chapter here provides for a contextual discussion of Italy's car industry.

As a result of the Marshall Plan and new free trade agreements, the European markets, including that of Italy, opened up from the 1950s.[49] Italian economic growth was comparatively impressive. Between 1950 and 1960, the Italian gross national product (GNP) increased annually by 5.9 per cent, while the corresponding number for France was 4.4 per cent, for Scandinavia 3.5 per cent and for Great Britain 2.6 per cent. Between 1946–1950 and 1956–1960, industry's contribution to the GNP jumped from 36.9 to 46.9 per cent. Investments in the manufacturing industry rose from 4.5 per cent of the GNP in 1953 to 5.2 per cent in 1956 and 6.3 per cent in 1962.[50]

The reasons for this remarkable development have already been noted: Marshall Plan aid, government intervention and the characteristics of the industrial structure. Two

additional elements should be mentioned: First, immense migration to the industrial centres in the north exceeded the demand for labour, resulting in high unemployment (averaging 7.3 per cent throughout the 1950s). Second, unemployment, combined with weak labour unions, allowed wages to remain modest, thereby improving profitability and avoiding inflation. At the same time, Italy managed to create a vital domestic market: consumption increased an incredible 59.8 per cent between 1950 and 1961.[51]

This considerable growth in private consumption and industrial output, and the rapid evolution of technology and production methods, strongly influenced Italian industrial design. Growing purchasing power enabled the public to shift from acquiring basic necessities to demanding more diversified, advanced and refined products to satisfy the expanding upper-level market. This development challenged the ascetic foundations of modernist ideas and changed design.

FROM *BEL DESIGN* TO ANTIDESIGN

Throughout the 1960s, Italy strengthened its position as a world-leading laboratory for new design ideas—for example, taking the lead in the antidesign movement of the late 1960s and in postmodernism a decade later. The growing distance of war and poverty informed the evolution of design in the first half of the 1960s. The 'proletarian' mindset diminished as the market for products that satisfied wants rather than needs increased. This development was reflected in the themes of the Triennali: the VIII Triennale in 1947 examined 'reconstruction as a social problem', the 1960 edition was dedicated to *la casa e la scuola* ('house and school'), and at the XIII Triennale of 1964 the theme was *Il tempo libero* ('free time') (Figure 0.7). Italian society and design had changed profoundly through the immense development of the 1950s, and the growth in wealth and technological invention continued in the 1960s.

In Italy, the term *bel design* represented the mainstream commercial design that experimented with new shapes and materials, incorporating the plastic revolution led by companies such as Kartell and designers including Joe Colombo, Marco Zanuso, Richard Sapper and Mario Bellini. The invention of polypropylene made it possible to make solid chairs, tables and domestic equipment from one cast in every conceivable colour and form.[52] The will and ability to experiment made Italy a pioneer in radical modern design. During the mid-1960s, the symbiosis of design and industry was heavily critiqued; among the first and most powerful reactions in Italy was the move among the country's designers to distance production and consumption.[53]

This development was a part of, and inspired by, new radical expressions in art, politics and the youth culture of the 1960s. Advances in space technology and cultural responses such as Stanley Kubrick's film *2001—A Space Odyssey* inspired designers to create futuristic habitats. The American hippie movement and the student riots in European cities presaged the occupation of the XIV Triennale during the summer of 1968.[54] Leading pop artists such as Roy Lichtenstein and Andy Warhol influenced Italian designers to play with forms, symbols and connotations. The result was objects that were more

Fig. 0.7 The times they are a-changing: the installation 'Il Caleidoscopio' by Vittorio Gregotti, Giotto Stoppino and Lodovico Meneghetti, projecting film montage by Peppo Brivio on the theme of leisure and labour on tilted mirror walls at the XIII Triennale di Milano (1964). Image courtesy of the Fondazione La Triennale di Milano.

statements than products, like the hat-and-coat stand Cactus by Guido Drocco and Franco Mello from 1971 and the chair/bed Pratone by Gruppo Strum from 1970.

Most of these *antidesign* experiments were carried out by design groups formed in the late 1960s, including Superstudio and Archizoom Associati, both founded in Florence in 1966 (led by Adolfo Natalini and Andrea Branzi respectively); Gruppo Strum, founded in Turin in the same year; Gruppo 9999, founded the following year in Florence by Giorgio Birelli, Carlo Caldini, Fabrizio Fiumi and Paolo Galli; and Gruppo G14, launched in the late 1960s by Gianfranco Fachetti, Umberto Orsoni, Gianni Pareschi, Guiseppe Pensotti and Roberto Ubaldi. Their common denominator was the desire to critique the world of consumption, and most of their projects remained as prototypes without ever being mass-produced. A notable exception was Piero Gatti, Franco Teodoro and Cesare Paolini's famous Sacco chair of 1968, which became a huge commercial success (Figure 0.8).[55]

THE POWER OF PLAY

Italy's succession of design groups adopted various approaches from the theoretical to the playful as late 1960s antidesign (radical design, critical design) and its critique of

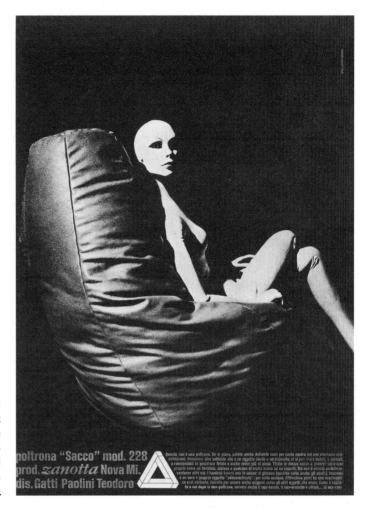

Fig. 0.8 Antidesign goes mainstream: advertisement for the 1968 Zanotta Sacco beanbag designed by Piero Gatti, Franco Teodoro and Cesare Paolini. Image courtesy of Zanotta S.p.A.—Italy.

consumption developed into the neoradical design of the late 1970s and early 1980s, partly in opposition to neomodernism. In 1973 Michele de Lucchi founded the group Cavart in Padua, and Ugo la Pietra co-founded Global Tools at the *Casabella* office with an amalgam of notable individuals and groups, including Andrea Branzi, Riccardo Dalisi, Michele de Lucchi, Alessandro Mendini, Ettore Sottsass, Gruppo 9999, Superstudio and Studio Alchimia, founded in Milan in 1976 by Alessandro Guerriero and still active today. Design activity and debate in Italy since 1970 have resulted from the work of design networks centred not only on design groups and key individuals (Sottsass preeminent among them; see Penny Sparke's chapter in this volume) but also on mediating channels, such as *Casabella* (edited by Alessandro Mendini from 1970 to 1975) and *Modo* (1977–2006, founded by Alessandro Mendini), as well as existing titles including *Domus* (1928–) and *Abitare* (1962–);[56] educational institutions, notably in Florence and Milan; and—as discussed below—exhibitions and trade fairs.

The pivotal 1972 exhibition *Italy: The New Domestic Landscape* at the MoMA in New York occurred at a point when the critical zeal of late 1960s antidesign had dissolved into another tranche of dissatisfaction, this time directed not at neomodernism but rather at the way even criticality had been commodified (see Catharine Rossi's chapter in this volume). Work on display at MoMA proposed that designers should shift from designing objects to 'designing behaviours'[57] and that a pastoral or primitive craft practice could form an antidote to industrial design for mass production. Sparke notes in her chapter here that Sottsass became depressed by the thought that he, as a designer, was an enemy producer of products. Yet, however politically committed radical and neoradical design might have been, it functioned, nevertheless, as a catalyst for design with a playful purpose.

Although Archizoom closed relatively early, in 1974 (the same year that Giugiaro's influential Volkswagen Golf was launched), it was the turn of the decade in 1980 that heralded a real shift in Italian design, within a context of political turmoil. As Italy emerged from the particularly turbulent years of the mid- to late-1970s, in which the country had sustained thousands of terrorist attacks and the kidnapping of President Aldo Moro in 1978 by the Brigate Rosse (founded in 1970), the post-war 'economic miracle', and its resultant secular consumerism, diminished the popularity of both communism and the Christian Democrats in Italy. Politically, the 1980s were characterised by pluralism: by 1981, when the census showed the Italian population had risen to 56.5 million, Giovanni Spadolini became the first non–Christian Democrat Italian prime minister. His five-party coalition government, the *pentapartito*, remained in power until 1992. In this political climate, the Radical Party (Partito Radicale), with support from other parties, was able to push through a series of legislative reforms including those related to divorce and abortion. During the 1980s in Italy inflation fell and the economy grew, with growth mostly among small- and medium-sized family firms and concomitant 'industrial districts' of specialisation in one product type.[58]

The year 1980 was a watershed for Italian design, both mass-market and avant-garde. The Compasso d'Oro had been relaunched in 1979, the same year that the remarkably prolific Giorgetto Giugiaro, who also designed the aforementioned Volkswagen Golf, designed the Fiat Panda. Launched in 1980, the Panda remained in production until 2003, when a first redesign was introduced; a second redesign followed in 2011. Worldwide 6.5 million Pandas have been sold (see Federico Paolini's chapter in this volume for more on the market penetration of the small family car). (See Figure 0.9.) If the Panda exemplified Italy's success in mass manufacture, it was a different aspect of her economic and manufacturing base that facilitated Italy's leading role in the emergence of postmodern design.[59] As Glenn Adamson and Jane Pavitt note in a recent survey of postmodern design, 'late capitalist, post-fordist service culture could meet localized, specialist and traditional forms of production, shake hands and do business'.[60] In 1980 Venice hosted the inaugural Architecture Biennale, with exhibits including Paolo Portoghesi's 'The Presence of the Past' and Alessandro Mendini's 'The Banal Object', which examined postmodernism and postradical design respectively. The following year, just as

Superstudio was winding down to its cessation in 1982 (Archivio Superstudio launched its ongoing exhibition programme in 2001), Memphis staged its first exhibition. Born of Sottsass's dissatisfaction with what Sparke terms the 'excessively theoretical and pessimistic' approach of Studio Alchimia, combined with his interests in Indian spirituality and US pop culture, Memphis encompassed both an imaginative, ritualistic approach to the object and mass appeal. The story of Italian postmodernism in the 1980s and 1990s is well known, with, for example, the household goods of Alessi S.p.A. epitomising domestic postmodernism.[61] Andrea Branzi's exhibition at the XIX Triennale di Milano (1996), 'Italian Design 1964–90', provided an opportunity to reflect on Italian postmodern design as well as contribute to its historiography.

The Italian 1980s were by no means untroubled: the 'years of lead' continued throughout, as did the continued use of the public sector as an arena for political horse-trading, with the result that by 1992 total public debt was 103 per cent of the gross domestic product, and this figure was set to increase.[62] While Italy's first postgraduate design school, the Domus Academy, opened in 1983, the same year that the International Council of Societies of Industrial Design (ICSID) international congress was held in Milan, it would be ten years before the Politecnico di Milano's influential degree in industrial design launched. The *tangentopoli* corruption scandal led to political collapse, the closure of all five of the *pentapartito* parties in 1994 and the rise of moderate right Forza Italia party

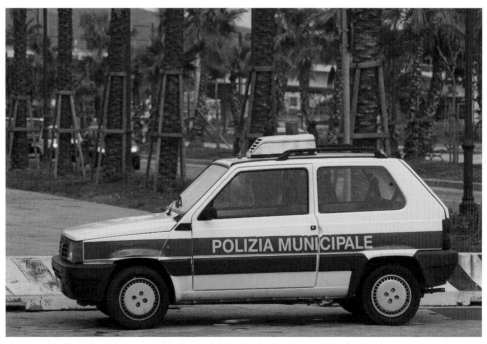

Fig. 0.9 Fiat Panda police car in Olbia, Sicily, March 31, 2009. © Superbass / CC-BY-SA-3.0 via Wikimedia Commons at http://commons.wikimedia.org/wiki/File:Fiat_panda_policia_olbia.jpg.

leader Silvio Berlusconi as prime minister until he, too, became embroiled in the cor-
ruption investigation. However, although the Italian Republic voted in its first left-wing
government in 1996, Berslusconi had regained power by 2001 and retained it until 2011,
with a two-year hiatus (2006–2008). Berlusconi's mutually reinforcing grip on Italy's
politics and media, and a regime of self-interest rather than public investment, has been
blamed for the country's perilous financial situation, yet Italy's commercial successes are
evident, not least in the fashion industry.[63]

Italy's pre-eminence in fashion may centre on high-fashion houses such as Armani,
Dolce & Gabbana, Prada and Versace, but her approach to mass-market brands is equally
innovative (see Simona Segre Reinach's chapter in this volume for more on market seg-
mentation in the Italian fashion industry). For Italian brands, mass-market appeal does
not necessitate an adherence to the constraints of the lowest common denominator.
For example, with Ettore Sottsass as their interior design consultant and Oliviero To-
scani's risqué advertising campaign images, clothes retailer Fiorucci arguably did more
to publicise the design philosophy of Memphis than all the Carlton bookcases in all the
museums around the world. In the early 1980s, Toscani worked on Esprit's 'Real People'
campaign in a design programme that included headquarters in Düsseldorf and Milan
that had been designed by Sottsass and Antonio Citterio respectively.[64] He also photo-
graphed lighting for Artemide and the Hotel Alessi range for Alessi. His work contin-
ued with the 'United Colours of Benetton' advertising campaign (1982–2000) featuring
photographs designed to generate debate—and publicity for Benetton—from a black
woman breastfeeding a white baby to a nun kissing a priest, and from Therese Frare's
image of a man dying of AIDS to an ad showing fifty-six sets of genitalia, which was
banned in the United Kingdom.[65] Toscani's controversial print and billboard campaigns
were supported by his launch of Benetton's *Colors* magazine with an annual budget of
$3 million, for which he worked as editorial director, with Tibor Kalman as editor in
chief from 1991 to 1995.[66] Benetton's current 'Unhate' campaign, featuring politically
opposed politicians and leaders kissing, bears Toscani's influence.

Since 1991 Renzo Rosso's jeans company Diesel, based in Breganze near Venice, has
pursued a print campaign that combines traces of Toscani's and Kalman's political in-
vestment with much irony (Figure 0.10). For design commentator Rick Poynor these
advertisements, featuring a 'riotous parade of leathery sun-worshippers; sadistic dentists;
generals in nappies; cannibal pigs; a boardroom full of blow-up dolls' and so on signalled
'madly that Diesel was every bit as wised-up and ironic as its young buyers, for whom
almost any subject—politics, religion, the family, love, history, the environment—was
suitable material for disengaged, postmodern fun'.[67] Like Benetton's 'United Colours'
and 'Unhate' campaigns, Diesel's in-house campaigns centre on globalisation. And just as
British clothing company Superdry has achieved enormous success with its faux-Japanese
aesthetic, Diesel has marketed itself as the all-American jeans company. In so doing, Die-
sel has ignored the 'made in Italy' advantage and has instead scoured the world in search
of design inspiration and has promoted a trenchantly global message.

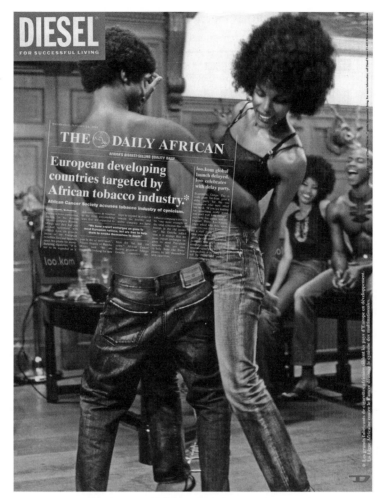

Fig. 0.10 'The Daily African' advertisement, Diesel 'For Successful Living' campaign, 2000. Image from the Advertising Archives.

BEYOND THE *TRIENNALI:* EXHIBITING TRADE AND INDUSTRY

Following the institution of the Biennali in Monza in 1923, the Triennale was launched in 1930 and moved to its present home in 1933. Triennale di Milano exhibitions recognised by the Bureau International des Expositions took place in 1933, 1936, 1940, 1947, 1951, 1954, 1957, 1960, 1964, 1968, 1988, 1991 and 1996.[68] While design historians have used the Triennali as rich case studies for understanding design practice and design philosophy in Italy in the twentieth century,[69] Italy's immensely commercially successful trade fairs are worthy of increased design historical attention. In 'rethinking a century of Italian design', this book seeks to provide a new contribution to the historiography based not only on recognising that 'made in Italy' is an international phenomenon in terms of its design and production, mediation and consumption but also on emphasising

non-elite everyday design. As well as functioning as a magnet for designers from around the world, the international leverage of 'made in Italy' is exercised not least through Italy's pre-eminent design expositions and trade fairs attracting buyers, retailers and mediators. It is these mediating actors who direct the attention of consumers around the world to design shown, if not made, in Italy.

Known in English as the Milan furniture fair, the Milan Salone or Milan design week, the annual Salone Internazionale del Mobile di Milano was launched in 1961 (with its first combined exhibit shown in 1965) to showcase Italian furniture manufacture. In 1961, 328 exhibitors (all Italian), ranged over 1,022 square metres (11,000 square feet) of exhibition space, attracted 11,300 Italian visitors and 800 foreigners. International exhibitors were admitted every other year from 1967 until 1989, and the Salone has been entirely international since its thirtieth anniversary in 1991. It is now the world's largest trade fair for home furnishings and is the furniture equivalent of the Milan, New York, London and Paris fashion weeks combined. The Salone has combined with various partner exhibitions including Euroluce, the international lighting biennial, and various kitchen, furnishing accessories and workspace fairs. In 2012 almost 300,000 industry attendees, two-thirds from outside Italy, as well as nearly 40,000 members of the general public and 6,500 media personnel came to see 965 Italian and 290 non-Italian exhibitors in an exhibition complex of more than 143,000 square metres (1.5 million square feet).[70] This scope means there is room for all corners of the home furnishings market, from high-end designer labels such as Missoni to more mass-market manufacturers (Figure 0.11).

A notable organiser of trade fairs was founded in 1954 as the Centro di Firenze per la Moda Italiana, with trading transferred to Centro Moda from 1983 and to Pitti Immagine from 1988. Building on the development of Florence as a fashion centre, and the first fashion show aimed at international buyers in 1951, the Palazzo Pitti hosted fashion shows from 1952 to 1982. By 1955 there were 500 buyers and 200 shows at the Pitti. From 1967 the high-fashion shows were staged in Rome (later moving to Milan), while Florence retained the boutique and knitwear shows. In the 1970s the Centro di Firenze per la Moda Italiana branched out into menswear (Pitti Uomo, founded in 1972), children's wear (Pitti Bimbo, founded in 1975), yarns and knitwear (Pitti Filati, founded in 1977) and domestic textiles (Pitti Casa, founded in 1978). Following a period of consolidation in the 1980s and 1990s, twenty-first-century introductions included Fragranze for fragrance (in 2004); ModaPrima (in 2006) for mass-market fast fashion; and TASTE, the Italian food industry fair (in 2006). In 2011 e.Pitti launched online virtual showrooms and fairs.[71]

The story and historiography of Italian design from the late 1960s through to the 1990s are dominated by a shift from radical design or antidesign to postmodernism. Yet the majority of Italy's design output in this period, from Iveco trucks to straw donkeys, remained largely unaffected by developments at the cutting edge of 'high design'. Furthermore, notwithstanding the catalytic role of outstanding individuals such as Sottsass, and a correspondingly canonical approach in much of the historiography, Italian design history from

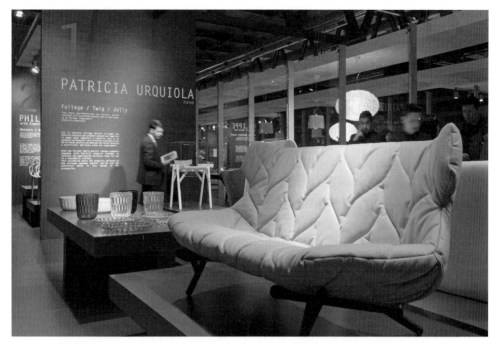

Fig. 0.11 Patricia Urquiola, Foliage sofa (polyurethane foam padding with quilted fabric upholstery and tubular painted iron legs) and Jelly vessels (polymethyl methacrylate; PMMA). Kartell Work in Project, Salone Internazionale del Mobile, Fiera Milano, Rho, April 9–14, 2012. Photograph by Saverio Lombardi Vallauri. Courtesy of Cosmit S.p.A.

the 1970s to the present is characterised by powerful collective endeavours from the most theoretical (Alchimia) to the most playful (Memphis) and from the most commercial (the Milan Salone) to the most reflective (the Triennale Design Museum, opened in 2007 with occasionally changing displays). Of course, quotidian design represents the majority of Italy's design output even though it has commanded very few of the numerous column inches devoted to mediating Italian design. *Made in Italy* contributes a historiographical corrective by attending to examples of these mass-market typologies that are hidden in plain sight, from ceramics to coffee machines, family cars to urban signage.

III. THE STRUCTURE AND CONTRIBUTION OF THIS BOOK

Made in Italy: Rethinking a Century of Italian Design offers a history of Italian design told not through a chronological structure but rather through five thematic parts, each containing a blend of broad survey chapters and detailed case study chapters. These parts draw attention to key stories and new directions in the scholarship of Italian design.

In the first chapter Maddalena Dalla Mura and Carlo Vinti review the historical and critical literature on Italian design since the mid-twentieth century in Italian and in English through a structure based on Grace Lees-Maffei's 'The Production-Consumption-Mediation Paradigm'.[72] They show the historical representation of design in Italy to have

been uneven in terms of approaches, methods and interests. Nevertheless, these discussions of Italian design have functioned to uphold a widespread belief in the singularity of Italian design.

We have noted the importance for Italian design of tightly enmeshed networks including family connections, local and regional identities and vernacular design practice, a particularly theorised understanding of design (stemming from the tendency for designers to enter industry following architectural training) and links between designers and design journalists. The opening part, 'Actors', recognises the role of individuals as catalysts in shaping, changing and reflecting on Italian design within these networks. It demonstrates the value of reassessing the well-known and celebrated figures that typically populate the canon of Italian design as well as recognising the contributions of lesser-known designers.

In chapter two, Penny Sparke explores the reasons for the emergence of a 'critical' design movement in Italy from the mid-1960s to the mid-1980s, with particular emphasis on the work of Ettore Sottsass and his influence on younger designers. Sparke suggests that it was because modern design was so embedded in the country's political, economic and cultural mission, and because post-war Italian design was rooted in modernist architectural ideology, that it was able to become its own self-reflexive critic within the era of late modernism and postmodernism. The actors addressed in this book are not only the canonised figures of Italian design history; marginalised figures also appear here. In chapter three, Jeffrey T. Schnapp discusses Roberto Mango's work as displaying the influence of both R. Buckminster Fuller and Franco Albini, bridging American and Italian industrial design. In chapter four, Raimonda Riccini explores Tomás Maldonado's design practice, rather than his more famous theoretical work, focusing on his collaboration with Olivetti to design products that, today, sit outside the group of 'made in Italy' icons. Such collaborations (whether or not they are deemed successful) demonstrate the influence of Ulm methodologies on large Italian manufacturers, that is, until structural changes favoured smaller companies and the emergence of postmodern culture.

As noted, Italy industrialised comparatively late, in the twentieth century, with the result that craft remains central to the practice and narrative of Italian design. Italian craft is also shaped by the strong regionalism of a country that unified only 150 years ago. Part two offers three new approaches to the significance of craft within the history of Italian design: in education, in industry and in design debates. Elena Dellapiana and Daniela N. Prina's chapter examines the contested origins of design education in Italy, its regional nature and its relations with art education, using the ISIA (Istituto Superiore di Industrie Artistiche, 1922–1943) and the Biennali di Monza decorative arts exhibitions as examples. Dellapiana and Prina show Guido Marangoni, a politician and the curator of Milan's Castello Sforzesco, and others working to merge design, manufacturing skills and Italian artistic traditions so that local networks of specialised artisans could catalyse different production methods. Maintaining a 'non-ideological' profile allowed designers and industrialists to continue working during the totalitarian

period and afterward, until the establishment of disciplinary status for industrial design in the early 1950s.

Lisa Hockemeyer's chapter further opens up the relationship between fine and applied art practice, a theme continued in chapters by Vanessa Rocco and Imma Forino. Italian design discourse has emphasised industry and neglected Italy's applied and decorative arts, even though Italy's artisanal traditions differentiate her output from those of other countries. Italy's vast ceramics 'industry' is its most aesthetically heterogeneous, oldest and geographically most widespread production sector. Majolica was among Italy's most profitable export industries, reaching a peak in the mid-1950s. This chapter continues the discussion of networks in part one and anticipates the analysis of Italy's key industries in part four.

In the closing chapter of part two, Catharine Rossi returns to the radical design addressed by Sparke to consider the ways in which craft was understood, politicised and ideologically charged. Enzo Mari's *Proposta per un'Autoprogettazione* (1974), Riccardo Dalisi's experiments in *tecnica povera* with Neapolitan street children (1971–1973), the work of Global Tools (1973–1976) and Superstudio's 'Cultura Materiale Extraurbana' (1976) each demonstrate a critical utopianism informed by Marxist opposition to mass production and consumption in which unalienated amateur artisanal making promised to mend the contemporary crisis in design.

Part three, 'Spaces', demonstrates the richness of an inclusive understanding of architectural place, space and display, ranging from the relatively intimate space of the private art gallery, via the exhibition of ideological narratives of and to the nation, to the public spaces of city transport infrastructure. Imma Forino traces the critical anti-establishment role played by private galleries in exhibiting selections of art by well-informed curators and pioneering owners in appropriately modified interiors from 1920 to 1960. These galleries were intellectual meeting places and sites for the exchange of ideas; they published books and catalogues, hosted lectures and mediated design to their visitors, not least through their arrangements of interiors, furniture and display stands for showing art. Vanessa Rocco examines Mussolini's desire to control and disseminate narratives of the Fascist regime to the masses through exhibition design. From Giuseppe Terragni's Sala O of La Mostra della Rivoluzione Fascista in Rome (1932) to the new prominence given to decorative art displays in the Venice Biennali from 1932 to 1942, these exhibitions demonstrated the reach of Fascism into all aspects of life and made everyday life the site of sanctioned spectacle. Closing part three, Gabriele Oropallo explores design of and in the city. While Bob Noorda's signage for the Milan underground (1964) and the New York subway (in collaboration with Massimo Vignelli) countered the top-down strategy of early modernists, and the direct opposition of the radical design groups, by bringing an idealised user (the designer himself) into a process of negotiation with community and transport officials, Albe Steiner followed architect Giancarlo De Carlo's emphasis on participatory design processes by trying to engage *actual* users both ideologically and pragmatically as key stakeholders in the design process in his design for the municipality of Urbino's corporate identity.

Production, consumption and mediation are of course intertwined and mutually con-
stitutive practices. In order to distinguish points in the design life cycle at which mean-
ings accrue, and to highlight the methodological benefits of these various focal points,
Made in Italy artificially separates production, addressed in part four, 'Industries', from
consumption and mediation, addressed in part five, 'Mediations'. That is not to say that
the chapters in part four do not deal with consumption—they do—but rather to draw
attention to the fact that these chapters take as their unit of analysis an entire industry or
product type in a macroperspective quite different from the case studies found elsewhere
in the book.

Part four focuses on three of the industries on which Italy's international reputation
for design excellence is centred: cars, coffee and fashion. Federico Paolini charts the
adoption of the car by the mass of Italian consumers. As well as revolutionising land
transport, Italian-made cars were primary actors in modernisation, symbols of freedom,
independence, well-being and progress. At home, cars such as Dante Giacosa's Fiat 500
were the most prominent symbols of modernisation, whereas the international reputa-
tion of Italian car design was boosted by Lancia and Alfa Romeo's elegant and expensive
cars. Jonathan Morris shows how the espresso machine is as much an icon of Italy as the
coffee itself. Since the first commercial espresso machines designed by Luigi Bezzera and
manufactured by Desiderio Pavoni were introduced a century ago, Italian firms have
continued to dominate the global market, accounting for some 70 per cent of produc-
tion. Morris traces the evolution of these machines as exemplifying, if not epitomising,
the transformation of Italy from an agrarian society into an industrialised consumer so-
ciety. Simona Segre Reinach questions the distinction between *Italian fashion*, the birth
of which is supposed to date back to the Florence fashion shows in the early 1950s, and
made in Italy, which is principally associated with Milanese prêt-à-porter fashion design-
ers of the 1970s and 1980s. While the French fashion industry is characterised by large
luxury groups that hold several brands, such as Kering and LVHM, in Italy brands are
more often family-owned. And Italy has not developed a street style or a culture of inde-
pendent designers, unlike the Anglo-Saxon countries. Post prêt-à-porter, Italian fashion
swings between fast-fashion logic and traditional craftsmanship.

The book's final part, 'Mediations', examines what happens to Italian goods after man-
ufacture. Italy's reputation for design excellence is based not only on design ideation and
manufacture but also on the ways in which Italian design has been mediated, for example
in design magazines and in corporate literature, and on practices of consumption. We
have established in our separately published work the methodological value of the rela-
tively recent mediation turn in design history,[73] and its application here to Italian design,
specifically, represents one strand of the new thinking offered in the book.

Kjetil Fallan shows how the rationalist logic and socialist ambitions that informed
the reconstruction efforts of the immediate post-war period slowly gave way to the more
experimental attitudes and liberal aspirations that came to characterise Italian design

culture. Alberto Rosselli's *Stile Industria* was established in 1954 as an offshoot of the architectural magazine *Domus*, edited by Rosselli's colleague and father-in-law Gio Ponti. Although *Stile Industria* never achieved the public and commercial success of its parent publication (it folded in 1963), it quickly became a primary arena for debate in the then-consolidating industrial design community and therefore functions as a barometer of significant changes in Italian design culture during a turbulent decade. Thomas Brandt reveals that the symbolic construction of the Italian Vespa has been informed by everything from bureaucratic decisions about traffic regulations to Hollywood cinematography. Brandt explains how Piaggio used the 'brand community' of the Vespa clubs to position its customers as 'good Italians', but a range of societal and cultural changes in the 1960s contributed to the clubs' decline in Italy and abroad. This story sheds light on how producers and consumers co-design the ways in which industrial artefacts are used and perceived. Finally, Grace Lees-Maffei interrogates the notion, myth or unofficial brand of 'made in Italy' as shorthand for indicating the quality and specialness of Italian design. She challenges the production emphasis of 'made' by recalling that, semantically, products are as much 'made' through their consumption and mediation as they are through their manufacture. The chapter also seeks to understand Italian design not only 'in Italy' but also outside Italy, using England as a case study, because national identities in design, as in all else, are formed internationally as well as at home.

CONCLUSION

In recognising the global, hybrid nature of design and designers we must not lose sight of national and regional influences that impact in numerous subtle and important ways on the things and processes people design, and the ways in which they do it. Italian design, particularly, has too often been aestheticised at the expense of a thoroughgoing design historical—meaning historically contextualised—production-, consumption- and mediation-oriented approach, as Dalla Mura and Vinti trace in the following historiographical chapter.

Made in Italy brings together new and innovative writing from an international group of experts to provide a coherent survey of the most innovative current work on Italian design. We intend that this book will inform the understanding of and approaches to Italian design by students, teachers, researchers and practitioners in a range of fields including not only design history, design criticism, design studies, design pedagogy, material culture studies, museum studies, architectural history, architecture, craft and all of the design disciplines represented in the book (including automotive design, fashion design, graphic design, corporate identity, information design, exhibition design, product design, ceramic design and interior and spatial design) but also Italian studies, area studies, cultural studies, popular culture studies and literary, media and communication studies. It is our hope that the chapters in this book, and the uses to which they are put, will give Italian design the critical analysis it needs and deserves.

NOTES

1. The thorny issue of national identity in the increasingly international car industry is discussed in Jeff Werner, 'The Advantages of Being Swedish: Volvo in America', in *Scandinavian Design: Alternative Histories*, ed. Kjetil Fallan (London: Berg, 2012), 206–221.

2. Benedict Anderson, *Imagined Communities: Reflections on the Origin and Spread of Nationalism* (London: Verso, 1983); and Ernest Gellner, *Nations and Nationalism* (Oxford: Blackwell, 1983).

3. Arjun Appadurai, *Modernity at Large: Cultural Dimensions of Globalization* (Minneapolis: University of Minnesota Press, 1996), 169.

4. Jilly Traganou, 'From Nation-Bound Histories to Global Narratives of Architecture', in *Global Design History*, ed. Glenn Adamson, Giorgio Riello and Sarah Teasley (London: Routledge, 2011), 166.

5. John A. Walker, *Design History and the History of Design* (London: Pluto, 1989), 120.

6. Kjetil Fallan, 'Introduction', in *Scandinavian Design: Alternative Histories*, ed. Kjetil Fallan (London: Berg, 2012), 4–5.

7. For an account of the American system of manufacture in the context of a national history, see Ruth Schwartz Cowan, *A Social History of American Technology* (Oxford: Oxford University Press, 1997).

8. Daniel Miller, 'Coca-Cola: A Black Sweet Drink from Trinidad', in *Material Cultures: Why Some Things Matter*, ed. Daniel Miller (London: University College London Press, 1998), 169–187; and Madeleine Akrich, 'The De-scription of Technical Objects', in *Shaping Technology/Building Society: Studies in Sociotechnical Change*, ed. Wiebe Bijker and John Law (Cambridge, MA: MIT Press, 1992), 205–224.

9. Marshall McLuhan, *The Gutenberg Galaxy: The Making of Typographic Man* (Toronto: University of Toronto Press, 1962).

10. Jeffrey L. Meikle, *Design in the USA* (Oxford: Oxford University Press, 2005); Tony Fry, *Design History Australia* (Sydney: Hale & Iremonger, 1988); Lasse Brunnström, *Svensk designhistoria* (Stockholm: Raster, 2010); Pekka Korvenmaa, *Finnish Design: A Concise History* (Helsinki: University of Art and Design Helsinki, 2009); Cheryl Buckley, *Designing Modern Britain* (London: Reaktion, 2007); Mienke Simon Thomas, *Dutch Design: A History* (London: Reaktion, 2008); Penny Sparke, *Japanese Design* (London: Michael Joseph, 1986); Penny Sparke, *Design in Italy: 1870 to the Present* (New York: Abbeville Press, 1990); David Crowley, *National Style and Nation-State: Design in Poland from the Vernacular Revival to the International Style* (Manchester: Manchester University Press, 1992); and Paul Betts, *The Authority of Everyday Objects: A Cultural History of West German Industrial Design* (Berkeley: University of California Press, 2004).

11. Anna Calvera, 'Local, Regional, National, Global and Feedback: Several Issues to Be Faced with Constructing Regional Narratives', *Journal of Design History* 18, no. 4 (2005): 371–383.

12. Yuko Kikuchi, 'Design Histories and Design Studies in East Asia: Part 1', *Journal of Design History* 24, no. 3 (2011): 273.

13. Emilio Ambasz, ed., *Italy: The New Domestic Landscape: Achievements and Problems of Italian Design* (New York: Museum of Modern Art, 1972), exhibition catalogue.

14. Andrea Branzi, *The Hot House: Italian New Wave Design*, trans. C. H. Evans (London: Thames and Hudson, 1984).

15. Nally Bellati, *New Italian Design* (New York: Rizzoli, 1990); and Sparke, *Design in Italy*.

16. Alberto Bassi, *Italian Lighting Design, 1945–2000* (Milan: Electa Architecture, 2004); and Michelle Galindo, *Italian Interior Design* (Salenstein: Braun, 2010).

17. Silvana Annicchiarico, *100 Objects of Italian Design* (Rome: Gangemi Editore, 2011); and Giampiero Bosoni and Irene de Guttry, *Il Modo Italiano: Italian Design and Avant-Garde in the 20th Century* (Milan: Skira, 2006).

18. Daniela Santos Quartina, ed., *Italian Design* (Cologne: daab, 2008); and Giampiero Bosoni, *Italian Design*, with an introduction by Paola Antonelli, MoMA Design Series (New York: Museum of Modern Art and 5 Continents, 2008).

19. Grace Lees-Maffei, '*Italianità* and Internationalism: Production, Design and Mediation at Alessi, 1976–96', *Modern Italy* 7, no. 1 (2002): 37–57.

20. Nicola White, 'Max Mara and the Origins of Italian Ready-to-Wear', *Modern Italy* 1, no. 2 (1996): 63–80; Penny Sparke, 'The Straw Donkey: Tourist Kitsch or Proto-design? Craft and Design in Italy, 1945–1960', *Journal of Design History* 11, no. 1 (1998): 59–69; Penny Sparke, 'Nature, Craft, Domesticity, and the Culture of Consumption: The Feminine Face of Design in Italy, 1945–70', *Modern Italy* 4, no. 1 (1999): 59–78; Adam Arvidsson, 'From Counter-culture to Consumer Culture: Vespa and the Italian Youth Market, 1958–78', *Journal of Consumer Culture* 1, no. 1 (2001): 47–71; Lees-Maffei, '*Italianità* and Internationalism'; Javier Gimeno Martinez, 'Women Only: Design Events Restricted to Female Designers during the 1990s', *Design Issues* 23, no. 2 (2007): 17–30; Michelangelo Sabatino, 'Ghosts and Barbarians: The Vernacular in Italian Modern Architecture and Design', *Journal of Design History* 21, no. 4 (2008): 335–358; Kjetil Fallan, 'Heresy and Heroics: The Debate on the Alleged "Crisis" in Italian Industrial Design around 1960', *Modern Italy* 14, no. 3 (2009): 257–274; Catharine Rossi, 'Furniture, Feminism and the Feminine: Women Designers in Post-war Italy, 1945 to 1970', *Journal of Design History* 22, no. 3 (2009): 243–257; and Annalisa B. Pesando and Daniela Prina, 'To Educate Taste with the Hand and the Mind: Design Reform in Post-unification Italy (1884–1908)', *Journal of Design History* 25, no. 1 (2012): 32–54.

21. Viviana Narotzky, 'Selling the Nation: Identity and Design in 1980s Catalonia', *Design Issues* 25, no. 3 (2005): 68.

22. Lise Skov, 'Fashion Trends, *Japonisme* and Postmodernism: Or "What Is So Japanese about *Comme des Garçons?*"' *Theory, Culture & Society* 13, no. 3 (1996): 129–151.

23. Fernando Ortiz, *Cuban Counterpoint: Tobacco and Sugar*, trans. Harriet De Onís (Durham, NC: Duke University Press, 1995; first published as *Contrapunteo cubano de tabaco y el azúcar*, 1940). Rose Cooper and Darcy White provide a design historical application of Ortiz's work in 'Teaching Transculturation: Pedagogical Process', *Journal of Design History* 18, no. 3 (2005): 285–292. See also Viviana Narotzky, 'Our Cars in Havana', in *Autopia*, ed.

Joe Kerr and Peter Wollen (London: Reaktion, 2002), 169–176; and Grace Lees-Maffei, 'Local/Regional/National/Global', in *The Design History Reader*, ed. Grace Lees-Maffei and Rebecca Houze (Oxford: Berg, 2010), 465–510.

24. Stina Teilmann-Lock, 'The Myth of Danish Design and the Formation of National Identity: From Made in Denmark to Designed in Denmark', paper presented at the conference Recycling Myths, Inventing Nations, at the University of Wales, Gregynog, UK, July 14–16, 2010.

25. Jonathan Morris, 'Epilogue: From the First to the Second Republic 1980–2001', in *Italy: A Short History*, by Harry Hearder, ed. Jonathan Morris, 2nd ed. (Cambridge: Cambridge University Press, 2001), 264.

26. For a critical discussion of the region as an analytical category in historical studies and its relation to material culture, see Helen Berry, 'Regional Identity and Material Culture', in *History and Material Culture*, ed. Karen Harvey (London: Routledge, 2009), 139–157.

27. On Cittaslow see, for example, Susan Radstrom, 'A Place-Sustaining Framework for Local Urban Identity: An Introduction and History of Cittaslow', *IJPP—Italian Journal of Planning Practice* 1, no. 1 (2011): 90–113, http://ijpp.uniroma1.it/index.php/it/article/view/46/25 (accessed June 27, 2012); and Sarah Pink, 'Sensing Cittàslow: Slow Living and the Constitution of the Sensory City', *The Senses and Society* 2, no. 1 (2007): 59–77.

28. Alberto Alessi, *Le fabbriche dei sogni* (Milan: La Triennale di Milano, Triennale Design Museum/Mondadori Electa, 2011), 5.

29. Paola Antonelli, 'The Land of Design', in Bosoni, *Italian Design*, 9.

30. For example, Hugh Aldersey-Williams, *King and Miranda: The Poetry of the Machine* (London: Fourth Estate/Wordsearch/Rizzoli, 1991).

31. Alessi, *Le fabbriche*, 325.

32. Eric Hobsbawm, *The Age of Extremes: The Short Twentieth Century, 1914–1991* (London: Michael Joseph, 1994).

33. F. Tommaso Marinetti, 'The Founding and the Manifesto of Futurism (Feb. 1909)', in *Modernism: An Anthology*, ed. Lawrence Rainey (Oxford: Blackwell, 2005), 3–5.

34. Reyner Banham, *Theory and Design in the First Machine Age* (London: Architectural Press, 1960), 99–137.

35. Ara H. Merjian, 'A Future by Design: Giacomo Bella and the Domestication of Transcendence', *Oxford Art Journal* 35, no. 2 (2012): 121–146.

36. Gillo Dorfles, 'Introduzione', in *Tradizione e modernismo: Design 1918/1940*, ed. Anty Pansera (Milan: L'Arca, 1988), 3.

37. Merjian, 'Future by Design', 142.

38. Francesca Lanz, 'The Interior Decoration of Ocean Liners: A Chapter in Italian Design History', *Interiors* 3, no. 3 (2012): 257–258.

39. Mary Nolan, 'America and Alternative Models of Modernity in Twentieth-Century Europe', in *Technologies of Consumption: Cold War Europe in the American Century*, ed. Per Lundin and Thomas Kaiserfeld (Basingstoke: Palgrave Macmillan, 2014).

40. Anty Pansera, *Storia del disegno industriale italiano* (Bari: Laterza, 1993), 27.

41. Filiberto Menna, 'Il Futurismo e le arti applicate. La Casa d'arte italiana', in *Studi di storia dell'arte in onore di Vittorio Viale*, ed. Association Internationale des Critiques d'Art / Sezione Italiana (Turin: Fratelli Pozzo, 1967), 91–97.

42. Gio Ponti, *Domus* 192 (December 1943).

43. Paul Ginsborg, A *History of Contemporary Italy: Society and Politics, 1943–1988* (London: Penguin, 1990), 142.

44. Ibid., 150.

45. The IRI had been set up in 1934 by a Fascist regime concerned about the effects of the economic depression; it continued to provide businesses with support in the post-war period and was seen as pivotal in the economic miracle of the 1950s and 1960s.

46. Renzo Zorzi, 'Civiltá delle macchine, Civiltà delle forme', in *Civiltà delle Macchine: Tecnologie, prodotti, progetti, dell'industria meccanica italiana dalla ricostruzione all'Europa*, ed. Valerio Castronovo and Giulio Sapelli (Milan: Fabbri, 1990), 144.

47. Ibid.

48. See Emanuela Scarpellini, *Material Nation: A Consumer's History of Modern Italy*, trans. Daphne Hughes and Andrew Newton (Oxford: Oxford University Press, 2011).

49. Giulio Sapelli, 'Le trasformazioni sociali e la differenziazione industriale', in Castronovo and Sapelli, *Civiltá delle machine*, 14.

50. Valerio Castronovo, *L'industria italiana dall'Ottocento a oggi* (Milan: Mondadori, 1980), 275–276.

51. Ibid., 276–277.

52. Enzo Frateili, *Continuitá e trasformazione: Una storia del design italiano, 1928–1988* (Milan: Greco, 1989), 77–78.

53. Ibid., 104–110.

54. Paola Nicolin, 'Protest by Design: Giancarlo De Carlo and the 14th Milan Triennale', in *Cold War Modern: Design 1945–1970*, ed. David Crowley and Jane Pavitt (London: V&A Publishing, 2008), 228–233.

55. Alfonso Grassi and Anty Pansera, *Atlante del design italiano 1940/1980* (Milan: Fabbri, 1984), 45, 160.

56. On the latter, see Franca Santi Gualteri, A *Trip through Italian Design: From Stile Industria Magazine to Abitare* (Bologna: Corraini, 2003).

57. Germano Celant, 'Radical Architecture', and Filippo Menna, 'A Design for New Behaviours', in Ambasz, *Italy: The New Domestic Landscape*, 380–387, 405–414.

58. Morris, 'Epilogue', 263–265.

59. An indication of Italy's pre-eminence in the development of postmodernism is found in Michael Collins, 'Pop and Liquorice Allsorts: The 1960s to Post-modernism', in *Towards Post-modernism: Decorative Arts and Design since 1851* (New York: Little, Brown for the New York Graphic Society/British Museum, 1987), 108–143.

60. Glenn Adamson and Jane Pavitt, eds., *Postmodernism: Style and Subversion, 1970–1990* (London: V&A Publishing, 2011), 18.

61. On Alessi's attempts to recuperate its reputation, see Grace Lees-Maffei, 'Balancing the Object: The Reinvention of Alessi', *things* 6 (Summer 1997): 74–91, http://herts.academia.edu/GraceLeesMaffei/Papers (accessed November 28, 2012).

62. Morris, 'Epilogue', 269.

63. Bill Emmott, *Good Italy, Bad Italy: Why Italy Must Conquer Its Demons to Face the Future* (New Haven, CT: Yale University Press, 2012).

64. Antonio Citterio follows Nally Bellati in describing the development of Italian design in terms of generations of designers (albeit with different generations and designers), with the first wave including pioneers such as Sottsass and Mendini, and with himself as part of the second wave, or 'middle' generation. In an example of passing the baton, Citterio recalls how Sottsass recommended him for a commission to create a new store, office and showroom complex for the Esprit Italy headquarters in Milan (1985–1987). Antonio Citterio, speaking during the lecture 'The Influence of Italian Design', co-presented by Antonio Citterio and Ross Lovegrove, part 5 of the 'Made in Italy' lecture series, hosted by Deyan Sudjic, The Design Museum, London, May 20, 2010; recorded by *Dezeen* magazine, http://vimeo.com/12458251 (accessed May 21, 2012). See also Citterio's architecture practice website: http://www.antoniocitterioandpartners.it/_citterio/cit_03_arc.html (accessed May 21, 2012); and Bellati, *New Italian Design*, 11.

65. The latter was explained as related to Toscani's show at the Venice Biennale. Martin Wroe, 'Obscene Benetton Ad Halted', *The Independent*, June 20, 1993, http://www.independent.co.uk/news/uk/obscene-benetton-ad-halted-1492880.html (accessed December 3, 2012). See also Paul Rutherford, *Endless Propaganda: The Advertising of Public Goods* (Toronto: University of Toronto Press, 2000), 156–165.

66. Rick Poynor, 'Thirteen Provocations', in *Tibor Kalman: Perverse Optimist* (London: Booth-Clibborn, 1998), 236–239, reprinted in Rick Poynor, *Obey the Giant: Life in the Image World* (London: August; Basel: Birkhäuser, 2001), 155–156.

67. Rick Poynor, 'Shopping on Planet Irony', in *Obey the Giant*, 83.

68. Bureau International des Expositions, 'Milan Triennial Exhibition of Decorative Arts and Modern Architecture', n.d., http://www.bie-paris.org/site/en/expos/trienial-milan.html (accessed November 28, 2012).

69. For example, Anty Pansera, Anna Venturelli and Antonio C. Mastrobuono, 'The Triennale of Milan: Past, Present, and Future', *Design Issues* 2, no. 1 (1985): 23–32.

70. The actual figures are 292,370 trade operators (188,579 of which were foreign), 39,279 public visitors and 6,484 communication operators. Cosmit S.p.A., 'Salone Internazionale del Mobile Figures', http://www.cosmit.it/en/milano/i_saloni/salone_internazionale_del_mobile/facts_and_figures (accessed November 28, 2012).

71. 'Pitti Immagine Timeline', http://www.pittimmagine.com/en/corporate/about.html (accessed December 3, 2012).

72. Grace Lees-Maffei, 'The Production-Consumption-Mediation Paradigm', *Journal of Design History* 22, no. 4 (2009): 351–376.

73. Ibid.; 'Mediation', section 11 in Lees-Maffei and Houze, *The Design History Reader*, 425–464; Kjetil Fallan, *Design History: Understanding Theory and Method* (Oxford: Berg, 2010); and Fallan, *Scandinavian Design*.

I A HISTORIOGRAPHY OF ITALIAN DESIGN

MADDALENA DALLA MURA AND CARLO VINTI

INTRODUCTION

By 2011, the year marking the 150th anniversary of Italy's unification, Italian design had seen more than its fair share of rhetoric. Certain exhibitions and publications have portrayed its history as key to understanding Italian society and identity, as well as being a stimulus for the future. According to this reading, after the Second World War, and in the wake of the economic miracle, a design phenomenon occurred, thanks to a relatively small group of passionate men and thanks, too, to enlightened (Milanese/Lombard) leaders of small and medium-sized companies, all of whom were motivated by a deep sense of beauty rather than by strictly commercial agendas. Although this process was chronologically behind that of other modern nations, Italian design maintained an avant-garde position. A group of products associated with the idea that Italian design and manufacture were superior, encapsulated in the slogan 'made in Italy', was established, ranging from domestic goods to automobiles. These products blended perceived artistic genius with excess, and rigorous design with traditional craftsmanship. A special approach to design developed that has contributed to reshaping daily life in Italy, while also becoming an internationally recognised model of high culture. This reading of Italian design as held together by a presumed unity reflects a historical and critical construction developed over a long period of time, one that requires revising so that a wider range of views may be taken into account.

The aim of this bibliographical essay is twofold: first, to outline the main features of historical writing on 'Italian design' up to the present century and, second, to examine the more diversified readings and lines of research that, over the past three decades, have dealt with the history of design in Italy and may help in re-examining the very idea of Italian design.

THE SINGULARITY OF ITALIAN DESIGN: A HISTORIOGRAPHICAL CONSTRUCTION

> . . . a very special, strange, and paradoxical situation, that of Italy, because while the 'official' profession of 'industrial designer' does not exist, there are personalities who are imposing themselves in the world right in the field of industrial design.[1]

Here, in a 1952 edition of *Domus* magazine, Alberto Rosselli described the situation of Italian design and the canon of the 'Linea Italiana'. He invited designers and entrepreneurs to 'close ranks' around Italian design so that it might be recognised on the

international market in association with a country 'whose vocation had always been to "create beauty"'. Rosselli renewed this call for Italian identity in 1960 in his magazine *Stile Industria* (see Kjetil Fallan's chapter in this volume) with a scrapbook-like series of notes and images edited by Bruno Alfieri. Covering the years 1939 to 1959, these notes and images sought to demonstrate the maturity of Italian industrial design in contrast to the crisis being reported by many within the Italian community of design.[2]

If it is true that historical writing started by chronicling heroes and events, it is precisely here in the 1950s–1960s—where a collective memory is built by those directly involved in the shaping of such events—that one identifies the first traces of the historiography of Italian design. Since then, there have been different and even conflicting constructions of these events. However, a double assumption seems to bind many of these accounts to those early reports: that an identifiably Italian design exists and that it is a singular type of design. The idea of this atypical feature—whether considered as a positive quality to sustain or as a deficiency that needs healing—has been particularly maintained by those authors, mainly Italian, who have attempted to give an account of the history of Italian design in its entirety.

Throughout the 1950s and 1960s debates continued about whether Italian design had reached maturity. Those who thought it had not had tended to compare it to the international situation in cultural terms, and with specific reference to the methodological and pedagogical legacy of the modern movement. Italian design oscillated between aspirations towards modernism and the rise of experiences that were theoretically and practically distant from it. Traces of this tension can be found in the varying notations with which, in 1968, the architect Vittorio Gregotti outlined the development of industrial design in Italy. Gregotti deemed the Italian experience as far from mature and characterised by production problems, in spite of its aesthetic joy. But while he placed the origins of Italian design within architectural culture, he also identified episodes of good design that had arisen 'spontaneously' from industry itself.[3]

Within just a few years, however, others placed the question of Italy's unique condition and its history outside the realm of international modernism. The exhibition *Italy: The New Domestic Landscape*, held in 1972 at the Museum of Modern Art and curated by Emilio Ambasz, introduced an American public to recent Italian design and architecture, showing that Italy had developed, and perceived itself, as an island outside of the European mainstream. In order to understand Italian design—it was explained—it was necessary to recover its historical origins and Italy's successive efforts towards modernity. Therefore, art nouveau and futurism as well as rationalism (the modern architecture and design movement in Italy, which began in the interwar years) appeared in the exhibition's catalogue essays.[4]

Also in 1972, historian and art critic Paolo Fossati declared that the alleged crisis of Italian design was a problem of discourse rather than of facts. The problem centred on the dominance of an interpretative model, functionalism, that was external to the Italian experience and therefore unable to account for its unique features and ambiguity. In his

book *Il design in Italia, 1945–1972*, Fossati traced the 'prehistory' of the 1930s and 1940s and the 'history' of the 1950s and 1960s in Italian design as the context for portraits of ten exemplary designers.[5] This account revealed that Italian design had essentially grown out of 'the shackles of the industrial system'[6] and of the functionalist ideal. Italian designers—who were not recognised as professionals—had worked rather in the promotion of existing products and with small industry, and arts and crafts practitioners, eventually developing formal solutions that, although not 'against' function in any strict sense, were always 'beyond' it, since they added 'something more' in terms of meaning. To sustain Italian design, Fossati claimed, an interdisciplinary openness towards architecture and the arts should be emphasised.

Clearly moving in the opposite direction was Gregotti. In his essay for the catalogue of the *Italy: The New Domestic Landscape* exhibition he focused on the post-war years of Italian design and broadened the chronicle of events, products and designers, up to the historicisation of the post-1950s crisis. He accused Italian design of mirroring the 'worst defects of our national character',[7] of being improvised and superficial, detached from society and generally lacking a real industrial culture. Gregotti's criticism of contemporary design compelled him to return repeatedly to the history of Italian design, with an industry-focused revisionism. He sought a context for contemporary designers based on a renewed sense of rationality, free from utopian and nihilistic tendencies. Through a series of collaborative publications,[8] Gregotti retraced the pragmatic and technical vein of the *cultura del progetto* (culture of design) back to the beginnings of industrialisation in Italy. Using the year 1860 as a starting point, he produced the first major chronological, geographical, typological and iconographic contribution to the history of Italian design. His wide-ranging study included heavy industry, patents, schools and museums of industrial arts, exhibitions and department stores, office and military equipment, airplanes and bicycles while not forgetting handicrafts, stile liberty (art nouveau) and futurism. His account, resolutely emphasising design as an industrial project, could not have gone unnoticed. For instance, Giovanni Klaus Koenig, an architect, designer and scholar, hailed it as the first draft of a 'true and complete' history of Italian industrial design and production, as he no doubt appreciated the ample treatment of anonymous products and episodes usually neglected by critical discourse.[9] On the other side, Gregotti's version of events did not please those who felt they had entered the 'second modernity'.

If one is to adopt the notions that were then in circulation, it could be argued that from the 1970s–1980s onwards, two streams of historical writing developed: on the one hand, the *cold* strand, representative of those who continued to associate Italian design with 'industrial design' and, ultimately, with the principles of modernism, however critically interpreted; and, on the other, the *hot* strand of the new avant-garde movements that were strategically engaged on several fronts, from magazines to exhibitions, in an effort to redefine design 'without specifications' as an alternative to the modernist orthodoxy.

Theorists of radical design attempted to rescue the history of Italian design from the umbrella of modernism with an approach that, although never taking the form of

historical enquiry, strongly influenced critical and historical discourse on Italian design, not least thanks to a style steeped in paradox and tautology. A first step in this process of appropriation was the exhibition Il Design Italiano Degli Anni '50 of 1977, which displayed design classics alongside crafts, small-batch productions, graphics and applied arts. In the catalogue, Andrea Branzi, one of the curators, maintained that post-war Italian design had been a style rather than an effective tool of sociocultural reform, and was a precursor of 'postmodernist choice'.[10]

Subsequently, Branzi retraced the ancient origins and historical continuities of a design culture that, as he argued in his book *The Hot House* (1984), has never really been industrial and has instead developed as a metalanguage, an 'opposition movement'.[11] Focused almost exclusively on the culture of the domestic sphere, Branzi drew attention to nineteenth-century eclecticism, crafts, decoration and the applied arts tradition, the scandalous modernity of futurism, the Latin modernity of metafisica and 'irrational' rationalism, neoliberty, pop art and fashion. Furthermore, in his *Introduzione al design italiano* (1999) Branzi placed Italian design within the broader cultural, social and political history of Italy, which he saw as a 'long period of crisis and discontinuity', always 'far ahead and far behind' Europe's developments and revolutions, as he explained.[12] Branzi's writing not only further emphasised the stereotype of Italian backwardness apparent in other accounts but also turned it into a positive rhetorical myth that pitted Italy's incomplete modernity against an idealised European modernity.[13]

Within the space between the divergent ideological histories that Gregotti and Branzi offered, more diverse historical writing developed. Besides exhibition catalogues riding the wave of New Design, rhetorically furthering the myth of Italian design, an increasing interest in design history in the 1980s led to the recovery and study of events that up until then had remained obscured. In particular, some Italian authors felt the need to bring the by then diversified history of Italian design back under the mantle of industrial design and modernity. While these attempts did not eradicate the idea of the singularity of Italian design, they revealed the problematic nature of an assumption that would gradually cease to function without thorough critical reflection on its very construction.

Anty Pansera is one such author. Since the end of the 1970s, she has maintained a consistent concern for the historiography of Italian design.[14] An art historian with a background in social history, Pansera aimed to clarify the history of Italian industrial design—which she, like other scholars, identifies with Milan and Lombardy—and design's 'official' and public dimension. Her work was therefore intended to be distinct from the anti-institutional redefinition carried out by radical design and from those accounts, such as Gregotti's, that risked dispersing the autonomy of design into too vast an industrial culture. Using primary sources and collaborating with other authors, Pansera has addressed the main fields of Italian design production and has, in addition, revealed the organisational structure existing in and around institutions and associations, exhibitions, magazines and awards. While not always succeeding in contextualising this life within the wider Italian socio-economic and political context (as she usually focuses on the

closed system of the design community), Pansera's contribution is significant, valuable and replete with suggestions for further investigation.

A more selective reading of events is presented by the architect and historian of art and architecture Renato De Fusco. Since the late 1970s De Fusco had championed historiography as a means of producing a synthetic discourse from the messy facts of reality. In the 1980s and 1990s, he achieved some influence over the development of Italian design historiography. In his 1985 international survey history of design, De Fusco traced the development of design in various countries as they gained a leading role in the international arena, with a final chapter on Italian design.[15] Focusing on paradigmatic works and themes, he read them through a 'quatrefoil' grid, as he called it, based on the coexistence of four aspects—project, production, sale and consumption—as a way of understanding design. This grid approach, however, once again portrayed Italy as anomalous, since there, as in no other country, those four moments appeared to be separated. And this very separation, according to De Fusco, was at the root of 'all sorts of contradictions'[16] in Italian design—this is how he values aspects of the latter such as individualism, the aesthetic emphasis, the persistence of craftsmanship and the high cost of products.

Around the same time, the architect and designer Enzo Frateili also published books on Italian design, based on his teaching at the Politecnico di Torino.[17] Frateili also sought to shore up Italian design against a perceived crisis of modernity, but he did so by presenting an 'ideological history', that is, the history of ideas that developed alongside that of objects. Without taking into account the larger sociocultural context, and focusing rather on technology as a guiding theme, he also contributed to creating written records of several episodes of which he also has had direct and personal knowledge, from production issues to design education and schools. Rather than bemoaning the multiplicity of languages and approaches that marked the course of design in Italy, however, he approached them through interpretive and critical writing, stressing 'continuity' as well as valuing the 'transformations', regardless of whether these changes came, for instance, from technological innovation, from the mutual exchange with other fields such as fashion or from the spirit of the new avant-garde.

In the late 1980s, a more dispassionate view of the special case of Italian design came from abroad. In *Design in Italy: 1870 to the Present* (1988), the British design historian Penny Sparke recounted the history of Italian design as a high-culture and self-conscious phenomenon that had dominated the international image of Italian modernity.[18] She focused on the most celebrated fields of Italian design, especially product design, and its most significant moments and most creative minds. In doing so, Sparke echoed the ideas, chronology and categories presented by other scholars, such as Gregotti and Pansera. However, Sparke critically integrated them with other sources on the sociopolitical and industrial history of Italy, thus offering a cogent portrait of the successes and repeated crises of Italian design, albeit with some occasionally overly deterministic connections. Sparke concluded that by the 1980s Italian design appeared 'somewhat conservative' compared to other international developments: in other words, its formula had come

to an end. In fact, it was the end of the mainstream image of Italian design that Sparke chose to recount. Yet, under the label 'design in Italy', part of the title of her book, many other versions of the story were waiting to be told.

By the end of the twentieth century, the main events of Italian design history (futurism, *bel design* of the 1950s, radical design, etc.) were incorporated into international histories of design, but attempts to qualify Italian design in its specificity and entirety did not come to an end in Italy. However, as if following an alternation rule, such attempts were made more often in terms of art, handicrafts and architecture than in terms of industry.

Several authors have aimed, in various ways, to amend a historical discourse that they have perceived as too heavily biased towards technology and industrial production. Often drawing on the ideas of Branzi and Fossati, this trend has shifted the focus towards the cultural-aesthetic features of Italian design and the great humanistic tradition of Italy and has certainly worked well in maintaining the allure of Italian style. One such author is the architect, critic and historian Giampiero Bosoni, who since the late 1980s has striven to overturn the route traced by Gregotti (even though he himself had contributed to it earlier in that decade). Acknowledging the unmethodical and emotional character of Italian design, Bosoni has examined product design's relationship with interior design, the decorative arts and art movements such as metafisica, futurism, rationalism and novecento.[19] With a different perspective Manlio Brusatin, an art historian and critic (and also an architect by education), has combined art history, theory and criticism to demonstrate, in his book *Arte come design* (2007), that art has not just influenced the technology and industry of Italian design, but has also shaped it in terms of taste.[20] Similarly, and significantly, De Fusco's book on Italian design, *Made in Italy* (2007), seemingly set aside his quatrefoil grid to focus on art historical notions of 'style' and 'formal constants' as parameters for defining 'Italian style'.[21]

In reviewing more than fifty years of historical writing, we see that Italian design has been understood in a range of contexts from industrial culture to art. Lacking in these accounts, however, is any questioning of the very existence and specificity of 'Italian' design. By now we could surely argue that the historiographical utility of the idea of Italian design's unity and singularity—to paraphrase what Italian studies scholar John Dickie wrote about the notion of Italy more broadly—has 'to be demonstrated rather than assumed'.[22]

READING DESIGN IN ITALY: MULTIPLE STORIES

Towards the end of the twentieth century, historical writing made apparent the complexity of Italian design and the impossibility of reducing it to a single historical formula. To some of those looking at the larger picture, the very idea of a polymorphous design gradually became another unifying feature of Italian design's singularity, which requires a dedicated method of study, as Branzi, for instance, has maintained.[23] However, recognition of that multiplicity has gradually expanded the reading of the history of design in Italy. A wealth of publications has appeared in the past three decades, in Italy and abroad,

that transcend the 'obsession' of defining Italian design by providing a general and ultimate account of its style, look, line or *modo* (way).

The first part of this chapter has outlined the main features of the historical construction of 'Italian design' in major general accounts; this second part shifts attention to this other, more diversified, side of historical writing and historiography. 'Design in Italy'—understood as the reading of the multiple stories of design—may provide an appropriate label for an eclectic and inconsistent ensemble of publications. A wave of historical research and writing has developed that has not been programmatically theorised or pursued, although it has certainly drawn on international debates in design history.[24] This wave has taken the form of monographic texts that are rather uneven in terms of approaches, objectives, methods, formats, writing styles and authors, both Italian and international. In this new wave, scholarly studies are surrounded by many occasional and even promotional publications, which are not without value in providing useful information on stories and sources. Moreover, material relevant to an understanding of the history of Italian design has come from the wider fields of cultural and historical studies. These diverse and multiple readings of 'design in Italy' can help to reassess Italian design for the new millennium.

In order to briefly map this varied and discontinuous panorama, and to provide at least some perspective on how to view its geography, the chronological succession adopted in the first half of this chapter would be unhelpful. Instead, we apply a model to the historiography of design that Grace Lees-Maffei has proposed for reading the English design historical literature of the same period: the 'production-consumption-mediation paradigm'.[25] This approach is perhaps particularly useful for examining the literature on design in Italy because it allows us to assess it in relation to approaches that are central to the international discussion of design history, as well as allowing discussion of contributions from related disciplines.

PRODUCTION

Beginning with the first stream of the paradigm, historical writing on design in Italy appears to have a clear bias towards production. The literature produced in the last three decades mostly contributed to deepening the knowledge of those products, designers and firms that have occupied the very core of the imagery of Italian design, both modernist and postmodernist. It focuses on the domestic sphere and the celebrated fields of Italian production: furniture, lighting, automotive design and appliances, but also some areas more closely related to artisanal or semi-craft production, such as glass and ceramics. This literature—to which the accounts featured in parts one and four of this volume add—has also shed light on figures and episodes that had been neglected or dispersed in publications treating the entire history of Italian design.

A significant number of monographs have been devoted to a handful of named designers, almost exclusively men. Among these, particular attention has been paid to figures who are thought to embody the unique nature of Italian style: designer-architects such

as Gio Ponti, Ettore Sottsass Jr. and Carlo Mollino, all of whose work bridges modernity and tradition. Designer profiles can also be found in the extensive literature of exhibition and museum catalogues, along with information about products and projects.[26]

Other surveys and studies closely examine a single type of product or, more unusually, a single material that has been significant to Italian design production. Recent studies of lighting design and ceramics, for example, have attempted to link and contextualise single stories of products, companies and designers, often succeeding in pointing out lesser-known episodes of production (see also Lisa Hockemeyer's contribution to this volume).[27]

Since the 1980s, the interest in design companies has also grown. A rather prolific editorial trend has developed where scholarly research and promotional objectives coexist as a result of growing self-awareness on the part of design companies that there is a need to chart their own histories and a need for marketing strategies aimed at cultivating them (see also Grace Lees-Maffei's chapter in this book).[28] Entrepreneurs have also attempted to emphasise the specific role they and the *fabbriche del design* (design factories) have played in building the cultural and economic success of Italian style and the history of Italian design. Leaders of famous companies such as Alessi and Kartell have participated in this endeavour, albeit in rather different ways. Notably, Giulio Castelli, the founder of Kartell, gave voice to some leading actors in Italian design companies by collecting and editing a series of 'conversations' with them.[29]

Places and regions of manufacturing are another organising principle in publishing on the history of Italian design. In addition to the expected studies of the main production areas of northern Italy, such as furniture in Lombardy and the automotive industry in Piedmont, other studies have widened the geographical map of Italian design following the international attention that the districts of the Italian industrial system of small- and medium-sized enterprises received in the 1990s. While some of these contributions have re-inforced stereotypes, they have nevertheless revealed the variety of stories of design in terms of geography, economic and production fields, practices, techniques, materials and concepts.[30]

Within the 'production' stream, at least two directions more explicitly express a will to reshape, or reread, Italian design. The first focuses on the technical and engineering side of design, while the second addresses the relationship between modern design and the decorative arts (see also Elena Dellapiana and Daniela N. Prina's contribution to this volume). Additionally, some recent studies have dealt specifically with the question of the permanence of craftsmanship in the history of Italian design. The first direction has developed in the wake of the work of Gregotti and the critical discussion of Tomás Maldonado and Giovanni Koenig, and thanks to the influence in Italy of authors such as Thomas Kuhn and George Kubler. Within this category we can place the various publications about designers who have had closer ties with engineering than with the arts or architecture, with design for public spaces and transport systems and with the different forms of design without a designer.[31] *Design anonimo in Italia* by Alberto Bassi, published in 2007 amid international interest in everyday design, documents a range of artefacts

designed by in-house company technical departments and the spontaneous craftsman-ship of Italian regions, from coffee cups to the Chiavari chair, from screws to the Bor-salino hat. But Bassi yields to the temptation of connecting these kinds of products to the canon of Italian design. Subsequent books surveying Italian design consider many of the objects treated by Bassi, juxtaposing them with the renowned masterpieces of Milanese designers and thereby transforming them into new 'made in Italy' icons.[32] Something similar can be concluded about the interest in patents displayed in recent publications documenting the materials kept at the Archive of the Patent and Trademark Office in Rome (Archivio Brevetti e Marchi di Roma), which have fed the questionable myths of a 'nation of anonymous inventors' and of Italian 'mass creativity'.[33]

In terms of the decorative arts and interior design and architecture, studies conducted since the 1980s have worked to integrate into the broader history of Italian design issues such as the debates on the reform of the applied arts, the question of national style and ar-tistic regional cultures, the role of magazines specialising in the applied arts, and the mul-tifaceted relationships between architecture and furniture production in the years between the two World Wars. Maria Cristina Tonelli Michail provided an original view of interwar Italian design, acknowledging its continuities in post-war design. The most recent litera-ture has also dealt with issues such as the role that the classical and vernacular styles have played in bringing the Italian middle class closer to modern design, and the importance of some fields of craftsmanship within Italy (ironworking, glassmaking, woodworking and all the crafts involved in furniture-making). Irene de Guttry and Maria Paola Maino, in particular, have helped to reassess figures previously overlooked in the history of Italian design: designers and craftspeople who maintained an eclectic approach and close ties with tradition.[34] The interplay between methods of mass production and artisanal know-how in Italy is long-standing; today this relationship often features within the literature cele-brating goods 'made in Italy', but it is only recently that the question of how craftsmanship has achieved central importance in the practice and discourse of Italian design has been addressed. Here a fundamental contribution has come from British design historians such as Penny Sparke, who have begun to investigate craft's role in defining Italian design after 1945. For example, the exhibition *Italy at Work*, held in 1951, and single business case studies, such as that of Alessi, have been examined through analysis of primary sources—both visual and textual—bringing to light the existence of complex and even intentionally ambiguous relationships between industrial design and craftsmanship, as well as between marketing strategies and the national identity of the products manufactured in Italy.[35]

Catharine Rossi's in-depth analysis of the coexistence of 'modern craft' and design in Italy is particularly promising (see her chapter in this volume). Rossi shows that a reas-sessment of the place of craftsmanship in the years when modern Italian design gained international recognition informs an understanding of the continuity of postmodern and radical movements with previous design developments in Italy. Paying attention to artisanal practices enables greater recognition of the role played by women designers in Italy, who thus far have been systematically excluded from, or hindered in, the design

profession. Aside from some mentions of women in the Italian design historical literature of the new millennium by authors such as Anty Pansera and Tiziana Occleppo, the adoption of a full-scale reassessment more clearly in line with women's studies has come, once again, from British scholars such as Sparke and Rossi, whose contributions certainly offer ground for future research.[36]

CONSUMPTION

The exclusion from historical accounts of the 'feminine face' of Italian design—as Sparke noted in 1999—is linked to the lack of attention paid to issues of consumption. Consumption formed part of the debate surrounding the crisis of design in the 1960s, when criticism of capitalist and consumerist tendencies in Italian design emerged and became more widespread.[37] In the following decades, the consumer became a central figure in the poetics of radical design. Since the 1980s, growing interest in both semiotics and sociological issues has also led to analyses of the relationship between consumers or users and designed goods, as part of wider lifestyle changes in Italy.[38] And yet these approaches to consumption have not led to any real shift in the historical study of Italian design capable of critically examining the dynamics of acquisition, the use of products and the negotiation of social and cultural meanings (but see Thomas Brandt's contribution to this volume). With few exceptions, then, the real impact of design on Italian society remains an open historical and critical issue. The literature reveals rather discordant attitudes: on the one hand, emphasis is placed on the gap between the work of Italian designers and everyday society, and Italian style is depicted as addressing mainly a foreign and elitist market; on the other, an opposite image of Italy exists, as the country where design is an integral part of the fabric of everyday life.

In recent years, however, insightful analyses of consumption have been written by historians working outside design. Enrica Asquer's work on the social history of the washing machine in Italy questions some common ideas about the impact of appliances in contemporary Italian life. Focusing on one type of appliance, she cleverly connects the development of the major Italian companies with the changes brought about by the domestic washing machine and changes in other domestic work practices. Asquer gives voice to female consumers, drawing from sources such as business magazines and periodicals, women's associations, manuals, surveys on public housing and promotional materials, without neglecting the role played by the industrial design culture in bringing the Italian public closer to the machine.[39]

Interest in microhistory and the histories of everyday life has produced investigations with design historical relevance, such as studies of the social and family rituals that take place within the domestic space. The recently launched research project 'Architectures for the Middle Class in Italy, 1950s–1970s' addresses the use of domestic space as part of a focus on urban history. Three aspects of this investigation are potentially useful for historical studies of design in Italy: first, a focus on the middle market for housing and the dynamics through which architects' more cultivated solutions trickled down to

middle-class housing; second, the use of oral history to reconstruct the ways in which interiors were perceived and experienced, used and modified; and, third, the roles of diverse mediating actors, such as property developers and construction companies, in encoding and negotiating the tastes of customers.[40]

MEDIATION

Beyond the domestic realm, products such as certain motor scooters and car models—usually acknowledged as purveyors of the imagery of the Italian lifestyle—have attracted the attention of scholars of consumption and cultural studies. For example, Dick Hebdige's study on Italian scooters (1981) and more recent work by Adam Arvidsson on the Vespa both investigate issues of consumption and mediation. Hebdige's study examines the negotiation of meanings around the scooter, both in Italy and internationally, and the design and technical features of products. Arvidsson highlights the active role of marketing and advertising—mediating actors between production and consumption—in the process of redesigning the meanings of the Vespa and subsequent Piaggio models.[41] Thomas Brandt's chapter in this volume provides a new analysis of ways in which the Vespa was mediated to, and by, its market, and Federico Paolini's chapter reviews the take-up of cars in Italy.

Although much of this research has not been produced within the disciplinary frame of design history, its examination of 'mediating channels' as sources is relevant. Until recently historians of Italian design have rarely used corporate magazines, advertising and promotional material, corporate documentaries and records related to consumer clubs and associations as primary sources. However, mediating channels such as institutions, awards, exhibitions and magazines have received attention from authors who write about the history of Italian design, for example in work on the Triennale di Milano and the Associazione per il Disegno Industriale (ADI)[42] and the examination of some specialised periodicals.[43] And yet publications dealing with institutions or magazines have not taken into account the very dynamics of mediation, remaining, rather, at the level of mere chronicle and information collection (but see Kjetil Fallan's contribution to this volume).

Magazines and other communication media, exhibitions and showrooms are essential elements in the mediation of design, but at the same time—as Lees-Maffei has noted—they are themselves designed artefacts and as such constitute a further and important area of study for historians of design. This consideration is certainly relevant for the history of design in Italy. Here, for instance, the activities surrounding the dissemination of existing products, such as exhibitions and displays, have been an integral part of design practice since its very beginning. Even though this point had already been underlined by Fossati in 1972,[44] and noted variously by other scholars in their general accounts, the specific role of exhibition design for design culture in Italy still deserves in-depth study (innovative examples of such studies can be found in Imma Forino's and Vanessa Rocco's contributions to this volume).[45]

However, exhibition design is not the only field worthy of attention. The issue of mediation inevitably brings us to consider a significant problem that concerns the historiography of Italian design: the unchallenged pre-eminence of product design and the relatively marginal position occupied by other areas of design with a historically strong tradition in Italy, such as fashion and graphic design.

BEYOND PRODUCT DESIGN

Fashion has been addressed at different points within the critical and theoretical discourse on Italian design; nonetheless, it has remained rather latent in historical study and writing. During the 1970s and 1980s, fashion and product design drew nearer to one another. Fashion studies advanced stimuli that were relevant to historical studies. In the 1980s, in fact, attempts were made to update the methods for documenting and studying Italian fashion and its history, precisely by exploring the industrial design process and all the aspects of product mediation. The primary contributions in this direction came from scholars working at the Centro Studi e Archivio della Comunicazione (Communication Study Centre and Archive) at the University of Parma.[46] However, despite the consideration that some studies and catalogues in the following years gave to certain striking episodes and figures, such as futurism and Nanni Strada, such an endeavour has yet to produce any real integration of fashion and industrial design. However, recent calls to proceed in this direction have been launched in Italy, at least within the field of fashion studies, whereas historians of industrial design remain rather silent.[47] Welcoming issues and methodologies from fashion studies could expand the territory of Italian design, including certain aspects that still remain shrouded in mist, such as the phenomenon of 'submerged' production or the very existence of an 'Italian' style and of 'made in Italy'. Simona Segre Reinach, who has a chapter in this volume, is a leading scholar of fashion studies who has contributed to the literature of fashion studies in Italy.

Graphic design's exclusion from general accounts of Italian design may appear even more surprising, especially given the close relationship, in both practice and thinking, between graphic designers and product designers in Italy. While this exclusion appears to persist even today, a wave of historical interest in graphic design occurred in the 1980s, with the organisation of exhibitions and publications by graphic designers themselves.[48] At the same time experts from other disciplines such as art history and communication studies turned their attention to issues such as those of nineteenth- and twentieth-century poster art, futurist graphics, Fascist-era graphic arts, typography and public lettering.[49] Recently, several books and catalogues have addressed the major protagonists of the Italian scene after the Second World War. Overall, however, the literature on Italian graphic design remains relatively scant and displays a production bias, with the focus being placed almost exclusively on designers and their masterpieces (but see Gabriele Oropallo's contribution to this volume for a significant exception). An integrative approach to product and graphic design is desirable only if it pays greater attention to issues of consumption and mediation. This kind of approach could yield valuable reassessments

of Italian design culture. For example, considering graphic design as an integral part of the history of design in Italy would help to question the most common assumption that heavy industry played only a marginal role in the development of Italian design. In fact, recent research shows that between reconstruction and the 'economic miracle' (1948–1965) Italian graphic designers established stable and long-lasting collaborative relationships with major businesses, and their interventions linked corporate propagandistic discourse to the specific culture and ideology of industrial design.[50]

FROM HERE ON

The year 2011 marked the 150th anniversary of the unification of Italy and the first conference of the recently founded Associazione Italiana degli Storici del Design (Italian Society of Design Historians). The society does not focus exclusively on the history of *Italian* design, but it includes many of the historians, mainly Italian, who work on that history. At its inaugural meeting, the association identified the need to review the state of the art of design history in Italy, including the role of design historians within design and academia. The conference aimed to examine various approaches to the study of design history, and most speakers used the event as an opportunity to declare their methods and intentions, as if a new foundation for the study of design history was needed. Limits persist in the study and literature of Italian design, and its methods do indeed require continual review and updating. However, attention should also be paid to existing and ongoing research and publications, within Italy and abroad, and within the disciplinary field of design history and beyond, not least for the stimulus they provide for future research in the field.

This chapter has demonstrated the range of literature on design in Italy, beyond the mainstream accounts. We hope these two strands will increasingly benefit one other. Those willing to outline once again the history of Italian design need to take into account all the diverse stories revealed thus far, as well as contributions from other fields of study. A critical deconstruction of the notion and image of Italian design is needed that reviews its history and tests its relevance for the contemporary design culture and the broader sociocultural context. We believe that *Made in Italy*, which brings together a variety of multidisciplinary perspectives and voices, represents a major move in precisely this direction.

NOTES

1. Alberto Rosselli, with Marco Revelli, 'Domus, l'arte nella produzione industriale', *Domus* 269 (April 1952): 54–55.
2. '1939–1959: Appunti per una storia del disegno industriale in Italia', *Stile Industria* 26–27 (May 1960): 3–28.
3. Vittorio Gregotti, *New Directions in Italian Architecture* (New York: Braziller, 1968).
4. Emilio Ambasz, ed., *Italy: The New Domestic Landscape: Achievements and Problems of Italian Design* (New York: Museum of Modern Art, 1972), a catalogue of the exhibition.

5. Paolo Fossati, *Il design in Italia, 1945–1972* (Turin: Einaudi, 1972).

6. Ibid, 7.

7. Vittorio Gregotti, 'Italian Design 1945–1971', in Ambasz, *Italy: The New Domestic Landscape*, 339.

8. See, in particular, the series of articles 'Per una storia del design italiano', written by Gregotti with Lorenzo Berni, Paolo Farina, Alberto Grimoldi and Franco Raggi and published in *Ottagono*'s issues 32, 33, 34 and 36 (1974–1975), and Gregotti's *Il disegno del prodotto industriale: Italia 1860–1980*, ed. Manolo De Giorgi, Andrea Nulli and Giampiero Bosoni (Milan: Electa, 1982). Gregotti was also the founder, in 1979, of the architectural magazine *Rassegna: Problemi di architettura dell'ambiente*, which, in the 1980s, also covered design in issues devoted to the rail transport system, rationalist furniture and interior design and industrial materials.

9. Giovanni Klaus Koenig, 'Design: Rivoluzione, evoluzione o involuzione?', *Ottagono* 68 (March 1983): 20. Koenig advanced critical analyses of Italian design's history in, for example, *L'invecchiamento dell'architettura moderna* (1965; new ed., Florence: Libreria editrice Fiorentina, 2007) and *Il design è un pipistrello mezzo topo mezzo uccello* (Florence: Ponte alle Grazie, 1991).

10. Andrea Branzi, introduction to the exhibition catalogue *Il design italiano degli anni '50*, ed. Andrea Branzi and Michele De Lucchi (Milan: Ricerche Design Editrice, 1985), 22.

11. See Andrea Branzi, *The Hot House: Italian New Wave Design*, trans. C. H. Evans (London: Thames and Hudson, 1984); the book is based on a series of lectures the author gave at the University of Palermo.

12. Branzi, *Introduzione al design italiano: Una modernità incompleta* (Milan: Baldini e Castoldi, 1999; rev. ed., 2008), 11, 13. See also by Branzi, 'The Italian Paradox', in *Learning from Milan* (Cambridge, MA: MIT Press, 1988), 31–35, and 'Italian Design and the Complexity of Modernity', in the catalogue of the exhibition curated by Germano Celant, *The Italian Metamorphosis, 1943–1968* (New York: Guggenheim Museum, 1994), 596–607. Recently Branzi condensed his main ideas on the history of Italian design in *Ritratti e autoritratti di design* (Venice: Marsilio, 2010). Branzi has also curated some prestigious exhibitions devoted to Italian design at the Triennale and at the Triennale Design Museum in Milan: see Andrea Branzi, ed., *Un museo del design italiano, Il design italiano 1964–1990* (Milan: Electa, 1996), and the catalogues he co-edited with Silvana Annicchiarico: *What Italian Design Is: The Seven Obsessions* (Milan: Electa, 2008) and *Series Off Series* (Milan: Electa, 2009).

13. Branzi's reading of Italian design may be compared with what John Agnew writes in 'The Myth of Backward Italy in Modern Europe', in *Revisioning Italy: National Identity and Global Culture*, ed. Beverly Allen and Mary Russo (Minneapolis: University of Minnesota Press, 1997), 23–42. Many of the sociological ideas discussed by Agnew can be detected in Branzi's texts.

14. Pansera's books include *Storia e cronaca della Triennale* (Milan: Longanesi, 1978); with Alfonso Grassi, *Atlante del design italiano 1940/1980* (Milan: Fabbri, 1980) and *L'Italia del*

design: Trent'anni di dibattito (Casale Monferrato: Marietti, 1986); *Storia del disegno indus-triale italiano* (Rome-Bari: Laterza, 1993), including a chronology and bibliographical infor-mation edited by Tiziana Occleppo; *Dizionario del design italiano* (Milan: Cantini, 1995); and *L'anima dell'industria: Un secolo di disegno industriale nel Milanese* (Milan: Skira, 1996). Pansera has also written collaboratively on the history of single product typologies, on design companies and on designers.

15. Renato De Fusco, *Storia del design* (Rome-Bari: Laterza, 1985; rev. ed., 2002). For De Fusco's theoretical approach to design historiography see 'La forbice di storia e storiografia', in *Design storia e storiografia*, proceedings of the international conference of the same name held in 1991, ed. Vanni Pasca and Francesco Trabucco (Bologna: Progetto Leonardo, 1995), 75–91.

16. De Fusco, *Storia del design*, 257.

17. Enzo Frateili, *Il disegno industriale italiano 1928–1981 (quasi una storia ideologica)* (Turin: Celid, 1983); the revised edition expands the narrative into 1980s: *Continuità e trasformazi-one: Una storia del disegno industriale italiano* (Milan: Alberto Greco, 1989).

18. Penny Sparke, *Design in Italy: 1870 to the Present* (New York: Abbeville Press, 1988).

19. See in particular Giampiero Bosoni and Fabrizio G. Confalonieri, *Paesaggio del design ital-iano, 1972–1988* (Milan: Edizioni Comunità, 1988); Bosoni, *Italy: Contemporary Domestic Landscapes, 1945–2000* (Milan: Skira, 2001); and the exhibition catalogue edited by Bosoni, *Il Modo Italiano: Italian Design and Avant-Garde in the 20th Century* (Milan: Skira, 2006).

20. Manlio Brusatin, *Arte come design: Storia di due storie* (Turin: Einaudi, 2007).

21. Renato De Fusco, *Made in Italy: Storia del design italiano* (Rome-Bari: Laterza, 2007).

22. John Dickie, 'The Notion of Italy', in *The Cambridge Companion to Modern Italian Cul-ture*, ed. Zygmunt Baranski and Rebecca West (Cambridge: Cambridge University Press, 2001), 17.

23. Andrea Branzi, 'Introduzione: Il design come cultura civile', in Branzi, *Un museo del design italiano*, 13–17; and Branzi, *Introduzione al design italiano*, 10. Branzi's call for an update of the historiographical method of study of Italian design bears comparison with Manolo De Giorgi's proposal for an archaeological approach, 'Oggetti in prospettiva archeologica', in *45.63 Un museo del disegno industriale in Italia*, ed. Manolo De Giorgi (Milan: Abitare Segesta, 1995), 12–23.

24. Since the 1980s Italian scholars have organised international conferences in Italy focused on design history and historiography. See the proceedings of the conferences held in 1987 and 1991 in Milan: Anty Pansera, ed., *Tradizione e modernismo: Design 1918/1940* (Milan: L'Arca, 1988), and Pasca and Trabucco, *Design storia e storiografia*. In 2008 the conference Design: Storia e Identità took place at the University Iuav of Venice, convened by Marco De Michelis, Vanni Pasca and Raimonda Riccini (the latter has a chapter in this volume), but no publication resulted.

25. Grace Lees-Maffei, 'The Production-Consumption-Mediation Paradigm', *Journal of Design History* 22, no. 4 (2009): 351–376.

26. See, for example, the output of the publishers Laterza, Electa, Silvana and Skira. See also the post-1990 bibliography at http://www.aisdesign.org/bibliografie.php (accessed May 1, 2012).

27. On materials, see *Rassegna*'s special issue edited by Giampiero Bosoni and Manolo De Giorgi, 'The Materials of Design', 14, no. 2 (1983); and Cecilia Cecchini, ed., *Mo . . . moplen: Plastics Design in Italy's Boom Years* (Rome: Dip.to Itaca, 2006). See also Jeffrey T. Schnapp, 'The Romance of Caffeine and Aluminum', *Critical Inquiry* 28, no. 1 (2001): 244–269. Books devoted to a single product typology include many publications on furniture design, among them Anty Pansera's *Il design del mobile italiano dal 1946 a oggi* (Rome: Laterza, 1990) and survey books by Giuliana Gramigna: *1950–1980 Repertorio: Immagini e contributi per una storia dell'arredo italiano* (Milan: Mondadori, 1985); *Repertorio del design italiano 1950–2000 per l'arredamento domestico*, ed. Sergio Mazza, 2 vols. (Turin: Allemandi, 2003); and *Le fabbriche del design: I produttori dell'arredamento domestico in Italia 1950–2000*, ed. Federica Monetti (Turin: Allemandi, 2007); and with Paola Biondi, *Il design in Italia dell'arredamento domestico: 473 progettisti degli ultimi cinquant'anni* (Turin: Allemandi, 1999). For lighting design and ceramics see Alberto Bassi, *Italian Lighting Design: 1945–2000* (London: Phaidon, 2004); and Elena Dellapiana, *Il design della ceramica in Italia: 1850–2000* (Milan: Electa, 2010).

28. See note 22. The attention that Italian design companies give to their own past is reflected in the institution of many company museums; see Fiorella Bulegato, *I musei d'impresa: Dalle arti industriali al design* (Rome: Carocci, 2008).

29. Giulio Castelli, Paola Antonelli and Francesca Picchi, eds., *La fabbrica del design: Conversazioni con i protagonisti del design italiano* (Milan: Skira, 2007). On Alessi, see the recent catalogue of the fourth iteration of the Triennale Design Museum: Alberto Alessi and Silvana Annicchiarico, eds., *Dream Factories: People, Ideas and Paradoxes of Italian Design* (Milan: Electa, 2010).

30. Publications focused on the central role played by Milan, the Brianza region and Lombardy include Pansera, *L'anima dell'industria*; Aldo Colonetti, ed., *Grafica e design a Milano: 1933–2000* (Milan: Abitare Segesta, 2001); and the exhibition catalogue by Alberto Bassi and Raimonda Riccini, with Cecilia Colombo: *Design in Triennale 1947–68: Journeys between Milan and Brianza* (Cinisello Balsamo: Silvana, 2004). See also John Foot, *Milan since the Miracle* (Oxford: Berg, 2001), chap. 7. A renewed interest in Piedmont as a design region is shown, for instance, by the appearance of publications such as the exhibition catalogue *Torino design: Dall'automobile al cucchiaio* (Turin: Allemandi, 1996), and Alberto Bersani and Paolo Fissore's *Dal disegno al design: Storia della carrozzeria in Piemonte: Dalla carrozza all'automobile* (Ivrea: Priuli & Verlucca, 1999), which focuses on car design. As regards Italian car design, however, see also the following exhibition catalogues: Angelo Tito Anselmi, *Carrozzeria italiana: Cultura e progetto* (Milan: Alfieri editore d'arte—Electa, 1978); and Istituto Nazionale per il Commercio Estero, ed., *Design automobile: Le maîtres de la carrosserie italienne* (Milan: Giorgio Mondadori, 1990). Augusto Morello in *Culture of an Italian Region: The Marche,*

Guzzini, and Design (Milan: Electa, 2002) contextualises the history of the Guzzini company, within the framework of the region's history and culture. Other cases of previously marginal regions and cities that have achieved prominence since the 1990s include Friuli Venezia Giulia and Naples: see Anna Lombardi, *100 anni di sedie: Friuli 1890–1990: Breve storia del design della sedia* (Udine: Campanotto, 1996) and *Dall'artigianato artistico al design industriale*, 2 vols. (Naples: Electa, 2004).

31. See, for example, the following issues of *Rassegna*: 'Vehicles, 1909–1947', 6, no. 18 (1984); and 'Ferrovie dello stato 1900–1940', 2, no. 2 (1980). Although not focused exclusively on Italian industrial design, Enrico Castelnuovo's three-volume edited book *Storia del disegno industriale* (Milan: Electa, 1989–1991) includes essays by various international scholars on the history of design in single countries and texts devoted to single product typologies—from the products of the aircraft industry to home appliances. See also Alberto Bassi and Raimonda Riccini, eds., *La locomotiva breda 830 del 1906: Lavoro, tecnica e comunicazione* (Cologno Monzese: Silvia, 2006). For business history and the history of technology see Valerio Castronovo and Giulio Sapelli, eds., *Civiltà delle Macchine: Tecnologie, prodotti, progetti, dell'industria meccanica italiana dalla ricostruzione all'Europa* (Milan: Fabbri, 1990); and Guido Boreani, *Un tram che si chiama Milano: Il tram tipo 1928 dalle origini ai giorni nostri: Storia e tecnica* (Cortona: Calosci, 1995).

32. Alberto Bassi, *Design anonimo in Italia: Oggetti comuni e progetto incognito* (Milan: Electa, 2007). Other recent survey books that mix renowned and anonymous design include Porzia Bergamasco and Valentina Croci, *Design in Italia: L'esperienza del quotidiano*, ed. Aldo Colonetti (Florence: Giunti, 2010).

33. Giampiero Bosoni, Francesca Picchi, Marco Strina and Nicola Zanardi, *Original Patents of Italian Design 1946/1965* (Milan: Electa, 2000); Alessandra M. Sette, *Disegno e design: Brevetti e creatività italiani* (Rome: Fondazione Valore Italia, 2009); and the catalogue of the exhibition by the same name, edited by Alessandra M. Sette and Enrico Morteo (Venice: Marsilio, 2011). See also Vittorio Marchis, *150 (Anni di) Invenzioni Italiane* (Turin: Codice, 2012).

34. See Maria Cristina Tonelli Michail's *Il design in Italia 1925–1943* (Rome: Laterza, 1987). See also the following works by Irene de Guttry and Maria Paola Maino: *Il mobile Liberty italiano* (Rome: Laterza, 1983); with Mario Quesada, *Le arti minori d'autore in Italia, dal 1900 al 1930* (Rome: Laterza, 1985); *Il mobile déco italiano 1920–1940* (Rome: Laterza, 1988); 'Forging Modern Italy: From Wrought Iron to Aluminium', in *Designing Modernity: The Arts of Reform and Persuasion 1885–1945; Selections from the Wolfsonian*, ed. Wendy Kaplan (London: Thames and Hudson, 1995), 169–193; and *Il mobile Italiano degli anni quaranta e cinquanta* (Rome: Laterza, 1992; new ed., 2010). On design and the applied arts under Fascism, see also Dennis Doordan, 'Political Things: Design in Fascist Italy', in Kaplan, *Designing Modernity*, 225–255. Maino in *Cent'anni di mobili per l'infanzia in Italia 1870–1970* (Rome: Laterza, 2003) focuses on furniture for children. On the vernacular in Italian design

and architecture see Michelangelo Sabatino, 'Ghosts and Barbarians: The Vernacular in Italian Modern Architecture and Design', *Journal of Design History* 21, no. 4 (2008): 335–358; and Marianne Lamonaca, 'A "Return to Order": Issues of the Classical and the Vernacular in Italian Inter-war Design', in Kaplan, *Designing Modernity*, 195–221. See also Antonio D'Auria, *Architettura e Arti Applicate negli Anni Cinquanta: La Vicenda Italiana* (Venice: Marsilio, 2012).'

35. Penny Sparke, 'The Straw Donkey: Tourist Kitsch or Proto-design? Craft and Design in Italy, 1945–1960', *Journal of Design History* 11, no. 1 (1998): 59–69; and Grace Lees-Maffei, 'Italianità and Internationalism: Production, Design and Mediation at Alessi, 1976–96', *Modern Italy* 7, no. 1 (2002): 37–57.

36. See Catharine Rossi, 'The Transition to Modernity: The Relationship between Design and Modern Craft in Post-war Italy' (PhD diss., V&A/Royal College of Art, 2010); Rossi, 'Making Memphis: Encounters between Design and Craft in Italian Postmodernism', in *Design and Craft: A History of Convergences and Divergences*, proceedings of the 7th Conference of Design History and Design Studies (ICDHS), ed. Javier Gimeno Martínez and Fredie Floré (Brussels: Koninklijke Vlaamse Academie van België voor Wetenschappen en Kunsten, 2010), 322–325; 'How Memphis Was Made', *Crafts Magazine* 232 (2011): 60–63; and 'Making Memphis: "Glue Culture" and Postmodern Production Strategies', in *Postmodernism: Style and Subversion, 1970–1990*, ed. Glenn Adamson and Jane Pavitt (London: V&A Publishing, 2011), 160–165. On gender and design see Penny Sparke, 'Nature, Craft, Domesticity and the Culture of Consumption: The Feminine Face of Design in Italy, 1945–70', *Modern Italy* 4, no. 1 (1999): 59–78; Tiziana Occleppo and Anty Pansera, eds., *Dal merletto alla motocicletta: Artigiane/artiste e designer nell'Italia del novecento* (Milan: Silvana, 2002); Javier Gimeno Martínez, 'Women Only: Design Events Restricted to Female Designers during the 1990s', *Design Issues* 23, no. 2 (2007): 17–30; and Catharine Rossi, 'Furniture, Feminism and the Feminine: Women Designers in Post-war Italy, 1945 to 1970', *Journal of Design History* 22, no. 3 (2009): 243–257.

37. Kjetil Fallan, 'Heresy and Heroics: The Debate on the Alleged "Crisis" in Italian Industrial Design around 1960', *Modern Italy* 14, no. 3 (2009): 257–274.

38. For example, the catalogue of the exhibition organised by the La Jolla Museum of Contemporary Art, *Italian Re-evolution: Design in Italian Society in the Eighties*, conceived by Piero Sartogo (La Jolla, CA: La Jolla Museum of Contemporary Art, 1982). See also the books edited by the Italian semiotician Omar Calabrese, such as the exhibition catalogue *L'Italie aujourd'hui: Aspects de la création Italienne de 1970 à 1985* (Florence: La Casa Usher, 1985) and *Il modello italiano: Le forme della creatività* (Milan: Skira, 1998).

39. Enrica Asquer, *La rivoluzione candida: Storia sociale della lavatrice in Italia, 1945–1970* (Rome: Carocci, 2007). On domestic appliances in Italy see also Tersilla Faravelli Giacobone, Paola Guidi and Anty Pansera, *Dalla casa elettrica alla casa elettronica: Storia e significati degli elettrodomestici* (Milan: Arcadia, 1989).

40. See Mariuccia Salvati, *L'inutile salotto: L'abitazione piccolo-borghese nell'Italia Fascista* (Turin: Bollati Boringhieri, 1983); Giuseppe Raimondi, *Abitare Italia: La cultura dell'arredamento in trent'anni di storia italiana* (Milan: Fabbri, 1988); and the findings of the research project 'Architectures for the Middle Class in Italy, 1950s–1970s', http://www.middleclasshomes.net (accessed January 18, 2012).

41. Dick Hebdige, 'Object as Image: The Italian Scooter Cycle', *Block* 5 (1981): 44–64; Adam Arvidsson, 'From Counterculture to Consumer Culture: Vespa and the Italian Youth Market, 1958–78', *Journal of Consumer Culture* 1, no. 1 (2001): 47–71; and, in Italian, Adam Arvidsson, 'La Vespa e il Mercato dei Giovani negli anni sessanta: Dalla controcultura alla cultura del consumatore', *Intersezioni: Rivista di Storia delle Idee* 1 (2001): 135–158. See also Thomas Brandt, 'La Vespa negli Stati Uniti: Il trasporto culturale di una merce italiana', *Memoria e Ricerca* 23 (September–December 2006): 129–140.

42. On the Triennale, besides Agnolodomenico Pica's book *Storia della Triennale 1918–1957* (Milan: Edizioni del Milione, 1957), see also Pansera's *Storia e cronaca della Triennale*; a recent study is Paola Nicolin, *Castelli di carte: La XIV Triennale di Milano, 1968* (Macerata: Quodlibet, 2011), devoted to the debated XIV Triennale. The history of the ADI is the focus of Grassi and Pansera, *L'Italia del design*, and the recent book by Renato De Fusco, *50 una storia dell'ADI* (Milan: Franco Angeli, 2010).

43. On specialised magazines, see Chiara Baglione, *Casabella 1928–2008* (Milan: Electa, 2008); Mario Piazza, ed., Abitare: *50 anni di design* (Milan: Rizzoli, 2010); Franca Santi Gualteri, A *Trip through Italian Design: From* Stile Industria *Magazine to* Abitare (Bologna: Corraini, 2003); and Massimo Martignoni, *Gio Ponti: Gli anni di stile 1941–1947* (Milan: Abitare Segesta, 2002).

44. Fossati, *Il design in Italia*, 12–31.

45. On Italian exhibition design a valuable reference is Sergio Polano, *Mostrare: L'allestimento in Italia dagli anni venti agli anni ottanta* (Milan: Edizioni Lybra, 1988). The atlas of works edited by Fiorella Bulegato in Sergio Polano, *Achille Castiglioni 1918–2000* (Milan: Electa, 2001) provides detailed information on the exhibits by Achille and Pier Giacomo Castiglioni. As concerns the Triennale see Pauline Madge, 'Italian Design since 1945', in *From Spitfire to Microchip: Studies in the History of Design from 1945*, ed. Nicola Hamilton (London: Design Council, 1985), 31–38; and Barbara Pastor and Sandro Polci, *La funzione della Triennale nello sviluppo delle teorie e delle tecniche espositive* (Venice: Quaderni di documentazione dell'U.I.A, 1985). See also Marco Rinaldi, *La casa elettrica e il Caleidoscopio: Temi e stile dell'allestimento in Italia dal razionalismo alla neoavanguardia* (Rome: Bagatto Libri, 2003); and Anna Chiara Cimoli, *Musei effimeri: Allestimenti di mostre in Italia, 1949–1963* (Milan: Il Saggiatore, 2007).

46. The mutual interest between design and fashion in the 1980s and 1990s was recorded by Grassi and Pansera (*L'Italia del design*), Frateili (*Continuità e trasformazione*) and Branzi (*Introduzione*). Gabriella D'Amato in *Moda e design: Stili e accessori del novecento* (Milan: Bruno

Mondadori/Pearson, 2007), 178–185, reflects on the relationship between radical design and fashion design. On the interest within fashion studies in industrial design see the two-volume publication edited by Gloria Bianchino, Grazietta Butazzi, Alessandra Mottola Molfino and Carlo Arturo Quintavalle, *La moda italiana*, vol. 1, *Le Origini dell'Alta Moda e la Maglieria*; vol. 2, *Dall'Antimoda allo Stilismo* (Milan: Electa, 1987); Bianchino and Quintavalle founded the Centro Studi e Archivio della Comunicazione at the University of Parma.

47. On integrating the study of fashion, design and the decorative arts with reference to the Italian case, see Alessandra Vaccari, 'Lo studio dell'abbigliamento tra arti decorative e design', in *Studiare la moda*, ed. Paolo Sorcinelli (Milan: Bruno Mondadori, 2003), 61–69. On Italian fashion design see Simona Segre Reinach, *Mode in Italy: Una lettura antropologica* (Milan: Guerini, 1999) and *La moda: Un'introduzione* (Rome-Bari: Laterza, 2005). With regard to figures like Elio Fiorucci and Nanni Strada and the notion 'made in Italy', see the articles by Luisa Valeriani, Vittoria C. Caratozzolo and Nello Barile in Paolo Colaiacomo, ed., *Fatto in Italia: La cultura del Made in Italy (1960–2000)* (Rome: Meltemi, 2006). Recent exhibition catalogues and books devoted to futurism, fashion and design include *Futurismo, moda e design: La ricostruzione futurista dell'universo quotidiano* (Gorizia: Musei Provinciali di Gorizia, 2009) and Mario Lupano and Alessandra Vaccari, eds., *Fashion at the Time of Fascism* (Bologna: Damiani, 2009), which offers a critical and interpretive visual essay on Italian fashion during the interwar period.

48. On the need to trace the history of Italian graphic design, see Giovanni Anceschi, 'Il campo della grafica italiana: Storia e problemi', *Rassegna* 3, no. 6 (1981): 5–19; the exhibition catalogue edited by Giancarlo Iliprandi, Franco Origoni, Alberto Marangoni and Anty Pansera, *Visual design: 50 anni di produzione in Italia* (Milan: Idealibri, 1984); Heinz Waibl, *Alle radici della comunicazione visiva italiana* (Como: Signo, 1988); and Giorgio Fioravanti, Leonardo Passarelli and Silvia Sfligiotti, *La grafica in Italia* (Milan: Leonardo Arte, 1997). See also the catalogue of the exhibition *TDM: Grafica Italiana*, eds. Giorgio Camuffo, Mario Piazza, Carlo Vinti (Mantova: Corraini, 2012).

49. On poster design see Mariantonietta Picone Petrusa, ed., *I manifesti mele: Immagini aristocratiche della belle époque per un pubblico di grandi magazzini* (Milan: Mondadori, 1988); and Alberto Abruzzese and Simona De Iulio, eds., *Lumi di progresso: Comunicazione e persuasione alle origini della cartellonistica italiana* (Treviso: Canova, 1996). On futurism and the graphic arts, see Giovanni Fanelli and Ezio Godoli, *Il futurismo e la grafica* (Milan: Comunità, 1988). Manuela Rattin and Matteo Ricci's *Questioni di carattere: La tipografia in Italia dall'unità nazionale agli anni settanta* (Rome: Stampa alternativa/Graffiti, 1997) is devoted to type design. On the Italian debate about the graphic arts during the 1930s, see Carlo Vinti, 'L'estetica grafica della nuova tipografia in Italia', *Disegno Industriale* 2 (2002): 6–30, and 'Design and Craft in the Definition of the Graphic Designer: The Debate in Italian Graphic Arts Magazines', in Gimeno-Martinez and Floré, *Design and Craft*. A notable contribution on public lettering in Italy is Armando Petrucci, *La scrittura: Ideologia e rappresentazione* (Turin: Einaudi, 1986).

50. Carlo Vinti, *Gli anni dello stile industriale 1948–1965: Immagine e politica culturale nella grande impresa italiana* (Venice: Marsilio, 2007); Carlo Vinti and Simona De Iulio, 'The Americanization of Italian Advertising during the 1950s and the 1960s: Mediations, Conflicts and Appropriations', *Journal of Historical Research in Marketing* 1, no. 2 (2009): 270–294; and Giorgio Bigatti and Carlo Vinti, eds., *Comunicare l'impresa: Cultura e strategie dell'immagine nell'industria italiana (1945–1970)* (Milan: Guerini e Associati, 2010). See also the online repertory of Italian in-house corporate magazines at http://www.houseorgan .net (accessed May 1, 2012).

PART I ACTORS

2 ETTORE SOTTSASS AND CRITICAL DESIGN IN ITALY, 1965–1985

PENNY SPARKE

Much has been written about the Italian neomodern design movement of the years 1945 to 1965 (see Maddalena Dalla Mura and Carlo Vinti's historiography in this volume for one characterisation of the literature).[1] The dominant narratives on the subject have emphasised the fact that many of the new post-war industries focusing on the production of consumer goods—domestic items, office equipment and automobiles among them—employed designers to create ranges of stylish, modern, mass-manufactured products for both the home and export markets. That focus on manufactured objects, for which Italy became internationally renowned in those years, has been supplemented by accounts of the support system, including journals and exhibitions, that underpinned it and helped to raise the intellectual temperature of the Italian design phenomenon such that it became not only a response to economic and technological conditions but also a strong cultural force. This familiar narrative about Italian design has emphasised the importance of the reconstruction years, the subsequent period of rapid economic growth and the slowing down of activity in the early 1960s as a result of the crisis in the economy and industrial turbulence. It has then, characteristically, jumped to the end of that decade and addressed what was alternatively dubbed at the time 'antidesign', 'counterdesign' or 'radical design'.[2] This latter section of the account has focused on the way in which the design achievements of the previous two decades were challenged by a number of designers and architects—both singly and in groups—such that a vigorous and influential critical design movement emerged in Italy at that time.

However, as this chapter will suggest, what has been depicted for the most part as a dramatic volte-face was, in fact, facilitated by a number of factors that were already in place. These included the alliance, from the 1950s onwards, of design in Italy with avant-garde fine art practice, which was becoming more conceptually oriented in the late 1960s.[3] Also, Italian design was already embedded within an academic discourse that had been developed through the work of critics, such as Gillo Dorfles and Umberto Eco, who were exploring the semiotic potential of design.[4] In addition, the economic conditions of the time meant that there was little work available for architects, who needed, therefore, to occupy themselves in other ways. Another factor was that, inasmuch as in the 1940s and 1950s one of its main aims had been to reject Fascism, post-war Italian neomodern

design had had a political agenda built into it from the outset. Finally, design in post-war Italy had always sought to transform behaviours.

The dominant narratives have then gone on to suggest that a rather bleak period ensued, the 1970s, in which Italian design went into a non-productive era, until a new burst of energy was witnessed in the late 1970s and early 1980s, in Milan, in the form of the outputs of the Studio Alchimia and Memphis groups of neoradical or, as they were sometimes called at the time, 'postradical' designers. While the shape of the narrative caricatured above does have some validity—especially when seen within an account of Italian design that takes the broad period 1945 to 1985 as its frame—I would like to highlight the period 1965 to 1985 and consider the key forces and circumstances that underpinned the developments of those years. Those forces, which importantly worked in conjunction with each other, consisted, in essence, of influential individuals (one in particular); design groups, networks and communities; a critical design support structure, including educational establishments and various forms of mediation and fora for debate, from journals to exhibitions and beyond; and specific geographical locations that helped engender cultures of radical design. This chapter focuses on the years 1965 to 1985 through the lens of these forces, seeing them as the agents of both continuity and development at a key moment within the history of modern Italian design. While some were merely facilitating circumstances, others provided structural support systems, and still others were hugely powerful and active driving forces. However, without the complete picture, arguably the events of the decade would not have come together in the way that they did.

This brief account of Italian critical design in these years will work from the outside in, that is, from a discussion of the broad circumstances and support structures through to the roles of groups and networks of architects and designers and thence to specific individuals—and one in particular, Ettore Sottsass—who worked in those important decades.

It is crucial at the outset, however, to say a little about what is meant by *critical design* in this context. In essence, the term, which became widely used in the early 2000s and is therefore being used retrospectively in this context, refers to the events, happenings, writings, images and designs created in Italy in the period in question that set out to challenge the cult of the industrially manufactured object, which by the mid-1960s had become the norm. Critical design questioned, and sought to provide an alternative to, the model of ideal, universally valid design that had been promoted by the 1920s international modern movement in architecture and design and, in Italy, by its interwar equivalent, rationalism, and that continued, albeit in a reconstituted form, in the neomodern Italian design movement of the years 1945 to 1965. Critical design supported, in the words of Franco Raggi, a leading protagonist of critical design in the 1970s and an editor of the influential magazine *Modo*, 'creative behaviour rather than codified custom, individual consciousness rather than the collective norm'.[5] As Raggi also explained at the time, 'Since 1972 . . . critics have been having difficulty in trying

to define, classify and justify a mass of phenomena presented with the appellation of "counter-design" or "anti-design" ', adding that 'design was seen as an operational field sufficiently open to messages of an emblematically subversive nature'.[6] For Raggi counterdesign did not exist as a continuity with what preceded it. Rather, he claimed that 'counter-design has been trying in a more or less lucid and contradictory way to go beyond the disciplinary aspect of design, beyond, that is, an obsolete sense of "good taste" and the mere production and consumption of the design object'.[7] Although from within the period, as Raggi testifies, it undoubtedly looked as if discontinuity had occurred, arguably, with the advantage of hindsight and a longer lens, a greater sense of continuity with the periods before and after it can now be discerned. Critical design did not take place in a vacuum, however, and it is important to understand a little of the context within which it occurred.

THE GEOGRAPHY OF CRITICAL DESIGN

Two main locations provided geographically specific backdrops for the emergence of Italian critical design from 1965 onwards. While one determined its academic nature, the other ensured that it was rooted, from the outset, within the established architecture and design professions and the commercial design system. The first location was Florence, where a number of architects associated with the University of Florence, whether as teachers, students or graduates, began from 1966 onwards to engage with critical design. The Art Tapes gallery in Florence helped to introduce international avant-garde artists, the American Sol LeWitt among them, to the city in the 1960s and thereby encouraged architects based in that city to align themselves with contemporary fine art practice. In addition, the work of the British critical architectural group Archigram was accessible to Florence-based architects through international journals.

The first manifestation of critical design emanating from Florence came in the form of an exhibition entitled *Superarchittetura*, which was held in Pistoia in 1966 and moved to Modena in the following year. The exhibit was organised by Adolfo Natalini, a teacher at the university, and Cristiano Toraldo di Francia, the founder, in 1966, of the highly influential radical design group Superstudio. Another key individual who made a significant contribution to the Florence-based critical design movement was Andrea Branzi—the co-founder, also in 1966, of the group Archizoom Associati—who graduated from the Architecture School in the same year. The following year saw Lapo Binazzi establish the radical group UFO—responsible for a number of interventions and 'happenings' over the following six years—in Florence.

In 1973 Michele de Lucchi, an architectural student of Natalini's at the university, established his critical design group Cavart with Piero Brombin, Boris Premru and Valerio Tridenti. For a period of six years the group was responsible for the production of films, publications, performances and projects that questioned the roles of architecture and design in contemporary society. Cavart represented the way in which the architecture department at the University of Florence, and, most important, its teachers, combined

with a set of strongly motivated individuals, provided an important backdrop for critical design activity and determined its largely academic nature. Among his daring interventions de Lucchi stood outside the 1973 Triennale di Milano dressed as a general, while in 1975 the group organised a seminar entitled 'Culturally Impossible Architecture'.[8] From 1976 onwards the members of Cavart worked separately. De Lucchi founded his personal design studio, Studio Architecture and Other Pleasures, and concentrated on the theme of nomadic architecture, creating ranges of work that included his Vertical Dwellings and Equipped Stilts.[9] Significantly, in the late 1970s, de Lucchi left Florence for Milan in order to work alongside Sottsass. In that capacity he contributed to Sottsass's mainstream work for Olivetti but also, more important in this context, became one of the leading figures, in terms of both its organisation and its design content, in the hugely influential Memphis movement of the early 1980s.

Florence played a key part, therefore, in the creation of the early Italian critical design movement, fuelling both its academic and its fine art orientations. In addition to its avant-garde and idealistic face, however, the movement also sought to engage with the professional and commercial contexts of architecture and design, as well as with the well-developed support system that existed in Milan. That northern Italian city had been the centre of Italian neomodern design since the interwar years and was home to many important design professionals who had been educated as architects at the Politecnico di Milano in the interwar years and who had moved on to become designers for industry immediately following the Second World War. Located near the furniture-manufacturing centre of Brianza, Milan had been, through the 1940s, 1950s and 1960s, the retail and fashion centre where many design-led companies— Cassina, Tecno, Artemide and Arteluce, among others—had showcased their highly styled goods.[10] One face of critical design both built on and subverted the deeply rooted modern design culture and traditions that had been part of Milan's growth and identity in the years after 1945. That remained the case from the mid 1960s right through to the mid-1980s. When Alessandro Guerriero's Studio Alchimia was formed in 1976, for example, it had its base in that city, while the Memphis shows of the early 1980s took place in a showroom in Milan's Corso Europa. The close proximity of those phenomena helped to maintain the existence of a community of architects and designers engaged in critical design practice. In turn, however, that closeness encouraged the emergence of factions and the proliferation of breakaway groups, with Memphis being a spin-off from Studio Alchimia, for example. The Milanese critical design movement was rooted, therefore, within a well-established and closely knit commercial and professional design culture against which it reacted; while it depended on its links with that culture, it simultaneously critiqued it. The work of the Alessi company, for example, which was based in Crusinallo outside Milan (but depended on that city for its dissemination), later demonstrated the crossover between mainstream and critical design and the inevitable absorption of the latter into a commercial context. (On Alessi, see Grace Lees-Maffei's chapter in this volume.)[11]

THE SUPPORT SYSTEM FOR CRITICAL DESIGN

As well as taking place in two main Italian centres, one academically oriented and the other commercially and professionally focused, critical design was also dependent on the existence of a particular support system and infrastructure. Milan was the home of the leading journals of the post-war era—*Domus, Stile Industria, Ottagono, Abitare, Casabella, Interni, Modo, Casa Vogue* and others—and was also the location of the important Triennale exhibitions.[12] When Ettore Sottsass began to exhibit his critical design objects in the mid-1960s he chose galleries in Milan, the Gallery Sperone among others,[13] in which to show them. This support structure underpinned critical design practice from the second half of the 1960s onwards.

Italian design had always been dependent on a set of internationally disseminated journals for its high profile. Critical design was equally journal dependent, and *Casabella* became the movement's main mouthpiece in the 1970s. Alessandro Mendini, another key protagonist in the evolution of the critical design movement and a contributor to both the Studio Alchimia and the Memphis experiments, was its editor between 1970 and 1975, and in his hands the journal dedicated itself to critical design. Franco Raggi then took over from Mendini and developed that same agenda. In 1973 *Casabella* assisted in the formation of Global Tools, a free school for the development of individual creativity that offered opportunities for discussion.[14]

A further important vehicle for the dissemination of critical design was the magazine *Modo*, which was launched in 1977 and remained in print until 2006. *Modo* was founded by Mendini, who remained in charge until 1979, after which Franco Raggi, Andrea Branzi, Christina Morozzi and De Angelis Almerico took over in turn. *Modo*'s subtitle, chosen by Mendini, was 'a design culture magazine', and it maintained its role as an agent provocateur throughout its quarter-of-a-century lifetime.[15]

Exhibitions also played an important part in disseminating critical design ideas and, in conjunction with the journals, stimulating debate. These ranged from large-scale events—notably the Triennali—to more modest shows, including the exhibitions of Sottsass's ceramics and furniture in Milan in the mid-1960s and the seminal 1966 *Superarchitettura* show, mentioned above. The XIV Triennale di Milano, held in 1968, was occupied by students before it opened. As Jesko Fezer has explained, 'Curator Giancarlo De Carlo had gathered his colleagues, the critics of modernism known as Team 10 (Peter and Alison Smithson, Aldo van Eyck, and Shadrach Woods), for a last appearance together at this exhibition of architecture. The protesting students demanded a sense of social responsibility from the designers and a more profound critique of existing power relations'.[16] This helped to encourage a political radicalisation of the critical design groups, Archizoom and Superstudio among them. The 1973 Triennale also closed down after only two months. It seems that, mindful of the protest movement of 1968, many countries had decided against participating. Sottsass's section at that event represented many of the theoretical assumptions of radical design.[17]

Other key exhibits of the period under scrutiny that played an important role in the story of critical design in Italy included the 1972 *Italy: The New Domestic Landscape* show held in New York's Museum of Modern Art (discussed in Catharine Rossi's contribution to this volume). The exhibition came at a moment when the American public had become aware of the developments that had been taking place in Milan and Florence, although critical design was still largely in its infancy. The older generation of radical designers, Sottsass and Gaetano Pesce among them, were included, but the Florence-based architecture and design groups Superstudio, Archizoom and UFO, whose members were still young designers at that time, were also given an opportunity to express their radical ideas to an international audience. The 1972 exhibition served to consolidate the fact that a critical design culture had grown up in Italy and that it represented a late stage of a very mature national design movement.[18]

When the next wave of Italian critical design broke in the late 1970s, it also used the medium of the gallery and the exhibition as a key strategy through which to present itself. Studio Alchimia's first *BauHaus* show took place in 1979, for example. In 1980 the group exhibited 'L'oggetto banale' at the Venice Biennale with objects designed by, among others, Alessandro Mendini, Paola Navone, Franco Raggi and Daniela Puppa. In 1981, as an appendage of the Salone Internazionale del Mobile di Milano in September of that year, Alchimia engaged in a live performance that involved a burning automobile, while Memphis's first show, held at the same time, was a truly memorable event, receiving more attention and press coverage than the exhibits at the main fair venue just out of town. All in all, the wide range of exhibitions focusing on critical design held between 1965 and the early 1980s served to demonstrate a continuity of activity and commitment through the period and a determination to disseminate key messages to as wide an audience as possible.

DESIGN GROUPS, COLLECTIVES AND NETWORKS

While critical design developed within specific geographical locales and thrived on the basis of being supported and disseminated by a well-defined and developed system of magazines and exhibitions, the designers made it happen. Critical design sought to overturn the primacy of the industrially manufactured cult object and the branded superstar designer, so the design group, or collective, made up of 'anonymous' designers and prioritising the work of the team, had a key part to play. There was a belief that working in a collective sent the right political message and avoided the added value of associating a well-known designer's name with a product that had become the norm in the context of internationally disseminated neomodern Italian design. In a dialectical fashion familiar to those engaged in Marxist strategies the critical designers overturned all of the assumptions that had underpinned the Italian neomodern movement of the two decades after 1945, while continuing to depend, nonetheless, on the same geography and infrastructure and support systems. Turning their backs on the large-scale exhibitions and embracing the small urban gallery, and founding new magazines dedicated to their

cause, many of the critical designers, architecturally trained for the most part, like those they were setting out to supersede, buried their egos and individualism beneath a shroud of collectivism.

Superstudio and Archizoom, as we have seen, led the way in this regard. Founded by Natalini and Branzi respectively (the latter, who moved to Milan, was to stay the course of radical design through to Memphis and beyond, while the former remained in Florence to set up an architectural practice), the two groups developed conceptual, material and spatial strategies in order to sidestep the authority of the highly aestheti-cised, neomodern, high-technology object. While Superstudio developed a language of neo-monumentalism, creating idealised grids that covered entire cities and embellished the surfaces of tables, Archizoom developed a negative utopia through a variety of other strategies, including the use of kitsch.

More specifically, from 1966 onwards Natalini and his Superstudio team defined three categories of future, anti-utopian research: the architecture of the monument, the architec-ture of the image and technomorphic architecture. In the early 1970s they fed into a num-ber of films intended 'to communicate their radical vision of an ideal world: one devoid of architecture'.[19] Superstudio's familiar black grid on a white background found its way into, among other artefacts, the Quaderna table designed for Zanotta, and their 'Continuous Monument' project was defined as 'the world rendered uniform by technology, culture and all the other forms of imperialism'.[20] (See Figure 2.1.) Much of their work was created not for mass manufacture but for exhibits and the pages of radical design magazines.

Archizoom, which was led by Branzi together with a team of architects (Gilberto Corretti, Paolo Deganello and Massimo Morozzi) and designers (Dario and Lucia Bartolini), drew on the British pop design movement in, among other projects, its Superonda (Superwave) sofa designed for Poltronova. The informal, unstructured form of that sitting object represented an attack on the overt functionalism and formal spatial concept of modernist designs. Other pop-inspired Archizoom projects included their Dream Beds and Gazebos. The latter were architectural spaces with no functional purpose. Archizoom's contribution to *Superarchitettura* was 'No-Stop-City', a depiction of a future city without boundaries, artificially lit and air-conditioned, and featuring continuous surfaces and multifunctional furniture and clothing. The vision was that of a life lived without the spatially bounded constraints of architecture. Their Centre for Eclectic Conspiracy focused on the issue of taste and embraced the aesthetic implication of mass consump-tion: kitsch. At the Museum of Modern Art's *Italy: The New Domestic Landscape* exhibi-tion Archizoom contributed an empty grey room that featured a girl's voice describing the light and colour of a beautiful house. The group went on to make a number of films about dress. It disbanded in 1974.

Superstudio and Archizoom established a direction of travel that was followed by many other architectural groups through the late 1960s and 1970s. Gruppo Strum, es-tablished in Turin and led by the architect Pietro Derossi, is best known for its design of the radical Pratone (Lawn) chair (1966), exhibited in New York, which consisted of

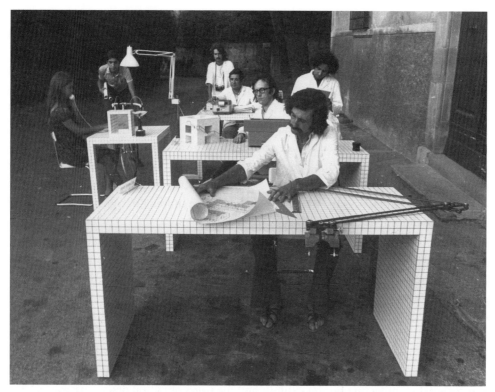

Fig. 2.1 Superstudio, Quaderna tables for Zanotta, 1971. Superstudio: Adolfo Natalini, Cristiano Toraldo di Francia, Roberto Magris, G. Piero Frassinelli, Alessandro Magris and Alessandro Poli (1970–1972). Courtesy of Archivio Superstudio.

a mass of closely grouped polyurethane foam stalagmites. This tall patch of 'grass' was painted with green varnish, and it invited its sitter to find a way of negotiating it rather than merely sitting in it passively. Other design collectives of the era included Gruppo NNNN and Gruppo 9999. The latter comprised the architects Giorgio Birelli, Carlo Caldini, Fabrizio Fiumi and Paolo Galli.

Global Tools, mentioned above, was less a collective than a loose network of individuals and groups including the leading radical architects and designers of the day—Archizoom, Remo Buti, Riccardo Dalisi, Ugo la Pietra, Gruppo 9999, Gaetano Pesce, Gianna Pettena, *Rassegna*, Ettore Sottsass Jr., Superstudio, UFO and Ziggurat—who came together to create a system of laboratories to encourage the use of natural materials in design and to facilitate individual creativity. The Florence-based design groups UFO and Cavart have already been discussed above.

By the mid-1970s the idea of the design group, collective or network was a well-known phenomenon within the world of critical design. At the end of that decade and the beginning of the next, a new burst of energy from a group of established radical designers, working by then with a younger generation of designers and entrepreneurs,

resulted in a decade of group design activity that was to extend Italian critical design from a movement that essentially reflected on the status and meaning of design within the country to one that had international reach and significance. What had begun as a local debate became, at that time, a global intervention that challenged design modernism wherever it could be found.

Studio Alchimia, which was founded in Milan by Alessandro Guerriero in 1976 at the height of radical design, began by curating an exhibition of vernacular (*casalinga*) furniture in that year. The studio was not a physical space but rather a means of bringing people together who shared a critical, problematising approach to design. By the end of the decade Guerriero had brought together de Lucchi, Mendini, Branzi, Sottsass, Raggi and Puppa in a series of exhibitions that featured their work.

Ettore Sottsass also understood that the most effective way of disseminating critical design ideas was to work with a group, and in the early 1980s he severed his links with Alchimia (which he found excessively theoretical and pessimistic) and looked to bring his own team together. He did this both formally on the level of professional practice, creating the consultancy Ettore Sottsass e Associati in 1980 with a number of young architects—Matteo Thun, Marco Zanini, Martin Bedin and Aldo Cibic—and informally through the creation of a network of people with whom he was closely associated, both in Milan and outside Italy, which came to be known as Memphis. It held its first group show in September 1981 to coincide with the annual Milan Salone del Mobile of that year.[21] Exhibitors at that show included, from Milan, Sottsass himself, de Lucchi, George Sowden, Bedin, Nathalie du Paquier, Thun, Zanini, Mendini, Cibic, Navone, and Branzi; from the United States, Peter Shire and Michael Graves; from Spain, Javier Mariscal; from the United Kingdom, Terry Jones and Daniel Weil; from Austria, Hans Hollein; and, from Japan, Shiro Kuramata, Arata Isozaki and Masanori Umeda. It was a powerful combination of people, both locally and internationally located, which succeeded in bringing Italian critical design to a global audience for the first time.

ETTORE SOTTSASS

The key role of design groups within Italian critical design did not obscure the contribution of individuals to that phenomenon. Indeed, as in all moments of historical change, individuals provided the ideas, the energy and the momentum. In the period 1965 to 1985 just a small handful of individual Italian designers could claim to have been agents of change in this context, whether as designers, editors, curators or entrepreneurs. They included Mendini and Branzi, who operated on numerous fronts; Natalini, a teacher and architect; Ugo la Pietra, a co-founder of Global Tools; Riccardo Dalisi; and Gaetano Pesce.

There can be little doubt, however, that the figure who towered over critical design was the architect-designer Ettore Sottsass. Through the injection of ideas borrowed from Indian spirituality and pop culture he pioneered that approach from the early 1960s onwards. Most important, he led the Memphis project in the early 1980s. Most accounts of

Italian critical design recognise his pre-eminence and agree that without his input Italian critical design would have been less influential internationally. Significantly, however, Sottsass challenged the supremacy of the mass-manufactured cult object through the very activity of designing objects.

Two key means of challenging neomodernism in Italian design preoccupied Sottsass. The first related to his discovery of a whole new meaning for the object, associated with ritual and spirituality, that he discovered during a visit to India in 1961. Among the many artefacts he created in response to that visit (Figure 2.2) he designed a number of small ceramic objects that deployed India-inspired imagery and that, he claimed, contained the message that 'love and attention can take the place of manipulation and use' and proposed 'a formal re-invention of objects simply through the mediation of the eastern figurative world'.[22] The second was linked to his encounter with pop culture during a trip to the United States. While the first helped him to understand how objects could perform a deconditioning function as much as a conditioning one (that is, they could liberate as much as they could enslave), the second offered a new meaning for the designed object that was innocent, spontaneous and, in his view, ideologically untainted.

Fig. 2.2 Ettore Sottsass, a sketch for his India-inspired 'Ceramics to Shiva', 1964. Courtesy of Studio Ettore Sottsass s.r.l.

Throughout his career Sottsass worked both as a consultant designer for industry—the Olivetti company in particular, for which he created functional objects—and as a critical designer, much more along the lines of a fine artist, keen to question the design status quo and to push forward the possibilities for, and the meanings of, design. On one level, therefore, Sottsass continually acted as his own critic, and frequently his two activities overlapped each other. In 1965 he created a furniture collection for Poltronova, which was inspired, in emulation of the strategies of the American pop artists, by banal objects such as traffic lights and bank safes. Writing about them, he explained that 'the object is no longer the cold and mechanical result of rigorous methodology but the magic and at times mystic vehicle in which the ritual of everyday life is condensed' and that the pieces represented a 'deconditioning from the psycho-erotic indulgences of possession/ furniture from which we feel so detached, so disinterested and so uninvolved that it is of absolutely no importance to us'.[23] The combination of the twin strategies of using Indian philosophy to uncouple the link, so strong in Italy at that time, between objects and conspicuous consumption and of referencing banal mass culture to sidestep the sense of desire evoked by highly styled, designed goods proved a powerful one for Sottsass. It was to remain visible as a strategy in his work, in various iterations, throughout the next two decades. Articulating his ideas through design activity, producing both furniture pieces and ceramic items, provided him with the possibility of creating one-off pieces that were less craft objects than prototypes. Working extensively with the wood craftsman Renzo Brugola and with a range of ceramic manufacturers in and around Florence, where craft skills were still in place, he produced pieces that he exhibited, mostly in Milan, which sat alongside his more mainstream designs for Olivetti. In 1967, for example, his exhibition *Menhir, Ziggurat, Stupas, Hydrants & Gas Pumps* consisted of huge, brightly coloured one-off ceramic objects that looked as if they could have been made from plastic and that aligned themselves with banal artefacts in the everyday environment.

By the late 1960s some of Sottsass's radical thinking had leaked sideways into his mass-manufactured products for Olivetti—his Valentine typewriter of 1969, for example—but in 1972 he took a further step away from engagement with production with a series of lithographs, entitled 'The Planet as Festival', that focused less on designed objects than on the depiction of a journey through exotic parts of the world.

Sottsass became increasingly disillusioned with the process of designing goods for mass production by the mid 1970s. As he explained, 'I thought that there was nothing left for me to design', adding that he saw himself as a 'solitary not group artist'. He explained that he was 'not engrossed in the destinies which worried [him] . . . political parties, armies and suchlike. . . . [He] thought there was no architecture left for [him] to draw'.[24] He became increasingly guilty about his chosen role in life, complaining, 'Now they're all saying that I'm a thoroughly wicked lot, really bad, because I'm a designer'.[25] By the end of the decade, however, he had joined the Studio Alchimia stable and begun to design large numbers of prototype domestic items that brought his long-term preoccupations with banal culture up to the present. By 1981 his new energy and commitment to critical

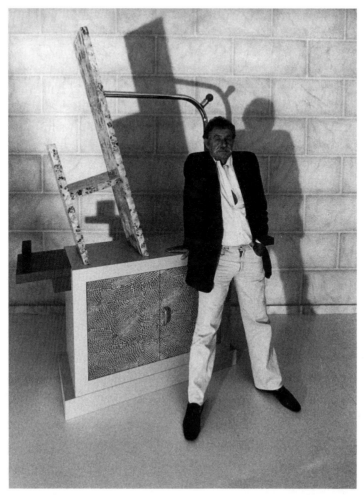

Fig. 2.3 Ettore Sottsass posing in front of Beverley, a cupboard/shelving system designed for Memphis, 1981. Courtesy of Studio Ettore Sottsass s.r.l.

design had engendered the widely debated Memphis experiment (Figure 2.3), which marked the final maturation and international dissemination of that Italian phenomenon.

CONCLUSION

Although the annual Memphis exhibitions went on until the late 1980s, by the middle of that decade the rapid and intensive internationalisation of Italian critical design, its absorption into the global umbrella design movement known as postmodernism and, in Italy, the work of Alessi and others returned critical design to the commercial mainstream, and it ceased to exist. From the vantage point of the second decade of the twenty-first century, one can see critical design in Italy as a twenty-year project that served both as a critique of the achievements of Italian design in the years 1945 to 1965 and, through

the emergence of a strong metadesign movement that was ultimately reabsorbed back into the very phenomenon it had set out to critique, as a development of it.

NOTES

1. For example, Penny Sparke, *Italian Design 1870 to the Present* (London: Thames and Hudson, 1988); and Andrea Branzi, *The Hot House: Italian New Wave Design*, trans. C. H. Evans (London: Thames and Hudson, 1984).
2. Branzi, *Hot House*.
3. Indeed, the fact that design aligned itself closely to fine art in the 1950s, in particular to the organic sculpture of avant-garde artists such as Hans Arp and Antoine Pevsner, accelerated the process of the acculturation of design in Italy in the two decades after the Second World War. The Italian section of the X Triennale, held in 1954, was entitled 'The Production of Art' in recognition of the strong alliance that existed between fine art and design at that time.
4. See, among other texts, Gillo Dorfles, *Il disegno industriale e sua estetica* (Bologna: Cappelli, 1965); and Umberto Eco, 'Cultura do massa ed evoluzione della cultura', *De Homine* 2, nos. 5–6 (1963): 57–69.
5. Franco Raggi, 'The Postradical Movement and the Explosion of the Interior', *Casabella* 380 (September 1973): 74.
6. Franco Raggi, 'The History and Aim of Negative Thinking in Radical Design since 1968—the Avant-Garde Role between Disciplinary Evasion and Commitment', *Casabella* 382 (November 1973): 37.
7. Ibid., 38.
8. See Alex Buck and Matthias Vogt, eds., *Michele de Lucchi* (Berlin: Ernsy & Sohn, 1993).
9. Ibid.
10. See Giampiero Bosoni, ed., *Made in Cassina* (Milan: Skira, 2008).
11. See Alessandro Mendini, *Paesaggio casalingo: Lo produzione Alessi nell'industria dei casalinghi dal 1921 al 1980* (Milan: Editoriale Domus, 1979).
12. See Anty Pansera, *Storia e cronaca della Triennale* (Milan: Editoriale Domus, 1978).
13. Sottsass's collection of ceramic objects *Menhir, Ziggurat, Stupas, Hydrants & Gas Pumps* was exhibited there in 1967, for example.
14. Jonathan M. Woodham, ed., 'Global Tools', in *Oxford Dictionary of Modern Design* (Oxford: Oxford University Press, 2006), 175.
15. See, for example, Luca Trombetta, 'Il caso *Modo*: Indagine sui processi di contaminazione tra editoria periodica di design e moda per la riprogettazione della rivista *Modo*' [The *Modo* case: Investigation on processes of contamination between fashion and design periodical publishing for the redesign of the magazine *Modo*] (PhD diss., Politecnico di Milano, 2007–2008).
16. See Jesko Fezer, 'Superstudio & Archizoom 1968–1972', *032c*, no. 6 (Winter 2003–2004): 94–101, http://032c.com/2003/superstudio-archizoom-1968-1972 (accessed January 28, 2012).
17. Untitled note, *Casabella* 385 (February 1974): 24.

18. See Emilio Ambasz, ed., *Italy: The New Domestic Landscape: Achievements and Problems of Italian Design* (New York: Museum of Modern Art, 1972).

19. See Jonathan Ringen, 'Superstudio: Pioneers of Conceptual Architecture', *Metropolis*, January 6, 2004, http://www.metropolismag.com/December-1969/Superstudio-Pioneers-of-Conceptual-Architecture/ (accessed February 21, 2012).

20. Ibid.

21. See Richard Horn, *Memphis* (New York: Columbus Books, 1986).

22. Penny Sparke, *Ettore Sottsass Jnr.* (London: Design Council, 1982), 65, 66.

23. Ettore Sottsass, 'Block Notes', *Casabella* 365 (June 1972): 41.

24. Ibid., 42.

25. Ettore Sottsass, 'Block Notes', *Casabella* 376 (May 1973): 14.

DOMES TO *DOMUS* (OR HOW ROBERTO MANGO BROUGHT THE GEODESIC DOME TO THE HOME OF ITALIAN DESIGN)

JEFFREY T. SCHNAPP

Design is a choral art. But histories of design are routinely staged as parades of soloists. Notions of individual creation, personality, originality and craft, once plausibly tethered to the reality of scattered small-scale studios, now provide little more than the facade for a system of brand names expertly managed by the masters of global marketing. The stages on which they perform are no less constructed than the stars themselves. Brand names like 'London', 'Milan', 'Paris', 'Tokyo' and 'New York' sparkle on shopping bags and bathe in the same artificial light, as if actual engines of creativity rather than mere shopfronts.

Behind the display windows, mostly concealed from view, lurk studios in industrial peripheries around the globe; complex connective tissues weaving together designers, studio assistants, model-builders, factory foremen, fabricators, factories, graphic arts studios and marketing departments; university programmes churning out a perpetually renewable army of interns as well as degree-toting 'designers'; swarm behaviours according to whose laws of perpetual imitation designs feed on designs that feed on designs; and the enduring dominance of anonymous over name-brand products within the overall cultural economy.

Naples has never been a star of first magnitude within the constellation of design capitals. And Roberto Mango, its most significant designer in the period from 1950 to 1970, has remained little more than a face in the chorus's back row.

Yet Mango is a significant figure in multiple regards. He created many successful period products like the Sunflower chair, the P37 Tecno armchair and T48 expandable table, the ITB park bench/recliner and various designs for foldable or expandable children's playpens. He was the author of a corpus of journalistic writings in the architecture press (*Domus, Interiors, Industrial Design, Stile Industria, Ottagono*). He was the organiser or architect-designer of exhibitions that brought the best in industrial design to Naples (the US Information Service *Disegno e produzione negli USA* [1960] and *Che cosa è il design* [1966] shows) or that promoted American or Italian design abroad (*USA Industrial Design*, Liège, Belgium, promoted by the US Department of Commerce, 1955; Italian Pavilion, Hemisfair '68, San Antonio, Texas, sponsored by the Italian Ministry of

Foreign Affairs, 1968). He was one of the first Italian architect-designers to dabble with computational tools; during a 1966 sojourn at Harvard University, he also frequented the Massachusetts Institute of Technology (MIT) and the Digital Mona Lisa project at Control Data Corporation's Digigraphic Laboratories. And he served as a longtime faculty member and leader at the School of Architecture of the University of Naples and was co-founder of its programme in industrial design.

In the immediate wake of Mango's death in 2003, a brief flurry of remembrances issued forth from within the circles of former collaborators and students. There were also tributes in design journals. Three years later these culminated in Ermanno Guida's monograph *Roberto Mango: Progetti, realizzazioni, ricerche*: an overview of Mango's career, including documentation of his major projects, testimonials and an anthology of excerpts from his writings.[1] But Guida's book is little more than an introduction, and his prefatory words remain just as true today as they were in 2006: 'not a great deal has been written about Roberto Mango, his contributions to the profession or his research'.[2]

The present chapter does not set out to remedy this lacuna. Rather, it aims to drill down deep into a single episode. In so doing, it examines the most important role that so-called peripheries and peripheral figures can perform with respect to global systems (whether of stars or showroom cities): namely, to serve as bridges, places of contact and contamination.

In the case of Mango, the role in question was anything but trivial. It cast the Neapolitan architect as a key mediator between the Italian design world of the 1950s through the 1970s and the North American scene, just as Italian and American design became dominant forces globally (Figure 3.1). Within this time span, unlike more celebrated peers, Mango shuttled back and forth frequently across the Atlantic, working for and interacting with protagonists in the United States; serving as a translator, organiser and collaborator; and promoting Italian design while adapting both the premises and the content of the most advanced American work to Italian and even Neapolitan tastes. This chapter reconstructs a single chapter from this larger tale of transatlantic translation and adaptation: that which explains how the first geodesic domes ever to be erected on European soil became the stars of the 1954 Triennale.

The period of Mango's training as an architect coincided with the years of the Second World War, so much so that his progress was interrupted for two years as, under wave upon wave of Allied bombardment, portions of the city were reduced to rubble. Soon after 1946, when he was able to complete his degree and deliver a thesis project on the use of tensile structures in industrial building types, we encounter him as an active member in Bruno Zevi's Associazione per l'Architettura Organica (Association for Organic Architecture). He was, in the words of its director, 'one of the most intelligent favorers and organizers of exhibitions, lectures and essays on the American school founded by Frank Lloyd Wright, from which our movement takes its inspiration'.[3] These transatlantic enthusiasms, shared by a new generation of architects who sought to distance the profession from the taint left by decades of dalliances between the modern movement

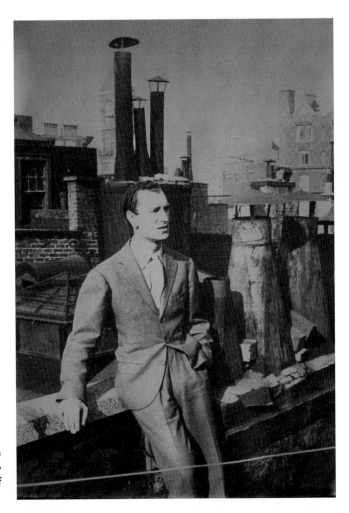

Fig. 3.1 Roberto Mango in New York City, c. 1951 (Archivio Roberto Mango). Courtesy of Stefano Mango.

and the Fascist regime, inspired a successful effort to secure a grant from the Ministry of Public Instruction in 1949. Mango's initial aim was to follow in Zevi's footsteps by taking up residency at the Harvard Graduate School of Design under the protective wing of Walter Gropius. But the Bauhaus founder was unable to accommodate Mango, and an effort to find a home at MIT also failed. So Mango instead arrived at Princeton in the fall of 1949 as a 'special student' and there dedicated himself to studies of American prefabrication techniques (with peers like the future author of *Learning from Las Vegas*, Robert Venturi, at his side).

Even before the start of his Princeton sojourn, Mango entered into direct contact with R. Buckminster Fuller, who, at the time, was in residence at Black Mountain College. On August 20, 1949, Fuller wrote back to the effect that 'I will be glad to discuss your project with you if you can arrange to call' in September, when Fuller was to be based in New York City.[4] The call took place, and face-to-face meetings followed in New

York and at Cornell University. From that time on, Mango began a period of intensive engagement with the Fuller Research Foundation in Forest Hills, New York. Two and a half years later, he had become the foundation's de facto Italian delegate as attested to by a letter to the cultural attaché of the US embassy, dated April 24, 1952, and signed by Fuller, which declares that

> Professor Robert Mango of the Department of Architecture at the University of Naples is carrying to Italy a collection of slides belonging to the Fuller Research Foundation which illustrate the latest developments in my research on Geodesic Structures. Professor Mango will use them in lectures to his students at the University of Naples, and also in lectures at other Italian universities, for the purpose of reporting the recent technical and scientific developments in the United States.[5]

(A request for facilitation of his 'reporting' followed.) The period culminated when Mango served as chief coordinator of the American Pavilion at the 1954 Triennale: a pavilion made up of two Fuller cardboard domes for which Mango built the foundations and designed the interiors. By that time he was Fuller's principal explicator and populariser on the Italian scene. Without Mango, it is probable that Fuller's gospel of tensegrity and comprehensive anticipatory design science would not have reached Italian or European audiences until the heyday of the counterculture, a decade and a half later.

How did an unknown thirty-year-old Neapolitan architect attain this status? The tale begins at Princeton, where Mango's work was concerned with one of the heroic themes of the post-war reconstruction: prefabricated housing. Levittown, New York, was only 120 kilometres (85 miles) away, with its Pennsylvania twin at less than 30 kilometres (20 miles) distance, and companies like Lustron were hard at work building production-line enamelled metallic housing for the masses in former aircraft factories.[6] Mango's interests were, however, less down-market than aligned with the genealogical branch extending from Joseph Paxton's Crystal Palace to Frank Lloyd Wright's Usonian homes to the Tennessee Valley Authority's (TVA) instant housing to Fuller's domes and Wichita House. Indeed, his Princeton thesis project surveyed the state of the art in standardised, modular construction techniques from wood stress-skin systems to steel strut and panel houses to cement shell construction systems, noting the constancy of the gap between a gradualist, evolutionary model of development and purely experimentalist approaches. In one revealing photo montage he juxtaposed the Crystal Palace's trussed gallery structures with Fuller's latest Standard of Living Package, as if to mark two bookends in the history of industrial approaches to construction.

This isn't to imply that Mango's universe during his American years (1949–1954) was narrowly Fuller-centric. On the contrary, as well as serving as the American correspondent for *Domus*,[7] he set to work right from the start on a wide range of projects including (in chronological order) the development of designs for the main office of a newspaper as part of a competition held by the Institute of Design in New York City (earning an 'honorable mention'; 1949); the development of a parabolic floor lamp (*lampada a vela*)

for a competition at the Museum of Modern Art (MoMA) for Heifetz and Company (again earning an 'honorable mention'; 1950);[8] work as an instructor of advanced interior design at Whitman School of Interior Decoration (1950–1951); installation designs as well as graphic design work on three exhibitions at the Tibor de Nagy Gallery (*Sculptures by Le Corbusier and Costantino Nivola* [1950]; *Photographs by Eugene Smith, Robert Frank and Ben Schultz* [1951]; and *Paintings by Ben Shawn* [1951]); an internship with Raymond Loewy Associates in which he worked on a wall design for the Lever Brothers headquarters and display modules for department stores (October 1950–March 1951);[9] the design of an installation for Italian furnishings for the Museum of Natural History, New York (early 1952); design consulting work on a *Fair of Italy* installation in Grand Central Station (1952); chair designs, some developed in collaboration with Romaldo (Aldo) Giurgola (1951–1954); work with Allan Gould Designs on the production and marketing of Mango's own chairs (1953–1954) (Figure 3.2); photographic studies of

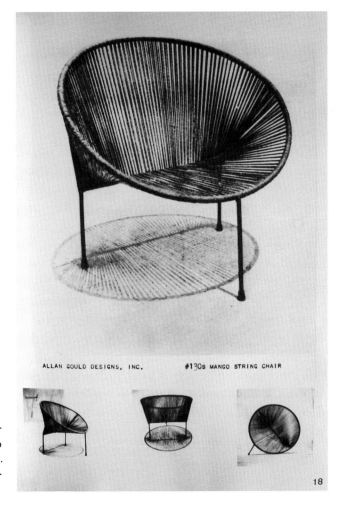

ALLAN GOULD DESIGNS, INC. #130s MANGO STRING CHAIR

Fig. 3.2 Advertising sheet for String chair, designed by Roberto Mango for Allan Gould Inc. (Archivio Roberto Mango). Courtesy of Stefano Mango.

18

New York City's urban decor (manhole covers and fire escapes), sold to *Life* magazine (1952);[10] and stints as a visiting teacher/critic at the Pratt Institute, Parsons School of Design and Columbia University (1952–1953). Somewhere in the midst of these activities, Mango entered the magic circle of Olga Gueft, the powerful editor of the review *Interiors and Industrial Design* (*Interiors*).

Mango's first appearance on the review's pages is datable to the July 1951 issue, which featured a playful proposal for a television viewing room entitled 2 x 2. Two issues later he began serving as the art director of *Interiors*, a role he shared with Giurgola between September 1952 and November 1955. (Giurgola, born in Rome but trained at the graduate level in the United States, would go on to become the chair of Columbia's Department of Architecture and a significant member of the so-called Philadelphia School with Venturi and Louis Kahn.) During these years Mango published well over a dozen pieces in the review featuring his own work as a designer, theorist and photographer, as well as carrying out layout, cover and advertising designs for the likes of the furniture manufacturer Widdicomb (Figure 3.3).

By the early 1950s, *Interiors* had consolidated its status as the leading East Coast publication in the field of design and as the main hub for Italian/American design conversations. So it is perhaps unsurprising that, after the polemics unleashed by the United States' participation in the 1951 Triennale, where an American Society of Industrial Designers photo exhibit found itself competing with a rival exhibit created by MoMA for the US Information Agency, it was none other than Gueft who was entrusted with creating a unified American presence in 1954.

Gueft proved as tenacious as she was effective in this leadership role. First, she sought funding from the US Congress and the State Department.[11] Rebuffed by both, she developed a two-pronged approach that relied on the support of industry and the design professions. On the one hand, with the head of the American Society of Industrial Designers, Peter Müller-Munk, she developed an exhibit of utilitarian objects by leading designers like Russel Wright, Eliot Noyes and Raymond Loewy. On the other, she set about working with Fuller and some partners in industry on securing one of Fuller's new ultralight geodesic domes, first tested at the Marine base in Quantico, Virginia, in August 1953.

Early in 1954 Gueft contacted Fuller, who, one month later, wrote back expressing his interest. Fuller stated that the project's feasibility would depend on assigning a key role to one of his former students from MIT, Zane Yost, in Italy on a Fulbright grant at the time, and insisted that 'with your editorial support and materials donated by American firms plus Zane's ingenuity directly at hand, *Roberto Mango may be able to bring this to pass*' (my emphasis).[12] He asked that Mango be forwarded a copy of the letter and closed with a flirtatious valediction to the effect that he hoped that Gueft had 'geodesic principles' applied by her surgeon 'to the restoration of your very beautiful nose' (recently broken in an accident).[13]

Two weeks later, from Mango's studio in Naples, Yost was reporting back on the solution worked out with Carlo de Carli and Marco Zanuso from the Triennale's organising committee:

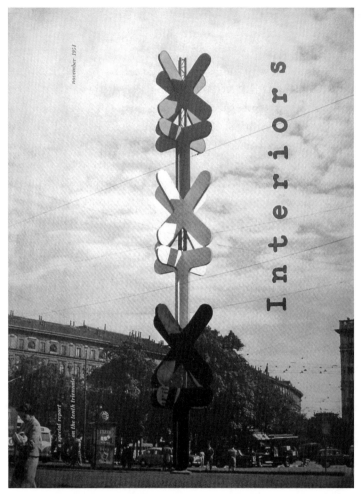

Fig. 3.3 Cover by Roberto Mango for the November 1954 issue of *Interiors*, dedicated to the Triennale di Milano (Archivio Roberto Mango). Courtesy of Stefano Mango.

Roberto, in connection with his other participation in the *Triennale*, had [an] opportunity to give the members of the committee a thorough (with his material) background of your work. They became excited over the potentialities of a Geodesic Dome for their flower show as part of the Triennale. But Roberto (sensing that if your structure was exhibited only as a greenhouse [it] would tend to ignore its greater significance in an exhibition largely devoted to industrialization in housing) got the Committee to agree to a second structure which would dramatically demonstrate its housing potential.[14]

The initial proposal was to fill the second dome with interior furnishings from a travelling MoMA show, *American Design for Home and Decorative Use*. But this proved impossible, and Mango was opposed to it, fearing that MoMA would subordinate the presentation

of Fuller's work to the advancement of its own interests.[15] So Mango became not only the site architect for the project but also the chief designer of the installations that filled the interiors.

In the meantime, Gueft, who judged Mango's solution 'far more exciting and meaningful' than that envisaged by MoMA, was mobilising the readership of *Interiors*.[16] In a feature editorial in the April issue, she decried the American government's lack of understanding of the importance of industrial design and the absence of a state-financed national pavilion. The editorial concluded by emphasising the Triennale's eagerness to host two innovative geodesic domes and called on industry to support the venture: 'We are counting on American industry to come through, and on many organizations and individuals in this field to participate in making American rapport felt in a part of the world where it would do us more good even than American dollars'.[17] A second passage in the same issue adopted an even more messianic tone. It proclaimed that 'Fuller's lifelong efforts to solve the problem of shelter are approaching a climax of tremendous economic and social implications'. All the mathematical-structural problems have been solved. The mass-production techniques are available to quickly and inexpensively produce printed, flat-packed structural components in cardboard for on-site erection of housing by unskilled labour. The Triennale is offering a stage on which to bring this solution to the post-war era's urgent need for housing to the attention of a worldwide audience. One thing alone is missing: '$15,000 in cash, and the paper and plastics that only American industry can produce'.[18]

American industry answered Gueft's call in the form of the Container Corporation of America: the world's leading producer of corrugated boxes and the materials contractor for the US Marines domes. The company knew that it would be a major beneficiary if the future of housing assumed the form of cardboard domes, and even though waterproof cardboard was not (yet) a reality, it was researching the development of aluminium foil and plastified cardboard laminates. So a transitional, as yet untried solution was embraced: the use of cardboard ('Kraft board') as an outdoor construction material with pre-cut, foldable forms, to be covered by a 'bathing cap' made of Krene sheeting.[19] The decision guaranteed an absolute novelty: the first experimental deployment of a cardboard dome inside a Marine hangar in Quantico would be swiftly followed by the first outdoor deployment at the Triennale during the course of a single month. In Mango's own words, 'it represented an "experiment within the experiment" that Fuller was carrying out for the US Marines with the use of emergency structures that can be transported by air . . . in the form of the first geodesic structures mounted and assembled in Europe'.[20]

While Gueft conducted the US campaign, the Italian front was manned by Mango. Mango first infected De Carli with his own enthusiasm regarding the revolutionary potential of cardboard domes as a form of *architecture out of the laboratory*, persuading the Triennale to assume some of the construction costs. De Carli confirmed his commitment in a mid-March letter: 'I urge you to move the Fuller initiative forward; it's magnificent and ultra-necessary for our exhibition'.[21] By mid-May, they had enlisted the aid of the

young Aldo Rossi (working as an aide to the Triennale management) in getting the former *Bauhäusler* Herbert Bayer to lean on the top brass at the Container Corporation of America: all in the name, as Rossi puts it in a letter, of 'a modest offensive'.[22]

By June, final arrangements had been made, and the proposal to use MoMA furnishings was dead, freeing Mango to transform the second of the domes into a full-blown Fuller showcase: 'We stick to our original plan' he wrote, 'SHOW TO THE ITALIAN PUBLIC THE FULLER DOME AS HOUSING INDUSTRIALIZED SOLUTION'.[23] The letter went on to request specifications for Fuller's 'standard-of-living' units, technical data, models and documentation for a three-dimensional display on partitioning structures within the domes. It concluded by stating:

> We are all positive at the Triennale that *this* is the real contribution which will be valid for our public. Your exhibition, inside the dome, completed of a quick survey of your past experiments, will positively introduce in Italy your wonderful results and will certainly receive the highest acceptance of our public. . . . You could count on my full cooperation and interest for every future adoption of domes in Italy. This is a great privilege I would like to get from you, as a tangible contribution to our housing problem and successful result of my plans to introduce your domes in Europe.[24]

Mango's offer, in effect, was to become Fuller's agent. It was seconded by the promise to provide 'a complete introduction to your technical and philosophical theory'.[25]

Such was indeed the trajectory followed by Mango during the period of the installation of the Fuller pavilion at the Triennale and in the half decade following its success. Joined by Fuller's partner Shoji Sadao for the final assembly, he became Fuller's European spokesman and is referred to as such in multiple documents from this period found in the Fuller Archive at Stanford University as well as in his personal archive in Naples (Figure 3.4).[26]

Twin structures were erected in the park surrounding Giovanni Muzio's Palazzo dell'Arte, the home of the Triennale since its move from Monza in 1933, on the basis of technical drawings produced by Mango that highlighted their greenhouse-like properties. Whereas the Marine domes were utility structures requiring little in the way of fenestration, the Triennale domes were at once exhibits and sites of display. Mango set about accentuating their translucency so that, during the day, the domes would provide luminous and airy domestic environments and, at night, illuminated from within, they could become the dominant features of the Triennale's night landscape. But this achievement was not without logistical snags involving customs: so many that, in a letter dated September 29, Fuller called the fact that the domes were up and functioning a miracle.[27]

Both domes were 11 metres (36 feet) in diameter, 5.5 metres (18 feet) in height and circa 95 square metres (1018 square feet) in surface area and weighed 272 kilograms (600 pounds) stapled together. Both took advantage of the sound- and temperature-insulating properties of the cardboard channels of which they were made. One rested on a wood railing embedded in the gravel of Parco Sempione and contained an artfully constructed desert garden: a greenhouse in the lineage of winter gardens extending backward towards

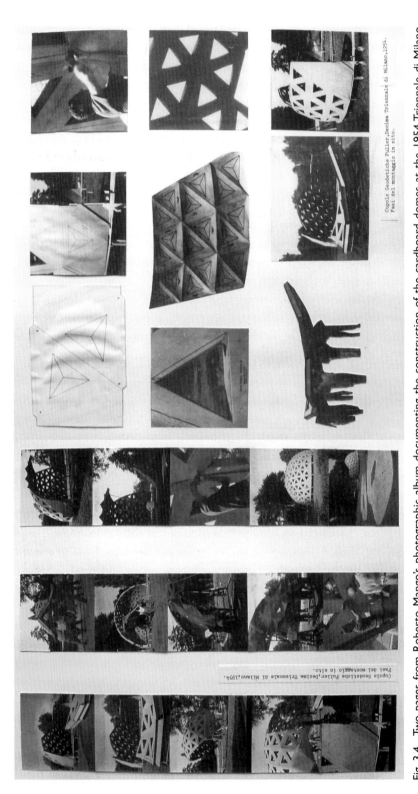

Cupole Geodetiche Fuller,Decima Triennale di Milano,1954.
Fasi del montaggio in sito.

Cupole Geodetiche Fuller,Decima Triennale di Milano,1954.
Fasi del montaggio in alto.

Fig. 3.4 Two pages from Roberto Mango's photographic album documenting the construction of the cardboard domes at the 1954 Triennale di Milano (Archivio Roberto Mango). Courtesy of Stefano Mango.

Paxton's Crystal Palace and forward towards Fuller's own dome over Manhattan, even if oddly semi-opaque. The other dome—the 'real contribution' alluded to in Mango's June letter—advanced Fuller's claim that he had solved the world's housing problems in the guise of a vacation home. In this case, Mango devised a wood platform to support the dome with slight changes in the floor level and low partitions so as to allow for an asymmetrical plan made up of hexagonal directional modules, thereby avoiding the twin perils of a pie-slice subdivision of the interior and the attempt to align furnishings in relation to the dome's circular walls.[28] The hexagons variously assumed the identity of bedrooms, a bath, closets, a kitchenette, a dining room and a living room with a sunken fireplace-garden with Mango's own designs for Allan Gould (the Sunflower chair and rocker) and Tecno (the T48 expansible dining table) featured among the sparse furnishings.[29]

The novelty of the two constructions, their double identity as greenhouse and home, the spectacle provided by the assembly process, their dramatic overturning of what Yost referred to in a letter as the 'compressive complacency' of the Italian architectural establishment, and the humbly industrial character of the construction materials employed, combined with routine demonstrations for the press of their exceptional lightness and strength, drew the attention of Triennale visitors from the start.[30] And although there were sceptics, there was also such a groundswell of curiosity and enthusiasm that the domes were eventually awarded the Triennale's Grand Prize.[31]

During the period that the Triennale exhibition was open, Mango was busy planting articles in *Domus*, *Casabella*, *Architettura/Cantiere* and *Sapere* that emphasised the domes' 'miraculous' efficiency and minimal cost (claimed at $280): the fact, for instance, that printed structures shipped in packing cases measuring a mere 2.7 cubic metres (96 cubic feet) could be quickly assembled by unskilled labourers into domes spanning 95 square metres (1018 square feet) of floor space and approximately 340 cubic metres (12,000 cubic feet) of clear span room—a compression ratio of 120 volumetric units per unit of packaged materials. He assisted Fuller's efforts to exploit the Grand Prize to reinforce the US Marine Corps' support of the development of a second generation of geodesic shelters. He relayed enquiries regarding the building of additional European domes to Geodesics, a newly founded company based in Raleigh, North Carolina.[32] And he became so integral to Fuller's thinking about the marketing and assembly of expanded lines of geodesic display structures for European trade fairs that Fuller discouraged him from returning to the United States. 'From my viewpoint [staying in Europe] will be most advantageous because it will leave you free, assuming that you still wish to pursue the function of my free-lance representative, to shepherd not only the installation events but also the larger contiguous responsibilities in respect to the organizational evolution of geodesic developments'.[33]

Such plans coincided with the period during which Mango wrote and published the first European monograph dedicated to Fuller's work: *Richard Buckminster Fuller: Design Science* (1957). Even though it was a pioneering work, the book failed to make a splash, perhaps because of the selection of a small German publisher, Gerd Hatje in Stuttgart.

Related publications continued on through 1959.[34] It is also during this period that Mango undertook the Italian translation of some of Fuller's writings, including the 1956 industrial poem 'A Comprehensive Anticipatory Design Science'.[35]

Dreams of a revolutionary solution to the question of shelter in the form of dome homes would, of course, fail to achieve fulfilment. This would prove true no less during the 1950s than over the course of subsequent decades, when, thanks to the counterculture's embrace of geodesics as the crystallisation of a new democratic counter-architecture, pure Fullerian domes found themselves in the company of mutant zomes and icosadomes scattered about utopian communes like Drop City in Colorado. Well known as much for his brilliance as for his optimistic thinking regarding the availability of simple fixes to intractable problems, Fuller would habitually terrify collaborators with pronouncements to journalists regarding the capabilities of his inventions or the immi-nence of a solution to any obstacle that stood in the way of their impact or use.

A case in point was waterproof cardboard. In an August 1954 report, Fuller acknowl-edged its non-existence while noting that 'promising results' were being obtained by the Forest Products Laboratory and that the Institute for Paper Chemistry, with a research budget of $6 million a year, considered such a material 'theoretically possible'.[36] That was good enough for Fuller, who had himself been experimenting with fibreglass coatings. 'Chemistry in this art is advancing so rapidly that we feel the answer will be here soon', he concluded, which is why 'we thought that the dry structural design should be attempted now'.[37] Years would go by, and the breakthrough would always remain six months away.

It is impossible to know whether technical setbacks of this sort (or endemic problems involving the design of doorways and windows as well as storage within geodesic struc-tures) tempered Mango's convictions as the 1950s wore on or whether he simply drifted towards architectural concerns of his own, like urbanism and urban decor. He was un-involved, for instance, in the construction of a geodesic dome at the 1957 Triennale. A decade later, however, in 1968, we find him no less interested in the industrial produc-tion of buildings than he was in the 1950s and working on a line of pre-cut cardboard furniture for the manufacturer Italcarton in Lucca (Figure 3.5).

Whatever the case may be, it is certain that the 1954 domes had a powerful impact on the European imagination, both within and beyond the orbit of the architecture, design and art communities, even as some of the expectations that accompanied their launch were revealed as overblown. Two stories proved just as irresistible to Europeans as they had already proved to Americans: the myth of a humble, ubiquitous, 'democratic' indus-trial material transfigured into the solution to universal human needs, and the myth of a sturdy, speedy, rational house that could be printed in millions of copies, shipped flat on a train or truck and stapled together by nearly anyone . . . in short, the dream of a post–Second World War continuation of the democratic dream of a do-it-yourself home for all, inaugurated by the American kit houses of the turn of the twentieth century.

As the Italian translator of this twofold fable, Mango's testimony in his final essay on the topic, published in the January 1959 issue *Stile Industria*, is lucid as regards the

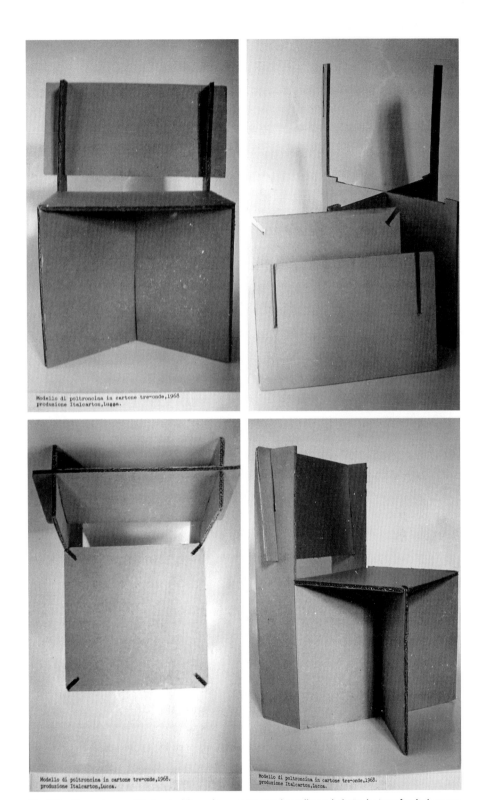

Within the images, the following captions are visible:

Modello di poltroncina in cartone tre-onde,1968
produzione Italcarton,Lucca.

Modello di poltroncina in cartone tre-onde,1968.
produzione Italcarton,Lucca.

Modello di poltroncina in cartone tre-onde,1968.
produzione Italcarton,Lucca.

Fig. 3.5 Four views of Roberto Mango's experimental cardboard chair designs for Italcarton, 1968 (Archivio Roberto Mango). Courtesy of Stefano Mango.

powers and limits of Fuller's world. Situating Fuller within a distinctly American ge-
nealogical sequence and locating geodesic shelters at once in the past and in the future,
Mango characterises their inventor as the last utopianist of the nineteenth century. And
he concludes both his essay and mine by noting insightfully that

> Fuller's shelters don't aspire to the status of architectural works. Rather, they are de-
> monstrative in nature. They give evidence of the technical and organizational poten-
> tial that industry possesses to address the pressing needs of the worldwide economy.
> Definitive results cannot be the outcome of individual efforts but only from ongoing
> technological progress. . . . It's clearly the case that, among other things, technical de-
> velopment [integrazione] doesn't propose a spatial thematics and, despite its system of
> premises, remains extraneous from the actual social sphere. Fuller can find no concise
> and satisfactory definition of art, even as he acknowledges that it is 'partially true that
> art implies order, even without recourse to self-conscious measurements'.[38]

NOTES

1. Ermanno Guida, *Roberto Mango: Progetti, realizzazioni, ricerche* (Naples: Electa Napoli, 2006).
2. Ibid., 11. This and all subsequent English translations are by the author.
3. A. D'Ambrosio, letter of recommendation dated April 22, 1948, Archivio Roberto Mango (ARM), Naples.
4. Dictated letter from R. Buckminster Fuller to Roberto Mango, dated August 20, 1949, ARM. On Zevi, see Roberto Dulio, *Introduzione a Bruno Zevi* (Bari: Laterza, 2008).
5. Letter in 'Attività Didattica 1946–1969' folder, ARM.
6. On this topic see my 'L'abitare mobile americano', in *Casa per tutti: Abitare la città globale*, ed. Fulvio Irace et al. (Milan: Triennale di Milano/Electa, 2008), 48–61.
7. A letter of recommendation from Betty Chamberlain, the Museum of Modern Art's public-ity director, dated June 14, 1951, states that he has been 'cooperating with the Publicity Department of the Museum of Art as the only correspondent for *Domus*, Italian magazine of architecture and design' (ARM). The notion is confirmed both by a first contribution that appeared in *Domus* 241 (December 1949) and by a letter dated August 29, 1951, in which Gio Ponti vouches for his role as correspondent (ARM).
8. Published as 'Una lampada a vela', *Domus* 264–265 (December 1951): 68.
9. In a letter dated March 15, 1951, Loewy would write to E. Minetti at the AICAR: 'Mr. Ro-berto Mango has just completed a stage with our organization in New York and is returning to Italy. He has great talent and we are sorry to see him leave' (ARM).
10. These were later published in Mango, *Industrial Design* 3 (May 1954): 90–93.
11. A letter to Gueft from Claire Boothe Luce, dated February 16, 1954, details the US Informa-tion Agency's efforts to secure recycled versions of two other MoMA shows: *American Design for Home and Decorative Use* and *Built in the USA—Postwar Architecture* (both of which failed) (ARM).

12. R. Buckminster Fuller to Olga Gueft, February 7, 1954, ARM.

13. Ibid.

14. Yost and Mango to Fuller, February 10, 1954, ARM. The letter goes on to lay out construction details for both domes, as well as the timeline for their realisation.

15. In a letter to Fuller dated April 11, 1954, Yost reports: 'Roberto, who seems to have no great love (nor great hate either) for certain personalities at the Museum, fears that by giving financial backing they may want to "run the show" in a manner *perhaps* not so much interested in presenting your work altruistically as "cashing in" for the Museum. . . . Quote (freely from R): "Will work for free for Bucky but never for the MMA"'. R. Buckminster Fuller Papers Series 2, box 80, folder 12 (vol. 152 in the Dymaxion Chronofile), Stanford University.

16. Gueft to Fuller, February 26, 1954, ARM.

17. O[lga] G[ueft], 'Opportunity in Milan', *Interiors* (April 1954): 53.

18. Ibid.

19. Vinyl-like, Krene was a pliable synthetic plastic form of sheeting or film from the late 1940s used in tarpaulins, shower curtains, curtains, window blinds and waterproof garments.

20. 'Programma di montaggio di due strutture geodetiche Fuller', undated typescript, ARM. Another undated document indicates that the US deployment took place on August 4, 1954; the Triennale opened at the end of the month.

21. De Carli to Mango, March 12, 1954, ARM.

22. 'Una piccola offensiva'. Rossi to Mango, May 12, 1954, ARM.

23. Mango to Fuller, June 29, 1954, ARM.

24. Ibid.

25. Ibid.

26. The R. Buckminster Fuller Papers Series 2, box 84, folder 4 (vol. 159 in the Dymaxion Chronofile), Stanford University, document how frequently Mango was present in Milan representing Fuller-related interests for the 1954 Triennale.

27. Fuller wrote, 'In view of the exquisitely short space of time which characterized the whole episode between possibility, probability and fulfillment, operating in the field of premiere industrial organizations, international relations, trans-oceanic shipping, industrial tooling, et al, it now seems approximately a miracle that the two domes are safely installed and functioning. That they have such excellent functions and such superpositioning in the Exposition is one more testimonial to your tireless efforts and supervision'. Fuller to Mango, September 29, 1954, ARM. A Bucky-centric account of the Triennale adventure is found in 'Architecture Out of the Laboratory', a piece redacted by students at the University of Michigan School of Architecture on the basis of Fuller's taped lectures, published in *Student Publication* 1, no. 1 (1955): 9–34.

28. Gueft celebrated Mango's solution as follows: 'The interiors of the "house" dome are extremely simple, but architect Mango has brilliantly solved the problem which has stymied everyone—Bucky Fuller included—who has tried to furnish a dome'. '2 Cardboard Geodesics from the U.S.A.', *Interiors* (November 1954): 114.

29. The other furnishings that I have been able to identify were designs by Osvaldo Borsani, also for Tecno.

30. Yost to John Dixon, April 11, 1954, R. Buckminster Fuller Papers Series 2, box 80, folder 12 (vol. 152 in the Dymaxion Chronofile), Stanford University. In a postcard dated September 17, 1954, Sadao reported to Fuller: 'everything complete at Milano: domes receiving radio, press, tv and news coverage. Staying in Venezia few more days then moving on to Ravenna, Florence, Rome and Naples'. R. Buckminster Fuller Papers Series 2, box 83, folder 1 (vol. 156 in the Dymaxion Chronofile).

31. The jury was presided over by Carlo Carrà and included Gillo Dorfles and Nathan Shapira, the future US-Israeli collaborator of Gio Ponti.

32. The Mango archive contains letters from Dario dal Monte Casoni (Milan), the engineer C. Domenighetti (SIMESA), the Università Internazionale degli Studi Sociali (Rome), the Compagnia Italiana Scambi Estero (Milan), Guerrino Assoni (a Milanese painter), the engineer Leone Turazza (Bologna), Renzo Molinari (a student from Savona) and *La Fiera di Ancona* regarding the construction of new domes.

33. Fuller to Mango, February 21, 1955, ARM.

34. The last such study appears to be Mango, 'Il comprehensive design di Buckminster Fuller', *Stile Industria* 20 (January 1959): 3–18.

35. The poem was published in *No More Secondhand God and Other Writings* (Carbondale: Southern Illinois University Press, 1963; 2nd ed., Garden City, NJ: Anchor Doubleday Books, 1971).

36. Cited from a document entitled 'X Triennale di Milano—Struttura geodetica di R. Buckminster Fuller', which goes on to cite from Fuller's report regarding the US Marine dome experiments (ARM).

37. Ibid.

38. Mango, 'Il comprehensive design di Buckminster Fuller', 4.

4 TOMÁS MALDONADO AND THE IMPACT OF THE HOCHSCHULE FÜR GESTALTUNG ULM IN ITALY

RAIMONDA RICCINI

MALDONADO IN ITALY

Tomás Maldonado is one of the acknowledged protagonists of design history in the second half of the twentieth century for the role he played at the Hochschule für Gestaltung (HfG) in Ulm, Germany, and his contribution to design theory, before and after he moved to Italy.[1] Less well known is his professional contribution to the practice of Italian design. This chapter examines his collaboration with Olivetti and La Rinascente between the late 1950s and the end of the 1960s—that is, while he was still living in Germany.

Born in Buenos Aires in 1922, Maldonado moved permanently to Milan in 1969. The Ulm school, where he began teaching in 1954 and later served as rector for many years, had only recently closed, in a tempestuous end to what proved to be one of the most important episodes/experiments in the history of design.[2] Maldonado's move from Germany to Italy is a sign of his deeply rooted relationship with Italy, dating as far back as his youthful experiences as an artist of the avant-garde. He had come to Italy as early as 1948, in one leg of his first travels to Europe in search of direct contact with the major exponents of the artistic movements on the continent. On that occasion Maldonado established his first contacts with Max Bill and other exponents of Swiss concretism;[3] in Italy he met personalities such as Gillo Dorfles, Bruno Munari, Max Huber, Piero Dorazio, Achille Perilli and Gianni Dova. These initial contacts with Italy—particularly in the area of Milan—were renewed when Maldonado arrived at Ulm in 1954 as a young professor. He gave up his artistic career to dedicate his work completely to this new adventure, and he was fully focused on the development of an educational approach, a theory and a practice of industrial design.

The year 1954 was, for Italian design, an annus mirabilis—as demonstrated in Kjetil Fallan's contribution to this volume. Starting in the early 1950s, the frenetic period of the reconstruction brought to light new subjects, institutions and personalities. The Fiera Campionaria in Milan became the centre for the diffusion of industrial products with two exhibitions on industrial aesthetics (1952 and 1953). In 1953 La Rinascente organised an exhibition entitled *L'estetica nel prodotto* (The aesthetics in the product), a prelude to the foundation of the Compasso d'Oro the following year; in January came the publication of the first issue of *Civiltà delle Macchine*, a magazine directed by Leonardo

Sinisgalli and published by Finmeccanica, preceding by just a few months the debut of the magazine *Stile Industria* by Alberto Rosselli. In 1954, at the Politecnico di Milano, Giulio Natta (1903–1979) discovered isotactic polypropylene, a macromolecule that would be the subject of experiments in the laboratories of the chemical company Montecatini, leading to the mass production of objects made of plastic (Moplen) and winning the engineer the Nobel Prize for chemistry in 1963.

The symbolic consecration would come at the X Triennale, which not only featured the first Triennale exhibition on industrial design (Mostra dell'Industrial Design) but also hosted the First International Industrial Design Conference (Palazzo dell'Arte, Milan, October 28–30, 1954). This was an extraordinary occasion: during the three days of discussion, leading national and international personalities succeeded one another on the dais: historians, philosophers and scholars such as Giulio Carlo Argan, Luciano Anceschi, Enzo Paci and Gillo Dorfles and architects, designers and artists such as Ernesto Nathan Rogers, Alberto Rosselli, Konrad Wachsmann, Jacques Viénot, Walter D. Teague, Lucio Fontana, Max Bill, Asger Jorn and many others. An exchange of comments about Maldonado's speech highlights the keen interest in the new German educational experience, demonstrated, too, by Bill's participation as a speaker on the first day of the conference. Rogers, in his role as president, commented:

> Maldonado expounded with great clarity on the concepts that he habitually presents in his excellent magazine [*Nueva Visión*]. I am particularly grateful to him for the details he provided on the new Bauhaus. Anyone who knows Max Bill and his collaborators can have no doubt that this new school, though inspired by the great teachings of the past, was necessarily destined to be different.[4]

That the cultural elite became interested in industrial design and what was happening at Ulm is not surprising. It is surprising, however, that Italy—a country still suffering from regional inequalities and economic uncertainty—paid such forward-looking attention to these issues. Thanks to enlightened entrepreneurs such as Olivetti and Pirelli, and influential managers of public enterprises as Enrico Mattei (AGIP-ENI) and Giuseppe Luraghi (Finmeccanica), a sensitivity to the issues of art, communication, telecommunication media and design and their possible relationships with the processes of industrial innovation prevailed and generated a truly activist approach in this field.[5]

This interest spawned magazines such as *Civiltà delle Macchine* and *Stile Industria*, titles that during those years became important incubators for debates on modernity.[6] Both played a significant role in the relationship between Maldonado, the HfG Ulm and Italy. One of the most critical issues was the education of new, emerging professional figures. In 1957 *Civiltà delle Macchine* printed an article by Maldonado on these issues.[7] The following year *Stile Industria* began to address educational issues and published the translation of an article written by Maldonado for *Form*, and in 1959 it published the complete speech given by Maldonado at the 1958 Exposition Universelle in Brussels and

dedicated a monograph issue to HfG Ulm, launching a debate on the teaching of design that was very influential in Italy.[8]

There was also a great deal of professional attention to the Ulm educational experience. In Italy, where there were no design schools, many architects, designers and artists considered an educational pilgrimage to the German city indispensable (Figure 4.1). Just as in the 1930s Italian culture had absorbed the lessons of the Bauhaus, between the late 1950s and the early 1960s a more enduring relationship intensified. Milan, which had historically remained open to wider Europe, and which was the centre of the industrialisation and communication processes in Italy at the time, became the epicentre of this phenomenon.[9] Italian visitors at Ulm included guest scholars, such as Gillo Dorfles, then the editor and driving force behind *Aut-Aut* magazine (which was directed by Enzo Paci)—who in May 1957 gave a lecture at the HfG Ulm titled 'Art and Communication'—and guest designers, such as Rodolfo Bonetto, the only Italian invited to teach a course in design at the HfG Ulm. It was in this context that several Italian companies began to consider the possibility of contacting the school to update their own design practices. As a result, a series of consulting contracts were established with Olivetti and La Rinascente.

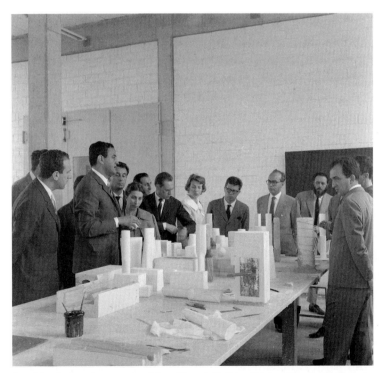

Fig. 4.1 Italian designers at Ulm: (*from left*) Fritz Fricker, Tomás Maldonado, Gianfranco Fratini, Raffaella Crespi, Enzo Frateili, Pier Giacomo Castiglioni, Pinuccia Castiglioni, Giancarlo Pozzi, Giulio Castelli, Pier Carlo Santini and Marco Zanuso. Courtesy of Tomás Maldonado.

OLIVETTI: A QUESTION OF KEYBOARDS

Olivetti survives in the national consciousness as the model of a modern civilised company, in which innovation and design coexist with an entrepreneurial vision driven by social considerations and a wide-ranging cultural outlook. In 2008, when the 100th anniversary of its foundation was celebrated with a programme of exhibitions, conferences and publications, it would have been reasonable to expect an interest in new historiographical approaches. However, with few exceptions, these events reinforced a focus on the charismatic figure of founder Camillo Olivetti and his son Adriano, counterbalanced by the epic collaboration of architects, artists and designers in initiatives in the fields of art, architecture and city planning.[10] The epic history of Olivetti's design as it has been told so far runs the risk of becoming mythologised. All mythologising processes eventually do a disservice to their subject by fossilising it, concealing the vital, problematic and contradictory aspects that are part of every great collective experience (the Olivetti experience was indeed both great and collective). One of the many issues that remains underplayed or ignored by scholars is Olivetti's relationship with the HfG Ulm, its design methods and its protagonists, principally Tomás Maldonado. This relationship developed in an era of great innovation in production and technological research, in which Olivetti played a key role, particularly in computing and electronics. The case of Olivetti helps us to understand a critical moment not only for this particular Ivrean company but also for the development of industrial design in Italy in general. Olivetti's relationship with Maldonado and Ulm presents a significant and exceptional case study in the history of Italian design in the 1950s and 1960s.

The first episode of relevance to the case study is the collaboration between Maldonado and Ettore Sottsass in the development of the Tekne 3, which has never been fully documented.[11] (The second episode is the collaboration in the development of the Elea.) At the end of the 1950s, Roberto Olivetti sent the engineer Enrico Sargentini to Ulm to explore the possibility of collaborating with the school. In May 1959 Sottsass went to Ulm, to make direct contact and to study the school's educational and design approach. As a result of these two visits, Maldonado was asked to participate in several projects, including one for 'the development of the keyboard for an electric typewriter, the study of a control panel system for an electronic computer and a programme for the creation of a centre for research into industrial design'.[12] (See Figure 4.2.) The last objective never got off the ground, whereas the project for a new concept in electric typewriters brought immediate results. Sottsass was commissioned to work on the formal aspects of the casing, whereas Maldonado, assisted by the technicians at the HfG Ulm, addressed the keyboard, including the form and position of the keys and the angle at which the keyboard was tilted. This particular commission demonstrates that Olivetti's interest in issues of ergonomics and man-machine interaction was in advance of that in the majority of Italian companies (Figure 4.3). The company thereby expressed its particular understanding of the function of products, not only in the context of the market, but also in terms of

corporate image, where the product becomes an expression of the company's vision and its participation in the processes of innovation: the new electric typewriter was interpreted as an element of prestige that epitomised the company's modernity.

The two designers were explicitly asked not just to 'electrify' the old mechanical models but to create a completely new product, with the quality and performance appropriate for the emerging market. In the recollections of Rinaldo Salto, who at that time was responsible for electric typewriters in Olivetti's in-house design department, this brief was contained in the 'specific project description included in the memo dated January 10 1957 in which the engineer Adriano Olivetti . . . said: "The approach to the new project need not take into consideration any previous relationship with manual typewriters" '.[13] Later correspondence between Roberto Olivetti and Maldonado reveals that the first proposal was considered 'very good, but too conservative'[14] and did not correspond to expectations.

As work proceeded on the model, which was being built in the HfG Ulm workshops,[15] a practical innovative proposal emerged for the 'carriage return and spacing', such that 'it will be necessary for the company to check whether this solution has already been patented. If it has not, it would be best to apply for a patent'.[16] The question of the relationship between the depth of the keys and the configuration of the keyboard

Fig. 4.2 Tomás Maldonado and Ettore Sottsass at Ulm, working on the Tekne 3 model, 1960. Courtesy of Tomás Maldonado.

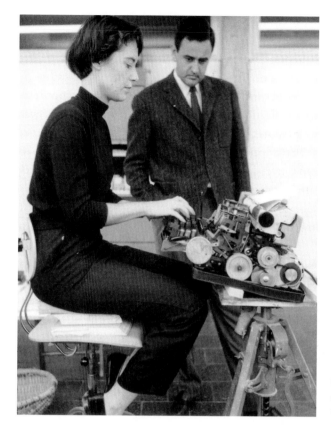

Fig. 4.3 Tomás Maldonado observing a typist testing the keyboard of the Tekne 3 model, Ulm, 1960. Courtesy of Tomás Maldonado.

therefore became central to the project[17] and was a source of discussion and some doubt in the mid-1960s (Figures 4.4 and 4.5). In particular, Maldonado refused to appear as co-creator of the Tekne 3 project because he believed that the angle chosen for the keyboard was ergonomically wrong. This may seem to be an almost insignificant detail. However, the importance of the keyboard problem is clearly shown in the communication and advertising that would accompany the typewriter. The instruction booklet emphasises the truly innovative nature of this element:

> The construction characteristics of the Tekne 3, which reduce the depth of the key stroke to a minimum, have made it possible to reduce the angle of the keyboard to as little as nine degrees, thereby allowing the typist to keep her fingers, wrists and forearms in a perfectly natural position. Getting accustomed to the Tekne 3 keyboard means getting accustomed to working in a position that will not be tiring.[18]

Maldonado's departure did not interrupt the development of the project. In 1962 it was delivered to the director of engineering to work out the production structures, and in 1964 the Tekne 3 was presented at the Fiera Campionaria di Milano.

There is no mention of the long gestation of the project in the documents in the archives or the official publications, except perhaps implicitly in Salto's reference to 'delays

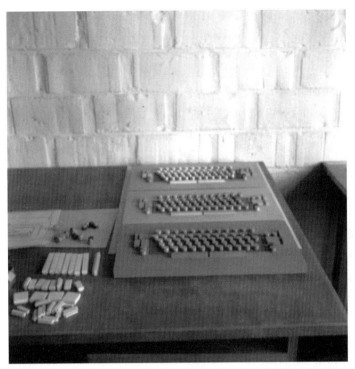

Fig. 4.4 Models of the keyboard of the Tekne 3, Ulm, 1960. Courtesy of
Tomás Maldonado.

Fig. 4.5 Models of the keys of the Tekne 3, Ulm, 1960. Courtesy of Tomás Maldonado.

and interruptions for causes unrelated to the problems of the project'.[19] Maldonado's departure appears to have occurred without consequences or litigation; he continued to work with Olivetti as intensely as ever as an electronics consultant.

The Tekne 3 is a profoundly 'Ulmian' typewriter in its form and body, designed by Sottsass with the collaboration of Hans von Klier. Reading Sottsass's account of the design of the typewriter today is like leafing through some of the great topoi of the Ulmian method, starting with the rejection of every form of styling (*stilizzazione*):

> I considered that a typewriter such as the Tekne was neither a bar of soap nor an object for the boudoir, nor a more or less intriguing little sculpture; that it was to concede nothing, for any reason, to the continuing taste for more or less aerodynamic styliza-tion that . . . is still far too widespread (this styling requires a vacuum cleaner to look like a jet, an iron to look like a submarine, a telephone like a meteorite, and so on).[20]

If the typewriter looks 'a little rigid and dry', with 'no frills', that is due to 'the effort to order and simplify the parts'. And if 'it looks like it has no aesthetic features', that is be-cause 'we believe that beauty is the result of an effort to simplify and order, rather than a product of the imagination'. Hence 'the design of the Tekne should not be examined, as usual, with the eye of a sculptor. It is anything but a sculpture'.[21]

Sottsass followed the same methodology for the design of electronic calculators: 'Basi-cally, to design for a manufacturer of electronic devices means giving form to machines or parts of machines that have never had a well-established appearance, but must look different each time depending on the size and on the performance required'.[22] The ques-tion of form and the relationship between form and function in these particular ma-chines was used by Sottsass as an opportunity to fundamentally reconsider the role of design, which involves the complex organisational aspects of the machine, and led him to address the interface and relationship between man and machine.[23]

It is well known that Olivetti had begun a significant programme in the field of elec-tronics, based on collaboration with the Department of Physics at the University of Pisa, and developed after 1958 at the Electronic Research Laboratory in Borgolombardo, near Milan. Thanks to his friendship with Roberto Olivetti, Maldonado was asked to par-ticipate in several phases of the design process for Elea, an acronym for the *elaboratore elettronico aritmetico* (arithmetical electronic computer), a name chosen with reference to the ancient Greek city on the coast of the Cilento, where Parmenides and Xeno sought truth in logic and mathematics. This was the first mainframe computer made entirely with transistors, of which only forty units were produced through 1964.[24]

Maldonado, who came in contact with the engineer Giorgio Sacerdoti in 1960, and later with the young director Mario Tchou,[25] was asked to study the complex system of the interface for the control panel of the Elea 9003. At that time, computer com-mands used words or abbreviations of words; the system of verbal symbolisation was difficult to interpret and was therefore inadequate for the international market. Mal-donado found the solution to the project in an ambitious communication programme

Fig. 4.6 Sign system for the Elea 9003 Olivetti mainframe computer. Design by Tomás Maldonado in collaboration with Gui Bonsiepe, 1960–1961. Courtesy of Tomás Maldonado.

that replaced the system of phonograms with pictograms and ideograms that would be equivalent to the nouns, adjectives and verbs of the spoken language. Each sign was to correspond to a functional unit of the computer (magnetic tape, punched paper tape, magnetic drum). The determining signs corresponded to 'states' and 'functions' of the computer, and syntactic relationships were established between different categories of symbols (Figure 4.6).

This programme was reminiscent of Isotype (the International System of Typographic Picture Education), the seminal visualisation project conceived in 1936 by Otto Neurath (1882–1945) and translated into drawings and icons by Gerd Arntz (1900–1988). However, while Isotype evolved to become a branch of modern information design, Maldonado's symbols remained unused and now seem dated, since only a few years later the development of computer science and electronics made it possible to create far more simplified interfaces. However, this does not diminish the fact that Olivetti had foreseen a crucial problem in the design of electronic machines.

But in design, like everything else, history belongs to the victor: although this episode exemplifies the highly experimental and innovative vision behind Olivetti's research, there is little trace of it in the documentation. In 1993 the American software company SunSoft asked for permission to reproduce the symbols in a book on the theme of interfaces. The reply, signed by engineer Alessandro De Maria, confirms that 'the set of characters was developed by Maldonado for the keyboard of the Elea 9000 [*sic*] as part of a commission from Adriano Olivetti' and that 'there is no trace of any related documentation except for indirect confirmation (see attachment) in texts that have been released and never challenged by Maldonado'.[26]

If I insist on the theme of suppression it is because symbolically this seems to mark a turning point in company policy after the death of Adriano in 1960 and the ensuing change in company ownership.[27] But it could also exemplify the plight of an industrial system that was reshaping the productive landscape: entrepreneurial dynasties and government-owned industry retreated, and the rise of an articulated system of small- and medium-sized companies was responsible for the advent of 'made in Italy'. This process has been referred to as a 'missed transition'[28] to a new and more modern model after the exceptional results of the 'economic miracle'.

On the other hand, these were the years in which a new generation of architects and designers began to reject the cultural legacy of rationalism and functionalism, initiating what turned into a battle against the HfG Ulm, considered the 'Winter Palace of orthodoxy'.[29] They had good reason, considering that Maldonado, in the minds of many, had become a leading figure in Italy's design culture.

THE CORPORATE IMAGE OF LA RINASCENTE

Maldonado's significance is best represented by his work as director of corporate image for La Rinascente from 1967 to 1969, in the era of Aldo Borletti and his chief executive officer Cesare Brustio:

It lasted less than three years: that was enough to demonstrate that it was possible to apply design methodology globally to an entire industry: that of mass distribution. . . . He was successful in impressing a dynamic unity to the entire range of La Rinascente's corporate image. What is important is that this was a systematic project that was totally new for Italy.[30]

Maldonado's contact within the company was Augusto Morello,[31] who worked in the Development Department. They had met at one of the conferences of the International Council of Societies of Industrial Design and while participating in the jury for the Compasso d'Oro, for which Morello organised operations.[32] In 1967, when Maldonado was in Milan to participate in the ninth edition of the Compasso d'Oro, Cesare Brustio offered him the position of corporate image director, as an independent consultant, for the Rinascente-Upim Group.[33]

When he came to the company headquarters in Milan, Maldonado encountered a particularly exciting environment, where attention to marketing concerns coexisted with experimentation into new forms of communication, such as in-store displays and cultural events. These initiatives, and more traditional modes of communication, were developed by brilliant architects, designers, graphic designers and photographers in close collaboration with the staff, which, just like at Olivetti, was directly involved in these initiatives. The Publicity Department oriented corporate image policies (such as window displays, especially those designed by Bruno Munari), and the Development Department worked on the packaging, focusing not only on the exterior form of the package but on the entire system (materials, size), on which a significant portion of the company image relied. La Rinascente was used to collaborating with the likes of Albe Steiner, Max Huber and Roberto Sambonet, and the arrival of Maldonado seemed to represent an increased commitment to communication, in apparent continuity with earlier phases in the history of the company's corporate image. But, in fact, the decision to appoint a director of corporate image to work with the other executive functions in the company represented an element of discontinuity. Within the new organisation into 'divisions', communication became, for the first time, an independent executive function.

This was the beginning of the image-planning phase, which meant going beyond the traditional approach based on purely visual tools such as publicity, graphic design and window dressing to highlight factors such as executive behaviour, retail structures, architecture and products. Interpreting corporate image as an executive function meant rationalising an area of extremely important processes, intervening directly in the decision-making process that serves as the means to make the image itself operational, by translating it into everyday actions.

A monumental emblem of the standardisation process in communication was the sixteen-volume corporate image handbook covering every aspect of Magazzini Upim's activity (Figure 4.7), from the internal signage to the retail store facilities, from the

in-house publications to the packaging and the indoor and outdoor architecture, from the means of transportation to the staff uniforms.[34] The handbook ordered the elements of the corporate image; it defined, down to the smallest details, the typefaces, the format of the paper and envelopes, the shape and size of the shopping bags, the sales counters and retail store furnishings, the colours and the advertising slogans. It set out a system of detailed, rigid, even pedantic standards, following a tradition that had been standard practice in the United States for many years. This was a synthesis between 'the more advanced ideas in the project for Neo-capitalist renewal, the modernist taste of graphic and product designers, and finally, the theories and professional know-how coming out of the United States'.[35] In the case of La Rinascente, the idea was to borrow this tradition but to renew it with experiences similar to the work developed by Otl Aicher for Lufthansa (Figure 4.8). As Maldonado recalls:

> I brought with me from Ulm a Teutonic and almost maniacal systematic approach, as maniacal as a whole series of formal, visual and methodological choices had been during the years of Ulm. In other words, the project for Upim reinterpreted the American corporate image tradition while relying on the rigorous and systematic approach developed in Germany.[36]

Therein lies the difference between the corporate image of La Rinascente and those of other Italian companies, including not just Olivetti but Italsider and Pirelli as well; these companies adopted a less systematic approach in which the figure of the intellectual, artist or designer remained prevalent.[37] As Maldonado himself suggested, whereas Olivetti pursued 'unity within diversity', the Braun model pursued 'unity within unity'.[38] This was the distinguishing trait of the La Rinascente experience: a unity that not only was to be visible on the outside but also formed an element of the internal organisation in all the operational sectors of the company, including the behaviour of the employees, the way

Fig. 4.7 Logos for different types of merchandise, from the Upim Corporate Identity Manual. Design by Tomás Maldonado in collaboration with Gui Bonsiepe, Tomás Gonda and Franco Clivio, 1967–1968. Courtesy of Tomás Maldonado.

Fig. 4.8 Model presenting a synthesis of all the applicable regulations, from the Upim Corporate Identity Manual. Design by Tomás Maldonado in collaboration with Gui Bonsiepe, Tomás Gonda and Franco Clivio, 1967–1968. Courtesy of Tomás Maldonado.

they dressed and the way they handled their customers. However, perhaps connected to the decline of large companies in Italy, this type of approach did not last long. On the contrary, even La Rinascente soon relinquished the strategy of the integral corporate image due to a 'generalized transition to forms of management in which marketing strategies became dominant. The end of the Brustio experience coincided with a shift in the way that industrial culture expressed itself, as "rational management" ceded to "market irrationality"'.[39]

CONCLUSION

This chapter ends at a point when the cultural elite rejected not only rationalism but industry in general; the latter was associated with negative values and coercive forms of power, paving the way for the pioneers of 'radical design', sustained by avant-garde experimentalism and its driving force in the person of Sottsass.[40] (See the contributions by Penny Sparke and Catharine Rossi in this volume.) From that point on, 'Italian design developed along totally different principles than those hypothesised by the Hochschule für Gestaltung at Ulm, in the context of a "weak" didactic culture, an eccentric design methodology, and a strong but unplanned industrial culture'.[41] This evaluation by Andrea Branzi is, all told, correct. What seems dubious to me is that he restricts his positive evaluation—which he shares with most Italian and foreign observers and historians—to this one direction in Italian design while totally ignoring the other tradition. My still fragmentary reconstruction wishes to shed new light on a period and on its protagonists, about which—contrary to all evidence—historical research still has much to say.

NOTES

This chapter was prompted by a conversation I had in May 2010 with Tomás Maldonado published under the title 'Un'impresa aperta al mondo: Conversazione con Tomás Maldonado', in *Comunicare l'impresa: Cultura e strategia dell'immagine nell'industria italiana (1945–1970)*, ed. Giorgio Bigatti and Carlo Vinti (Milan: Guerini e Associati, 2010), 135–152.

1. The complex figure of Maldonado and his multifaceted work have been the subject of many studies and two exhibitions over the past decade: *Tomás Maldonado: An Itinerary* (Milan: Skira, 2007) at the Museo Nacional de Bellas Artes in Buenos Aires and *Tomás Maldonado* (Milan: Skira, 2009) at the Triennale di Milano. In particular, the second exhibition placed the accent on his Italian itinerary: see Raimonda Riccini, 'L'esperienza italiana', in *Tomás Maldonado* (Milan: Skira, 2009), 156–177; see also Giovanni Anceschi, 'Il personaggio', in *Ad Honorem*, ed. Graziella Buccellati and Benedetta Manetti (Milan: Politecnico di Milano, 2001), 159–173; Medardo Chiapponi, 'Per Tomás Maldonado', in *Ad Honorem*, xxviii–xxix; Laura Escot, *Tomás Maldonado: Itinerario de un intelectual técnico* (Buenos Aires: Rizzo Patricia Editora, 2007); and Mario H. Gradowczyk, ed., *Tomás Maldonado: Un moderno en acción. Ensayos sobre su obra* (Caseros, Brazil: Eduntref, 2008).

2. About the Ulm school see *Rassegna* 19, no. 3 (1984); Herbert Lindinger, ed., *La Scuola di Ulm: Una nuova cultura del progetto* (Genoa: Costa & Nolan, 1988), an exhibition catalogue; Ulmer Museum/HfG-Archiv, *Ulmer Modelle—Modelle nach Ulm: Hochschule für Gestaltung Ulm 1953–1968* (Ostfildern: Hatje Cantz, 2003), an exhibition catalogue; René Spitz, *The View behind the Foreground: The Political History of the Ulm School of Design* (Stuttgart: Edition Axel Menges, 2002); and Kenneth Frampton, 'Apropos Ulm: Curriculum and Critical Theory', in Frampton, *Labour, Work and Architecture: Collected Essays on Architecture and Design* (London: Phaidon, 2002), 45–63.

3. Tomás Maldonado, *Arte e artefatti*, interview by Hans Ulrich Obrist (Milan: Feltrinelli, 2010), 12–14.

4. Triennale di Milano, *Memoria e futuro: Primo Congresso Internazionale dell'Industrial Design* (Milan: Skira, 2001), 87. Rogers is one of the links between the Argentinean and the European Maldonado. He wrote the article 'Unitad de Max Bill' for the first issue of *Nueva Visión* 1 (1951): 11–12.

5. See Franco Amatori and Raimonda Riccini, eds., *Copyright Italia: Brevetti marchi prodotti 1948–1970* (Rome: Biblioteca dell'Unità d'Italia, 2011), an exhibition catalogue.

6. From that period, mention should be made in particular of *Pirelli* (1948–1972) and *Cronache della Rinascente-Upim* (1947–1972). For Italian company publications see Comunicare l'impresa, http://www.houseorgan.net.

7. 'L'insegnamento superiore e la crisi dell'educazione', *Civiltà delle Macchine* 5–6 (1957): 82–89. See the critical reactions in *Zodiac* 5 (1959), the architectural review founded by the Edizioni di Comunità in 1957, initiated by Bruno Alfieri.

8. 'Le nuove prospettive industriali e la formazione del designer', *Stile Industria* 20 (January 1959): 9–12; a report on the school, 'hochschule für gestaltung. ulm' by Angelo Tito Anselmi, appeared in *Stile Industria* 21 (March 1959): 4–20. The article in *Form* was edited with the title 'Scienza, tecnologia e forma', *Stile Industria* 18 (August 1958): 44. The magazine later returned to these issues: Maldonado, 'Formazione e alternative di una professione', *Stile Industria* 34 (October 1961): 21–24. The reason behind this attention was that Italy lacked a school providing training in this field, a gap that continued until the 1990s, when the Politecnico di Milano opened the first public undergraduate course in industrial design, a result of Maldonado's own tenacious work.

9. See Raimonda Riccini, 'Il disegno industriale in Lombardia', in *Storia d'Italia: Lombardia*, ed. Duccio Bigazzi and Marco Meriggi (Turin: Einaudi, 2001), 1163–1193.

10. Manolo De Giorgi and Enrico Morteo, eds., *Olivetti: Una bella società* (Turin: Allemandi, 2008), 45.

11. This was discussed by Maldonado for the first time in the interview 'Un'impresa aperta al mondo' (see note 1). My reconstruction is based on the documents contained in Maldonado's personal archive in Milan.

12. Maldonado Archives, 'Memorandum', May 28 and 29, 1959.

13. Rinaldo Salto, 'La Tekne 3: Una macchina elettrica nuova', *Notizie Olivetti* 83 (1965): 30.

14. Maldonado to Sottsass, July 29, 1959, Maldonado Archives.

15. Ibid.

16. Maldonado to Rinaldo Salto, July 29, 1959, Maldonado Archives.

17. In a private email dated February 4, 2012, Gui Bonsiepe wrote:

> The work on the keyboard and the symbols on the keys were my first practical work in the Development Group 6, headed by TM. I remember, that one concern was to avoid that the secretaries with their long fingernails would unintentionally touch a neighbouring key—in difference with mechanical typewriters, the inclination of the keyboard of the electrical typewriter could be considerably reduced; furthermore the secretaries had to change the way in which they touched the keys: much less pressure, only a slight touch to release the key whose movement was now powered by electrical energy and not by the physical energy of the operator.

18. *DCUS-Direzione Comunicazione Ufficio Stampa*, Primo versamento (first delivery), 303, Olivetti Archives.

19. Salto, 'La Tekne 3', 30.

20. Ettore Sottsass Jr., 'Il design della Tekne 3', *Notizie Olivetti* 83 (1965): 38.

21. Ibid., 40.

22. Ettore Sottsass Jr., 'Forme nuove per I calcolatori elettronici', *Notizie Olivetti* 65 (1959): 27. See also Ettore Sottsass Jr., 'Il disegno dei calcolatori elettronici', *Stile Industria* 22 March (1959): 5–6.

23. Ettore Sottsass Jr., 'Automatizzazione e design', *Stile Industria* 37 April (1962): 5.

24. Domenico Tarantini, 'La scienza diventa tecnica', *Notizie Olivetti* 68 (1960): 15. The editorial in the same issue of the magazine was by Roberto Olivetti, 'Una via di sviluppo del prossimo cinquantennio', 13–14. The Elea 9003, which is still surrounded by a mythological aura that renders many historical reconstructions unreliable, won the Compasso d'Oro in 1959. On the story of Olivetti's Electronics Division, see Luciano Gallino, *La scomparsa dell'Italia industriale* (Turin: Einaudi, 2003); and Marco Pivato, *Il miracolo scippato: Le quattro occasioni sprecate della scienza italiana* (Rome: Donzelli, 2011), 19–60. The innovations that were subsequently handed over to the American company General Electric included the first personal desktop computer. Pier Giorgio Perotto, *Programma 101: L'invenzione del personal computer* (Milan: Sperling & Kupfer, 1995).

25. Maldonado to Giorgio Sacerdoti, November 28, 1960, Maldonado Archives.

26. Quality, Identity and Naming, (7) 34, the Daniela Cambiani Archives collection, Olivetti Archives.

27. In 1964 the Electronics Division became a spin-off company owned jointly by Olivetti (25%) and General Electric (75%).

28. Franco Amatori, 'Entrepreneurial Typologies in the History of Industrial Italy: Reconsiderations', *Business History Review* 85 (2011): 151–180, in particular 168ff.

29. Andrea Branzi, *Pomeriggi alla media industria* (Milan: Idea Books, 1968), 44.

30. Vittorio Gregotti, *Il disegno del prodotto industriale: Italia (1860–1980)*, ed. Manolo De Giorgi, Andrea Nulli and Giampiero Bosoni (Milan: Electa, 1982), 278; my own translation.

31. Born in Turin in 1928, and active since 1954 in the organisation of the Premio Compasso d'Oro, Morello was one of the founders of the Associazione per il Disegno Industriale (ADI) in 1956 and was president of the XXI Triennale di Milano, a mandate that ended abruptly with his death in 2002.

32. Maldonado was a member of the international jury of the fifth Compasso d'Oro (with Franco Albini, Giulio Carlo Argan, Aldo Borletti, Silvio Coggi, Ivan Matteo Lombardo and Pierre Vago), in 1959; of the sixth (with Franco Albini, Cesare Brustio, Kaj Franck and Nikolaus Pevsner), in 1961; and of the ninth (with Aldo Bassetti, Felice Dessi, Gillo Dorfles and Eduardo Vittoria), in 1967.

33. See Franco Amatori, *Proprietà e direzione: La Rinascente 1917–1969* (Milan: Franco Angeli, 1989); and Elena Papadia, *La Rinascente* (Bologna: Il Mulino, 2005).

34. To develop this project Maldonado relied on the collaboration of designers from the HfG Ulm: Gui Bonsiepe (designer and theoretician), Tomás Gonda (assistant to Otl Aicher for the design of Lufthansa's corporate image, graphic designer for *Casabella*, directed by Maldonado from 1977 to 1982), Franco Clivio (designer of products for Gardena and Erco) and Manfred Winter and Werner Zemp (graphic designers).

35. Carlo Vinti, 'I rapporti con la cultura statunitense: Mediazioni e conflitti nella comunicazione della grande impresa italiana', in Bigatti and Vinti, *Comunicare l'impresa*, 107.

36. From interview with Riccini, 'Un'impresa aperta al mondo', 150.

37. However, several companies demonstrated their interest in the approach to corporate image proposed by Maldonado, such as Snia Viscosa, which at the end of the 1960s was interested in creating a 'corporate image policy' similar to that of La Rinascente. Maldonado, 'L'immagine aziendale', draft of the presentation at Snia Viscosa, May 14, 1970, Maldonado Archives.

38. Maldonado, *Disegno industriale: Un riesame: Definizione, storia, bibliografia* (Milan: Feltrinelli, 1991), 68.

39. From interview with Riccini, 'Un'impresa aperta al mondo', 152.

40. Enzo Frateili, *Continuità e trasformazione: Una storia del disegno industriale italiano* (Milan: Alberto Greco, 1989), 75.

41. Branzi, *Pomeriggi alla media industria*, 44.

PART 2 CRAFTS

5 CRAFT, INDUSTRY AND ART: ISIA (1922–1943) AND THE ROOTS OF ITALIAN DESIGN EDUCATION

ELENA DELLAPIANA AND DANIELA N. PRINA[1]

The debate on design education in Italy started well before designated training institutions were introduced. This chapter retraces the origins and subsequent developments of design education in Italy, which were marked by continuous oscillations between craft and industry, modernity and tradition.

EARLY STEPS TOWARDS DESIGN EDUCATION

In 1861, the year of Italy's unification, industrial manufacture was developing, just as the organisation of basic and artistic education was being transformed. In that year the minister of education Francesco De Sanctis invited professors from academies of fine art from all over the country to develop and expand 'education in ornamentation, so as to spread good taste to every branch of industry'.[2] The following year the Regio Museo Industriale Italiano in Turin was established 'with the aim of promoting industrial education and [the] advancement of industries and commerce'.[3] Subsequently, the issue of the quality of industrially manufactured goods, and its enhancement through education, emerged at both international and national exhibitions, the latter specifically promoted to show Italian industrial progress.

Turin's Esposizione Generale Italiana of 1884 (General Italian Exhibition of 1884) led to the formation of the Commissione Centrale per l'Insegnamento Artistico e Industriale (Central Commission for the Teaching of Art and Industry).[4] The commission brought together politically active intellectuals, artists and entrepreneurs in the young nation state. It was tasked with developing integrated educational programmes, from primary to vocational and higher education, with the aim of improving the quality of industrial products and manufacture while maintaining the established characteristics of the different trades and manufacturing districts. The commission's work was not fully recognised, with greater reforms having been attributed to the Academies of Fine Arts, and educational programmes bridging art and industry were by then widespread, such as the work of the Società Umanitaria, established in Milan in 1892.[5] Formed around socialist-inspired welfare programmes, vocational education became a central concern for the society. Through contacts with industry, the promotion of new systems for organising work processes, and the provision of drawing courses, the Umanitaria publicly promoted good taste in utilitarian products. From 1905 Augusto Osimo's leadership reflected the significant formal

innovations seen at the last Esposizione Internazionale d'Arte Decorativa Moderna in Turin in 1902, where a need to simplify objects in order to adapt them to rationalised industrial production was noted. In addition to strengthening traditional craft skills, the Umanitaria courses demonstrated new trends in teaching—examples of which are discussed below.

L'UNIVERSITÀ DELLE ARTI DECORATIVE

During the first two decades of the twentieth century, industrial growth intensified in some areas of north-western Italy, particularly on the outskirts of Milan. For example, the city of Monza can be said to have mirrored Italy's social change and economic growth.[6] In Monza modern industrial innovations coexisted with an artistic tradition of Italian classicism, such as in the Villa Reale and surrounding park built in 1777 by Giuseppe Piermarini. The public and administrators alike voiced concerns over the vacant villa and its future use. The municipalities of Milan and Monza joined a consortium to outline a common programme, and Osimo, who became involved in the debate, brought in Guido Marangoni,[7] a politician and curator of Milan's Castello Sforzesco, who shared his secular and socialist visions of the decorative arts and education.[8] Milan's Scuola Superiore d'Arte Applicata had been set up in 1884 in the city's Museo Artistico Municipale (est. 1877) as an early attempt at design education in Italy and one of seven schools in the country to follow the South Kensington Museum's model.[9] Against this backdrop, Marangoni proposed to use the premises of Monza's Villa Reale to host the already popular joint exhibitions of the Castello Sforzesco collections and the Umanitaria schools, rethinking in the process their educational role. Marangoni's vision included the establishment of a school intended as an alternative to academies and trade institutes, complemented by a system of temporary exhibitions demonstrating to students—and to an educated and interested public—the improvements made in the field of the decorative arts. The Villa Reale went on to house l'Università delle Arti Decorative (the University of the Decorative Arts, or UAD) and the Biennale di Monza.

The university—as *Universitas Studiorum*—was inaugurated in November 1922, as shown in the invitation card in Figure 5.1, in the presence of representatives from industry, commerce, local government and existing applied arts schools. The designation of the school as a university was a cultivated attempt to assimilate the newborn institution to modern universities, where applied sciences were taught. University training offered a good balance between theory, practices and methodology: it was far from the instruction delivered by both technical schools and the Academies of Fine Arts.

Ugo Ojetti, a distinguished art critic loyal to the Italian classic tradition but nonetheless open to new international tendencies, delivered an opening speech.[10] Ojetti condemned the confinement of 'art' education to the Academies and advocated the teaching of artistic techniques to serve the needs of industry in new schools open to a wide cross-section of students, from aspiring artists to apprentice craftspeople.[11] Ojetti argued that the recent industrial progress of Germany, Austria and Hungary, which were rapidly catching up with England, France and Belgium, was due to the establishment of

UNIVERSITÀ DELLE ARTI DECORATIVE

INAUGURAZIONE XII NOVEMBRE
MCMXXII

'Per dare segno di bellezza ad ogni cosa, per elevare il lavoro e confortare di gioie spirituali i lavoratori, per contribuire a risuscitare e a educare in Italia e negli italiani ricondotti in pace di coscienza, di propositi, di azione la genialità di nostra gente e le innate energie di attività produttiva, l'

UMANITARIA

creatrice dell' Università delle Arti Decorative affidatale dal Consorzio Milano-Monza-Umanitaria, raccoglie intorno a sè uomini di ogni parte e di ogni fede uniti da concordi aspirazioni e da un solo tenace volere.

SCUOLA DEL LIBRO MILANO

Fig. 5.1 Invitation for the inauguration of l'Università delle Arti Decorative (the University of the Decorative Arts) in Monza, designed by the Scuola del Libro students, 1922. Archivio della Società Umanitaria, Milan 389/5.

industrial art schools such as those promoted in Germany by Hermann Muthesius and the Deutscher Werkbund.

Ojetti had previously chaired the commission for the reorganisation of art teaching in 1920 and had drafted a bill focused on the links between art education and local culture,[12] a project echoed in the newly established UAD. Despite an emphasis on practical knowledge, Ojetti's arts pedagogy was not lifted from the workshop system made famous at the Bauhaus: indeed, Ojetti complained about the thirst for modernity in foreign schools and their unwillingness to accommodate local artistic traditions. Praised by the Parliament, the bill was overturned in 1923 by the neo-idealist philosopher and minister of education Giovanni Gentile's reforming law on education, which allocated all kinds of arts education to the Academies of Fine Arts.[13] However, the minister's resignation the following year left many nodes of the law unsolved, including a long-debated draft on industrial arts education. In the meantime, the opening of the courses at Monza seemed

to give hope to the project that Ojetti, Osimo, Marangoni and others had shared in 1920. Monza's new decorative arts school offered a substantial theoretical education that encompassed art history, a history of styles and all fields of artistic knowledge, holistically considered, with the implication that art could thus encompass all classes.[14]

The school was organised into sections that reflected the second fundamental component of Marangoni's undertaking in Monza: the biennial exhibitions of decorative arts. The founding congress in May 1922 had defined its mission and programme, and the first exhibition, inaugurated the following year, provided an unprecedented occasion to showcase decorative art objects in complete domestic environments, thus merging the different school workshops in a unifying project, as demonstrated by the coordinated image shown in Figure 5.2.

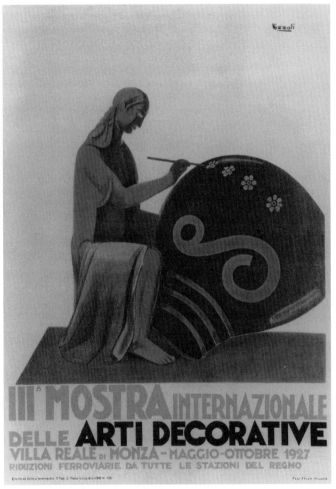

Fig. 5.2 Marcello Nizzoli, poster for the Third Biennial of Decorative Arts in Monza, 1927. Biblioteca Centrale della Facoltà di Architettura, Turin.

The Biennale and the school were integrated under the joint supervision of Marangoni and Osimo. The exhibitions displayed student work side by side with interiors and objects from all over Europe, so that professors and students could learn from and be inspired by them. The exhibition programme aimed at bringing 'all progress, all achievement of Italian and foreign industrial and applied art, to a higher purpose of modern stylization and daring renewal'. The aim was to unite form and functionality, rejecting both the sterile copying of the past and the pursuit of novelty for its own sake: 'the past will find full citizenship only to recognize its commendable and logical function of inspiring new and original forms'.[15] A virtuous circle emerged based on the university, the Biennali and the urban infrastructure integrating Milan and its hinterland, epitomised in a cultural and urban regeneration project completed in 1925 and coinciding with the second Biennale di Monza.

Also in 1925, Marangoni published his *Enciclopedia delle moderne arti decorative italiane*, intended to document how 'for a decade now the Italian decorative arts have . . . [undergone an] . . . awakening'.[16] This lavishly illustrated, monumental work covered the history of decorative arts in Italy from antiquity to the present, ending with the products displayed at the Biennali until 1925, when Marangoni withdrew from the organisation because of irreparable conflicts with the Fascist regime that had been established by then. Marangoni's encyclopaedia was, of course, informed by his training as an art historian, and it emphasised production methods, ancient and modern manufacturing districts and schools, all infused with socialist discourse. As such, it was a distinctively modern project, anchored in tradition.

Around the same time, links were forged between the industrial/applied arts and architectural discourse at the Biennale di Monza. The exhibition spaces in the Villa Reale were always organised by architects, even before the Biennale engaged explicitly with the discipline of architecture. At the Triennale di Monza in 1930 (marking the shift from biennial to triennial exhibitions), the architectural collective Gruppo 7 and Luisa Lovarini designed model homes erected in the Villa Reale Park, while Emilio Lancia and Gio Ponti presented the Domus Nova: a holiday home where architecture and furnishings were integrated and subjected to seriality. This represented an Italian reinterpretation of international rationalism, which was also being introduced by Edoardo Persico and Giuseppe Pagano into the courses they taught at the school, which had, in the meantime, been renamed, to conform to the national educational outline, the Istituto Superiore di Industrie Artistiche (ISIA, or Higher Institute of the Artistic Industries).

A CHALLENGING BEGINNING

The courses taught at ISIA did not follow a defined pedagogy: instead, they were characterised by tensions between modernity and tradition, ambitious openness to Europe and relapses into localism. Initially, the UAD worked towards a didactic model situated somewhere between the arts and crafts ideology of William Morris and parts of the 'art in industry' programme of the Deutscher Werkbund, with the aim of reviving traditional

local techniques and manufacture. This pedagogical lineage led to a focus on furniture and wrought-iron workshops that reiterated the importance of Italy's craftsmanship. This approach was challenged at a national level in 1925 with the foundation of the Ente Nazionale per le Piccole Industrie (ENPI, or National Board for Small Industries, later the Ente Nazionale per l'Artigianato e le Piccole Industrie [ENAPI]),[17] aimed at reforming Italian craft. The ENPI assigned several artists to design ceramics, textiles, glass and wood and metal objects for local workshops and thereby succeeded in modernising and improving the production and providing new impetus to craft, which was seen as an outdated and overly traditional sector—albeit one based on technical excellence, as reflected in the Biennali di Monza of 1923 and 1925.[18]

Since its foundation, then, the school presented itself as a coherent national model perfectly in tune with contemporary institutions elsewhere in Europe, such as the Bauhaus. However, comparisons with the Bauhaus ignore the emphasis on local traditions that underpinned the teaching at the UAD/ISIA. Although the UAD/ISIA and the Bauhaus both offered an educational model based on workshops and community life that allowed an ongoing dialogue between students and professors from various regions and backgrounds, there are several differences. Unlike the Bauhaus, the UAD/ISIA sought to communicate an understanding of the cultures of artistic practices and their languages and espoused historical styles as an indispensable repository of knowledge for the artist and the designer.[19] At the UAD/ISIA, the morality and social significance of utilitarian objects were recognised, but an alliance with industry remained implicit. The practical emphasis was maintained, while ambitions to broaden the cultural outlook of the school were pursued both by the recruitment of professors who had been trained abroad and through exchanges with foreign institutions that were implemented and strengthened through exhibitions.

Based on the legacy of nineteenth-century design reform,[20] the didactic model of the UAD/ISIA centred on drawing as a rational means of communication, useful for the world of work and production. A variety of compulsory courses—including history, geography, the Italian language, civics, the physical and natural sciences, technology, art history, plastic arts and various degrees of technical drawing—were designed to prepare students for employment in various fields.[21] The school's first director, Guido Sullam (1922–1924), assembled a staff educated during the artistic renewal of the turn of the century, and under their influence students experimented with new artistic languages and ideas, such as decoration developed from geometric analysis and abstract representations of nature. Ugo Zovetti, a textile and graphic designer who had worked at the Wiener Werkstätte in Vienna with Kolo Moser and Joseph Hoffmann, was teaching at Società Umanitaria's Scuola del Libro (school of graphics and bookbinding) in Milan when appointed professor of decoration at the UAD. His long tenure gave stability to the school's teaching standards.

Initially, only the workshops for decoration, ironwork, woodworking and carving were fully operational.[22] The wrought-iron workshop was presided over by Alessandro

Mazzucotelli, a renowned art nouveau blacksmith whose artistic outlook had been informed by regular study trips abroad. He focused on practical techniques such as damascening (inlaying different metals) and niello (black copper and silver inlay), producing a vast formal repertoire of handcrafted objects. The woodworking and carving workshop was headed by Angelo Assi, an experienced craftsman affiliated with the Umanitaria and interested in interior design. Here, teaching centred on the design and construction of furniture for domestic interiors but also included a course in 'wood art'. The latter was initially run by a French professor named Bury,[23] who introduced a more modern conception of furniture design, removed from the slavish imitation of past styles. Bury aimed to improve the quality of Italy's furniture products, inspired by the achievements of the Compagnie des Arts français, established in France in 1919.[24]

The school's curriculum was established by Sullam, who had experience in teaching at various art schools. This renowned art nouveau architect, trained under the influence of the secession movement, advocated the need to reassess craft and the applied arts in order to raise the quality of architecture. His presence also meant that the school engaged with architecture from the start, yet this relationship was not well defined and continued to evolve over the following years through collective experiments during which all workshop activities served the purposes of architectural projects, some built, others planned for exhibitions.

After Osimo's death in 1923, Mazzucotelli became director of the school (1924–1925), leaving his assistant and former student Gino Manara in charge of the iron workshop. This initiated a tradition whereby many alumni began teaching at the school. Despite the frequent renewal of the staff, this approach brought continuity to the didactic orientation and methods employed.

Keeping the school afloat financially was a continuous struggle. Following Osimo's death, the school's ideology was counter to Gentile's reform, and its organisational and management problems escalated. Persistent administrative and economic uncertainties forced curriculum changes, and the school was placed under the supervision of Colonel Ettore Grasselli, an external commissioner without teaching functions. Economic management and didactic practices were therefore divided.

NEW PRODUCTION METHODS

Around 1926 the relocation of the school to Milan and its transformation into an Istituto Superiore ('higher institute') were considered; however, these plans were hindered by the political consolidation of Fascism, which also challenged the Umanitaria. An unsigned report (attributed to Giovanni Bevione)[25] highlighted the need for a review at the school, with an 'industrial' emphasis. The school thus changed its name to ISIA. Its revised 1929 curriculum offered three different course levels and eight workshop disciplines, later expanded to ten, in addition to free continuing education courses.

In this new phase for the ISIA, the emphasis shifted from bespoke craftsmanship to serial production. The 1927 Biennale had already showcased this new approach.[26] An

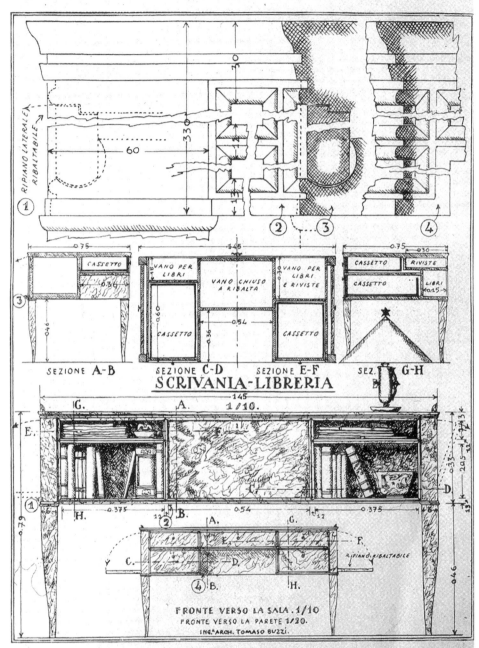

Fig. 5.3 Tommaso Buzzi, drawing plans for a double-sided desk-bookcase. *Domus* 2, no. 14 (March 1929): 37. Biblioteca Centrale della Facoltà di Architettura, Turin.

industrial emphasis carried much potential: Gio Ponti together with proponents of Italian rationalism believed that large-scale serial production could adopt pure forms and appropriate elements of Italian tradition in a new, modern vision. Tradition was, however, implicated as a model of propriety and accuracy in design, rather than as a historical reference or style. The methods, techniques and languages used in the workshops were reformed under the directorship of Guido Balsamo Stella (1929–1932), a distinguished artist trained in Munich and Stockholm who introduced to Italy and Murano glasswork the etched glass wheel technique mastered at Orrefors, Sweden. Balsamo Stella made innovations particularly in the woodworking workshop headed by Tommaso Buzzi, an architect closely associated with Ponti and the group of architects known as Novecento Milanese, whose projects appeared in *Domus* magazine (see Figure 5.3).[27]

New professors, particularly foreign hires, brought northern European educational models to Italy. Among them, the German master Karl Walter Posern combined his expertise in ceramic techniques with aesthetic simplicity, and Anna Åkerdahl, the Swedish wife of Balsamo Stella and also his assistant director, coordinated the newly established weaving workshop, assisted by fellow Swedish artist Aina Cederblom and by Anita Puggelli, an expert in embroidery. The weaving workshop was restricted to women only, who were excluded from boarding at the school and from other workshops due to Fascist regulations demanding separate classes for men and women, while shared accommodations were considered improper. This is unsurprising, however, because even at the Bauhaus women remained mostly confined to 'female practices'.[28] However, Balsamo Stella's tenure remained anchored to the myth of traditional craftsmanship under the guidance of charismatic masters. For instance, Raffaele De Grada (the teacher of 'Life Drawing') pushed his students to use self-made colours prepared with pigments and encouraged outdoor painting. The same practical applications were also adopted in other courses.

In the late 1920s the prestige of ISIA grew: the school reached 100 enrolments in 1930, and student work, which had circulated among local collectors since the school's inception, received extensive exposure at the Triennale the same year.[29]

RATIONALISM AT ISIA

In 1932 Elio Palazzo, a professor of descriptive geometry (a system of representing three-dimensional objects through drawing on a two-dimensional surface), began his tenure as director (1932–1943) at ISIA. He had been responsible for major redevelopments within the Umanitaria and instituted new measures at ISIA dictated by pragmatism, including the reduction of specialties less requested by the market and therefore deemed obsolete, such as embroidery, weaving and marquetry, and the introduction of graphic design courses and conferences on contemporary art issues. Palazzo sought to renew the school's identity through innovations in courses and techniques and through the recruitment of the most prominent promoters of Italian rationalism, such as the architects and critics Agnoldomenico Pica and Edoardo Persico. Persico was co-editor of *Casabella* magazine and the author of articles on applied arts and exhibitions in Monza, as well as

polemical writings on architecture and art, issues reflected in the ISIA curriculum. Also recruited were architect Giuseppe Pagano, director of *Casabella* from 1933; critic Raffaello Giolli, who worked with Persico on conferences dedicated to contemporary art criticism; and Marcello Nizzoli, later to become one of Italy's most renowned industrial designers. Teaching graphic composition and advertising, he brought to ISIA intimate knowledge of different avant-garde conceptions and an experimental attitude to new visual languages. Around the same time, a furniture workshop was established under the leadership of the architect Giovanni Romano. All these practitioners contributed to a vibrant discourse on architecture, art and design running in magazines at the time and, particularly, debates about housing and living, aimed at fostering a culture of the home that would benefit the design industry. A core of high-quality magazines developed to accommodate debates about the wider issues of design and modernity and continued after the war, paving the way for the dissemination of design culture in the 1950s and the 1960s, a period often referred to as the golden years of Italian design (see Kjetil Fallan's contribution in this book).

Palazzo's tenure was also characterised by international exchanges with foreign institutions, reinforced by the intake of students from Germany, Switzerland, Lithuania and Latvia. Some of ISIA's brightest students were enrolled at this critical juncture. Nizzoli's graphics and advertising class opened in 1933 and was extremely successful at generating effective published outcomes; his students' work was often presented at the Littoriali (cultural events for university students) and was prominently displayed at the 1936 Triennale di Milano. Some of his students, such as Giovanni Pintori and Costantino Nivola, were employed by far-sighted manufacturers such as Olivetti or collaborated with their professors as graphic designers.[30] Successful practitioners emerged from other departments as well, of course, such as ceramics, but the latter was largely focused on craft production, as shown in Figure 5.4. Mario Sturani, who graduated in 1927, established a long collaboration with the Lenci manufacture, and Giovanni Fancello collaborated with his tutor Virgilio Ferraresso in Padua during the 1930s and subsequently with other ceramicists in Albisola.[31]

The 1930s also saw an effort to coordinate the school's activities in a collective cultural project, in accordance with an aspiration expressed in writings by Pagano and Persico. Although it was not supported by a harmonised methodology, this approach aimed at integrating all the visual arts and design in an architectural project, including, for example, mural painting, an art form that is traditionally associated with expressions of power but was also taught at the Bauhaus.[32] The project's success was limited by a lack of theorisation to support actual industrial production; the school lacked a coordinated teaching programme and did not openly support a political ideology. Although ISIA functioned without much interference from the Fascist regime, the school supported some of the official art forms, from graphic and visual communication to mural painting. With the Ente Nazionale della Moda (National Board of Fashion), founded in 1935, the Fascist regime recognised the potential of design to influence the economy, but this recognition

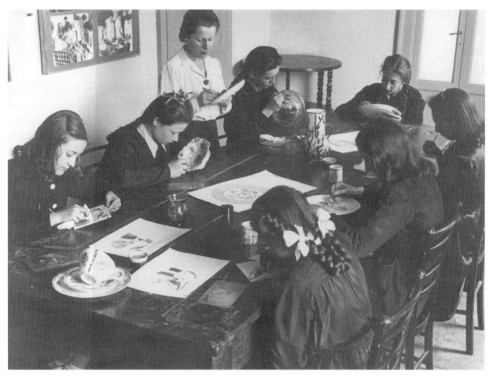

Fig. 5.4 Classroom of pottery decoration, Istituto Superiore di Industrie Artistiche (ISIA), first half of the 1930s. Archivio Storico del Comune di Monza, Sez III, 340/3.

was not extended to other design fields such as product and furniture design in spite of the good results achieved in 'modern' competitions, as depicted in Figure 5.5.[33] ISIA's multifaceted identity, along with its demonstrable ability to tackle financial problems and more complex changes of an economic and political nature, helped to secure the school's survival for two decades.

The school closed in 1943. Its last years were played out in the afterglow of the previous decade, when professors and students with remarkable talents 'worked and invented together', in Ponti's words, in a manner reminiscent of a traditional Italian workshop.[34] The ISIA model established a virtuous relationship that functioned both in education and in the profession: students sometimes became professors; they collaborated outside the school with their tutors or worked in studios or workshops owned by colleagues; and they collaborated with local or national industries. However, aside from its achievements in visual communication, expanded in the years to follow,[35] the school failed to make a tangible contribution to design for industrial production. The lifetime of the UAD/ISIA, practically coinciding with the Fascist dictatorship, reflects Italy's decisive shift from tradition to modernity. The school bridged the nineteenth-century principles that inspired its genesis and the aspirations of an artistic and architectural culture seeking a modernity

Fig. 5.5 Project for Securit crystal furniture, 3rd Student Competition Award. *Casabella* 113 (May 1937).

that was not only imagined but finally materialised in the forms of industrial production after the Second World War.

THE LEGACY OF ISIA

The closure of ISIA in 1943 was certainly associated with a difficult, even tragic, period in Italian history. But a direct causal link to Fascist regime politics would be too simplistic. The major cause of the ISIA's 'failure' was, rather, due to the school's theoretical and ideological permeability, which was also a crucial characteristic in the future structure of the industrial design culture in Italy, allowing the unexpected and unfamiliar to make a considerable impact on mainstream practice.

The ISIA oscillated between traditional craft and modern industry and placed great emphasis on technical execution. This fairly general claim could, of course, describe

the work of several other actors who were not directly involved in the school but were nevertheless prominent in the associated debates. ISIA's need to establish contacts with local furniture manufacturers and its desire to improve education in the field mirrored the debates on residential housing so predominant in Italian design discourse at the time. The foundation in 1928 of the magazines *Domus* by Ponti and *La Casa Bella* (later renamed *Casabella*) by Marangoni created the perfect setting to merge the domains of design and architecture. When Ponti tried in 1933 to define the Italian house, he stated, 'The Italian house is simple outside and inside. It accommodates furnishings and beautiful works of art and it wants order and balance between them, not an insane hotchpotch. It is enriched through greatness, not just preciousness'.[36] It is easy to imagine furnishings and beautiful works of art like the ones made in the ISIA workshops, as well as by manufacturers such as Richard-Ginori or the Società Ceramica Italiana, in the home Ponti describes.[37] It seems that the idyllic workshop atmosphere evoked by Ojetti in his inaugural speech could not be disturbed by an industrialisation that was evolving, despite many difficulties, as proved by the success of Pagano's chromium-plated aluminium furniture or by Pagano and Ponti's Breda ETR 200 train.

The 'Italian house' theme took on a role of greater importance than the issues usually debated by designers. Since Gentile's law, courses in furniture and interior design were offered in the newly formed Istituto Superiore di Architettura (Higher School of Architecture), thus reflecting the project of Gustavo Giovannoni and the group that had worked with him for the 'architetto integrale'.[38] This project attempted to define the proper relationship between practical and aesthetic concepts in architectural practice,[39] providing both interior and furniture design courses during the fourth year of study. Furniture design and architecture were almost always taught by professors who were architects, thereby emphasising the link between the objects and the spaces that contained them.[40] During the 1930s, one could find Annibale Rigotti and Ottorino Aloisio in Turin, Giovanni Michelucci in Florence, Mario De Renzi in Naples, Vittorio Morpurgo in Rome, Gio Ponti in Milan and Carlo Scarpa in Venice. Throughout the 1930s and until the Second World War, then, architecture represented the bonding agent that tied the different design disciplines to industry. Many architects, including professors, dealt with design and serial production: Pagano, Ponti, Michelucci, Piero Bottoni, Luigi Figini, Gino Pollini, Scarpa and Giuseppe Terragni not only worked as interior designers but collaborated with manufacturers to modernise their industrial production. Italian architecture schools represented a venue of extraordinary integration of fine art and technology and provided a rich environment for industrial design education. This was the framework from which Italian design developed in the 1950s: it mainly focused on furniture design, with two strong points of reference in the architectural discipline and in the advanced craftsmanship of the manufacturing districts cultivated at ISIA.

Something similar happened in the field of graphic design (see Gabriele Oropallo's contribution in this book). The vicissitudes of ISIA and of the Umanitaria continually overlapped, at least until 1932, when Palazzo finally established a graphic design course

at ISIA.[41] The different roles that Palazzo played in the two institutions avoided the risk of duplicating the Milanese school; at Monza, Nizzoli and Persico helped to achieve an integrated approach. However, the Scuola del Libro was, along with ISIA, instrumental in securing the foundations of visual communication in Italy, as proved by the continuous presence of the works of its alumni at the Triennale (Figure 5.6). In 1933 Carlo Dradi and Attilio Rossi, two alumni of the Scuola del Libro, launched the magazine *Campo Grafico*, which reflected the debate on graphic design that was taking place in the school, and in the same year the first Italian advertising studio was founded, the Studio Boggeri.[42] In both cases connections with ISIA and the Scuola del Libro were explicit, but within the design field more broadly, the language of design in Italy was improved as a result of demands made by companies that relied on advertising to mark their transition from craft-based to industrial operations. Unlike ISIA, the Scuola del Libro reopened after the war. Scuola del Libro tutors Max Huber and Albe Steiner, and later Bruno Munari, Luigi Veronesi and Carlo Dradi, worked with influential companies, designing their publications, such as Olivetti's *Edizioni di Comunità*, which integrated industrial and graphic design.

In the aftermath of the Second World War, industrial design education remained a pressing issue for debate: the urgency of reconstruction led to an emphasis on the industrial (previously extended by the pre-war pioneers to also include the applied arts). At the 1952 meeting of the Istituti per l'Educazione Artistica (Institutes of Art Education), the art historian and critic Giulio Carlo Argan argued for the need to organise industrial

Fig. 5.6 Display stand of the Scuola del Libro exhibiting students' work at the V Triennale di Milano, 1933. Archivio della Società Umanitaria photo collection, Milan.

design education in order to promote the diffusion of consumer goods. Similar arguments for establishing specialised design schools, centred on using social, economic and technical knowledge to meet people's needs through design, were voiced at the first international industrial design congress at the X Triennale di Milano, in 1954.

Two relevant initiatives were established at that time: the private Centro Studi Arte-Industria, founded in Novara by the artist Nino di Salvatore in 1954,[43] and the first public industrial design course, in 1955, taught by Leonardo Ricci at the Faculty of Architecture in Florence. Di Salvatore gathered the most important Italian graphic and product designers to teach design method, not style. Ricci reintegrated design in the architectural domain. Both approaches continue today, even though industrial design education policy adheres to the latter, remaining closely linked to architecture. In Naples, Roberto Mango opened an industrial design course in 1958 (see Jeffrey T. Schnapp's contribution in this book), while the Corso Superiore di Disegno Industriale (Higher Course of Industrial Design) opened in Venice in 1960 as an independent institution affiliated with the undergraduate Art Institute. The Venice course was influenced by the model of the Hochschule für Gestaltung Ulm;[44] comparisons with foreign design schools were prominent in discussions at the X Triennale.[45] Educational questions persisted in Italian design discourse: as late as 1965, a special issue of the magazine *Edilizia Moderna*[46] denounced the unsolved problem of identifying and communicating the designer's professional identity.[47] The identity of the designer had been boosted by forward-looking companies throughout the past fifteen years, yet designers at that time still craved the academic legitimisation accorded to architecture: in this way, the process of transforming everything into design would finally be achieved, it was thought.

NOTES

1. The views expressed throughout this essay are the result of a constant dialogue between the authors; sections 1 and 3 were written by Elena Dellapiana and section 2 by Daniela N. Prina.

2. Quoted in Elena Dellapiana, *Gli Accademici dell'Albertina: 1822–1884* (Turin: Celid, 2002), 38.

3. De Sanctis, quoted in Cristina Accornero and Elena Dellapiana, *Il Regio Museo Industriale di Torino tra cultura tecnica e diffusione del buon gusto* (Turin: Quaderni CRISIS, 2001).

4. Annalisa B. Pesando, *Opera vigorosa per il gusto artistico nelle nostre industrie: La Commissione Centrale per l'Insegnamento Artistico Industriale e il 'sistema delle arti' (1884–1908)* (Milan: Franco Angeli, 2009).

5. Riccardo Bauer, *La Società Umanitaria: Fondazione M. P. Loria, 1892–1963* (Milan: Bertolotti, 1964); and Massimo della Campa and Claudio A. Colombo, eds., *Spazio ai caratteri: L'Umanitaria e la Scuola del Libro* (Cinisello Balsamo: Silvana, 2005).

6. Rodolfo Profumo, 'L'Università delle Arti Decorative e l'ISIA', in *1923–1930: Monza verso l'unità delle arti: Oggetti d'eccezione dalle esposizioni internazionali di arti decorative*, ed. Anty Pansera and Mariateresa Chirico (Cinisello Balsamo: Silvana, 2004), 76.

7. *Guido Marangoni: In memoria* (Milan: E. Gualdoni, 1941).

8. Rossana Bossaglia, ed., *L'ISIA a Monza: Una scuola d'arte europea* (Cinisello Balsamo: Silvana, 1986).

9. Elena Dellapiana, *Il design della ceramica in Italia: 1850–2000* (Milan: Electa, 2010), 27–35.

10. Giovanna De Lorenzi, *Ugo Ojetti critico d'arte: Dal Marzocco a Dedalo* (Florence: Le Lettere, 2004).

11. The text of the speech is at the Umanitaria Library, Milan, misc. n/N24.

12. Fiorella Bulegato, *I musei d'impresa: Dalle arti industriali al design* (Rome: Carocci, 2008), 35–49.

13. Giovanni Genovesi, *Storia della scuola in Italia dal Settecento a oggi* (Rome: Laterza, 1998), 123–149.

14. *Programma per l'anno scolastico 1922–1923*, Umanitaria Archives, Milan, file P XXIX n. 1, doc. N. 23.

15. 'Programma per la Prima Esposizione Internazionale di Arti Decorativa', Monza, May 19–October 21, 1923, in Pansera and Chirico, eds., *1923–1930: Monza*, 194.

16. Guido Marangoni, *Enciclopedia delle moderne arti decorative italiane*, vol. 1 (Milan: Ceschina, 1925), 7.

17. 'Regio decreto 8 ottobre 1925: Costituzione dell'Ente Nazionale per le Piccole Industrie con sede in Roma', *Gazzetta ufficiale del Regno d'Italia—parte prima* 287 (1925): 4866–4867.

18. O. Selvafolta, 'Il regionalismo alle Biennali di Monza', in *Nivola, Fancello, Pintori: Percorsi del moderno*, ed. Roberto Cassanelli, Ugo Collu and Ornella Selvafolta (Milan: Jaca Book, 2003), 31–45.

19. 'Programma per la Prima Esposizione'.

20. Annalisa B. Pesando and Daniela Prina, 'To Educate Taste with the Hand and the Mind: Design Reform in Post-unification Italy (1884–1908)', *Journal of Design History* 25, no. 1 (2012): 32–54.

21. *Programma per l'anno scolastico 1922–1923*. See also Franco R. Gambarelli, 'All'ISIA di Monza, in quegli anni', in Cassanelli, Collu and Selvafolta, *Nivola, Fancello, Pintori*, 95–139.

22. Roberto Papini, 'Relazione di Roberto Papini al Ministero della Pubblica Istruzione sul funzionamento della scuola, 25 agosto 1924', in Bossaglia, *L'ISIA*, 187–190.

23. Ibid. Bury's first name is not provided by the source.

24. Florence Camart, *Süe et Mare et la Compagnie des Arts français* (Paris: Editions de l'Amateur, 1993).

25. 'Relazione di G. Bevione sulle nuove proposte didattiche dell'ISIA', in Bossaglia, *L'ISIA*, 190–193.

26. Anty Pansera, 'Da Biennale a Triennale: Percorsi, presenze, premi', in Pansera and Chirico, *1923–1930: Monza*, 58–62.

27. Paola Tognon, 'L'ideario dell'architetto', in Alberto Giorgio Cassani, ed., *Tommaso Buzzi: Il principe degli architetti 1900–1981* (Milan: Electa 2008), 277–315.

28. Anja Baumhoff, *The Gendered World of the Bauhaus: The Politics of Power at the Weimar Republic's Premier Art Institute, 1919–1932* (Frankfurt am Main: Peter Lang, 2001).

29. Rossana Bossaglia, "L'ISIA a Monza: Una scuola d'arte europea', in Bossaglia, *L'ISIA*, 41–42.

30. Pier Paolo Peruccio, 'Nivola, Pintori, Sinisgalli e la grafica Olivetti', in Cassanelli, Collu and Selvafolta, *Nivola, Fancello, Pintori*, 193–207.

31. Elena Dellapiana, 'Lenci e gli oggetti d'uso', in *Lenci, sculture in ceramica 1927–1937*, ed. Valerio Terraroli and Enrica Pagella (Turin: Allemandi, 2010), 55–61; and Alberto Crespi, *Salvatore Fancello* (Nuoro: Ilisso, 2005).

32. Giuseppe Pagano, *Arte decorativa italiana* (Milan: Hoepli, 1938).

33. 'Regio decreto legge 31 ottobre 1935: Modificazione della costituzione dell'Ente Autonomo per la Mostra Nazionale della Moda', *Gazzetta ufficiale del Regno d'Italia—parte prima* 291 (1935): 5660. See also Mario Lupano and Alessandra Vaccari, *Fashion at the Time of Fascism: Italian Modern Lifestyle in the 1920s–1930s* (Bologna: Damiani, 2010). For further developments see Simona Segre Reinach's contribution in this book.

34. Gio Ponti, 'Conoscere le nostre scuole d'arte', *Domus* 17 (February 1939): 56.

35. Giovanni Anceschi, 'Il campo della grafica italiana: Storia e problemi', *Rassegna* 3, no. 6 (1981): 5–19.

36. Gio Ponti, *La casa all'italiana* (Milan: Edizioni Domus, 1933), 10–11.

37. Dellapiana, *Il design della ceramica*, 81–113.

38. Guido Zucconi, ed., *Gustavo Giovannoni: Dal capitello alla città* (Milan: Jaca Book, 1997).

39. Gustavo Giovannoni, *Corso di Architettura* (Rome: Paolo Cremonese, 1932), particularly 'Introduzione', 1:7–17.

40. Elena Dellapiana, 'L'insegnamento dell'architettura dall'Accademia Albertina al Politecnico', in *Soleri: La formazione giovanile (1933–1946)*, ed. Antonietta Jolanda Lima (Palermo: Dario Flaccovio, 2009), 63–73.

41. Alberto Crespi, 'Maestri e allievi Umanitaria di Milano e ISIA di Monza', in Cassanelli, Collu and Selvafolta, *Nivola, Fancello, Pintori*, 63–80.

42. Pierluigi Cerri, Campo Grafico *1933–1939: Rivista di estetica e tecnica grafica* (Milan: Electa, 1985); and Bruno Manguzzi, ed., *Lo studio Boggeri 1933–1981* (Milan: Electa, 1981).

43. Nino di Salvatore, *Scuola Politecnica di Design* (Milan: Scuola Politecnica di Design, 1970).

44. Monica Pastore, *Il Corso Superiore di Disegno Industriale di Venezia 1960–1972: La comunicazione visiva nell'offerta didattica e il suo ruolo nella formazione di nuove figure professionali* (master's thesis, Università Iuav di Venezia, 2007).

45. *La memoria e il futuro: Il Congresso Internazionale di Industrial Design: X Triennale di Milano 1954*, Conference Proceedings (Milan: Skira, 2001).

46. Vittorio Gregotti, ed., 'Design', special issue, *Edilizia Moderna* 85 (1965).

47. Alberto Bassi and Raimonda Riccini, eds., *Design in Triennale 1947–1968: Percorsi fra Milano e Brianza* (Cinisello Balsamo: Silvana, 2004), 141–148.

6 MANUFACTURED IDENTITIES: CERAMICS AND THE MAKING OF (MADE IN) ITALY

LISA HOCKEMEYER

These handicrafts, while representing a distinct contribution to the decorative arts by their beauty and good taste, at the same time contribute substantially to the volume of Italian exports.

—Italian Institute for Foreign Trade (1948)[1]

Until now most Italian design history has, especially in Italy itself, been written from an 'outsider' perspective that emphasises industrial design and marginalises Italy's artisanal manufacturing history and the applied and decorative arts that differentiate the Italian story from that of other countries. The importance of the craft sectors for Italy's post–Second World War reconstruction efforts and their role as significant players in both the formation of what has become widely known as 'Italian design' and the fabrication of the image package that constitutes the 'made in Italy' ideal have remained largely unacknowledged.[2] The reasons for this are several, with the result that many of Italy's cultural production sectors are excluded from histories of design, and recognition of their importance is suppressed.

One of those is Italy's vast ceramic 'industry', the country's oldest and geographically most widespread artisanal production sector, made up of numerous small- and medium-scale workshops and manufacturers. It is also Italy's most heterogeneous sector in aesthetic terms, producing an enormous variety of generic types of ceramic wares displaying great stylistic diversity, often betraying centuries-old traditions. Already a lucrative export industry during the interwar years, it was among the first manufacturing sectors to resume production following the Second World War and was soon characterised by steadily rising export figures. Between 1949 and 1958, Italy's ceramics-manufacturing sector comprised a staggering 18 per cent of the total national production of the so-called *piccole industrie*, or small industries, also including furniture and fashion.[3] The majority of the ceramic industry's exports (about 91 per cent) consisted of decorative and ornamental items in majolica, porcelain and terracotta, and only the remaining 9 per cent was made up of domestic utensils.[4] In the early 1950s about two-thirds of these wares were sold to the United States, while the balance was distributed among several other countries.[5] (See Figure 6.1A.) The American market played a key role in the growth of Italian majolica manufacture, and this cultural production sector was among Italy's

A

Italian ceramic exports to the USA and other countries in 1938, 1949 and 1953 in 100 kg.

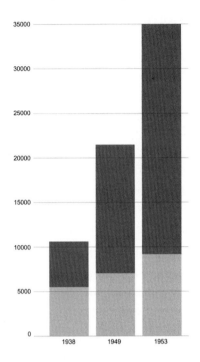

	1938	1949	1953	
United States	5147	14386	26287	100 kg
Canada	28	1768	1395	100 kg
Sweden	492	52	1191	100 kg
Belgium	180	2682	1165	100 kg
Australia	37	66	1156	100 kg
Switzerland	8	688	815	100 kg
Union of South Africa	718	115	568	100 kg
France	17	132	550	100 kg
United Kingdom	31	27	475	100 kg
Venezuela	562	318	451	100 kg
Egypt	1122	301	309	100 kg
West Germany	4	145	266	100 kg
Cuba	223	141	172	100 kg
Mexico	98	84	147	100 kg
Denmark	62	219	136	100 kg
Malta	6	76	119	100 kg
Peru	2	6	53	100 kg
Libia	1028	39	49	100 kg
Turkey	9	146	37	100 kg
Uruguay	467	0	15	100 kg
Eritrea	193	14	10	100 kg
Somalia	180	3	0	100 kg

B

Italian majolica export 1950-1958 (in 1.000 Lire)

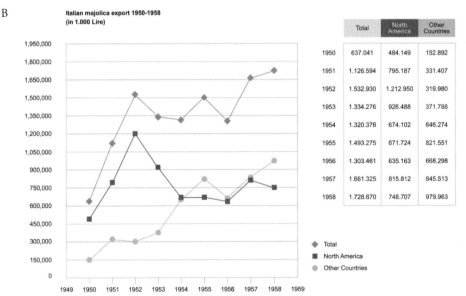

	Total	North America	Other Countries
1950	637.041	484.149	152.892
1951	1.126.594	795.187	331.407
1952	1.532.930	1.212.950	319.980
1953	1.334.276	926.488	371.788
1954	1.320.376	674.102	646.274
1955	1.493.275	671.724	821.551
1956	1.303.461	635.163	668.298
1957	1.661.325	815.812	845.513
1958	1.728.670	748.707	979.963

◆ Total
■ North America
● Other Countries

Fig. 6.1 (A) Total Italian ceramic exports to the United States and other countries between 1938 and 1953, by weight. (B) Italy's majolica exports to the United States and other countries between 1949 and 1958, by monetary value. Courtesy of Lisa Hockemeyer.

most profitable export industries at the time, contributing substantially to the total revenue. The steady rise in exports to the United States following the Second World War reached its climax in 1952, followed by a relatively harsh decline in the mid 1950s, before stagnating in the second half of that decade (Figure 6.1B).

This period forms the backdrop to this chapter's case study of Italy's small- and medium-scale ceramic manufacture within the wider framework of Italy's post-war reconstruction efforts. The chapter evaluates some strengths and shortcomings, as well as the networks that helped the exports of this industry during an era of remarkable genesis and rapid decline, in relation to wider sociohistorical, political, economic and cultural changes. Particular emphasis is placed on individuals and different interest groups, and private and public organisations involved in the restructuring of Italy's ceramic industry and the marketing of its wares. Major platforms of promotion, such as exhibitions held in museums or department stores, and other exceptional venues, such as transatlantic ocean liners, are shown to have contributed to the increase in sales of Italian majolica, particularly in the United States. We will consider the rhetoric that accompanied these events and the wording used by the contemporary press and publications to portray Italian majolica wares. This will highlight the pre-eminent role of Italy's small- and medium-scale industry and artistic ceramic output in the creation of an identity that transcended and brought together many different product types, materials and aesthetics under the umbrella of an early 'made in Italy' ideal. Even though the alliance between the ceramic industry and the coming of age of the image that represented the ideals associated with the 'made in Italy' label was brief, tracing this development will reveal the shifting meanings and roles variously attributed to, imposed on and played by Italian majolica production within the wider spectrum of Italian material culture production and will contribute to the recognition of the crafts within histories of Italian design.

MAKESHIFT APPROACHES AND OPTIMISM: A BRIEF POST-WAR PRODUCTION PROFILE

The immediate post-war recovery of Italy's ceramic industry was founded on its existing vast production infrastructure of artisanal small- and medium-scale ceramic workshops and manufactories. They proved far more versatile, responsive and adaptive in the context of Italy's immediate post-war economy and damaged infrastructure than larger enterprises. Italy's few medium- and large-scale plants, including the Ceramics Co-operative in Imola and the porcelain manufactory Richard-Ginori, suffered in particular from war damages to their own establishments and the country's communication and transport systems, as well as the nation's weak post-war economy. The post-war market was flooded with warehoused inventory, which caused price fluctuations that made planning production and gauging real demand difficult.[6] In addition, Italy's internal economy and home market were paralysed by rising post-war inflation that the then governor of the Bank of Italy, Luigi Einaudi, tried to stem by introducing severe credit controls; this restrained economic expansion and industrial development and restored monetary stability by 1948. While Einaudi's policy generated enormous obstacles to internal reconstruction

and especially to the restoration of the larger industries, the severe collapse of the lira in the immediate post-war years made Italian production particularly attractive to many European countries. This, and the reopening of the international market, resulted in a booming demand for Italian goods abroad that Italy's small producers in particular were able to exploit as they could mobilise to produce exportable goods much faster than the specialised manufacturers that depended on expensive and elaborate production technologies and organisation and were often decentralised.

Italy's small- and medium-scale ceramic workshops and manufactories numbered in the hundreds and were based in and around Italy's many historical centres of ceramic production that spanned the peninsula, including Sicily and Sardinia.[7] The majority of them used very basic means. Electricity or lignite was a rarity, and wood-fired kilns were the norm; these were often only a cubic metre (yard) in size and were built by the owners. The smallest enterprises were operated by two to four people, who between them handled all the different tasks of preparing, moulding, decorating and firing as well as selling the finished products.[8] Many of the smaller workshops were located in the ceramicist's own house and run in improvised and sometimes even impoverished conditions. These were recorded as late as 1953 by the journalist Flavio Colutta, who, writing on Apulian majolica, noted that the majority of the thirty-two ceramicists in the historical ceramic-making town of Grottaglie and its surrounding area operated in the same way they had thousands of years ago, 'in caves hollowed out of limestone and standing with their bare feet in the mud that covered the ground'.[9]

Following half a century of economic uncertainty and hardship—based on the aftermath of the First World War, Italy's economic depression of the late 1920s and early 1930s, and the economically unviable politics of the Fascist regime (including its disregard for international trade, which practically closed the foreign market, and its policy of self-sufficiency)—the strength of Italy's total post-war ceramic industry lay in its small workshops' ability to draw on long experience in defying hard times with makeshift methods. Having all manufacturing processes and know-how under one roof required minimal organisation and space, basic technological means and little capital. Long before 1945, many small ceramic workshops safeguarded themselves against economic downfall by diversifying their manufacture into the production of at least two different types of wares, often providing goods for both the industrial market and the art markets simultaneously. In the interwar period many collaborated with artists such as Lucio Fontana, Arturo Martini and Fausto Melotti, who used the facilities and technical know-how of the artisanal ceramic workshops for their own creative work. At the same time, some master ceramicists such as Pietro Melandri ventured into the realm of the plastic arts, producing large-scale ceramic sculptures that won them international acclaim.[10] Much credit for the dissolution of the artistic hierarchies within Italy's interwar and post-war ceramic culture is accorded to Gio Ponti; he incessantly strove towards the cross-fertilisation of the artisanal, artistic and industrial ceramic industries, from art objects to bathroom fixtures.

The reform movement of the interwar years helped pave the way for an emerging generation of post-war artists who 'hijacked' ceramics to make ends meet when there was little demand for fine art and thus complemented the characteristic makeshift mentality, enthusiasm and spirit of survival that distinguished Italy's post-war ceramic workshops and ceramicists who were exploring the realm of artistic ceramics. The newly gained freedom of expression and widespread cross-fertilisation of artisanal and artistic ceramics contributed new aesthetic approaches to Italy's ceramic industry and even brought forward new product typologies. As the critic Gillo Dorfles noted in 1954, artists were

> served by ceramics as a means of producing objects of common daily use (plates, vases, pots) and also as an ornamental medium of the first order, especially in the decoration of modern interiors, where fire-places, floors, decorative panels and even tables, lamps and balconies are constructed of simple terra-cotta.[11]

This sudden cultural and aesthetic explosion of Italy's ceramic culture, the existing widespread production network, the makeshift approaches and the deeply rooted high-quality craft skills, infused by post-war optimism and enthusiasm, became the industry's strongest assets for immediate recovery. The small workshops were less affected by or could bypass most of the technological, structural and demographic obstacles as well as the problems of an oversaturated market that the larger manufactories suffered, and could produce and even offer novelties to supply a rising demand for Italian majolica wares, especially in the United States. The United States recognised early on the potential of Italy's craft industry, and particularly its ceramics, for the country's post-war economic and infrastructural recovery.

AMERICANS TO AID CRAFTS OF ITALY

Following the Second World War Italy had to adapt to export-oriented manufacturing and concentrate on products that would appeal to foreign markets, especially those countries with a strong post-war economy and dollar economies. The United States was Italy's most important export market for majolica wares before the Second World War (Figure 6.1A). Disrupted by the unviable foreign and economic policies of the Fascist regime and the war, contacts and distribution networks for Italy's majolica export had to be re-established after the Second World War.

While the ceramics sector lacked a dedicated representative organisation, private and public bodies dedicated to the promotion of Italy's craft sectors emphasised their importance in rebuilding Italy's post-war society, infrastructure and productivity. Among the organisations that supported the small- and medium-scale industries were the Artigianato Produzione Esportazione Milano (Milan Artisanal Production Exports), set up in 1943 to provide craft producers with guidance on exporting their products; the Ente Nazionale per l'Artigianato e le Piccole Industrie, founded in 1925; and the Istituto Nazionale per il Commercio Estero (Italian Institute for Foreign Trade), founded in 1926.[12] In 1945 the Italian Institute for Foreign Trade judged Italy's crafts industry to be its 'greatest

asset in providing the means to revive the Italian economy as economic normalcy gradu-
ally returns to the world'.[13] This opinion was also upheld in the United States.

Design historian Wava Jean Carpenter has elaborated the key role played by Dr. Max
Ascoli, an Italian American political theorist and founder of Handicraft Development
Inc. (1945), in the recovery of Italy's artisanal industries.[14] Ascoli, who had close ties to
the Roosevelt administration and was familiar with its early relief efforts, such as Ameri-
can Relief for Italy (launched in 1944), shared its belief in the rehabilitation of Italy, and
the potential for lasting economic stability and democracy, through intervention in the
Italian economic system. Anticipating the Marshall Plan by three years, he envisaged
a non-profit foundation of benefit to both Italy and the United States, by helping to
rebuild Italy's industry, which could then contribute to the nation's foreign trade income,
allowing Italy to repay its loans in the short term and stimulating consumption in both
countries in the long term.[15]

Ascoli's conviction that his organisation should focus on the handicrafts sector was
significantly influenced by official statistics that rated Italy's artisanal industries as re-
sponsible for about one-fourth of the total industrial occupation and employment. His
choice was supported further by the fact that craft manufactories required less capital
investment for their rehabilitation than large-scale industry and needed little imported
raw material, thereby reducing their reliance on foreign shipping. The crafts therefore
promised the faster results needed to kick-start the Italian economy.[16] With no equiva-
lent in American industrial production, Italian handmade commodities could also fill a
market niche without competing with American industry.

Ascoli's organisation, called Handicraft Development Inc. (HDI), was founded in
January 1945 and backed by some of the United States' most wealthy and influential
businessmen, politicians and personalities from the arts and design sector. Supporters
included politician, businessman, philanthropist and assistant secretary of state Nelson
A. Rockefeller and René D'Harnoncourt, handicraft advocator, curator and, from 1949
onwards, director of the Museum of Modern Art.[17] In 1947 HDI opened the House of
Italian Handicrafts (HIH) in New York as a focal point for its activities. Its high-profile
board of directors included Dorothy Shaver, president of the prestigious New York City
department store Lord and Taylor, and Adam Gimbel, president of Saks Fifth Avenue,
thereby pointing to the organisation's entrepreneurial and commercial intentions in dis-
seminating Italian manufacture in the United States.[18]

Ascoli's efforts and the activities of HDI, the HIH and its collaborators and allies all
contributed to a large-scale operation to help Italian craftspeople. By the summer of
1945 a group including the industrial designer and influential home furnishings con-
sultant Freda Diamond left for Italy to survey the state of its applied and industrial arts
institutions and its artisanal manufactories and workshops. The group informed Italian
producers about current market trends for craft commodities in the United States. While
there, Ascoli also established CADMA (Comitato Assistenza Distribuzione Materiali, or
the Committee for Assistance and Distribution of Materials), a Florence-based group

headed by the critic and art historian Carlo Ludovico Ragghianti which was to act on the behalf of HDI in surveying the crafts sector and administering and distributing aid to craftspeople and arts and crafts schools.[19]

By July 1946 HDI had shipped over 130 crates of materials to CADMA, including printed information concerning American consumers' preferences as predicted by Diamond. By the end of 1947, HDI had organised three exhibitions at the HIH presenting new Italian craft commodities to American consumers and retailers. The first presented about a thousand artefacts and coincided with the inauguration ceremony of the HIH. The second showed examples of Italian craft products selected by the APEM and anticipated the even more ambitious *Handicrafts as a Fine Art in Italy* exhibition held later that year. Majolica wares featured prominently in all three exhibitions and in the newspaper coverage they generated.[20]

The foundation's efforts were substantially rewarded late in 1947 when Ascoli's programme was allocated a large slice of Marshall Plan aid, consisting of a loan of $4,625,000 obtained from the Import-Export Bank, which administered the funds of the European Recovery Program. The money was destined for an Italian handicraft industries corporation, Compagnia Nazionale Artigiana (CNA, or the National Confederation of the Crafts and the Small and Medium Businesses), established by HDI in Rome in October 1948 to help develop the Italian craft industries.[21] Significantly, CNA's elected president, Ivan Matteo Lombardo, who was the Italian minister for industry and commerce from 1948 to 1951 and president of the Triennale di Milano from 1949 to 1961, was the former chief of the Italian delegation to the treaty negotiations with the United States.

Now, suitable platforms and distribution systems for creating and maintaining an American mass market for Italian craft products were needed, as well as an identity suitable for marketing a variety of different commodity types, materials and aesthetics, all under the (handi)crafts banner, from furniture, toys and musical instruments to leatherwork, metalwork, glasswork, woodwork and jewellery in historicised and modern fashion.

THE CREATION OF A HOMOGENEOUS MARKET FOR HETEROGENEOUS ONE-OFF OBJECTS

Unrivalled by other craft commodities in its popularity and exposure within the American market, Italian majolica occupied a special place, economically and aesthetically, among Italy's craft sectors. Majolica played a key role in the creation of the ideals used to promote Italian crafts in the post-war United States and was later associated with Italian design products. A large-scale 'Survey Conducted for Italian Goods', based on replies received from 4,000 questionnaires sent out by the HIH to retailers throughout the United States in spring 1948, ascertained that of all Italian craft wares, majolica held the greatest appeal to American buyers and was sold in 62 per cent of American department stores and about 70 per cent of gift shops.[22]

Following years of depression and war, Italian ceramics satisfied the growing American consumer demand for home furnishings and decor during the post–Second World War

housing boom and were attractive for their novelty factor and otherness, especially during the early post-war years. Different from the traditional tastes of the average American bourgeois consumer and outside the aesthetic ideals championed by the US 'Good Design' lobby, Italian ceramics answered an emergent demand for household goods that were neither crafty in appearance nor factory-produced but were well manufactured and looked modern, original and individual. Italian post-war majolica as a generic group conveyed above all the spirit of a new, freer society. It offered an enormous variety of product types of great stylistic diversity, most of which evolved from Italy's rich regional stylistic pluralism and some of which were truly novel, conveying a great sense of aesthetic freedom. The language used to promote Italian ceramic goods in the immediate post-war years reveals that they were appreciated for their skilful execution, originality and individuality and were seen as embodying post-war optimism in their colourful, aesthetically innovative, sophisticated, elegant, fun and sometimes whimsical qualities. Above all, however, they were linked to Italy's glorious artistic past and likened to art.

Newspaper headlines of the time, such as 'Italian Art Work Placed on Exhibit' or 'Heirs of Cellini', both referring to Italian ceramics, played on their association with Italy's artistic heritage and echoed the titles of significant exhibitions in museums and department stores showcasing and promoting Italian ceramic wares.[23] *Handicrafts as a Fine Art in Italy* was shown at the HIH in 1947, and the landmark travelling exhibition *Italy at Work—Her Renaissance in Design Today* was hosted first in 1949 by the Brooklyn Museum of Fine Art in New York and then toured for three years to eleven US venues.[24] While the earlier exhibition's title refuses the conservative connotations of traditional craft works by elevating their cultural value to that of fine art, the second links the emergence of contemporary design with both a rebirth resulting from Italy's energetic post-war activity and her cultural heritage.

The intentional blurring of the traditional boundaries between the fine arts and crafts manufacture was specific to the Italian ceramic medium and echoed its presentation in contemporary promotional publications, such as the English-language catalogues *Handicrafts of Italy* and *Italian Ceramics*, published by the Italian Institute for Foreign Trade and the Ente Nazionale Artigianato e Piccole Industrie at the suggestion of CNA in the late 1940s and in 1954 respectively (Figure 6.2). While *Handicrafts of Italy* paid significantly more attention to ceramics than to the other thirteen product categories it discussed, reconfirming once more their pre-eminence among Italy's craft sectors, *Italian Ceramics* introduced over 360 artisans, artists, ceramicists and small manufacturers, including their addresses.[25] While the products were divided into four categories—'For the Home', 'Tableware', 'Decorative Plaques, Tiles and Tile Facings' and 'Costume Jewellery'—the illustrations jumbled contemporary, rustic or historicised artistic, artisan and folkloristic commodities, among them sculptures, fireplaces, water fountains, door handles, tabletops, soap holders, crucifixes and balcony facings.[26] For example, modernist functional and decorative pieces by ceramicists and artists like Marcello Fantoni and Fausto Melotti were shown next to items reminiscent of traditional Umbrian Renaissance majolica or

the famous Ligurian 'white and blue' ceramics of the sixteenth century (Figure 6.3). This apparently haphazard juxtaposition functioned to support this industry's strongest characteristics, and the ones most difficult to commercialise—individuality, versatility and diversity—and helped to create a homogeneous market for heterogeneous one-off objects.[27] Other prominent platforms that intentionally amalgamated works of fine art executed in the ceramic medium with the decorative tradition of pottery included the ceramic display at the IX Triennale di Milano of 1951, curated by Ponti, and the magazine he edited, *Domus*. These and exhibitions like *Handicrafts as a Fine Art in Italy* and *Italy at Work* did not diminish the cultural value of the fine arts but helped to raise the appreciation of Italian majolica manufacture to the same level. In all instances, this phenomenon was claimed to be unique to the Italian artisanal tradition, thereby creating an

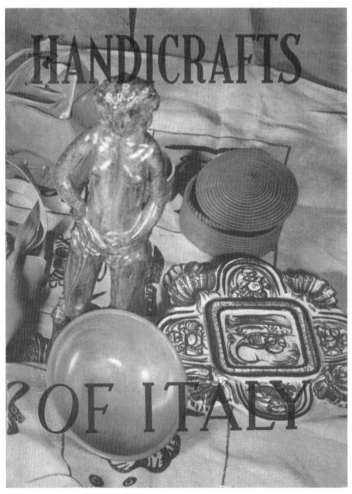

Fig. 6.2 Cover page of the catalogue *Handicrafts of Italy*, published by the Italian Institute for Foreign Trade in the late 1940s (no publication date). Courtesy of Arti Grafiche Amilcare Pizzi S.p.A.

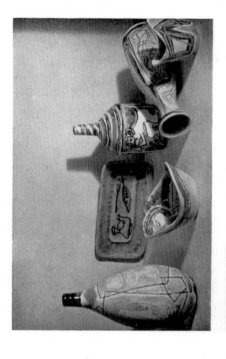

FLOWER VASES, BOTTLE, PLATTER, BOWL, AND ASHTRAY - CERAMICHE FANTONI, FLORENCE.
Decorative pieces in white enamel. - Fausto Melotti, Milan

UMBRIAN JUG WITH TRADITIONAL DECORATION - SOC. MAIOLICHE DERUTA, PERUGIA
VASE AND AMPHORS - MAZZOTTI GIUSEPPE, ALBISOLA MARINA

42

43

Fig. 6.3 Pages 42 and 43 of the *Italian Ceramics* catalogue, c. 1954, showing (from left to right, top then bottom row) 'Umbrian Jug with traditional decoration—
Soc. Maioliche Deruta, Perugia'; 'Flower vases, bottle, platter and ashtray—Ceramiche Fantoni, Florence'; 'Vase and Amphors—Mazzotti Giuseppe, Albisola
Marina'; and 'Decorative pieces in white enamel—Fausto Melotti, Milan'. Courtesy of Arti Grafiche Amilcare Pizzi S.p.A.

identity that associated both Italian pottery and other artisanal production with fine art ideals and set them apart from those of other countries.

CERAMICS ON THE 'SUNNY SOUTHERN ROUTE'

Among the most ambitious and successful attempts to create a homogeneous image for all types of Italian commodity production and link it to the idea of lifestyle, and vice versa, were the transatlantic ocean liners of the Italian Line passenger shipping company. Its fleet, which numbered more than twenty vessels during the interwar years, had been lost during the war, and its restoration was of utmost economic importance and indispensable for restoring national pride. The 'new' Italian Line fleet, comprising refurbished and brand-new vessels, was highly subsidised by Marshall Plan aid. These ships functioned as unofficial ambassadors symbolising Italy's post-war rebirth in an otherwise ravaged Italy.[28] The fleet included the *Conte Grande*, the *Conte Biancamano*, the *Giulio Cesare* and the company's flagship, the newly constructed luxury liner *Andrea Doria*, which was launched in 1951 for service on the so-called sunny southern route from Italy to New York. The interior decoration schemes were overseen by the architects Nino Zoncada and Gio Ponti. Using the most modern materials, furnishings and lighting design and commissioning the work of artists and artisans, Zoncada and Ponti turned the company's ships into sophisticated elegant floating art galleries with an equal emphasis on innovation, tradition and avant-garde ideals. The vessels were thus moving mediators of Italian design and ambulatory versions of the art galleries discussed in Imma Forino's chapter in this book. Their decoration reflected Ponti's opinion that

> our ships have to be 'dedicated to Italy'. . . . Their decoration, their paintings, their ornamentation need to recall the 'legend of Italy', the famous architecture, gardens, antiquity . . . Italy of the artists and the crafts of today, Italy of the wonderful ceramics, the promising glass, the famous enamels and the wonderful fabrics: the legendary Italy of art and history.[29]

Gold or silver-anodised aluminium, bronze, Pirelli rubber and linoleum flooring were matched with rich, elaborate fabrics of modern design and intricate trompe l'oeil paintings, Cassina armchairs, Pavoni coffee machines and artworks, particularly in Ponti's favoured majolica. Many of the artists who were included in the momentous *20th Century Art* exhibition held at the Museum of Modern Art in New York in 1949 helped to 'decorate' the *Conte Grande*, including Carlo Carrà, Massimo Campigli, Giacomo Manzu, Marino Marini, Arturo Martini and Lucio Fontana. Fontana and Pietro Melandri, Guido Gambone, Fausto Melotti, Luigi Zortea and Leoncillo Leonardi were all represented with ceramic works, many of them large-scale, such as two polychrome glazed majolica caryatids executed by Melotti, which were positioned on the central staircase leading down to the first-class dining hall (Figure 6.4). Ponti and Zoncada used every available space to showcase Italian crafts, which were integrated in the general interior decoration scheme or displayed as isolated objects in glass cases (Figure 6.5). The *Andrea Doria* was hailed as

the most technologically advanced passenger ship of its day and considered 'democratic' for its three swimming pools, one for each class, and for its artistic interior design, which was extended to the cabin and tourist class. The *New York Times* frequently likened it to an 'ocean going gallery, a ship built around a painting'.[30] For this project, Zoncada and Ponti commissioned the work of forty artists, craftspeople and designers, among them Salvatore Fiume, Pietro Fornasetti, Lucio Fontana, Guido Gambone, Romano Rui and Leoncillo Leonardi. The *Andrea Doria* epitomised Italy's post-war optimism and spirit of renewal, an idea of the Italian lifestyle that united technological advances and new, post-war democratic ideals with luxury and the values of heritage, individuality, originality and art.

Fig. 6.4 Gio Ponti and Nino Zoncada, *Conte Grande*, central staircase leading down to the first-class dining hall, detail showing caryatid in majolica by Fausto Melotti, c. 1949. Reproduced from Paolo Piccione, *Gio Ponti: Le Navi: Il progetto degli interni navali*, copyright IdeArte 2007 info@ideabooks.com.

Fig. 6.5 Gio Ponti and Nino Zoncada, *Giulio Cesare*, first-class saloon with a showcase featuring glass works by Paolo Venini; ceramics by Guido Gambone, Pietro Melandri, Fausto Melotti and Luigi Zortea; and objects in enamel by Paolo De Poli, c. 1948. Reproduced from Paolo Piccione, *Gio Ponti: Le Navi: Il progetto degli interni navali*, copyright IdeArte 2007 info@ideabooks.com.

CHANGING MARKETS AND SHIFTING MEANINGS

Italy's impressive figures for ceramic exports to the United States began to dwindle after 1952 (indicated in Figure 6.1B) and stagnated in the second half of that decade. The numerous reasons for the gradual decline of exports occurred simultaneously and were interrelated. They were also reflected in a change in the role that Italian majolica production played within the wider spectrum of Italian material culture. While in the initial post-war years Italian ceramics as a generic group embodied Italy's new image, combining modernity, fine art connotations and the ideals of heritage with aesthetic freedom and post-war optimism, this homogeneous identity gradually disintegrated during the

1950s, and different types of majolica wares took on the differentiated roles of art, craft, design and kitsch.

New aesthetic ideals and innovative materials that were carriers of new aspirations, such as plastics and linoleum, which offered similar material characteristics to ceramics (for example, colour, malleability and waterproof qualities), contributed significantly to a change in market demand that played a significant part in the ceramic industry's decline.[31] Italy's vast, geographically dispersed and aesthetically heterogeneous small- and medium-scale ceramic industry in particular proved inept to respond to the changing export market demand, for there existed no official organisation capable of guiding their production and coordinating their promotion and marketing, as well as conducting the market research in importing countries needed to coordinate production and demand. While early support networks such as CADMA, HDI, the HIH, CNA, *Domus* and the Triennale contributed significantly to the rebirth of Italy's post-war ceramic industry and provided valuable platforms for the initial distribution of its wares, it was beyond their scope and capacity to coordinate, let alone to physically reach, Italy's hundreds of culturally and historically disassociated regional workshops in order to create function-ing competitive marketing and distribution systems and to implement strategies to align production with demand.[32]

Whereas Italy's ceramic exports to the United States faced little competition during the early post-war years, the 'Report on Italian Ceramics Exports to the USA' of 1954 men-tions in particular Japan and Germany as competitors for a share of the American mar-ket.[33] The wares of both countries were said to be superior to the Italian ones in execution and quality, shipping and packaging and, above all, price. The Japanese excelled through on-site market research and the study of advanced American production technologies. This enabled them not only to produce exclusively for commissions received directly from American wholesalers and shops but even to copy Italian wares they had studied on the American market, producing look-alikes at much lower prices than the Italians.[34] Exaggerated prices and the small Italian workshops' failure to adapt their production to the market demand resulted from their disassociation from the consumer market. They neither had access to market research or marketing strategies nor exerted control over the distribution of their wares, which were sold to agents who bought for larger syndicates that, in turn, would sell the merchandise on to American department stores. In 1956 the *New York Times* mentioned the 'Italian's lack of knowledge about the American market plus their failure to understand that they lack this knowledge' as their ceramic industry's greatest obstacle to the expansion of exports to the United States.[35] While some small- and medium-scale workshops succeeded in creating a market niche for themselves by rigorously sticking to expensive, high-quality artistic production, others sought to col-laborate with large industry by designing and producing prototypes for mass production, while still others turned their artisan workshops into small industrial concerns, often concentrating on cheap, low-quality wares. The last group, especially, was able to take advantage of the demand for souvenirs generated by the growing tourist industry.

CONCLUSION

Italy's post-war ceramic industry played a profound role in the country's overall reconstruction effort and post-war economic recovery, as well as in the shaping of the 'made in Italy' idea. It is important to emphasise that long before critics and economic visionaries paid it any attention, Italy's small- and medium-scale artisanal ceramic industry was a national resource that had evolved historically and an aesthetically heterogeneous manufacturing sector that had been shaped by centuries of regional cultural, aesthetic and secular traditions. The identity that Italian ceramics assumed after the war, and the meaning attributed to Italian majolica artefacts, mirrored the ideals that were upheld by Ponti's IX Triennale di Milano of 1951. Ponti's edition was sandwiched between the 1947 one, guided by Ernesto Nathan Rogers and Lodovico Barbiano Belgioioso, which explored the theme of 'reconstruction as a social problem', and the 1954 edition, which followed the dogma of Max Bill and was largely dedicated to 'industrial design'. Ponti's edition, on the other hand, celebrated the 'expressive moment of the arts' or 'the synthesis of the arts' to reflect and approach a moment of uncertainty as regarded the future of material culture production.[36] At that time, as the export figures of majolica wares indicate, ceramics were as valued, culturally and economically, as industrial design products, if not even more so. Ceramic artefacts were able to convey an image of 'made in Italy' that united Italy's tradition of art and culture with the ideals of individuality, originality and modernity, expressing a new, freer and less hierarchical approach towards style and lifestyle. Italian ceramics were among the first products that successfully penetrated the post-war US market. They helped prepare the American consumer to accept Italian commodities and were instrumental in the fabrication of the image package that was to define Italian design for years to come.

NOTES

1. Italian Institute for Foreign Trade (Istituto Nazionale per il Commercio Estero [ICE]) and Handicrafts and Small Industries Agency (Ente Nazionale per l'Artigianato e le Piccole Industrie [ENAPI]), foreword to *Handicrafts of Italy* (Rome: ICE and ENAPI, n.d., c. 1948), 5.
2. Notable exceptions are Penny Sparke's 'The Straw Donkey: Tourist Kitsch or Proto-design? Craft and Design in Italy, 1945–1960', *Journal of Design History* 11, no. 1 (1998): 59–69; and Wava J. Carpenter's 'Designing Freedom and Prosperity: The Emergence of Italian Design in Postwar America' (master's thesis, Cooper-Hewitt, National Design Museum, Smithsonian Institution and Parsons the New School for Design, 2006), http://hdl.handle.net/10088/8788 (accessed January 10, 2012). Both concentrate on the role of the crafts in the formation of what became known as Italian design. This chapter is developed from parts of my PhD dissertation, Lisa Hockemeyer, 'Italian Ceramics 1945–1958: A Synthesis of Avant-Garde Ideals, Craft Traditions and Popular Culture' (Kingston University, 2008), which examined Italy's small- and medium-scale ceramic industry, from production, economic, commercial and consumption perspectives, and aesthetically situated its produce in its contemporary design, art and craft context. Carpenter's research has added many new insights to this essay.

3. The percentage has been established from the analysis of economic data published monthly in the journals *Industria della Ceramica e dei Silicati* and *Ceramica* between 1949 and 1958. See Hockemeyer, 'Italian Ceramics', 292.

4. ICE and ENAPI, *Italian Ceramics* (Milan: Amilcare Pizzi, n.d., c. 1954), 175.

5. Ibid.

6. Fiorenza Tarozzi, *La Società Cooperativa Ceramica di Imola—Un'esperienza ultracentenaria*, ed. Piero Giussami (Milan: Silvana, 1998), 70–71.

7. Hockemeyer, 'Italian Ceramics', 36–42.

8. Lisa Hockemeyer, *The Hockemeyer Collection: 20th Century Italian Ceramic Art* (Munich: Hirmer, 2009), 24.

9. Flavio Colutta, 'Nobiltà dei ceramisti Pugliesi', *Ceramica* 8, no. 7 (1953): 26–30. In this article Colutta further notes the desperate lack of water and electricity and, among the population, a general ignorance of economic development.

10. In 1937 Pietro Melandri's large-scale majolica relief *Perseus and the Medusa*, nine by seven metres (thirty by twenty-three feet) in size, won him the prestigious grand prix for sculpture at the Paris world exhibition. See Hockemeyer, *The Hockemeyer Collection*, 209.

11. Gillo Dorfles, 'Ceramic Art in Italy Today', *The Studio* 142, no. 732 (1954): 83.

12. For APEM see 'Italian Art Work Placed on Exhibit', *New York Times*, June 16, 1947.

13. Max Ascoli quoting the Italian Institute for Foreign Trade in 1945, quoted in Carpenter, 'Designing Freedom', 39.

14. Ibid., 2.

15. Ibid., 37–39.

16. Ibid., 38.

17. Ibid., 148–149.

18. Ibid., 45.

19. Ibid., 40–42.

20. Hockemeyer, 'Italian Ceramics', 331.

21. 'Italian Trade Aid Seen in Bank Loan', *New York Times*, December 8, 1947.

22. See 'Survey Conducted for Italian Goods', *New York Times*, March 28, 1948; and 'Pottery Put First in Italian Lines', *New York Times*, January 18, 1949.

23. 'Italian Art Work Placed on Exhibit', *New York Times*, June 16, 1947; and Jane Ellis, 'Heirs of Cellini', *New York Times*, November 2, 1947.

24. Hockemeyer, 'Italian Ceramics', 314–319.

25. ICE and ENAPI, *Handicrafts of Italy*; ICE and ENAPI, *Italian Ceramics*, 133–172.

26. Ibid.

27. Hockemeyer, 'Italian Ceramics', 330.

28. Ibid., 261–275.

29. Gio Ponti, 'Interni delle nuovi navi italiane', *Domus* 263 (November 1951): 23.

30. Aline B. Louchheim, 'Art Suited to a Luxury Liner', *New York Times*, February 1, 1953.

31. Hockemeyer, 'Italian Ceramics', 341.

32. In 1949 Max Ascoli considered his vision of helping rebuild Italian industry and revitalise its economy as having been sufficiently fulfilled to terminate his involvement with HDI, leaving the organisation to its own devices. The same year, the HIH changed its name to 'The Piazza' and limited its activities to retail until it closed in 1956. CADMA and CNA disassociated themselves from their American affiliation and took on their own lives. See Carpenter, 'Designing Freedom', 58.

33. 'Rapporto sulle esportazione delle ceramiche italiane in U.S.A', *Ceramica* 10 (October 1954): 57–58.

34. Ibid., 58.

35. Michael L. Hoffman, 'Trade Know How Urged for Italy', *New York Times*, April 23, 1956.

36. Hockemeyer, 'Italian Ceramics', 371.

7 CRAFTING A DESIGN COUNTERCULTURE: THE PASTORAL AND THE PRIMITIVE IN ITALIAN RADICAL DESIGN, 1972–1976

CATHARINE ROSSI

INTRODUCTION

The opening in 1972 of *Italy: The New Domestic Landscape: Achievements and Problems of Italian Design* at the Museum of Modern Art (MoMA) in New York is recognised as a landmark moment in Italy's design history.[1] Curated by the Argentine architect Emilio Ambasz, the eagerly anticipated and heavily publicised show celebrated design's contribution to Italy's post-war development and its success in the international marketplace.

The esteem for Italy's architect-designers was based on two very different approaches: on the one hand, luxurious products designed by pre-eminent architects such as Gio Ponti and Vico Magistretti and, on the other, countercultural imaginings by a younger generation led by Ettore Sottsass and Superstudio. Together, the exhibition showed that Italy's architects were still leading the design of desirable commodities but were also at the vanguard of a critical position towards consumer society and architects' role therein.

This countercultural element in Italian design was not new. It had first appeared in the wave of contestation that had swept through Europe in the late 1960s, in which architects were active participants.[2] In 1968 architecture students and professionals occupied and vandalised the XIV Triennale di Milano, criticising an exhibition seen to embody a commercially oriented design establishment.[3] This anti-authoritarianism also informed the fledgling radical design movement; the irreverent, pop-inspired designs by Archizoom Associati, Sottsass and Superstudio countered the dominant modernist orthodoxy and the desires of the mainstream marketplace through their ironic turn to the language of bad taste, kitsch and historical eclecticism. Produced by Poltronova, a Tuscan-based manufacturer established in 1957, objects such as Archizoom's Superonda sofa and Superstudio's Passiflora lamp, both designed in 1966, were on display at the MoMA exhibition.[4]

By the early 1970s, however, the optimism of 1968 had largely turned into frustration at the lack of societal reform. In this context the radicals' products were seen as ineffective and problematic critical strategies. The Marxist architectural historian Manfredo Tafuri lambasted these architects for peddling an 'increasingly commercialized' form of irony.[5] In the Marxist rhetoric that pervaded the dominant leftist discourse in Italy at this time,

the radicals' pop products were seen as inadequate tools for social change; too readily consumed as status symbols by a younger generation of consumers, they spoke only of the market's ability to swallow up any attempts at subversion.[6]

The perceived failure of radical design's strategies in the late 1960s could also be seen in the displays of *Italy: The New Domestic Landscape*. This is another—albeit largely unacknowledged—reason why the exhibition was important, for it not only showed what Italy's architects had been up to in the last decade but also displayed what was coming next. As such, the exhibition marked the end of the first wave of radicalism and the emergence of the second, and final, wave.

While Marxist ideas continued to inform the majority of these architects' practice, their strategies demonstrated a marked change in approach and an increasingly utopian nature. In the exhibition catalogue art critics Filiberto Menna and Germano Celant described these new ways in which Italy's avant-garde architects sought to overcome the alienation that they perceived at all stages of design production, consumption and mediation. This was a 'crisis of the object' in which architects were shifting away from designing products to what Menna described as 'designing behaviours'.[7] This was evident in environments such as Superstudio's proposal (Figure 7.1) for a 'life without objects', a 'negative utopia' of perpetual nomadism in which objects were reduced to 'neutral, disposable elements' devoid of any commodity fetishism.[8]

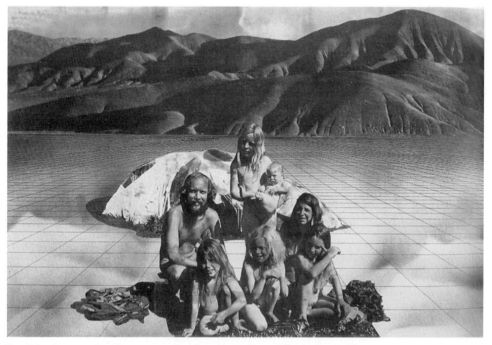

Fig. 7.1 Superstudio, 'Encampment' collage from their 'Life without Objects' environment at the exhibition *Italy: The New Domestic Landscape: Achievements and Problems of Italian Design*, curated by Emilio Ambasz, at the Museum of Modern Art, New York, 1972. Courtesy of Alessandro Poli.

This emphasis on behaviours was also evident in one of the least discussed environments, designed by the Florentine Gruppo 9999. This contribution remains largely unrecognised partly because it existed only on paper: Gruppo 9999 was one of two winners of the exhibition's 'Competition for Young Designers', whose entries were displayed as paper-based proposals on the museum's walls.[9] This chapter briefly examines Gruppo 9999's entry before conducting a broader analysis of the role of craft for a number of architects involved in the second wave of Italy's radical design movement. This aspect, just like the Florentine group's MoMA environment, has been largely overlooked in the telling of post-war Italian design's history and yet was a vital part of this story.

GRUPPO 9999 AND THE PASTORAL MODE IN RADICAL DESIGN

Gruppo 9999 was set up in 1967 by four Florentine architects: Giorgio Birelli, Carlo Caldini, Fabrizio Fiumi and Paolo Galli. Their environment for *Italy: The New Domestic Landscape*, entitled 'Vegetable Garden House', consisted of a series of collages on graph paper that combined text with depictions of children and adults in various states of undress as well as illustrations and photographs of Brussels sprouts, cabbages and vegetable patches (Figure 7.2). The collages were intended to represent three components of the house's bedroom: water, a vegetable garden and an airbed.[10]

As with all the environments in the exhibition, Gruppo 9999's contribution had its roots in earlier practice. Theirs was the result of research and experiments conducted at the progressive Space Electronic nightclub they had established in 1969 in Florence.[11] Among the performances and installations that took place there, Gruppo 9999 created a two-room prototype of the 'Vegetable Garden House'. The first part was a living room, which was the continuation of a research project set up in 1970 with Superstudio, entitled 'S-Space (Separated School for Expanded Conceptual Architecture)', which the latter described as 'engaged in experimental teaching and the exchange of information'.[12] The second was the three-part bedroom exhibited at MoMA.[13] (See Figure 7.3.)

The bedroom offered a different emphasis from the pedagogical orientation of the living room. In the text part of the collage, Gruppo 9999 described the rationale behind their vegetal vision for the domestic environment: 'up until now, technology has followed a completely autonomous path, one, we might say, in conflict with nature'.[14] To counteract this distance between nature and technology they proposed

> returning once more to elements that have long been lost and are by now forgotten: ancient and primordial things like food and water, side by side with technological inventions. It is our attempt to bring man back into relation with nature, even in this modern and hectic life.[15]

On the one hand, their manifesto epitomised the radical avant-garde's identification of an alienating distance between humans and their environment. It also conformed to Menna's identification of the radicals' focus on changing behaviours, rather than creating

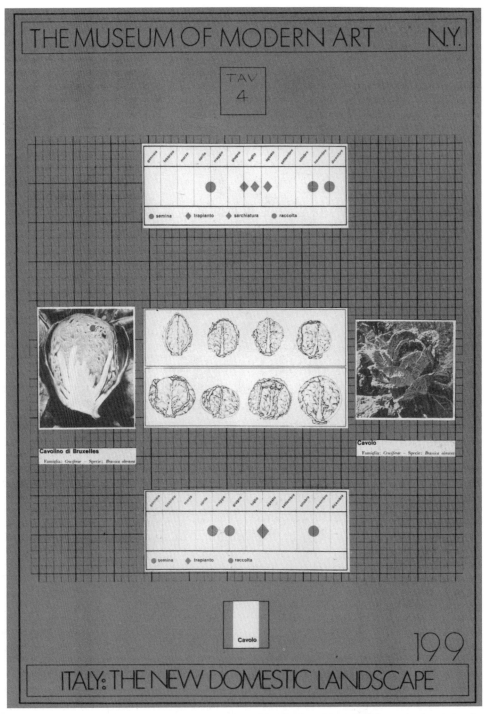

Fig. 7.2 Gruppo 9999, extract from their 'Vegetable Garden House' collage displayed in the 'Environments' section at *Italy: The New Domestic Landscape*, Museum of Modern Art, New York, 1972. Courtesy of Carlo Caldini.

Fig. 7.3 Gruppo 9999, prototype of 'Vegetable Garden House' at Space Electronic nightclub, Florence, c. 1972. Courtesy of Carlo Caldini.

products, to address this. On the other, its rhetoric exemplified the presence of a concept that is one of the foundations of this chapter and that can, furthermore, be seen as a quality associated with craft. Gruppo 9999's environment was premised on nature's condition as a primitive and remote 'other' to technological modernity. Described in a MoMA press release as 'arcadia reformulated', it can therefore be seen as an expression of the pastoral mode, conforming to the original literary meaning of the term as an idealisation of nature, a celebration of the simple and commonplace.[16]

'Vegetable Garden House' also expresses some of the qualities attributed to the pastoral since its origins are in the classical tradition.[17] It exemplifies the political appropriation of the pastoral in this period—as in the Welsh cultural critic Raymond Williams's Marxian use of the term in his 1973 *Country and the City*—in order to expose class conflict and inequality.[18] Gruppo 9999's pastoral expressed a commodity critique described by Italian critic Renato Poggioli in the 1960s as characteristic of the avant-garde: 'foremost among the passions that the pastoral opposes [is] . . . the possession, of worldly goods'.[19] This is evident in Gruppo 9999's inclusion of an excerpt from Virgil's *Georgics* in which the Latin poet describes the seasonal work of a beekeeper. Although it was a comparatively

humble existence, the beekeeper was happy with his (or her) lot: 'as he planted herbs here and there among the bushes, with white lilies about, and vervain, and slender poppy, he matched in contentment the wealth of kings'.[20]

While the *Georgics* is mostly a didactic depiction of agricultural life, Williams affirms that parts of the poem are pastoral. This is due not just to their 'idealising tone' but to the fact that this 'idyllic note is being sounded in another context', expressing a cultural and temporal remoteness that is another key pastoral characteristic.[21] Both Gruppo 9999 and Superstudio locate their antimaterialist utopia in a distant nature: in the former this was the vegetable garden; in the latter it was the mountainous landscapes that serve as the backgrounds for the isolated 'encampments', their remoteness amplified by the use of the perspectival grid.[22]

Conventionally a literary trope, the pastoral can also be seen as a quality associated with craft. In his *Thinking through Craft* of 2007, Glenn Adamson identifies the pastoral, alongside supplementarity, skill, materiality and the amateur, as craft's five 'interrelated core principles'. Specifically, Adamson sees both the pastoral and the amateur as exemplary of 'craft's situation in the modern social fabric', two 'conceptual structures in which craft's marginalisation has been consciously put to use'.[23] Although Adamson describes craft's position in relation to art, Gruppo 9999 and Superstudio indicate that the same can be said of craft in relation to design: while neither group refers to the pastoral explicitly, arguably both adopted the pastoral precisely due to its existence outside of the modern industrial design mainstream.

This chapter argues that the pastoral was one of a number of craft concepts that informed Italy's radical counterculture. These concepts, tied up with the anthropologically informed approaches of this second wave of radical design, are entirely absent from any existing reflections on the era and yet were central to the movement's activities. Using contemporary periodicals and archival material, and informed by a craft-based approach, this chapter will therefore examine a number of the ways in which craft can be seen to have informed radical design practice.

In order to examine the role that craft played in Italy's design counterculture, this chapter now expands its gaze beyond Gruppo 9999 to consider the wider context of craft in early 1970s Italy and the multiple ways in which key architects and collectives associated with what is variously known as radical design, antidesign or counterdesign all engaged with the handmade. These are Enzo Mari, Riccardo Dalisi and the Global Tools collective, in which Gruppo 9999 and Superstudio both participated. The second and third sections of this chapter focus on Superstudio, particularly the group's interest in Aboriginal and Italian peasant material culture. Although the importance of all these groups to Italy's design history is well recognised, none has received sufficient critical attention, and none has been examined in terms of their relation with craft. As such, this chapter not only reassesses one of the most fascinating periods in Italian design but also suggests the potential for using craft as an approach to design history in other contexts.

CRAFT AND THE DESIGN COUNTERCULTURE IN 1970S ITALY

This examination of the role of craft in Italy's design counterculture is part of a larger attempt to reassert craft's centrality in Italy's post-war design history. Craft has been largely marginalised in Italian design historiography, and yet it was key to the development of its post-war design culture. In Italy's fragmented and localised history of industrial development, craft was a vital means of production: even following the wave of rapid industrialisation in the early 1950s, the scale and sites of furniture and product manufacture stayed largely artisanal in nature.[24] The British design historian Penny Sparke, who pioneered craft-oriented approaches to Italian design in the 1990s, has demonstrated how craft materials and traditions remained important to Italy's architects throughout the 1950s and 1960s, from Ponti's vernacular-inspired straw-seated Superleggera chair for Cassina to Sottsass's Tuscan-made ceramics and Murano blown glassware.[25] Craftsmanship has continued to be an important quality in the consumption of Italian design, as the contemporary desirability of luxuries 'Made in Italy' demonstrates.[26]

The turn to craft by Italy's countercultural architects in the early 1970s was informed by a wider surge of interest in the handmade. On the one hand, this period saw a growing popularity for do-it-yourself (DIY). Writing in *Modo* magazine in 1977, Claudia Donà noted how DIY had formerly been a minor concern in Italy, as the urban housing stock was largely made up of rented accommodation in which landlords were responsible for maintenance duties, and repairmen were in any case inexpensive. However, in the economic depression of the early 1970s, even these apartments' inhabitants were looking for ever cheaper ways to make do and mend.[27]

In 1974 the outspoken architect Enzo Mari appropriated this trend for amateur making to radical ends. In 'Proposta per un'Autoprogettazione' (Proposal for a self-design) Mari invited the public to make their own furniture according to a series of his own simple, utilitarian designs that were published in a freely distributed catalogue.[28] In tune with the architect's Marxist politics, this was a project of consciousness-raising, one that used the craft figure of the amateur for its realisation. Mari hoped that by getting consumers to make their own furniture they would experience an unalienated mode of production and be freed from the binds of commodity fetishism.

The craft revival that was sweeping through North America and western Europe in the 1960s and 1970s was also felt in Italy.[29] This was evident in the presence of studio potters such as Alessio Tasca at the inaugural Sezione del Lavoro Artigiano (Section of Artisanal Work) at the XV Triennale di Milano in 1973. While craft had been present at previous Triennali, this was the first time its presence was framed by its cultural difference from industrial production. The studio crafts were seen as promising individuality in an otherwise homogeneous, mass-produced world.[30]

As the architecture critic Joseph Rykwert noted in *Domus* at the time, this anti-industrial craft discourse signalled 'a kind of protest against the consumer society [that was] familiar in the Anglo-Saxon world' but unusual in the Triennale context.[31] Rykwert's

critique is a reminder of the specificity of craft in Italy, where, in contrast to conventional Anglo-American discourse, it has not, historically, been constructed as ideologically different from industrial production. This is partly due to the nation's industrialisation process. As Italy did not experience the erasure of artisanal workshops that occurred in nineteenth-century Britain, there was no need for an arts and crafts movement to call for their revival.[32] This was compounded by a rejection of socialism among Italy's intellectuals at the turn of the twentieth century, when the movement's ideas were disseminated.[33] While I do not want to oversimplify Italy's craft history, and in the absence of extensive research conducted in this area, this does mean that the difference between craft and industry in Italy has been seen as mostly a question of scale rather than ideology.[34]

However, there were signs of the construction of craft as a site of authentic alterity, which has dominated what Adamson and other craft voices term 'modern craft', meaning craft that is seen to contain values that are considered 'other' to the condition of industrial modernity within which it is produced.[35] For example, Michelangelo Sabatino has described a turn to the vernacular by rationalist and neorationalist architects in the inter- and post-war periods, as practitioners such as Giuseppe Pagano and Giancarlo De Carlo sought an alternative to the dominant architectural language.[36]

It was only in the 1970s that Italy's architects appropriated craft as an alternative to the values of industrial modernity on any large scale. Speaking at a conference organised on the occasion of the 1973 Triennale, the Neapolitan architect Riccardo Dalisi identified how a 'crisis . . . of the cultural value of the industrial product' was leading to a re-evaluation of the handmade and all its 'formal, social, economic values'.[37] Dalisi had been invited to the conference to speak about his experiments in *tecnica povera* ('poor technique') conducted since 1971 in the impoverished Neapolitan quarter of Traiano.[38] Informed by *arte povera*'s interest in public participation and the use of unmediated, or *povera*, materials, Dalisi encouraged street children to spontaneously make furniture and structures with the simple tools and materials at hand.[39] He perceived a greater creativity among 'the children of the lumpen proletariat' in comparison to his own architecture students, a lack of inhibition attributed to the fact that these children had not experienced the stultifying effects of Italy's education system or the repressive rhythms of the assembly line.[40] As part of the project, Dalisi kept a diary and took photographs to document the children's behaviour; this identifiably anthropological approach indicated the wider influence of anthropology on design at this time.[41]

In his conflation of children with unalienated, pre-industrial makers, Dalisi also demonstrates another quality that can be associated with craft. The architect identified children as undivided selves closer to a natural state of spontaneous creativity—a distinction between the totality of the primitive other and the fragmented self that Daniel Miller has described as being at the root of the primitivism that underpins modern art practice.[42] As this chapter will go on to suggest, primitivism can be seen as another characteristic of radical design in this period, as shown in Global Tools' interest in pre-industrial methods and makers and in Superstudio's research into the Tuscan peasant Zeno Fiaschi.

Set up in 1973 at the offices of *Casabella* magazine, the Global Tools collective was made up of the leading architects in Italy's radical counterculture; its members included Andrea Branzi, Dalisi, Michele de Lucchi, Alessandro Mendini, Sottsass, Gruppo 9999 and Superstudio. Like Dalisi, Global Tools was interested in free creativity and expressed this in explicitly craft terms: members proposed the 'teaching of crafts' in order 'to recuperate creative faculties atrophied in our work-directed society'.[43] The group planned to do so through a series of workshops that would be organised on the basis of five areas of activity: the body, construction, communication, survival and theory. Superstudio and Gruppo 9999 made up the survival group, and in the second of the two Global Tools bulletins that were published, they laid out their plans for research. As we shall see, these demonstrated the same qualities of the pastoral discussed in the introduction to this chapter, only this time with a distinctly primitive element.

GRUPPO 9999, SUPERSTUDIO, ABORIGINES AND THE PASTORAL PRIMITIVE

For Global Tools, Gruppo 9999 and Superstudio proposed a comparative study of 'the survival struggle', examining the production and consumption of items such as food, clothing, objects and tools in two contrasting locations: the 'town and . . . the country'. In this project of 'self-anthropology', the group described themselves as 'intellectuals on the Florence-Milan axis' who represented the town.[44] Although the text is silent on who the 'country' subjects were, the photograph of an Aborigine rubbing sticks to create fire is highly suggestive of their identity.

In 1975 Superstudio presented the research that had been outlined in the Global Tools bulletin in *Avanguardie e cultura popolare*, an exhibition curated by Giovanni M. Accame and Carlo Guenzi at Bologna's Galleria d'Arte Moderna that also included Dalisi's *tecnica povera* and Mari's *Autoprogettazione*. According to Accame, the exhibition aimed to bring together 'those whose profession is the creation of culture with those who have no culture other than their own way of life'.[45] Superstudio's interest in the latter can be seen as illustrative of a rediscovery of folklore and popular culture in Italy, domains regarded as untainted by the consumerist values of contemporary society.[46] Superstudio was not immune to this interest in non-intellectual culture, as their interest in comparing urban and rural, intellectual and Aboriginal, cultures demonstrates.

This perception of difference based on assessments of cultural level is another quality associated with the pastoral that was demonstrated by Superstudio and the exhibition curators. Thomas Crow, following William Empson, discussed the 'pastoral contrast' in terms of such a distinction: 'those who fashion or enjoy cultivated forms of art are compelled to compare their own condition, which permits this refinement, with that of the rustic whose existence affords no such luxury but who enjoys in compensation a natural, more "truthful" simplicity of life'.[47] Yet another element can be added to this pastoralism: in their anthropological identification of the Aboriginal 'other', Superstudio expressed the same primitivism seen in Dalisi's experiments. In the catalogue Superstudio denied this, however, claiming that they chose the Aboriginal community precisely to avoid

falling into such a trap: 'Why have we chosen to compare ourselves with them? Because it is harder to apply to them than to other "primitives" the myths of the "good savage" and "happy islands"; because it is easier to see in them the signs of pain, of the difficulties, of diseases, of the effort of living'.[48] The fact that Superstudio felt the need to defend itself against accusations of primitivism implies its presence. This is confirmed by the fact that despite the Aborigines' harder existence, Superstudio saw something preferable in their lesser reliance on material possessions: 'we can learn from them the value of regaining a bit of freedom; and we can do this by getting rid of some of our objects, [such as] those least needed'.[49]

Superstudio was partly interested in Aborigine culture as representative of what their own Italian society had been like before the march of industry, progress and modernity. John Storey has noted a similar interest in late Victorian Britain, when folklorists explored the 'primitive' both in the far-flung reaches of the empire and in Britain's folk culture. As Storey argues, Britain's 'pastoral life' was construed as a 'primitive culture', a conflation between the 'savage' and the 'peasant' that translated into a 'primitive pastoralism'—a term that can clearly also be applied to Superstudio's interest in Aboriginal culture.[50] This 'primitive pastoralism' was not evident just in Superstudio's interest in Aborigines. It was also found in Superstudio's largest project of anthropological research, their 'Cultura Materiale Extraurbana' (Extraurban material culture), conducted between 1973 and 1978.

SUPERSTUDIO, ZENO FIASCHI, 'CULTURA MATERIALE EXTRAURBANA' AND THE PASTORAL PRIMITIVE

As the 1970s progressed, Superstudio's members devoted an increasing amount of their time to teaching at the University of Florence's architecture faculty. In their 'Cultura Materiale Extraurbana' course and research project, Superstudio employed 'anthropological techniques' of observation and written and visual records to examine and document the materials and tools of the Tuscan peasant culture.[51]

Anthropological techniques were also employed when the group's research focused on one figure—Zeno Fiaschi, a seventy-year-old peasant whom Superstudio member Alessandro Poli had met while buying a house in the Tuscan countryside.[52] As part of his fieldwork, conducted between 1975 and 1976, Poli took photographs and drew up annotated diagrams of Fiaschi's house, surroundings and possessions. Poli clearly believed that he had found an adult, Italian-based maker endowed with the same free creativity as Dalisi's Neapolitan children and the same unalienated relationship with objects as in Aboriginal culture and among Mari's would-be amateurs. As Poli later described it, 'Zeno's objects and utensils were paradoxes he had built for actual use and not for display . . . that arise from a total self-managed relationship between the individual, society and the environment'.[53]

Superstudio's concentration on Fiaschi conformed to another facet of the pastoral: the focus on isolated individuals (Figure 7.5) that made up the pastoral's landscape. He was what Leo Marx called a 'liminal figure', 'an efficacious mediator between the realm

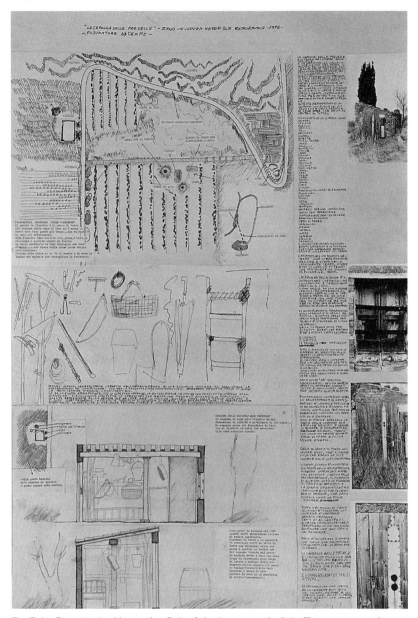

Fig. 7.4 Drawing by Alessandro Poli of the homestead of the Tuscan peasant farmer Zeno Fiaschi for research into a self-sufficient culture, 1979–1980. Courtesy of Alessandro Poli.

of organized society and the realm of nature'.[54] This interest in the pastoral figure was also evident in the work of Global Tools. A 'fundamental concept' of their research was 'the non-intellectual man, with his age-old innate wisdom, and all the possibilities which may derive from this, even to the point of reverting to a nomadic way of life, destruction of the city, etc.'[55] This was part of Global Tools' larger interest in pastoral simplicity, also seen

Fig. 7.5 Photograph taken by Alessandro Poli of Zeno Fiaschi in his house in Riparbello. Courtesy of Alessandro Poli.

in Gruppo 9999's turn to nature: 'the terminology, tasks, methods, and structure of the school are amazingly simple, as is all essential for those who wish to bridge the alienating gap which has been created between the functions of the hands and those of the mind'.[56]

In line with the pastoral's marginal status, Fiaschi was not representative of a dominant way of being in Italy's rural regions. Rather, against a larger context of ongoing decline in Italy's agricultural sector and a concomitant flight from the rural regions to the cities, he struck an increasingly lonely figure. As Poli later noted, Fiaschi was 'the figure who represented the exception of continuity in these cultures that were disappearing due to migration and urban acculturation'.[57] Fiaschi was the one who stayed behind, a figure increasingly as marginal and remote from the Italy of the 1970s as was the culture of its disappearing rural traditions.

CONCLUSION

Superstudio's research into Zeno Fiaschi and Tuscan peasant material culture has remained one of their less-known projects. According to the architect Peter Lang, who is an authority on the group, this is because it 'lacked the checks, balances and earlier ironies that might have successfully lifted this project back on to a more international platform'.[58] Arguably, it was also due to the cojoined artisanal and agricultural nature of their subject matter, qualities that this chapter has demonstrated were central to radical design and yet have been largely overlooked in Italian design history thus far.

This chapter has focused on the second wave of radical design that sprang up in the increasingly violent early 1970s and was first exhibited in *Italy: The New Domestic Landscape*. If the bright, pop-like colours and forms of radical design in the late 1960s marked the optimism of the first wave, then arguably the marginality and remoteness of the pastoral were equally fitting for the second wave of radicalism in the 1970s. This period marked the end of radical design; in 1976 Global Tools folded, and several months later Studio Alchimia was set up. This postmodern group had Mendini's nihilism at its core, and the utopianism of the previous years had no place. However, although the 'primitive pastoral' was effaced from the short-lived second wave of the radical design movement, its influence can be seen in other moments in Italy's postwar design history. Sottsass's interest in suburban laminate coffeeshop counters in his Superboxes and designs for the Memphis group could be read as instances of a cojoined 'pastoral primitivism'. Ultimately, therefore, this focus on the pastoral and primitive demonstrates the potential of using craft-based approaches to revisit Italy's design history as a whole and to apply the multifaceted concept of craft to other cultures and contexts.

NOTES

1. For example, Jane Pavitt, 'The Bomb in the Brain', in *Cold War Modern: Design 1945–1970*, ed. David Crowley and Jane Pavitt (London: V&A Publishing, 2008), 117.

2. For more on this period see Jan Kurz and Marica Tolomelli, 'Italy', in *1968 in Europe: A History of Protest and Activism, 1956–1977*, ed. Martin Klimke and Joachim Scharloth (Basingstoke: Palgrave Macmillan, 2008), 83–96.

3. Paola Nicolin, 'Protest by Design: Giancarlo De Carlo and the 14th Milan Triennale', in Crowley and Pavitt, *Cold War Modern*, 228–233.

4. Emilio Ambasz, 'Objects Selected for Their Sociocultural Implications', in *Italy: The New Domestic Landscape: Achievements and Problems of Italian Design*, ed. Emilio Ambasz (New York: Museum of Modern Art, 1972), 108, 100.

5. Manfredo Tafuri, *History of Italian Architecture, 1944–1985*, trans. Jessica Levine (Cambridge, MA: MIT Press, 1989), 99.

6. On Marxist politics and 1970s Italy, see Paul Ginsborg, *A History of Contemporary Italy: Society and Politics, 1943–1988* (London: Penguin, 1990), 298–347.

7. Germano Celant, 'Radical Architecture', and Filippo Menna, 'A Design for New Behaviours', in Ambasz, *Italy: The New Domestic Landscape*, 380–387, 405–414.

8. 'Negative' utopias refers to the fact these architects' utopias were not constructive but destructive—they aimed at destroying the problematic nature of existing society rather than creating a new one. Superstudio, 'Description of the Microevent/Microenvironment', in Ambasz, *Italy: The New Domestic Landscape*, 246; and Ambasz, 'Summary', in Ambasz, ed., *Italy: The New Domestic Landscape*, 421.

9. The other winner was Studio Tecnico Gianantonio Mari.

10. Mark Wasiuta, Luca Molinari and Peter Lang, 'Fabrication Laboratory 9999', in *Environments and Counter-environments: 'Italy: The New Domestic Landscape', MoMA 1972* (Barcelona: Disseny Hub Barcelona [DHUB], 2011), n.p., http://www.petertlang.net/design-culture/environments-and-counter-environments-dhub-barcelona-2010-11/ (accessed December 10, 2011).

11. Ibid.

12. Superstudio, 'Superstudio', in Ambasz, ed., *Italy: The New Domestic Landscape*, 240.

13. Wasiuta, Molinari and Lang, 'Fabrication Laboratory 9999'.

14. Gruppo 9999, 'Group 9999', in Ambasz, ed., *Italy: The New Domestic Landscape*, 276.

15. Ibid.

16. Museum of Modern Art, 'Italy: The New Domestic Landscape Competition', press release no. 56, 1972, http://www.moma.org/docs/press_archives/4834/releases/MOMA_1972_0063_56X.pdf?2010 (accessed December 8, 2011); and Raymond Williams, *The Country and the City* (New York: Oxford University Press, 1973), 17.

17. On the history of the pastoral, see Paul Alpers, 'What Is Pastoral?' *Critical Inquiry* 8, no. 3 (1982): 437–460.

18. Raymond Williams, *The Country and the City* (New York: Oxford University Press, 1973).

19. Renato Poggioli, *The Oaten Flute: Essays on Pastoral Poetry and the Pastoral Ideal* (Cambridge, MA: Harvard University Press, 1975), 4.

20. Virgil, *Georgics*, V, 124–145, quoted in Gruppo 9999, 'Group 9999', 277.

21. Williams, *The Country and the City*, 17. See also Poggioli, *Oaten Flute*, 1; and Glenn Adamson, *Thinking through Craft* (Oxford: Berg, 2007), 104. On the cultural and temporal remoteness of ideals, and the necessity that ideals remain elusive and unrealised, see also Grant McCracken, *Culture and Consumption: New Approaches to the Symbolic Character of Consumer Goods and Activities* (Bloomington: Indiana University Press, 1990), 107.

22. Adamson, *Thinking Through Craft*, 104.

23. Ibid., 4–5, 4.

24. John Foot, *Modern Italy* (Basingstoke: Palgrave Macmillan, 2003), 3.

25. Penny Sparke, 'The Straw Donkey: Tourist Kitsch or Proto-design? Craft and Design in Italy, 1945–1960', *Journal of Design History* 11, no. 1 (1998): 59–69; and Sparke, 'Nature, Craft, Domesticity, and the Culture of Consumption: The Feminine Face of Design in Italy, 1945–70', *Modern Italy* 4, no. 1 (1999): 59–78.

26. On the contemporary desirability of Italy's products, see Rachel Sanderson, 'Value of Being "Made in Italy"', *Financial Times*, January 20, 2011, 16. For a discussion of the increasingly problematic nature of this label, see Simona Segre Reinach's contribution to this volume.

27. Claudia Donà, 'Bricolage, un problema di definizione tra tempo libero e tempo liberato', *Modo* 1, no. 2 (July–August 1977): 52.

28. Enzo Mari, *Autoprogettazione?* (Mantua: Corraini, 1974; repr., 2008), n.p.

29. For more on the craft revival see Marcia Manhart and Tom Manhart, eds., *The Eloquent Object: The Evolution of American Art in Craft Media since 1945* (Tulsa, OK: Philbrook Museum of Art, 1987).

30. 'Sezione del Lavoro Artigiano', in *Quindicesima Triennale di Milano: Espozione Internazionale delle Arti Decorative e Industriali Moderne e dell'Architettura Moderna* (Florence: Centro Di, 1973), 51.

31. Joseph Rykwert, '15 Triennale', *Domus* 530 (January 1973): 2.

32. On crafts in the conditions of Britain's industrial modernity, see Peter Dormer, Tanya Harrod, Rosemary Hill and Barley Roscoe, *Arts and Crafts to Avant-Garde: Essays on the Crafts from 1880 to the Present* (London: Southbank Centre, 1992).

33. Adrian Lyttleton, 'Italian Culture and Society in the Age of *Stile Floreale*', *Journal of Decorative and Propaganda Arts* 13 (Summer 1989): 28.

34. See the responses to 'Points of View: An Enquiry on Handicrafts (Où en sommes nous-avec l'Artisanat?)' *Zodiac* 4–5 (1959): n.p.

35. Glenn Adamson, Edward S. Cooke Jr. and Tanya Harrod, 'Editorial Introduction', *Journal of Modern Craft* 1, no. 1 (2008): 5–11.

36. Michelangelo Sabatino, 'Ghosts and Barbarians: The Vernacular in Italian Modern Architecture and Design', *Journal of Design History* 21, no. 4 (2008): 335–358.

37. Riccardo Dalisi, 'Artigianato e Lotta di Quartiere', presented at *Convegno 'Significato e Creatività del Lavoro Artigiano nella Realta' d'Oggi'*, Archivio Storico—La Triennale di Milano, Milan, 3–4 November 1973.

38. Dalisi, 'Guerriglieri della cultura e gioco dell'emarginazione', in *Avanguardie e cultura popolare*, ed. Giovanni M. Accame and Carlo Guenzi (Bologna: Galleria d'Arte Moderna, 1975), 65–68.

39. Germano Celant, *Arte Povera: Histories and Protagonists* (Milan: Electa, 1985).

40. Dalisi, 'La tecnica povera in rivolta: La cultura del sottoproletariato', *Casabella* 365 (May 1972): 29.

41. Alison J. Clarke, 'The Anthropological Object in Design: From Victor Papanek to Superstudio', in *Design Anthropology: Object Culture in the 21st Century*, ed. Alison J. Clarke (Vienna: Springer, 2011), 74–87.

42. Daniel Miller, 'Primitive Art and the Necessity of Primitivism in Art', in *The Myth of Primitivism: Perspectives on Art*, ed. Susan Hiller (London: Routledge, 1991), 37–38.

43. Global Tools, 'Document-O No. 3, "The—L'Ac-ttivit-y-a",' in *Global Tools* (Milan: Edizioni L'Uomo e L'Arte, 1974), n.p.

44. Superstudio, Gruppo 9999, 'Sopravvivenza', in *Global Tools* (Milan: Edizioni L'Uomo e L'Arte, 1975), n.p.

45. Giovanni M. Accame, 'Cultura come trasformazione', in Accame and Guenzi, *Avanguardie e cultura popolare*, iii.

46. Carlo Guenzi, 'Avanguardia e popolo: Dialogo immmaginario a motivazione di molti contributi della mostra', in Accame and Guenzi, *Avanguardie e cultura popolare*, vii.

47. Thomas Crow, *Modern Art in the Common Culture* (New Haven, CT: Yale University Press, 1996), 176–177.

48. Piero Frassinelli, 'Essi sono quello che noi non siamo', in Accame and Guenzi, *Avanguardie e cultura popolare*, 106.

49. Ibid.

50. John Storey, *Inventing Popular Culture: From Folklore to Globalization* (Oxford: Blackwell, 2003), 6–8.

51. Superstudio, quoted in Peter Lang and William Menking, *Superstudio: Life without Objects* (Milan: Skira; New York: Rizzoli, 2003), 224.

52. Alessandro Poli, 'Nearing the Moon to the Earth', in *Other Space Odysseys*, ed. Giovanna Borasi and Mirko Zardini (Montreal, Québec: Canadian Centre for Architecture; Baden: Lars Müller, 2010), 115.

53. Ibid., 114.

54. Leo Marx, 'Pastoralism in America', in *Ideology and Classic American Literature*, ed. Sacvan Bercovitch and Myra Jehlen (Cambridge: Cambridge University Press, 1986), 43.

55. 'Document-o No. 2', in *Global Tools* (1974), n.p.

56. Ibid.

57. Poli, 'Nearing the Moon', 113.

58. Lang, 'Suicidal Desires', in Lang and Menking, *Superstudio*, 47.

PART 3 SPACES

8 PRIVATE EXHIBITIONS: GALLERIES, ART AND INTERIOR DESIGN, 1920–1960

IMMA FORINO

ENTERING THROUGH A SECONDARY DOOR

This chapter enters the history of Italian interior design through the 'secondary door'[1] of private galleries—a paltry number of designs developed from the early twentieth century until today by Italian architects for whom gallery designs were an important exercise, before bigger and more famous commissions. Although, for the most part, these designs were soon lost, they were nevertheless significant if observed in the cultural context in which they were made. In fact, interiors for art were entrusted to designers by enlightened dealers and from the very beginning were established as terrains of design mediations: progressive dealers commissioned interiors for art that were not merely physical environments for the exhibition and sale of works of art but also spaces in which different areas of design could, and still can, come together.

An 'Italian style' for private galleries was clearly identifiable, in the form of *interiorscapes* in which the visitor was profoundly involved, to the same extent as the dealer and artist. This Italian style can be seen above all in the period between the early twentieth century and the 1970s, and design schemes for the arrangement of the space and the installation of artworks peaked with extraordinary projects during the 1940s (with the private galleries of BBPR [Gian Luigi Banfi, Lodovico Barbiano da Belgiojoso, Enrico Peressutti and Ernesto Nathan Rogers], Carlo Scarpa and Franco Albini) and the 1950s (with Vittoriano Viganò's galleries). During the post-war period the problem of reconstruction and the interpretation of the past became a peculiarity of Italian art museums,[2] but interventions on pre-existing structures were actually already part of gallery design, in a series of sporadic minor interventions, almost always of limited size, designed for private clients who felt the need to create special places for exhibiting and selling contemporary art to an elite public.

From the 1970s onwards, a radical change in the art scene in Italy as well as in the rest of the world—seen in, for example, *arte povera*, large installations, performances and body art—created a need for new types of spaces. There was a turn away from galleries with an almost domestic quality, environments as confined as they were refined, and towards large spaces, frequently former garages or basements, in which architectural intervention seemed less necessary. The gallery therefore became a place for events, in which art as experience imposed itself on the architectural space and its visitors. The

exhibitions at Fabio Sargentini's L'Attico caused a sensation, for example: in 1969 Jannis Kounellis set twelve live horses to graze in the gallery, which was located in a garage in Via Beccaria, Rome. More striking still, in 1976, was the flooding of the very same space with 50,000 litres (13,208 US gallons) of water to symbolise the closure of the space and the beginning of a new phase of research for Sargentini and his artists.

Only in the mid-1990s did Italian galleries adjust to an art market that did not appeal only to investors with vast economic means, as well as adapting, especially, to a change in social and cultural customs, by offering sophisticated spaces to the public, mostly characterised by the international 'white cube' style. The Italian style of gallery design seemed to wane, in the name of a formal conformism that, on the one hand, brought the panorama of Italian spaces in line with international standards and, on the other, seemed to erode its authentic and unique character.

THE ITALIAN STYLE: 1920–1960

For a long time Italy lacked a cultural policy for the promotion of contemporary art by state institutions, such as public art museums and galleries.[3] In this context, private galleries had a fundamental role. They guaranteed plurality, promoted young artists, made contemporary art accessible to a non-specialist audience by means of exhibitions and independent publications and encouraged a different kind of economy. Support for contemporary art, then, was rallied largely thanks to private initiative. It is only in recent years that the public museum in Italy has reconfigured its role, no longer limiting itself to exalting the past by housing its masterpieces alone but putting itself forward as an informative and promotional vehicle for contemporary art.

The Italian style in gallery design is best viewed not as an aristocratic search for 'taste' but rather as a dynamic way to 'externalize and educate in seeing'.[4] This was achieved both through their entirely independent role and through the design of the spaces. Suspended between interior architecture and exhibition design, these spaces refuse easy disciplinary classification and suggest, instead, a separate, although contained, field of investigation. During the twentieth century, gallery design in Italy, along with the related area of exhibition design, 'made art visible to the country of art';[5] that is to say, it drew art out of an idealised realm and reconnected it with reality. Traditional treatments of gallery space and furnishings were challenged, and questions raised about the possibility of a global design, to be realised in the considerably limited dominion of the gallery.

The modern spaces of the art market were inaugurated in the early twentieth century thanks to an interested and enthusiastic audience of collectors. From the very beginning, the gallery adopted a critical stance towards academicism; works were selected by well-informed curators or 'ideological dealers',[6] motivated not only by profit but also by the desire to promote an artistic avant-garde or support an individual artist. The modulation of gallery spaces contributed, then, to a critical vision of contemporary art that was a far cry from the overdressed style in interiors that characterised other art environments of

the time. The ability to create a gallery that became a hotbed of debate was, in fact, a litmus test for designers, whether already well known or on the brink of becoming so.

Initially, the general feel of these galleries was subdued; they communicated an exclusive character with, for example, overhangs at the entrances or windows onto the street, which reinforced the idea of a closed, and sophisticated, cultural circle. The idea of a club for a select few was further substantiated by the provision of art libraries, in line with a model in vogue in France at the time, and rooms for reading, meetings and conferences. Almost all of the galleries published a *bollettino*, a kind of newsletter and a synthetic text that expressed the organisational criteria of the gallery along with specific notes on the various exhibitions.

THE 'DOMESTIC' GALLERIES

The first Italian galleries of the early twentieth century stood out as places in which to cultivate art and literature, rather than as mere exhibition rooms or places for the sale of art. Open to a select public, they were 'atmospheric' places, more suited to causing a stir than spreading knowledge of contemporary art.

In 1917 the Galleria Pesaro opened in Milan. It was skilfully run by Lino Pesaro, who began by organising auctions of private collections.[7] He very soon became an important figure on the artistic scene: he arranged solo and group exhibitions that followed 'new, sound and strict criteria, so that the artist . . . can truly communicate with the public [and] freely convey his art'.[8] Between 1923 and 1929 the Galleria Pesaro promoted the *novecento italiano* artistic movement with various exhibitions, supported by the critic Margherita Sarfatti.[9] Moreover, thanks to the success of sales to private buyers and public institutions, the gallery demonstrated to the international public the central role of the city of Milan in Italian artistic life—a role that, in those years, was supported by 'union exhibitions' and large institutional exhibitions such as the Biennale di Monza, and then the Triennale di Milano, which functioned in part as an answer to the Biennale di Venezia and the Quadriennale di Roma. The critic Pietro Maria Bardi collaborated with Pesaro for a brief period (in November 1926),[10] but the fame of the Galleria Pesaro was so consolidated that it was still renowned twenty years after it opened. Subsequently, Pesaro adopted a more commercial exhibition programme and targeted the middle class, offering mostly nineteenth-century paintings or the work of established contemporary artists.[11]

The Galleria Pesaro was situated next to the current Museo Poldi Pezzoli, in Via Manzoni, and occupied the entire left side of the ground floor. The space (probably designed by Pesaro himself) included three rooms in the neoclassical style with vaulted ceilings, where the granite columns created the impression of minor rooms, used as offices, service areas and libraries. Wide velvet curtains divided the spaces, while the furnishings were by various well-known stile liberty (Italian art nouveau) artists and craftspeople, including wrought-iron work by Alessandro Mazzucotelli and walnut display cases by the cabinet-maker Eugenio Quarti.[12]

Galleria Pesaro's equal in terms of exhibitions dedicated to nineteenth-century art was the Bottega di Poesia, which was opened in 1920 at Via Montenapoleone 14 (Palazzo Taverna, then Radice Fossati) by gallery owners Luigi Adone Scopinich, Emanuele di Castelbarco, Alessandro Piantanida and Walter Toscanini.[13] Alongside its exhibitions— mainly organised by Castelbarco and focusing on artists such as Giovanni Segantini, Gaetano Previati and Giuseppe Pellizza da Volpedo—the Bottega di Poesia engaged in intense publishing activity through the publishing house of the same name, run by To- scanini (son of the conductor Arturo). Exhibition catalogues and monographs on the artists shown alternated with literary or popular works, such as the pamphlet *Per l'Italia degli Italiani* (1923) by Gabriele D'Annunzio. At the gallery visitors could consult books, reviews and sheet music. Finally, there was a regular trade in carpets, prints and ceramics, with auctions held periodically.

Although it was not much frequented by the upper class, the Bottega di Poesia was a meeting place for the Milanese bohemia of the time; intellectual exchanges took place there between artists, writers and musicians who were attracted by the multidisciplinary character of the gallery's programmes, which included painting, music, theatre and lit- erature. The gallery owners entrusted the design to architect Giuseppe De Finetti, who in 1923 created a simple and straightforward structure for the gallery, by means of a

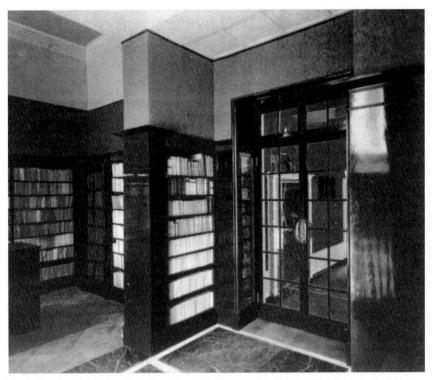

Fig. 8.1 Giuseppe De Finetti, Bottega di Poesia gallery, Milan, 1923: library room. From P. Mezzanotte, 'Quattro interni milanesi', *Architettura e Arti Decorative* 2, no. 8 (1923).

composition divided into individual rooms, preceded by a ground-floor entrance hall. The exhibition and reading rooms were based on the architectural depth of the geometrically clean furnishings (bookcases and containers), which championed an *ante litteram* rationalism for a place that, also by virtue of its spatial configuration, aimed to revolutionise the taste of the collectors of the time. The exhibition room had an elongated exedra shape and was illuminated from above by a large pendant lamp. The library-cum-bookshop was characterised by precious geometrically patterned marble floors and strong wooden bookcases (Figure 8.1). Finally, the room for consulting sheet music, reviews and magazines was furnished in the style of a bourgeois living room: with this room, De Finetti achieved a calm, almost domestic idea of intimacy, a space to be shared by friends rather than collectors and dealers.

EARLY RATIONALISM'S 'FACE OF THE CENTURY'

During the 1930s the role of the art gallery seemed quite opposed to the Fascist celebration and propaganda of the large official exhibitions (see Vanessa Rocco's chapter in this book).[14] Especially in the early part of the decade, rationalist ardour nourished the exhibition design as much as the furnishings of private art galleries.

The versatile intellectual Pietro Maria Bardi cultivated a correspondence between the artists and critics of the time at the Galleria Bardi (1928), which was first located at Via Brera 16 and then moved to number 21, opposite the Accademia di Belle Arti. Its five large and elegant rooms were illuminated with natural light from the windows: versatile curtains, easels and movable partitions facilitated the exhibition design (which was probably undertaken by the critic himself). Exhibitions, wrote Bardi, 'concern ancient art as much as modern art, without any fetishisms for one or the other, but great affection for both'.[15]

Galleria Bardi's collaboration with Edoardo Persico—editor of the magazine *La Casa Bella* (later renamed *Casabella*)—seemed increasingly to lead the cultural programme of the gallery towards a critical activism, perceived by Persico as a battle for cultural and social coherence in defence of the contemporary. 'There is . . . a hard and difficult task that in every age is borne by a small minority of bright and coherent men: the defence of certain principles of honesty and decency', he wrote.[16] The exhibition of the Sei di Torino group,[17] organised by the critic in November 1929, was in fact quite the opposite—atmospheric, antiplastic, anticlassical—of the novecento group. Persico's cultural programme then continued with other exhibitions devoted to avant-garde art and the publication of the *Bollettino d'Arte* (for which he undertook the graphic design), launched in Bardi's journalistic and synthetic style in 1928.[18]

Galleria Bardi's innovative intention was therefore to open itself up to a vast and eclectic public of art lovers, architects, collectors, artists, scholars, decorators and anyone who was merely curious, in line with a decidedly educational approach to contemporary art. At the same time Bardi confirmed the idea of the gallery as a commercial enterprise, not necessarily favouring one artistic movement over another but rather oscillating between provocative and other more conservative selections.

Upon Bardi's departure for Rome,[19] the gallery was sold under the name Il Milione (1930) to new gallery owners, the brothers Gino (Virginio), Peppino (Giuseppe) and Livio Ghiringhelli together with Daniele Roma. Persico was still entrusted with its management, and he wrote of the gallery, 'I'm furnishing it so as to make it the most beautiful gallery in Milan'.[20] While the Neapolitan critic might have given some instructions, in reality its design was executed by Pietro Lingeri, who between the spring and summer of 1930 created one of the first Italian rationalist environments. Il Milione was a clear example of the revolution in Italian taste that was expressed through interior design during the 1930s.

Lingeri highlighted the gallery's dual function as exhibition room and bookshop with a small entrance hall, characterised by two 'luminous' pillars made of opal glass with details in nickel-plated brass, where the different rooms converged. The wooden bookshelves were arranged in parallel rows so as to retain as much space as possible for the books without occupying further walls (Figure 8.2). To the art critic Carlo Belli—author of the famous book *Kn* (1935) on Italian abstractionism—the importance of Il Milione lay primarily in the fact that the gallery

> became the regular meeting place for the most famous Italian and European artists, a haunt for painters, writers, sculptors, musicians, architects and poets, who [were] all committed to *creating the face of the century* in their own sector, that is to say creating a unique aspect that was strictly relevant to the time in which they lived and worked and in perfect harmony with the various classes of art.[21]

On November 5, 1930, Il Milione opened with an exhibition dedicated to Ottone Rosai. The cultural programme continued with original shows on the principal artistic movements of the twentieth century, such as cubism, expressionism, metaphysics and abstractionism. Furthermore, it held conferences on architecture, rationalism and literature; concerts; and debates on philosophy and the relationships between psychoanalysis and art. Finally, it hosted many emerging European artists, which made Il Milione a centre for cultural debate on art.[22] Persico also organised drawing exhibitions—a practice that was not widespread at the time—probably as a way of highlighting the bookshop area, which offered books, newspapers and art reviews from all over Europe. The Ghiringhelli brothers, on the other hand, were focused on their role as dealers: in fact, the programme was initially designed to create another market for contemporary art, as an alternative to the market that had developed around the painters of the novecento, who were frequently exhibited at the rival Galleria Barbaroux run by Vittorio E. Barbaroux.

Next, Il Milione held exhibitions dedicated to graphic design, poster art and furnishings. In *Il mostra autunnale dell'ambiente moderno* (1932), the architects Luigi Figini and Gino Pollini presented the complete furnishings for an apartment. Their exhibition design embodied an opposition to a backward-looking culture in the field of architecture as much as that of furnishings. For Persico the exhibition was the perfect occasion to clarify his ideas on furnishing not as mere 'decorative art' but rather as architecture.[23]

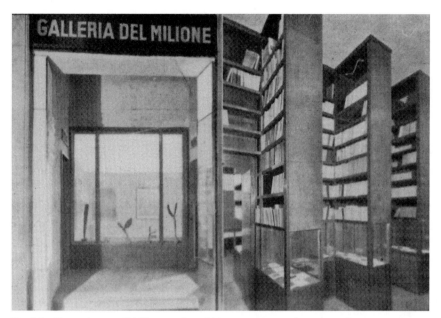

Fig. 8.2 Pietro Lingeri, Il Milione gallery, Milan: entrance and interior photomontage in a gallery advertisement (detail). Appendix to *L'Orto* 6 (1936).

The search for a 'modern taste' in architecture took place in private galleries: it was here that architects, fascinated by European rationalism, displayed furnishings that adopted new materials (for example, linoleum and chrome steel tubes), while critics spread a new idea of aesthetics to the public.

THE SPATIAL PLAY OF FORMS

The relationship between gallery owners and architects continued throughout the Second World War. Although the Allied bombings forced many galleries to close or move their artworks elsewhere—Il Milione, for example, was irreparably destroyed—others commissioned architects to design their interiors. In this new work, the pre-war rationalism was joined by freer, less stereometric forms and a careful eye for detail.

In 1942, BBPR designed the Galleria della Spiga e Corrente (Via Spiga, Milan), owned by Alberto Della Ragione.[24] Their contribution was an informal intervention in which rationalism was overtaken in terms of the design of the space as well as the furnishings. The walls were almost entirely covered in waxed wood and formed small clustered rooms, illuminated by directional brass lamps. The furnishings, on the other hand, were made of chestnut and provided dynamic, asymmetrical solutions, with a clear preference for diagonals and sectional alterations of the thickness of the elements, in keeping with a style the architects had also used when furnishing the offices of Società Belsana (Milan, 1944). The furnishings of the Galleria della Spiga e Corrente seemed to respond to the

streamlining aesthetic, especially when used as displays for books and catalogues from the gallery's publishing activity under the Edizioni della Spiga imprint.

Carlo Cardazzo also opened the Galleria del Cavallino (1942) in Venice during the Second World War, on the Riva degli Schiavoni, not far from the Biennale gardens, which almost seemed to compete with the quality of the exhibits.[25] A collector, art publisher and then dealer, Cardazzo gathered a large group of artists, writers, art lovers and collectors around him: his gallery was a lively and cultured environment. Lucio Fontana, Mario De Luigi, Massimo Campigli, Carlo Carrà, Paolo Massurig and Giuseppe Cesetti exhibited there: the gallery owner promoted Italian artists especially, including the spatialist movement, and young Venetian painters.[26]

The gallery design was by Carlo Scarpa, who altered the ground floor of an existing building with a dense organisation of interiors, modulated differently by natural light from skylights and artificial lighting. The art was revealed slowly and to the visitors' surprise: the first exhibition room was anticipated by a small entrance hall with a glass door, behind which was *Cavallino* by Marino Marini (1939) and an easel displaying the poster of the current exhibition, and a dark corridor with shallow display stands for publications and prints. Connected to the quadrangular exhibition room was Cardazzo's studio, while a short funnel-shaped passage led to the larger long exhibition room, at the end of which was a small storage room, hidden by a dark panel. The larger room was virtually divided into three parts by solid pillars protruding from the walls and was lined with panels covered in grey cloth, separate from the floor and ceiling (Figure 8.3). The floor was herringbone-pattern wood, while the other rooms were dominated by terracotta tiles. Scarpa's gallery was informed by a museographic[27] approach to space: 'as much for the use of zenithal and artificial lighting from above, . . . as for the creation of a series of visual and emotional events in a sequence'.[28]

After five years the Galleria del Cavallino was demolished to make way for the expansion of the Hotel Danieli. Cardazzo reopened it in 1949, still in Venice, but on Frezzeria.[29] The design was once more entrusted to Scarpa: a single exhibition room, closed at the entrance by a double window, and two small adjoining spaces for the gallery manager's office as well as a storage room. The architect redesigned the perimeter of the room, affixing a new 'cover' to the walls, painted black like the ceiling, to cancel out the pre-existing space. The cover comprised exhibition panels 2.7 metres (about 5 feet) high, supported by metal props. It was bent at an acute angle, in order to demarcate the entrance (highlighted by a wooden sculpture by Scarpa), project the visitor into the centre of the room and completely deny the previous perimeter of the room. On the ceiling a system of light-coloured wooden planks, juxtaposed at different angles, contributed to the regeneration of the new space. It was a more closed layout, but dynamic when compared to the museum structure of the previous space.

In 1952 the Galleria dell'Annunciata in Milan was partially transformed by Bruno Grossetti into an innovative 'bar-cum-art gallery'. Franco Albini's design corrected the height of the room using a raised balcony that could be accessed from a ladder positioned

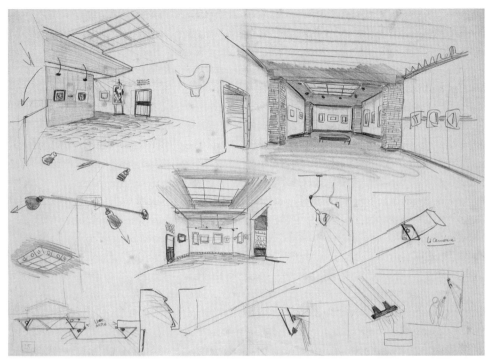

Fig. 8.3 Carlo Scarpa, Galleria del Cavallino, Venice, 1942: interior sketches. Archivio Carlo Scarpa, Fondazione Maxxi—Museo delle Arti del XXI secolo, Rome. Courtesy of architect Tobia Scarpa.

at the entrance to the bar. The room behind the bar was dedicated to exhibitions and had an independent entrance onto the street, despite remaining connected to the bar. The new elevated room was named the 'helicopter room' by Bruno Munari due to its structure; it seemed to be detached from the walls, giving it the appearance of a platform suspended in space. Munari deemed it 'an original, almost futuristic solution, perfect for hosting certain types of events'.[30] It was here that the artist-designer held his *Mostra degli oggetti trovati* (1951), an exhibition of parts of machines and objects deformed by time or nature. The exhibition offered a new way of seeing art in a variety of possible manifestations. In the subsequent exhibition *L'arte e il caso* (1952) Munari displayed objects produced by chance, by accident or by neglect, such as scraps covered in rust and mould.

The Bar dell'Elicottero became the principal exhibition space for exhibitions of the Movimento Arte Concreta (MAC), an artistic movement of which Munari was an exponent,[31] but the bar gallery also experienced difficulties resulting from the mixture of spaces with very different purposes, to the extent that the dealer was forced to change locations.

SPAZIEGGIARE (SPATIALISATION)

During the 1950s Vittoriano Viganò designed interesting private interiors for art: the Galleria del Fiore (1953), the Galleria Apollinaire (1955) and the Galleria del Grattacielo

(1958) concentrated a significant architectural experience in the Milanese neighbour-hood of Brera.[32] At Via Fiori Chiari 2, Luciano Cassetto's Galleria del Fiore, painted in tones of black and white, simple and linear, was dedicated by the architect to his abstract artist friends. Cassetto, who had in the past been devoted to nineteenth-century art, opened his gallery to painters such as Alberto Magnelli, Enrico Prampolini, Mario Radice and Mauro Reggiani.[33] Enclosed in a cramped and introverted long space, the gallery had easels, tables, uprights and supports made of black-lacquered iron. Subtle fluorescent lamps were hung from steel cables, while the display cases were lit by horizontal or screened lamps that could move from top to bottom along two vertical rails: 'Not much anyway, but hopefully everything I need', wrote Viganò on the matter.[34]

Similar in layout, but on a smaller scale, was Guido Le Noci's Galleria Apollinaire (at Via Brera 4), developed along the theme of 'spatialisation'. Here, the design not only references coeval works by Fontana—in which the artist gained space by overcoming the two-dimensional nature of the picture plane—but also echoes Bruno Zevi on the reasons for architecture, in the focus on the internal space.[35] This theoretical position was emphasised by the art critic Giulio Carlo Argan when he wrote, 'The process of architectural construction is no more than the process of placing or determining the space, of "spazieggiare"'.[36]

Viganò applied these concepts to the exhibition of art; it is a matter of 'a plastic game to spatialize painting too, all in terms of arte povera', he wrote.[37] The gallery occupied a single square room, with a glass door and windows onto the street. The design was simple and austere; the walls were left in bare plaster, a colourless surface that acted as a backdrop to the works, enhancing materials and colours, especially if frames were not used. The paintings were hung on suspended aluminium uprights and detached from the ceiling (painted white) and the floor (wooden). The lighting was unconcealed and positioned a short distance from the ceiling. A small door, also detached from the floor, led to a small storage room and bathroom. Le Noci was a very active dealer on the Milanese scene and opened his gallery to artists of international importance, breaking up arte informale with nouveau réalisme.

Not persuasion but stimulation without redundancies was the design theme developed by Viganò in Giuseppe Gadda's Galleria del Grattacielo. The gallery's exhibition programme, directed by Enzo Pagano, followed two artistic veins—figurative experiences and abstractionist currents—presented in distinct exhibitions, which the architect chose to present with sophisticated simplicity. The exploitation of the existing octagonal space with a vaulted roof constituted the hinge around which the entire composition revolved. The design comprised few elements, but those that were used were loaded with symbolic meaning. The homogeneous treatment of the surfaces contrasted with the co-lour of the works. The environments had walls and ceilings covered in a special plaster, sprayed asbestos cement (a warm grey colour), with sound-proofing properties. The floor of the octagonal room was made of hexagonal *gres* tiles in brown, and the doors and fur-nishings were of walnut. The paintings were supported by perforated uprights in wood, suspended by metal supports fixed into the wall.

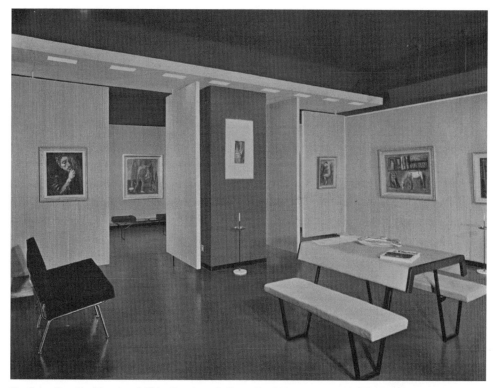

Fig. 8.4 Camillo Magni and Aldo Cerchiai, Galleria Blu, Milan: interior (second exhibition room). Aldo Cerchiai, 'Una nuova galleria d'arte moderna a Milano', *Edilizia Moderna* 62 (1957): 79–82. Courtesy of Archivio Salvati.

In contrast, the design for Peppino Palazzoli's Galleria Blu (Via Andegari, Milan, 1957), by Camillo Magni in collaboration with the painter Aldo Cerchiai, considered the depth that colour might give to interiors. This approach was in line with the dealer's choices; he favoured spatialist artists such as Fontana, Hans Arp, Alexander Calder and especially Alberto Burri, whose work explored depth of colour and material in those years. This gallery was created from a converted apartment on the first floor of a nineteenth-century building; the large exhibition room was divided into two parts using movable partitions that revolved around a central pillar (Figure 8.4). The space ended with a wall that was made more dynamic by three angular overhangs, which increased the exhibition space. Three tones of blue (light blue and turquoise for the ceiling, dark ultramarine for the walls and floor) entirely flooded the environment, except for the partitions, which were covered in matting on which the paintings were hung.

CONCLUSION: INTERPRETING THE SPACE

This chapter has examined trends in the design of Italian galleries from 1920 to 1960. However, in closing, it is important to recognise that after 1960 a few Italian galleries

countered these trends. During the 1960s and 1970s, some dealers drew on the usual do-it-yourself method for spaces that now welcomed more performances and installations than pictorial or sculptural pieces. A mature Franco Albini (with Franca Helg) provided a design for the Galleria Sistina (Milan, 1963) in which exhibitions were presented through the manipulations of scenery and brief metal backgrounds, in a departure from the approach of the 1930s. Alberto Salvati and Ambrogio Tresoldi also experimented intensely with the spatial theme, albeit with volumetrically graphic intentions. In the Galleria Vismara (Milan, 1971) the existing gallery was restored with a strong geometric false ceiling, positioned in the connecting spaces between the different rooms, which visibly increased the extremely white space (Figure 8.5). As we have seen, at its best, the Italian style in gallery design can be interpreted as a process of research into a plausible relationship between interior architecture and the art on display. Intervention in the existing space, sometimes cramped and with little architectural significance, in fact revealed itself

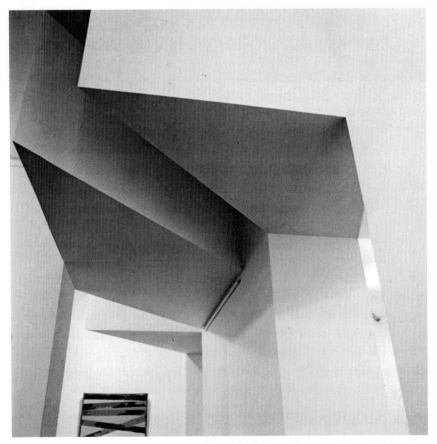

Fig. 8.5 Alberto Salvati and Ambrogio Tresoldi, Galleria Vismara, Milan, 1974: ceiling (detail). Courtesy of Studio Salvati.

to Italian designers of galleries as a profitable occasion for a difficult comparison—not according to atmospheres of the 'sanctification of art'[38] but rather through generating spaces with a human dimension in which a dialogue with the work is possible.

NOTES

1. Paolo Fossati, *Il design in Italia, 1945–1972* (Turin: Einaudi, 1972), 12, analyses Italian design through the 'secondary phenomenon' of exhibitions.
2. These were poised somewhere between 'interpretative restoration' and creative exhibition design. See, for instance, the famous projects by BBPR, including the Castello Sforzesco (Milan); Carlo Scarpa's restorations of the Palazzo Abatellis (Palermo) and Castelvecchio (Verona); and Franco Albini's Museo Rosso and Museo Bianco (Genoa).
3. During the Fascist period Giuseppe Bottai's Ministry of Education was the exception; it supported private galleries as a method of public education.
4. Manlio Brusatin, *Arte come design: Storia di due storie* (Turin: Einaudi, 2007), 139.
5. Ibid., 170.
6. On the 'ideological dealers' see Nachoem M. Wijnberg and Gerda Gemser, 'Adding Value to Innovation: Impressionism and the Transformation of the Selection System in Visual Arts', *Organization Science* 11, no. 3 (2000): 326.
7. Sileno Salvagnini, *Il sistema delle arti in Italia, 1919–1943* (Bologna: Minerva, 2000), 173.
8. *La Galleria Pesaro in Milano* (Milan: Galleria Pesaro, 1917), 22.
9. The novecento artistic movement developed in Italy during the 1920s. It fought for a 'return to order' (Italian primitive and Renaissance figurative traditions) instead of the poetic, futuristic dynamic. The artists exhibited in the 1923 exhibition were Mario Sironi, Ubaldo Oppi, Anselmo Bucci, Leonardo Dudreville, Emilio Malerba, Pietro Marussig and Achille Funi. The movement was officially recognised in the 1926 exhibition, organised by Sarfatti at the Permanente in Milan and opened by Benito Mussolini. Mussolini had visited an earlier novecento exhibition at the Galleria Pesaro in 1923. Subsequently, Il Duce lost interest in the artistic movement.
10. From 1926 to 1927, Bardi managed the Galleria Micheli, in Via Brera 7.
11. In 1938 Lino Pesaro killed himself, after having unwittingly sold a fake painting. In the same year another gallery owner, Ettore Gian Ferrari, arranged a charity auction sale for the Pesaro family. Subsequently, the gallery was led by Pesaro's family.
12. Ercole Arturo Marescotti, 'Arte-Lana fecit', *Emporium* 47, no. 277 (1918): 205–206.
13. Initially the founders of the Bottega di Poesia concentrated on publishing and the sale of prints. Swamped by debt, the gallery closed in 1928.
14. Vittorio Fagone, 'Arte, politica e propaganda in Italia negli anni Trenta', in *Gli anni Trenta: Arte e cultura in Italia*, ed. Nadine Bortolotti (Milan: Mazzotta, 1982), 43.
15. Pietro Maria Bardi, 'Presentazione', *Bollettino d'Arte* 1 (1928): 9.
16. Edoardo Persico, 'Bardi in via Brera', *Belvedere: Giornale d'Arte* 2 (1930): 14.

17. In 1928 Persico joined some of the painters gravitating around Felice Casorati under the name I Sei di Torino, including Enrico Paulucci, Carlo Levi, Francesco Mencio, Gigi Chessa and Jessie Boswell. The group dissolved in 1931.

18. From 1929 to 1932, Bardi dedicated himself especially to the review *Belvedere: Giornale d'Arte*.

19. Under the auspices of the Sindacato Fascista Belle Arti, Bardi opened the Galleria di Roma in Rome, at Via Vittorio Veneto 7; the gallery hosted exhibitions of art, aeronautics, stage design and architecture.

20. Edoardo Persico, *Oltre l'architettura: Scritti scelti e lettere*, ed. Riccardo Mariani (Milan: Feltrinelli, 1977), 316. From 1932 onwards Persico was replaced by Carlo Belli.

21. Carlo Belli, *Il volto del secolo: La prima cellula dell'architettura razionalista italiana* (Bergamo: Lubrina, 1988), 95.

22. Subsequently, and briefly, Il Milione merged with Romeo Toninelli's Galleria del Camino; they separated due to artistic and organisational differences.

23. Persico, 'Una mostra a Milano', *La Casa Bella* 57 (September 1932): 25.

24. The gallery was born from the previous Bottega di Corrente, at Via della Spiga 9. Alberto Della Ragione entrusted the running of the gallery to Raffaele De Grada.

25. Cardazzo opened his first gallery in Turin in 1926. In the post-war period, he opened the Galleria del Naviglio in Milan (1955), where Jackson Pollock exhibited in Milan for the first time, and the Galleria Selecta in Rome (1955).

26. The artistic movement of spatialism was founded by Fontana in 1947 and was followed by artists such as Roberto Crippa, Tancredi Parmeggiani, Enrico Baj, Giuseppe Caporossi, Emilio Scanavino, Mario De Luigi and Giorgio Morandi, among others.

27. In Italy a distinction is made between museographic practice (the design of spaces and exhibitions by architects) and a museological approach (adopted by scholars or critics of art).

28. Orietta Lanzarini, 'Carlo Cardazzo committente di Carlo Scarpa: La Galleria del Cavallino (1942, 1949) e il Padiglione del Libro d'Arte (1950)', in *Carlo Cardazzo: Una nuova visione dell'arte*, ed. Luca M. Barbero (Milan: Electa, 2008), 97. See also Nanni Baltzer, 'Fabbriche di idee fra Naviglio e Laguna: La galleria del Milione e la Galleria del Cavallino', in *Studi su Carlo Scarpa 2000–2002*, ed. Kurt W. Forster and Paola Marini (Venice: Marsilio, 2004), 197–228.

29. The second Galleria del Cavallino was also demolished.

30. Bruno Grossetti, *Il mercante dell'Annunciata: Confessioni e memorie* (Milan: Mazzotta, 1988), 61.

31. The MAC was founded in Milan in 1948 by the artists Atanasio Soldati, Gillo Dorfles and Bruno Munari, who were subsequently joined by Gianni Bestini, Ferdinando Chevrier, Salvatore Garau, Mario Nigro, Galliano Mazzon and Luigi Veronesi.

32. Viganò was also responsible for other interesting galleries in Milan, such as the Galleria Schettini (1955, a temporary solution), directed by Guido Le Noci, and the Galleria Levi (1961–1969) by Beniamino Levi.

33. The gallery closed in 1957 after Cassetto's death.

34. Vittoriano Viganò, 'Una galleria in bianco e nero', *Edilizia Moderna* 54 (1955): 73.

35. Bruno Zevi, *Saper vedere l'architettura* (Turin: Einaudi, [1948] 1951), 22.

36. Giulio Carlo Argan, 'A proposito di spazio interno', *Metron* 28 (1945): 21.

37. Vittoriano Viganò, 'Allestimento di una mostra, allestimento di una galleria', *Domus* 315 (February 1956): 35.

38. Brian O'Doherty, *Inside the White Cube: The Ideology of the Gallery Space* (Berkeley: University of California Press, 1976).

9 EXHIBITING EXHIBITIONS: DESIGNING AND DISPLAYING FASCISM

VANESSA ROCCO

Exhibitions exerted a pervasive power in the politically aestheticised environment of Fascist Italy. Benito Mussolini considered himself an artist, a poet and a storyteller, and he aimed to control the regime's narrative to the masses through the use of spectacle. As an apparent marriage of art and spectacle, exhibitions were ideal vehicles. These included not just exhibitions of so-called fine art but also those regarding every visual aspect of daily life. This chapter examines the role of various forms of Fascist design from the late 1920s through to the 1930s, and the ways they, in turn, were exhibited in displays that 'narrated' the regime's priorities. Examples include Mario Sironi's installations of books and the press (the Italian Pavilion at the International Press Exhibition, Cologne, 1928, and the Italian Press and Book Exhibition at the Exposición Internacional de Barcelona, 1929); the audacious use of experimental architecture combined with photography in Giuseppe Terragni's Sala O of the Mostra della Rivoluzione Fascista in Rome in 1932 (subsequently referred to as the Mostra); and the new prominence given to decorative art displays in the Biennali di Venezia from 1932 to 1936. The final section includes an examination of Italy's presence—in particular, Giuseppe Pagano's pavilion design for Sironi's mural *Fascist Labour*—at the Exposition Internationale des Arts et Techniques in Paris (1937), a massive world's fair that provides, in retrospect, a fascinating snapshot of the tumultuous state of 1930s European politics. Taken together, these exhibitions demonstrate how Fascist design throughout the years of Mussolini's leadership permeated all aspects of life, rendering everyday life the site of sanctioned spectacle in order to distract the public from the realities of mass disenfranchisement.

DISPLAY AND 'ARRESTED' FLOW

Cultural critic Peter Wollen has parsed the distinction between 'spectacle' and 'display' in his proposal that visual display is 'the other side of spectacle'.[1] He justifies this difference by referring to display as equivalent to the producer, the agent or the designer as opposed to the consumer, the patient or the viewer. Although he agrees with the situationist Guy Debord in principle that 'an excess of display has the effect of concealing the truth of the society that produces it', he goes on:

> Display, however, *when its flow is arrested*, can still have a revelatory power, provided it is seen, not in terms of the image, but in terms of the symptom. In fact, it is *only*

through display that truth is revealed—not, of course, directly, but obliquely. . . . It is through modes of display that regimes of all sorts reveal the truths they mean to conceal. . . . The main effect of the interminable transience of modern spectacle, as Debord noted, is to efface history and historical understanding. Each historic period has its own rhetorical mode of display, because each has different truths to conceal.[2]

In the course of this chapter, I attempt to arrest the flow of Fascist displays, unveil their rhetorical modes and see what truths can be found embedded within the dialectic space between objects and the ways they are displayed. This exercise should, in effect, unmask Fascist spectacle. I analyse, for each display, what was exhibited and how it was exhibited. Going beyond Wollen's formulation, however, I focus attention on the viewer and consumer in the form of attendance figures and critical reception. The differentiation between national and international exhibitions helps to overcome what would otherwise be an utter vacuum vis-à-vis unbiased uncritical reception. As one travels through these shows, it is helpful to think of exhibitions themselves as a medium—the objects on display are there as a result of being exhibited and therefore 'mediated' (see part five of this volume for more studies of mediation).[3]

'EACH EXHIBITION REALIZED IS A REVOLUTION': INTERNATIONAL PAVILIONS IN COLOGNE AND BARCELONA

The Italian Fascist regime—which had, since its rise to power in 1922, been infatuated with the interrelated tools of persuasion, their version of history and spectacle—began to think of itself, and therefore to present itself, in an obsessively historicised manner beginning in the late 1920s. This was partly due to the ten-year anniversary of the founding of the *combattimento di fasci* in 1919.[4] Hence the late 1920s ushered in a more aggressive participation in international exhibitions, including the International Press Exhibition in Cologne (1928) and the Italian Press and Book Exhibition at the Exposición Internacional de Barcelona (1929).

'Each exhibition realized is a revolution'[5] was one of the mottos of the Fascist and futurist artist Mario Sironi, who collaborated with Giovanni Muzio on the Italian pavilions of both shows and who understood that Mussolini's *style* of politics and the production of large exhibitions were 'inseparable'.[6] If the purpose of spectacle is to distract from the truths that regimes wish to conceal, then Mussolini's regime was born with a narrative of spectacle intended to distract. Although he came to power through a backdoor negotiation with King Emanuele III, the tale of his rise was reconfigured as one of violent insurrection through the so-called March on Rome in October 1922—which was, in fact, a celebratory parade before Mussolini and the king. Such a spectacle was needed to distract from the more bureaucratic and less virile political machinations that transpired. Likewise, exhibitions with mass appeal were increasingly designed to distract from the totalitarian political realities of exclusion. Sironi's ability to choreograph these distractions certainly increased over time. Both the Cologne and Barcelona exhibitions were fairly dry presentations and purported to be histories of the publishing press in Italy, dating back to the Renaissance, but with an emphasis on recent production.

In Cologne the centrally placed Adolf Wildt bust of Mussolini (Figure 9.1, right) gives a sense of how the objects in Fascist exhibitions revolved around the cult of Il Duce, sometimes directly through busts or profiles, sometimes indirectly, or even metaphorically, in the form of maps or the iconography of ancient Roman architecture. The Italian Pavilion was in the International Hall, along with several other pavilions. The glass box entrance was designed in the international style, but the Sironi- and Muzio-designed rooms inside were more eclectic, combining contemporary Fascist kitsch with stained-glass windows and heavy display vitrines. These primarily contained copies of the Fascist newspaper *Il Popolo d'Italia*, for which Sironi designed many issues. The most sophisticated moment of this otherwise directionless interior emerged in the form of a vertical frieze separating two of the other ephemera-filled rooms (Figure 9.1, left). Il Duce still anchored the centre, but at least here there was a stylistic harbinger, particularly in the unfurling of images in a vertical, celluloid-like sequence, of some of the revolutionary design techniques that would make El Lissitzky's massive, horizontal, photojournalistic frieze in the Soviet Pavilion of the Cologne exhibition such a sensation. Indeed, international critical reception has shown that most of the other pavilions were considered staid and boring in comparison to Lissitzky's: 'Amongst all the Pavilions of the various nations, the Russian one has the most visitors. . . . Compared with it, the other Pavilions seem colourless.'[7] The excitement

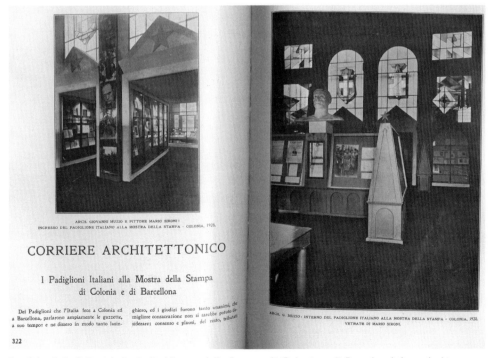

Fig. 9.1 'I Padiglioni Italiani alla Mostra della Stampa di Colonia e di Barcelona', from *Architettura e Arti Decorative*, (March 1930): 322–323.

generated by Lissitzky's design was linked to the cinematic (the jump cut, the montaged sequence), which dovetailed with ruptured modern viewing. These techniques were still in the embryonic stage in Italy at this time but were later seen in full force at the Mostra.

The Barcelona fair, in fact, functioned as a visual segue between Cologne and the later Mostra. Present were some of the myriad fusions between two-dimensionality and three-dimensional sculpture that would become hallmarks of the Mostra. The bust and the maps continued to posit Mussolini as the *conquistatore* (Figure 9.2), yet in the *Il Popolo d'Italia* glass case (not visible in Fig. 9.2) there was also a more interesting moment of display than seen at Cologne. Here the viewer confronted newspaper spreads, juxtaposed with printing drums and a raft of newspapers lying in front, all crowned by large-scale typeface. These examples, or motifs, of how the objects on display actually functioned in the material world would seem to be didactic in an engaging way, but this was, unfortunately, offset by representing a newspaper that so clearly editorialised from a single point of view.

Sironi was credited within his milieu as the most capable designer for dynamising endless pages of newsprint. As Emily Braun has explored, Fascist critic Pietro Maria Bardi and others considered Sironi's illustrations to embody 'the very mood of insurrection'.[8] The more visually arresting combination that Sironi developed here, of the object itself plus the display mechanism, would continue to be modernised at the Mostra. He

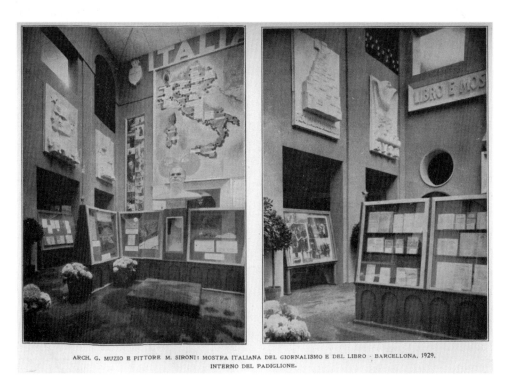

ARCH. G. MUZIO E PITTORE M. SIRONI: MOSTRA ITALIANA DEL GIORNALISMO E DEL LIBRO - BARCELLONA, 1929.
INTERNO DEL PADIGLIONE.

Fig. 9.2 'I Padiglioni Italiani alla Mostra della Stampa di Colonia e di Barcelona', from *Architettura e Arti Decorative* (March 1930): 327.

was beginning to understand that Fascist display modes needed to look more contemporary, to achieve the veneer of progressiveness. Focusing too heavily on past glories would reveal one of the truths to be concealed: that the regime was, in fact, rigidly regressive.

'EXHIBITION TECHNOLOGY HAS ASSUMED A NEW CHARACTER . . . THE DESIRE NOT TO TIRE ONESELF IN ORDER TO KNOW AND TO UNDERSTAND': THE MOSTRA IN ROME

Mussolini's desire to solidify his more glorious notion of violent revolutionary ascension in the minds of the masses propelled the 1932 Mostra event forward.[9] In this exhibition, the regime's mastery of aestheticised politics would reach its apotheosis. The mass media of photography, illustrated magazines and poster sloganeering were married to grandiose architectural forms, intended to simultaneously overwhelm the visitors and falsely convince them of their part—that they actually played a role—in a larger, sanctified narrative, the central ruse of Italian Fascism. The Mostra attracted nearly four million visitors during its two-year run, approximately 10 per cent of the entire Italian population. Visitors were drawn from various classes, epitomising the perversion of what Benjamin Buchloh has defined as the fleetingly progressive leftist concept of 'simultaneous collective reception'.[10]

Sala O (or 'room O') (Figure 9.3) was the climactic moment of the visitors' trip through a series of peripheral rooms organised around a central plan. It was designed by Giuseppe Terragni, a 28-year-old proponent of the rationalist movement in Italian architecture, which merged the use of materials preferred by practitioners of the international style (glass, steel, reinforced concrete) with fierce nationalist aims.[11] Sala O was devoted to the key year of Mussolini's consolidation of power, 1922, but its historical programme ended before the actual March on Rome—that was addressed in Sala P, one of the Sironi-designed spaces. Sala O was an integration of architecture and photography of rich and dense complexity, as Terragni set out to stimulate the viewer's senses from all angles. This included the core organisational element of the ceiling, which contained a room-long, criss-crossed X (roman for 'ten' and a prevalent icon throughout the show), covered in the flags of the socialist and anarchist parties antagonistic to Fascism, which were nailed into place with daggers, symbolising—with a characteristic lack of subtlety—the defeat of those last opponents to Fascism.

Following the trajectory of one side of this X, a wall unfolded with an enormous tripartite profile of Il Duce, outlined in metal. Diagonally slashing slogans abutted the profile, including one touting the 'Organization of the Forces of the Young'. The profile points towards a photo enlargement, again plastered on the wall on the diagonal, of one of the Roman-columned buildings where Mussolini preferred to make his speeches in front of massed crowds. As Jeffrey T. Schnapp has pointed out, emblems such as architectural sites, ruins, churches and squares were routinely used to anchor the oceanic crowd scenes that Mussolini loved to reproduce in the popular press; it was intended that the viewer would be consoled by the negation of an amorphous, unruly crowd and the presentation of an orderly national crowd, 'shaped by a sense of place and tradition'.[12] This impulse in Sala O is clearly reminiscent of the centrally placed busts in Cologne and Barcelona, but with a

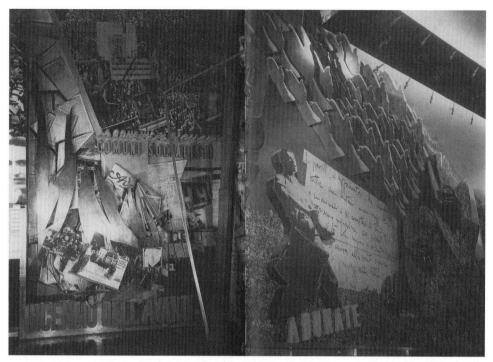

Fig. 9.3 Two views of Sala O from the Mostra della Rivoluzione Fascista, 1932. Courtesy of Archivio Centrale dello Stato, Rome.

greater sense of how to achieve the masquerade of modernity: such columns and signifiers were usually off to the side of the mass oceanic crowds, still anchoring but not central.

Crowds played an even larger role in the area of Sala O most widely written about: the mural running under the other side of the X, with its airplane turbines constructed of photographs of the mobs that assembled in the days leading up to the March on Rome, and the hugely enlarged words of Mussolini, quoting the nineteenth-century poet Gio-suè Carducci, in a handwritten text: ' "those who oil the wheels of motion with blood" achieve the supreme goal: the greatness of their Homeland'.[13] In bringing together mass crowd photographs and architectural structures, Terragni effectively masked the totalitar-ian aims here behind the notion of technological progress.

At the tail end of the X trajectory was a display of several newspaper enlargements, including one of *Il Popolo d'Italia*, ensconced within a metallic wall covering. The indus-trial material evoked those nearby turbines, starkly modern and reflected in the shiny surface of the black granite floor. This emphasis on new formal elements and industri-alised materials like metals was key in Mussolini's mind, as he stated in the guidebook: 'Make it new, ultramodern and audacious therefore, free from melancholic echoes of the decorative styles of the past'.[14] The subsequent designs of the late 1930s would render this statement utterly defunct with their reversion to nostalgia.

In addition to these monumental architectural gestures, various niches housed a tour de force of architectonic photography, which recalled the goals laid out in the original guidebook: that 'the *documentary material . . .* was to be implanted architectonically with unchallenged domination over every other element' and that the documents would therefore work a 'suggestive, vital and emotional action on the visitor's mind'.[15] One niche presented a massive 'metal man' surrounded by slogans against the paralysing strikes, which were blamed on the socialist trade unions. Coming out of the niche, the towering letters spelling out the Italian for 'legalist strike' (*sciopero legalite*) formed a huge web above, which was described as wrapping 'itself around the nation', suffocating the economy.[16] This area again included Il Duce's favourite visual flourish, massive crowd scenes montaged on one another to evoke the sense of an oceanic mass. In another case (see left of Fig. 9.3) they hovered above cartoon-like constructed metal flames licking up towards them, along with headlines about the burning of the socialist newspaper *Avanti's* headquarters, an ecstatic moment for the Fascists. These spaces show the extent to which the photographic document, far from being a neutral presence, can be used to promote almost any message if constructed within dynamic and physically imposing elements, and the way in which its presence stimulates the conviction with which the crowd might receive that message.[17]

THE 'FUNDAMENTAL IRONY' OF 'INTERNATIONAL ART IN A PERIOD OF INCREASING NATIONALISM':[18] THE BIENNALI DI VENEZIA

Despite having become one of the premier international sites of art exhibition, the Biennali di Venezia were, from 1930, a welcome opportunity for the regime to realise its promotional spectacles.[19] A marked desire is shown to shift the paradigms of high culture so that more of the Italian populace felt embraced by this previously intimidating event. The regime's central ruse of inclusion informed the cultivation of additional Biennale audiences. The Fascist organisers achieved this primarily by including popular forms of media that had formerly been excluded (film, music, decorative arts, public art) and by harnessing the tools of the marketing and leisure industries to attract new groups to the Biennali. The Fascist drive 'to involve a broader public . . . was often resolved by a plan to control the major organizational and exhibiting structures of art'.[20]

The accompanying music festival debuted in 1930, and the first Biennale di Venezia International Film Festival was inaugurated in August 1932. The film festival would go on to become independent of the Biennale, as the still extant and prestigious Venice Film Festival, but initially it was viewed as a new audience magnet for the Biennale as a whole. And it succeeded mightily, with attendance at the film festival increasing from 25,000 in 1932 to over 40,000 in 1934, thus adding tens of thousands of new visitors who might also attend the other parts of the Biennale. Indeed, the overall Biennale attendance of 250,000 in 1932 jumped to 450,000 in 1934 as the outreach to the middle class extended to such channels as advertisements in telephone directories and train stations.[21]

The sense of inclusion was supported by expanded coverage in the exhibition. Before 1932 the Biennale's art displays were limited to painting, sculpture and drawing. In 1932 a Venice Pavilion was added that included displays of decorative arts such as glassware, lacework and textiles. These served multilayered purposes in 'narrating' the regime's priorities: jettisoning perceived snobbery in favour of inclusivity, increasing mass appeal and injecting nationalism by celebrating home-grown craft skills such as Murano glass, Venetian lace, Venini vases and swatches of fabrics from Venice and Asolo. The expansion included making art purchases affordable to the masses as, up to 1938, objects at the Biennali were for sale. Marla Stone has determined that the average price of a painting in 1934 was 1,000 to 5,000 lire, and that of glassware 100 to 300 lire; hence even coveted glassware was vastly more affordable.[22] The fold-out floor plan included in the 1934 Biennale catalogue shows that decorative arts were given a very prominent position, to the immediate right of the exhibition entrance. This prominence did not carry over to reproductions in the catalogue, with only 6 pages of over 200 devoted to objects in 1934 and with those placed at the end of the plate section. The 1936 catalogue had an even worse ratio, albeit with fewer images: 104 pages of plates, with 4 pages of decorative objects at the end.

Despite the seemingly progressive attempt to increase accessibility at the 1930s Biennali, and the fact that installation shots dating from as late as 1942 prove that a sleek design approach was used, the 1934 catalogue text demonstrates how this outreach was couched in nationalistic and backward-looking language: one of the goals expressed was to 'care year after year for the treatment of some branches of decorative art production with particular reference to the more typical Venetian tradition'.[23]

'ANYONE WHO WANTS TO KNOW HOW EACH NATION REGARDS ITSELF … CAN NOW SAVE THEMSELVES THE TROUBLE OF A WORLD CRUISE': EXPOSITION INTERNATIONALE DES ARTS ET TECHNIQUES, PARIS, 1937

The Swiss journalist Max Liehburg's statement about the international pavilions at the Paris Exposition Internationale des Arts et Techniques establishes the usefulness of the Paris exhibition for analysing Italy's self-regard through the mode of exhibitions.[24] The Italian Pavilion in Paris, designed by Marcello Piacentini, did not garner much critical attention, particularly in comparison to the commanding face-off between the German and Soviet structures on the Trocodéro. But the relationship between Sironi's mosaic mural *Fascist Labour* on the top floor and Giuseppe Pagano's design of the interior space in which the Sironi work resided is still an invaluable opportunity to unmask Fascist self-regard and its concealed truths (Figure 9.4).

Fascist Labour was almost ludicrously grandiose: eight metres high and twelve metres across (over twenty-six feet high and eighty-five feet wide), it was made up of thousands of semi-precious stones and pieces of coloured glass. Sironi cultivated a look of ancient ruin within the mural, resulting in an anachronistic hybrid of past and current implied Roman glories. And yet the manner in which Pagano chose to display it reveals the vacuous nature of the hybrid; it was alone in the space but at a remove from the wall. Such

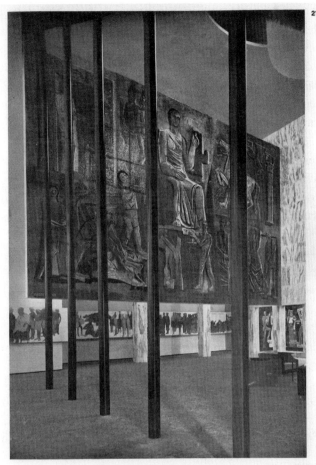

Fig. 9.4 'Mosaico di Mario Sironi', from *Casabella* 115 (July 1937): 21. Courtesy of Casabella/Arnoldo Mondadori Editore S.p.A.

11 MOSAICO DI MARIO SIRONI NELLA PARETE CENTRALE DEL SALONE D'ONORE

placement thus revealed its blank back and the fact that it was essentially a non-mural, detached from the wall, with none of the permanence normally inherent in the medium.[25] Why would Pagano expose the mural's fraudulent character in such stark terms?

In fact, the gap between the pseudo-mural and the walls of the exhibition hall became the site of Pagano's critique of Piacentini and the regime itself. As a rationalist architect, Pagano had become increasingly disenchanted with the regime, and he no longer viewed it as progressive. Although there was not an absolute rigid line of distinction, the regime had devolved more and more into the kind of morbid nostalgia we see flamboyantly exposed in the Sironi, in contrast to previous attempts at concealment.[26] By the time of the Paris fair, Pagano had taken over the editorship of the architectural periodical *Casabella* from his assassinated friend Edoardo Persico, who had been a vociferous critic of the regime (for another aspect of Pagano's and Persico's activities during this period—design education— see Elena Dellapiana and Daniela N. Prina's contribution to this volume).[27] This may partly explain why he left the pseudo-mural abandoned in mid-air, in what Romy Golan

has called 'a gesture of mimetic subversion', with the back exposed.[28] It is also a reminder of why the space between the object and the way it is displayed is such a rich interstice for analysis of whatever truths may be concealed. It points to a moment that cannot be fully controlled by the producer of the object nor by the exhibition designer: how the receiver will relate the object to the display mechanism and whatever else surrounds it. The viewer may look left or right, may be struck by the bare back or may not care much—but the manner of display will necessarily have some inflection on the experience.

Golan has explored the critical reception—or lack thereof—of the Italian Pavilion at length and has found that the French Polish critic Waldemar George produced the only substantive critique. Although he admired aspects of Pagano's interior design, George found that it engaged an 'unholy' alliance between modernity and the ancient, and he expressed a subsequent revulsion against such hybridisation:

> Relations between sculpture and architecture are subject to caution. Nothing justifies them except a reprehensible desire for novelty and modernity. A similar mistake was made on the floor where the beautiful mosaic by Sironi was placed in the centre of the room. A mosaic is, by definition, a wall revetment.[29]

In other words, a non-mural that wanted to be a mural was inherently repellent.

As has been shown through this discussion of design since the 1920s, Il Duce's regime was always steeped in nostalgia. After a respite in the early to mid 1930s, when it achieved a more convincing facade of progressivity through the work of unusually talented designers, that nostalgia seeped through the forms of display once more—and in even more morbid form than was seen in the busts and maps of Barcelona and Cologne, for in Paris it adopted the dead form of a bare-backed mosaic.

CONCLUSION

Aspects of the Fascist critical reception of exhibitions in the 1930s seem rife with anxiety about the temporal nature of contemporary display even as the regime was increasingly devolving into overwrought historical nostalgia. In response to the 1936 Triennale di Milano, the critic Roberto Papini lamented the 'exiled' art that was created for temporary exhibitions. He seemed repelled by that which brought attention to the fleeting nature of exhibitions and found such site-specific installations as hovering in an unsatisfying way between 'architecture and theatricality';[30] in other words, the impermanent aspect of what designers like Pagano engaged in was most problematic to the Fascist critics. Conversely, support for such temporality lauded a raw honesty about the equation between modernity and the ephemeral—a facing up to a truly modern sensibility. As Pagano expressed it, 'Exhibitions are the most efficacious vehicles for the knowledge, the diffusion, and the theorization of the concepts that dominate the modern sensibility'.[31]

What were the truths the regime wanted to conceal behind the spectacle? And do the display modes expose those truths? The ruse/spectacle was that of contemporary mass appeal. The truth to be concealed was that there was no resulting mass inclusion in the

process of governing everyday life. How did they massage this contradiction? They did so through newly appealing mediations like mass-media photography, film and design products, combined with generalised references to the glorious ancient and Renaissance pasts. This assisted in the all-important rhetoric of anti-elitism. But the truth behind this 'mass liturgy'[32] and involvement of the body politic in public life was that Il Duce had rejected democratic processes, including the parliamentary system, since the founding of his movement. Many seemed distracted from taking much notice, both by being convinced that they personally were enabled to express themselves and by concurrently having their senses overwhelmed in a Fascist brand of shock and awe.

In each show one must look at the dialectic between object and display, to unveil both the ruse and the truth. In environments like the Cologne and Barcelona exhibitions, this entailed the display of mass media like books, journals and magazines, surrounding kitsch busts of Il Duce and maps, indicating power. One must also closely analyse such design apparatuses as the *Il Popolo d'Italia* vitrine, with its spread of lowbrow materials and printing drums. Both of those ingredients possessed the implication of educating people about processes, but the process involved printing only a single point of view. The exhibitions of the early to mid 1930s demonstrated a much more sophisticated understanding of how to use the ruse. The Mostra fully embedded banal forms of photography, much of which was actually submitted by the mass audience, within spectacular structures that were formulated with the sole purpose of heavy persuasion. And the Biennali di Venezia showed an absolute mastery of outreach, with the regime harnessing all the marketing apparatuses at their disposal to attract the lower middle to middle classes who had formerly been intimidated by the gathering together of the 'high arts'. This also involved having on display objects that would comfort those viewers with the familiar: music, films and applied arts. If the current regime went to such lengths to embrace previously ignored classes, one can imagine that, particularly in the cultural sphere, those classes would have little desire to return to the days of elitist marginalisation.

At the Paris Exposition Internationale des Arts et Techniques of 1937, Fascist representation began to turn inward on itself in a nostalgia personified by Sironi's *Fascist Labour*. Any autocratic regime that stays in power long enough faces challenges in continuing with the 'indictment of stasis'[33] as it becomes self-protective, and the *ventennio* (Mussolini's twenty years) was no exception. Even formerly rabid proponents like Pagano began to mutiny, more willing to risk a concentration camp in Austria than to be an inauthentic progressive within a decaying centre. As the expressions of the regime became more self-indulgent, and less able to hide behind contemporary forms of spectacle, the unmasking became easier and more self-evident, the truths harder to conceal. So Pagano arrested Sironi's flow by exposing his mural's back, perhaps intuiting that he would find an increasingly receptive audience.

This chapter has attempted to arrest the flow of a particular milieu of exhibitions, to show that beneath the Fascist veneer of mass appeal and progressivity sits the truth: the rot of exclusion and the presence of the regressive. Examining such dialectics continues to be

an urgent exercise, as the art of spectacle services dominant regimes in our global landscape today like never before. Stopping the flow of displayed images in their tracks can still assist in unmasking the truth, and there is often space to do so in the dynamic relationship between *what* is displayed and *how* it is displayed. To revisit Wollen: 'Above all, it is necessary to place the myriad contemporary forms of display in a historical context. The main effect of the interminable transience of modern spectacle, as Debord noted, is to efface history and historical understanding'.[34] History lingers in the present, and our shared history of Western autocratic spectacle is no exception. We must place our own forms of display in context, lest such ruses as those perpetrated by the Fascists continually appear as truth.

NOTES

Special thanks to Vivien Greene, Guggenheim Museum curator, and her intern Clémence Imbert for sharing their deep reservoir of research on Italian exhibition culture of the 1930s.

1. Peter Wollen, 'Introduction', in *Visual Display: Culture beyond Appearances*, ed. Lynne Cooke and Peter Wollen (New York: New Press, 1998), 9.

2. Ibid., 10 (emphasis mine).

3. See the introduction to section 11, 'Mediation', in *The Design History Reader*, ed. Grace Lees-Maffei and Rebecca Houze (Oxford: Berg, 2010), 427–428. Lees-Maffei articulates the importance of this methodology in focusing attention on that which transpires between producer and consumer. This 'phenomenon', I believe, is partly comprised of the relationship between objects and the way they are displayed. Also useful is Clive Dilnot's formulation of design itself as 'the process of negotiating and hence mediating'. See 'Some Futures for Design History?' *Journal of Design History* 22, no. 4 (2010): 381.

4. The name given to the Fascist cells. In fact, the Mostra in 1932 was originally planned for 1929 for that reason but had to be delayed.

5. Jeffrey T. Schnapp recounts that Sironi declared this in 1933 to his nemesis Roberto Farinacci in his essay '"Ogni mostra realizzata è una rivoluzione", ovvero le esposizioni sironiane e l'immaginario fascista', in *Mario Sironi 1885–1961*, ed. Fabio Benzi (Milan: Electa, 1993), 48.

6. Ibid.

7. Sophie Lissitzky-Küppers, *El Lissitzky: Life, Letters, Texts* (London: Thames and Hudson, 1968), 85, which reproduced numerous reviews from 1929, including one from *Nouvelles litteraries*. *Paris-Midi* also stated that the Soviet Pavilion 'wields the strongest power of attraction for the public', and according to the *Yorkshire Evening News*, 'pride of place must go to the outstanding Russian exhibit'. Ibid.

8. Emily Braun, *Mario Sironi and Italian Modernism: Art and Politics under Fascism* (Cambridge: Cambridge University Press, 2000), 142.

9. An expanded version of the material in this section can be found in my essay 'Acting on the Visitor's Mind', in *Public Photographic Spaces: Exhibitions of Propaganda from Pressa to The Family of Man*, ed. Jorge Ribalta (Barcelona: Museu d'Art Contemporani de Barcelona, 2008),

245–255. The quotation above is from a review of the Mostra: P. M. Bardi, 'Esposizioni', *Bibliografica fascista*, November 1932, 701.

10. Benjamin Buchloh, 'From Faktura to Factography', in *Contest of Meaning: Critical Histories of Photography*, ed. Richard Bolton (Cambridge, MA: MIT Press, 1989), 49–81.

11. Terragni was also the architect of what is probably the most uncompromisingly modernist building in Italy, the Casa del Fascio in Como, which began construction the very same year (1932).

12. Jeffrey T. Schnapp, 'Mob Porn', in *Crowds*, ed. Jeffrey T. Schnapp and Matthew Tiews (Stanford, CA: Stanford University Press, 2006), 20. Schnapp has also described how these 'masses' in 'constant movement' deny both reflective distance and historical process. See Jeffrey T. Schnapp, 'Fascism's Museum in Motion', *Journal of Architectural Education* 2, no. 2 (February 1992): 93.

13. The larger context of Mussolini's text and the Carducci attribution can be found in the original exhibition catalogue entry on Sala O. See the translation, 'Room O', in Ribalta, *Public Photographic Spaces*, 241–242.

14. Quoted in Schnapp, 'Fascism's Museum in Motion', 89.

15. Dino Alfieri and Luigi Freddi, *Guida alla Mostra della Rivoluzione Fascista* (Bergamo: Italian Institute of Graphic Arts, 1933; repr., Milan: Candido Nuovo, 1982), 72 (emphasis mine; page numbers are from the reprint edition.)

16. Ibid., 185.

17. See Diane Ghirardo, 'Architects, Exhibitions, and the Politics of Culture in Fascist Italy', *Journal of Architectural Education* 42, no. 2 (February 1992): 69, cited in Rocco, 'Acting on the Visitor's Mind', note 9.

18. Lawrence Alloway, *The Venice Biennale, 1895–1968: From Salon to Goldfish Bowl* (Greenwich, CT: New York Graphic Society, 1968), 93.

19. In Marla Stone's words: 'Spectators were the pivotal spoke in the wheel of Fascist state patronage . . . together with the desire to mobilize the population within controlled conditions'. She goes on to discuss strategies used to make the party both more 'popular and populous'. Stone, *Patron State: Culture and Politics in Fascist Italy* (Princeton, NJ: Princeton University Press, 1998), 99.

20. Simonetta Lux, ed., *Avanguardia, traduzione, ideologia: Itinerario attraverso un ventennio di dibattito sulla pittura e plastica murale* (Rome: Bagatta Libri, 1990), 4, quoted in Stone, *Patron State*, 100.

21. See statistical analysis in Stone, *Patron State*, 121–123.

22. Ibid., 111.

23. '[C]urare anno per anno la trattazione di alcuni rami della produzione d'arte decorative con particolare riferimento, alle più tipiche tradizioni veneziane'. 'L'Arte Decorativa', Venice Biennale, official catalogue (1934), 18.

24. Max Eduard Liehburg, quoted in Wolfgang Friebe, *Buildings of the World Expositions* (Leipzig: Edition Leipzig, 1985), 152.

25. Indeed, it had already been partly installed at the 1936 Triennale di Milano and then was taken down in order to travel. I owe this passage to Romy Golan's riveting analysis of the blank back of the Sironi mural in *Muralnomad*, a book devoted to the study of murals that are 'not really' murals and the political significance of this in interwar Europe. See in particular the chapter 'Sironi's Pseudo-ruin', in *Muralnomad: The Paradox of Wall Painting, Europe 1927–1957* (New Haven, CT: Yale University Press, 2009), 83–121.

26. Pagano was described by his compatriot Ernesto Nathan Rogers as arguing that the increasingly reactionary architecture was 'sinful, misguided. . . . The "true" fascist architecture was theirs, the modern one'. Golan, *Muralnomad*, 91.

27. Pagano subsequently had a dramatic political conversion, working for the Italian resistance beginning in 1942 and dying in the Austrian camp of Mauthausen in 1943.

28. Golan, *Muralnomad*, 105.

29. Waldemar George, 'Les Pavilions étrangers à l'exposition de 1937', *L'Architecture*, August 17, 1937, 466, quoted in Golan, *Muralnomad*, 90.

30. 'E un compromesso fra scenografia e architettura . . .' This was Papini's critique of Perisco's design of the Sala della Vittoria at the 1936 Triennale. *Emporium* 84 (August 1936): 72.

31. 'Uno dei più efficace vercoli per la conoscenza, la diffusione e la saggiatura delle idée che presidono al gusto moderno é rappresentato dale esposizioni'. Giuseppe Pagano, 'Parliamo un pò di esposizioni', *Casabella-Costruzioni* 159–160, special double issue (March–April 1941): n.p.

32. The concept of 'mass liturgy' is well articulated in Simonetta Falasca-Zamponi, 'Introduction', in *Fascist Spectacle: The Aesthetics of Power in Mussolini's Italy* (Berkeley: University of California Press, 1997), 7.

33. Ibid.

34. Wollen, 'Introduction', 10.

10 THIS WAY TO THE EXIT: THE RE-WRITING OF THE CITY THROUGH GRAPHIC DESIGN, 1964–1989

GABRIELE OROPALLO

INTRODUCTION

The 1964 Triennale di Milano marked a turning point in the self-perception of Italian design. That year the exhibition was curated by the semiologist Umberto Eco and architect Vittorio Gregotti, and 'Free Time' was its theme. This decision was in stark contrast to a post-war tradition of more committed and moralistic Triennali dedicated to issues such as the reconstruction, the rationalisation of town planning, schooling or mass housing. The standard of discussion expected from the event within industry and the general public was high, and the decision to focus on free time immediately sparked an intense debate.[1]

The rationale behind the curators' choice, however, would become clear only a few steps onto the exhibition floor, after the visitor encountered one of the most iconic elements of the exhibition design: a claustrophobic trapezoidal tunnel on the sides of which one could watch two frenetic and hypnotic montages of video clips prepared by director Tinto Brass (see Figure 0.7 in the Introduction): *Tempo libero* and *Tempo lavorativo*. The entire length of the tunnel was used for the projection, so visitors were not simply exposed to the images as if sitting in a cinema but were actually setting in motion the horizontal narration of the films by walking. There were two narrative directions: one internal to the clockwork of the projection loop and the other linear, activated by the beholders.

The installation, designed by Gregotti, Giotto Stoppino, Lodovico Meneghetti and Peppo Brivio, featured strategically placed mirrors that visually expanded the space and reflected the image of the users alongside the projection. Clips on one side of the tunnel showed people at work in factories, and on the other side people spending time in holiday spots and entertainment venues. For Eco and Gregotti leisure time was modelled on labour time. The pace of consumption followed the same alienating rhythm as production. In the context of the Triennale, this formed an unambiguous criticism of contemporary Italian design, which, in spite of great expectations that it would function as a mass instrument of cultural renewal, had actually become domesticated and formed a fully integrated part of the contemporary culture industry.[2]

This identity crisis would play a crucial role in the further development of Italian design. Debates on the modes of production and consumption of design would inspire a variety of design responses to the treatment of the mass-produced industrial product, from total rejection of the object to a joyful embrace of its escapist role. These divergent responses are today both recognised as quintessentially 'Italian design' because of the eloquence of their visual languages. The extent to which one response or the other criticised, signalled or actually triggered shifts in material culture is a matter of continuing debate in design history and design studies. However, this discussion also distracted attention from other fields of design practice, like graphic design, and other approaches that were meanwhile being explored. Giovanni Anceschi's attempt to connect the field of Italian graphic design with a more constructivist approach to the practice of design somehow still remains isolated. In his 1981 essay 'Il campo della grafica italiana', Anceschi argued that in the field of Italian graphic design it is possible to identify a series of experiences in which, more often than in product or interior design, designers followed a less self-centred approach because they were pursuing a more carefully reformist and research-based path.[3] Such a strategy was particularly effective in a cultural landscape in which the politicised and utopian Italian take on the modernist orthodoxy was itself experiencing a crisis.

This was particularly evident in a series of projects commissioned from graphic designers by municipalities and local administrations. During the industrialisation wave of the 1950s and 1960s Italian cities grew dramatically in size and complexity. Information design and urban signage systems increasingly became crucial tools for their navigation, and so graphic design acquired a new, architectural dimension. This chapter looks at some of these experiences: projects that, albeit heterogeneous in nature and scope, attempted to domesticate a multiplied urban space by means of graphic design. On which tools and strategies did these projects rely, and what are their implications? What is their relevance to a rethinking of this period of transition in Italian design?

This graphic design involved reconsidering aspects of design that had emerged during the early period of modernism, like standardisation and mass production, and trying to adapt them into instruments to reach and empower wider audiences.[4] The visual and conceptual mechanisms embedded in these citywide graphic design projects relied on user participation to activate their machinery, and this was achieved through the physical displacement and inclusion of users. The next two sections of this chapter examine these two elements of their design and their implications.

MOVEMENT AS MEDIATION BETWEEN SPACE AND INFORMATION

Close spatial interaction of designers, manufacturers, venues and clients transformed the city of Milan in the 1950s and 1960s into a sort of design laboratory, a network that provided opportunities for interaction and experimentation on large and small scales.[5] The results of these experiments then cascaded throughout Italy and the wider world, mediated by publications, fairs and awards (see Kjetil Fallan's chapter in this book).

In this context, exhibition design played a pre-eminent role and rapidly developed to keep up with the country's new wave of industrialisation. Ephemeral spatial design systems were perceived to be a fusion of architecture and graphic design, as reflected by the Italian portmanteau neologism created to define them: *archigrafia*.[6]

Previously confined to international exhibitions and public events, such as those used by the Fascist regime for self-promotion (see Vanessa Rocco's chapter in this book), the development of a predominantly industrial and trade economy during the 1950s and 1960s resulted in archigrafia and the design of retail spaces becoming staple commissions for graphic designers. Exhibition spaces like Milan's Fiera Campionaria functioned as syntactic systems that articulated communication into complex ecologies built around products, in which value was continuously created and reformulated. Archigrafia was an important training field, for it offered the opportunity to experiment with design on different scales and to project relations into new dimensions. Most important, it included the treatment of movement as one of its most crucial ingredients. Visitors are led through a temporary space of panels, faux walls and other devices that dictate direction and pace. This is a form of peripatetic learning in that visitors are provided with visual and verbal information about the exhibits while moving around the ephemeral spaces. It is also a point-to-point narrative that aims to offer a particular interpretation of things, a spatial story that invites participants to draw certain conclusions about the quality and values of the products or services presented. Visitors are incorporated into the exhibitory device by the very act of walking through it. They activate it, and in so doing they sustain its underlying narrative and ideology.

The same centrality of movement as a device to solve possible tensions between space and information features in the information design of the first line of the Metropolitana di Milano (MM1), which was inaugurated in 1964, after seven years of design and construction work. Milan's Metropolitana today comprises three lines and, unlike many other underground networks, was created without relying on any existing urban railway. Its wayfinding system was an exercise in design mediation and presented many features later utilised in similar projects worldwide.

The opening of the MM1 was one of the events that reinforced in the collective psyche the idea that the country had finally emerged from the rubble of the war, while its information system had an immediate impact on contemporary graphic design, clearly pointing to new potential spheres of action. The stations were designed by the rationalist architects Franco Albini and Franca Helg, while the Dutch-born graphic designer Bob Noorda was responsible for all graphics, both at stations and at the overall system level, including signage, name plates and a diagrammatic map. A graduate of Amsterdam's Instituut voor Kunstnijverheidsonderwijs (IvKNO),[7] then directed by Gerrit Rietveld, Noorda moved to Milan in 1954 and quickly gained a reputation for his posters and corporate identities, mostly working for design-aware clients such as Pirelli, La Rinascente and Olivetti.

The communication system was created while the infrastructure was being planned and built. Thanks to Noorda's early involvement, the project featured a structural

integration of graphic design into the three-dimensional spaces of trains and stations. Most of his design solutions for the Milan underground were innovative for a time when coordinated wayfinding systems were relatively rare. A wild variety of overlapping styles plagued most urban transport systems, including the infamous case of the New York subway. A notable exception was the London Underground, which adopted Edward Johnston's Underground sans serif typeface in 1916 and Harry Beck's iconic diagrammatic map in 1931.[8] An immediate precedent and likely source of inspiration for the MM1 was the third terminal of London's Heathrow Airport, then known as the 'Oceanic Building'. Its signage system was developed in 1961 by Colin Forbes using consistent modular panels that displayed a combination of direction arrows and sans serif lettering in black on white. The typeface used for the signage was designed by a young Matthew Carter and based on the most common sans serif available, Akzidenz-Grotesk, simply called 'Standard' in Great Britain.[9]

Noorda, dissatisfied with the weights then available for Helvetica—still a novel typeface at that time—drew by hand the sixty-four glyphs of a custom alphabet for the Milan underground.[10] Noorda's goal was to use a typeface that could easily be read by commuters from the train in transit. The problem with the available weights of Helvetica was their readability in negative, that is, white on colour (in the MM1 case, a red background). The brightness of white letters is amplified in negative, and the figure-ground relationship becomes confused. To solve this problem Noorda reduced the height of the capitals and the depth of the descenders and achieved a proportional increase in the x-height of the typeface. Another element that increased readability was the use of matte surfaces, an important feature in an environment destined to be experienced exclusively by artificial light. Station names and exit signs were printed in capitals, while the rest of the information, including landmark names, was printed in a regular combination of lower and upper case. Reductive geometry was also applied, for instance by ensconcing direction arrows within circles that visually isolated them. Noticing that commuters would not be able to read the name of the station from the two extremities of the train, or while still in transit, Noorda decided to have the name reprinted every five metres (about sixteen feet) in the enamel band above the platform (Figure 10.1), a practice that has since become standard worldwide.

Conceptually significant was the red band that ran along the wall of the station above the platform, displaying all crucial information. This band continued into the handrails that led commuters from the street into the underground station, which were also painted red (Figure 10.2). Handrails and coloured bands are both structure and information at once; they serve a practical purpose but also clearly reiterate the identity of the metro line. Their very form—elongated, continuous—is a visual metaphor of the railway. Existing structural elements of the system, in other words, were selected by the designer, emphasised and adopted as means to convey factual and symbolic information. Unfortunately, in the following decades, the original design was not always respected and has been updated using glossy Helvetica—or even Arial—stickers in incongruous colours, kerning and spacing.[11]

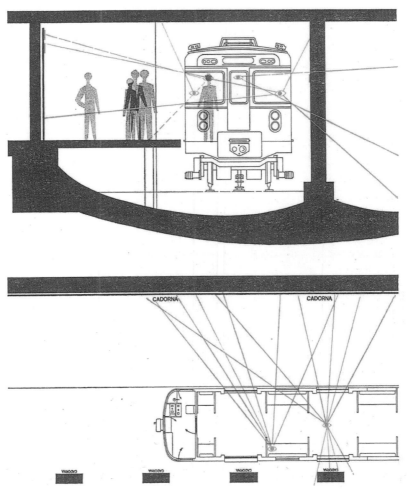

Fig. 10.1 Centrality of the user experience in a diagram designed by Bob Noorda to illustrate some innovative solutions for the Metropolitana di Milano Linea 1. Originally published in *Domus* 438 (May 1966): 47. Courtesy of Editoriale Domus S.p.A., Rozzano, Milano, Italy, all rights reserved.

Noorda's modernist empiricism was based on a commitment to the final user, which functioned through pre-emptive identification and mimesis rather than the addition of educational commentary. This approach was close to the positions of the Hochschule für Gestaltung Ulm; its emphasis on clarity, functionality and the systematic dimension was deliberately technocratic and practical (the school's influence in Italy is discussed in Raimonda Riccini's chapter in this volume). The purpose of this approach to graphic design was to create artefacts that would be readable, with messages being easy to recognise from most locations in the station and even from the trains, and legible, that is, with structures and formats that clearly articulated the overall rationale of the signage system.

Fig. 10.2 Visual metaphor: the bright red handrail designed by Bob Noorda leads commuters from the street into the underground station and also symbolises the network itself. Courtesy of Daniele Rossi.

Giovanni Baule and Valeria Bucchetti described Noorda's work as the first 'systematic project of social graphic design' in Italy, 'one of the first examples in which providing appropriate information design was considered intrinsic to the provision of public services'.[12] Many of the features of the MM1 signage system indeed became standard among designers working on public sector commissions.[13] They shared Noorda's ambition to represent complex and heterogeneous information through two-dimensional artefacts immediately understandable by users unfamiliar with the context and prepared to be directed through space.

The MM1 project was also pivotal in Noorda being commissioned to develop a new signage system for the New York subway in 1965, this time with Massimo Vignelli. However, the situation in New York was radically different, and Noorda and Vignelli met with several difficulties there. New York did not offer the opportunity to work along the flexible and yet tight lines of an intensified network like the Milanese one. The

Metropolitan Transport Authority's in-house sign shop was reluctant to surrender control to external consultants and was determined to preserve its almost artisanal unity of designing and making. Vignelli's 1972 diagrammatic map survived only seven years before a more traditional topographic one was reinstated.[14]

Noorda later worked on similar commissions in Italy, including the Naples underground and Lombardy regional train network, as well as the São Paulo underground in Brazil. Interestingly, the São Paulo design stayed faithful to Noorda's original intuitions, growing organically as lines and stations were added over the years. In the burgeoning South American metropolis, like in Milan in the 1960s, the network literally broke new ground while growing and encountered little resistance along the way.

GRAFICA DI PUBBLICA UTILITÀ: QUEST FOR INCLUSION

In 1970, after the first regional elections, the regional autonomy formally established by the 1946 Italian constitution was finally implemented. With the power devolution that followed, local administrations gained more freedom to recast their visual identities both on paper and on the streets. A first attempt to provide theoretical and methodological tools for designers working on these commissions came from Albe Steiner, one of the pioneers of modern Italian graphic design. Steiner had been actively involved in the anti-Fascist resistance before and during the Second World War, and after the conflict he successfully combined commercial and public commissions. His work ranged from archigrafia to corporate identity and included the layout of *Il Politecnico*, an influential cultural and political paper edited by the writer Elio Vittorini, and several posters for the Communist Party of Italy. Because of his work as an educator at the Scuola del Libro della Società Umanitaria in Milan and the Istituto Statale d'Arte in Urbino, Steiner exerted his influence on a generation of graphic designers. He was also one of the initiators of the Compasso d'Oro award, conceived in 1954 when he was working as art director for the department store La Rinascente.

In a 1966 article, 'Formato cultura', Steiner discussed the most appropriate formats for projects aimed at the dissemination of culture.[15] He referred to all forms of graphic design intervention into public space, including commercial or public display signs, banners and posters, as 'arte pubblica'. Today the term *public art* is commonly used to refer to artworks and art installations conceived to be staged in spaces accessible to anybody. Many forms of professional practice that are today commonly referred to as branches of design would still have been described as arts in the post-war period, because they were thought of as applied or decorative arts.

Posters, as Steiner put it, are both decoration and communication, but these two potentially contradictory aspects can actually work together and complement each other, he argued, if the programme of the artefact is kept open. Rather than the output of a codified process, a final product, the poster for him should be the result of what he defined as 'studio culturale'. This 'cultural study' is design thinking triggered by a problem and yet not limited to problem-solving. This openness allows the designer to take context

into account through an inclusive dialogue with the target audience. The outcome of a cultural study is both a document of the process and a set of educational tools. A poster designed according to these principles is, according to Steiner, not confined to a surface-level message. One could think of it as of a moral tale, with a fable and a series of deeper, inherent meanings. His objective was declaredly engagé; he pursued a political agenda and was accordingly interested in the educational content of his work.

Steiner's 'public art' eventually became known as *grafica di pubblica utilità*, which can be translated as both 'graphic design for the public benefit' and 'graphic design as a public service'.[16] The expression was used by Steiner for the first time at the end of the 1960s to refer to a project he developed with his students while teaching at the Istituto Statale d'Arte in Urbino.[17] The project, realised in 1968, produced an integrated system of posters, street signs, publications and visual identity for the Urbino municipality.[18] The term *grafica di pubblica utilità* originated from the necessity to replace the old emblems used by Italian cities—originally created as patrician pictorial devices indicating possession or political hegemony—with new ones that could be useful to the whole community. The most revealing word of the term used by Steiner is, in fact, *public*. When associated with *graphic design*, it comes to describe a potential configuration of the design profession, with two legitimate clients for the graphic designer's work: the authorities that outsource their visual communications and the citizenship. The project's methodology was influenced by that of the architect and planner Giancarlo De Carlo, who was involved in several projects in Urbino in the same years and relied extensively on citizen participation through public meetings and debates. Also, Steiner conceived of the Urbino project as group work done by himself and the students. The research and the results were presented to the public in 1969 at an event that was simultaneously an exhibition, conference and public consultation.[19]

Steiner's Urbino project did not proceed beyond the preliminary models presented in the 1969 event, which was conceived as a form of walk-in public consultation (Figure 10.3). However, in the context of the administrative devolution of the 1970s, it served as an example of good practice for several other similar projects. Relative autonomy at the local administrative level provided the conditions for establishing several significant collaborations between professionals and local governing bodies. Massimo Dolcini's work in Pesaro (1971–1987) and A G Fronzoni's work in Genoa (1979–1981) can be taken as examples of the range and scope of these interventions.

Dolcini studied in Urbino with Steiner, and his approach clearly connected with his tutor's ideas. He designed almost continuously for the Pesaro municipality, renewing its visual identity and realising extensive information campaigns designed to open and maintain channels of communication with the public, much as websites do today. All official communications from the administration were visually articulated by Dolcini with the same care and attention given to commercial commissions (Figure 10.4). His graphic design was conceived and functioned as basic public service. Dolcini as author receded from the spotlight and chose his visual language from an extremely large palette of design

Fig. 10.3 An 'environmental model' designed by Albe Steiner and his students to recreate the user experience and showcase their work for the Urbino municipality in 1969. Courtesy of Archivio Albe e Lica Steiner, Milan.

tropes instead of developing a recognisable personal style. In his work, communication is central, and the public sphere coincides with the linguistic one.

Fronzoni's work is different in many ways and cannot be considered grafica di pubblica utilità proper.[20] Yet he embarked on a similar enterprise when he designed and coordinated the entire visual identity, including the stationery and exhibition design, of Arte e Città (Art and City), a programme of cultural events marking an alliance of culture and politics promoted by a new, left-wing administration in 1979 (Figure 10.5). The designer's ambitious programme in Genoa aimed to deal with the 'untidiness of its urban image'.[21] His interventions—including black monochrome posters, banners, ephemeral signage and exhibition design—literally materialised his ambition to lay out a grid overlapping the existing urban fabric, to provide structure and smooth out the striated, fragmented raw matter of a stratified historical city centre, a thick urban tangle that had formed itself through uncontrolled building activity dating from as early as the seventeenth century. Culture was presented as a forum within which individuals could participate, ultimately stimulating individual consciences but also consolidating consensus around the new administration. In Genoa Fronzoni's skilful use of negative space, developed during his long career as a poster designer, was transferred onto the three dimensions of the city.

Fig. 10.4　Massimo Dolcini, *Let's Open the City*, 69 by 99 centimetres (29 by 39 inches), serigraphy, 1985. This poster announced the public presentation of a research study on the physical obstacles to the movement of the disabled in the city in an example of graphic design functioning as public forum. Courtesy of Assessorato alla Sanità, Comune di Pesaro, Italy.

The empty spaces he allowed in his design offered themselves to the user as a visual and material metaphor of the experience of space as an opportunity for speculation and critical understanding, and ultimately a form of personal development. However, this abundant negative space also inherently represented a silent threat, its unsettling vastness inspiring in the user a sensation of being cast at sea. The user is grateful to follow the sparse elements offered by the designer like a flimsy thread in a maze.

The 'Charter of Graphic Design', published in 1989 and endorsed by all of the designers mentioned in this chapter, effectively represented a posthumous manifesto of grafica di pubblica utilità. Written by Giovanni Anceschi, Giovanni Baule and Gianfranco Torri

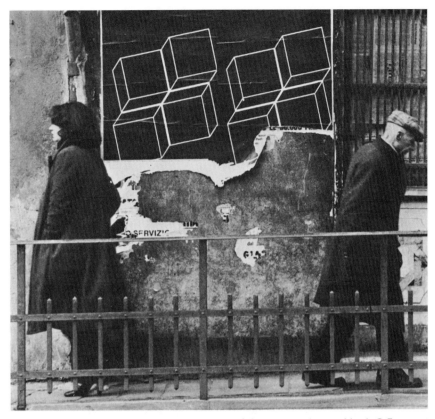

Fig. 10.5 Confronting entropy head-on: some of the posters designed by A G Fronzoni for the city of Genoa. Courtesy of Mondadori Portfolio.

at the invitation of the Italian Association of Graphic Designers, the Associazione Italiana Artisti Pubblicitari, it argued for the significance of graphic design among other forms of design, describing it as a basic grammar through which social communication can be studied and social issues can be voiced.[22] In an interesting turn, the charter also explicitly reminded practitioners of their responsibilities to the users, primarily by urging them to always make their messages accessible.

CONCLUSION

The approach shared by the projects examined in this chapter was not typical in the landscape of Italian late modernist design. Despite their variety, they all aimed at reaching a balance among the forces involved in the design process rather than materialising an opposition against the status quo, as in the case of radical design, or an imposition on the environment, as in the case of the large post-war Corbusian housing schemes that suffocated delicate urban ecosystems. From this point of view, grafica di pubblica utilità was particularly successful in emphasising and utilising graphic design's innate suitability to combine with the built environment and become both structure and aspect of the urban fabric.

From archigrafia through grafica di pubblica utilità, the treatment of movement was crucial in this respect. Noorda's work for the Metropolitana di Milano was based on a preliminary phase he spent in the underground stations, preparing diagrams that anticipated the fluxes of future passengers and identified the decision points where signage would be necessary. A popular interpretation of modernism in post-war Italy saw design as an important route to educating the masses, and this was usually done by deliberately adding layers of interpretation. Noorda avoided this and did not superimpose his identity onto the systems he designed, in which functional elements intrinsically and explicitly form the identity of the projects. Rather than emerge as an author through a personal style or other discrete choices he chose not to expose his authorship through design but to entrust it to conceptual aspects, like the continuity of the red line, or attentive design strategies, such as the repetition of the station name at five-metre (sixteen-foot) intervals. This softening of authorship was particularly relevant in the context of Italian design, where the extensive mediation of design results in the construction and promotion of a reference system made of recognisable authors and brands that function like immediate markers.

Meanwhile, the main strategy behind grafica di pubblica utilità was based on interpretation rather than mere translation of information. The right to information was in fact perceived as central to the empowerment of the users, whether by granting them direct access to information and or by briefing them on the functioning of public administrations and the nature of the decisional processes. Ultimately, grafica di pubblica utilità represented an interpretation of design in which designers function as facilitators and guide users through the visual and material environment of the city.[23]

In *The Open Work* (1962) Umberto Eco argued that artworks should be interpreted as 'fields of meaning' rather than 'strings of meaning'. He proposed an understanding of texts as internally dynamic systems that constantly change as readers move within them.[24] The (open) artwork comes to life when the reader or the viewer actually enters, activates and modifies it. Therefore, the consumers of the artwork are in effect both observing participants and structural elements. The concept was also clearly illustrated by the peripatetic structure of the *Tempo libero/Tempo lavorativo* video installation at the Triennale di Milano that Eco co-curated in 1964. Designers wishing to act as facilitators can allow user participation by consulting users or by presenting the finished work as a toolbox designed to empower the user. User participation allows designers to soften the boundary between the design output and its context, and hence promotes a sense of identification. However, as long as the designer is involved in the process, truly open design remains an imagined ideal, because the very opportunity and space for participation have to be designed or designated and are subsequently implicitly limited. When design is used as a form of mass education, some suspension of disbelief on the part of the user is necessarily implied. To some extent, user interest, participation and movement are redirected and harnessed to become the motor of the design, the fuel of its narrative. As Silvia Sfligiotti recently noted, an open problem of grafica di pubblica utilità is that it

was based on the unspoken assumption that education and good intentions are enough to equip designers with the ability to imagine or construct users.[25] Another problem is more subtle and concerns the fine line between user participation and user mobilisation. In this respect, it is particularly useful to trace the genealogy of the encounter between graphic design and urban space in Italy and to reread Anceschi's 1982 account.

The emergence of grafica di pubblica utilità is best looked at within the context of the contemporary crisis of the modernist narrative. By the 1960s and 1970s modernist aesthetics had been appropriated for use in corporate identities, while its reformist agenda had been sublimated into an obstinately utopian programme.[26] Many graphic designers sought to eschew the discourse on formal beauty and boundless creativity that had become hegemonic in most fields of design in Italy. In contrast, limited but practical interventions in the urban space such as those seen in this chapter promised a way out of an impasse; they offered a viable alternative to the polarisation between professional mannerism and uncompromising ideological commitment, which in itself at that point seemed to offer only two strategic options: sabotage or resignation.

NOTES

1. Compare issue 109 (1964) of Bruno Zevi's *L'Architettura*, which was more sceptical of the curatorial choices, and Ernesto Nathan Rogers's *Casabella-Continuità* 290 (August 1964), in particular the articles by Rogers, Gillo Dorfles and Francesco Tentori.

2. *Culture industry* is a term developed by the German social theorists Theodor W. Adorno and Max Horkheimer in the 1940s to refer to the commodification of culture in capitalist societies. See, for example, Adorno, *The Culture Industry: Selected Essays on Mass Culture* (London: Routledge, 1991).

3. Giovanni Anceschi, 'Il campo della grafica italiana: Storia e problemi', *Rassegna* 3, no. 6 (1981): 5–19.

4. On the implications of the use of the terms *modern*, *modernity* and *modernism*, see Kjetil Fallan, *Design History: Understanding Theory and Method* (Oxford: Berg, 2010), 109–112.

5. The notion of the network as a multi-reciprocal system of heterogeneous elements in which intentionality is distributed emerged in actor-network theory and has been extensively used in recent design history. See Fallan, *Design History*, 66–78.

6. Italo Lupi, Ico Migliore and Mara Servetto, *Vuoto x Pieno: Architettura temporanea italiana* (Milan: Segesta, 2005). On the extent to which exhibitions are architecture, see Léa-Catherine Szacka, 'Showing Architecture through Exhibitions: A Taxonomical Analysis Applied to the Case of the First Architecture Biennale (1980)', in *Writing Design: Words and Objects*, ed. Grace Lees-Maffei (Oxford: Berg, 2011), 191–203.

7. Today the Gerrit Rietveld Academie.

8. Beck's diagram, periodically updated and organically growing with the network, is less an artefact than an operating system. See Dipti Bhagat, 'The Tube Map', in *Design Studies: A Reader*, ed. David Brody and Hazel Clark (Oxford: Berg, 2009), 485–489.

9. Theo Crosby, Alan Fletcher and Colin Forbes, A *Sign Systems Manual* (London: Studio Vista, 1970), 5.

10. Bob Noorda, interview in *Lezioni di design 25: Grafica e graphic design*, documentary (colour, Rai Educational, Italy, 2000), directed by Maurizio Malabruzzi. The typeface is simply known as Noorda.

11. Italo Lupi and Federico Tranfa, 'Goodbye to Milan's Subway', *Abitare* 490 (2009): 34–37.

12. Giovanni Baule and Valeria Bucchetti, 'Le mutazioni del design della comunicazione', in *La cultura italiana*, vol. 9, *Musica, spettacolo, fotografia, design*, ed. Ugo Volli (Turin: Utet, 2009), 617.

13. See Bob Noorda, Massimo Vignelli and Peter Van Delft, 'Segnaletica dei sistemi di sotterranee', *Rassegna* 3, no. 6 (1981): 76–83. Some Italian examples are Giulio Cittato, who designed an integrated visual navigation system for Venice's water public transportation routes (1977), and Mimmo Castellano, who developed a detailed pictorial system and map of the Aeolian Islands' touristic and travel-related services (1983). For a thorough study of the Italian context, see Andrea Rauch and Gianni Sinni, eds., *Disegnare le città: Grafica per le pubbliche istituzioni in Italia* (Florence: Lcd, 2009), and in particular Mario Piazza's chapter, 'Le immagini della città: Storie di grafica', 137–214.

14. The story of the endeavour to create a standardised wayfinding system and finally impose Helvetica as its typeface in 1989 is recounted in Paul Shaw, *Helvetica and the New York City Subway System: The True (Maybe) Story* (Cambridge, MA: MIT Press, 2011).

15. Albe Steiner, 'Formato cultura: i grafici nel cassetto', *Parete*, no. 6 (1966): 12–15. See Luciana Gunetti and Gabriele Oropallo, 'The Typographic City: Social Commitment and Graphic Design in the Urban Space in Two Late Modernist Italian Projects', *Design Principles and Practices: An International Journal* 5, no. 6 (2011): 491.

16. See Giovanni Anceschi, 'Circostanze e istituzioni della grafica di pubblica utilità', in *Prima biennale della grafica: Propaganda e cultura*, ed. Giovanni Anceschi (Milan: Mondadori, 1984), 5–19.

17. Albe Steiner, *Il mestiere di grafico* (Turin: Einaudi, 1978), 82–86.

18. Gunetti and Oropallo, 'Typographic City', 491–493.

19. Test prints, photographs and all other artefacts documenting the project were donated to the Politecnico di Milano and now form part of the Archivio Albe e Lica Steiner. The materials are still mostly uncatalogued, and the author wishes to thank Dr. Luciana Gunetti for her help in navigating the archive.

20. On Fronzoni's organic unity of design principles and design aesthetics, see Gabriele Oropallo, 'Design as a Language without Words: A G Fronzoni', in Lees-Maffei, *Writing Design*, 205–218.

21. Christian Aichner and Bernd Kuchenbeiser, *A G Fronzoni* (Baden: Lars Müller, 1997), 17.

22. The charter was later published in English and Italian in *Design Issues* 8, no. 1 (1991): 67–73.

23. The idea of the 'designer as mediator' has been revamped in recent years as part of the quest for a form of 'ethical design'. See, for example, Guy Julier, *The Culture of Design* (London: Sage, 2007), 204–207.

24. Umberto Eco, *The Open Work* (Cambridge, MA: Harvard University Press, 1989; originally published in Italian in 1962).

25. Silvia Sfligiotti, 'L'utilizzatore finale non è perseguibile: Progettare per, con o contro l'utente?', *Progetto grafico* 17 (April 2010): 2566–2571. See also Regina Lee Blaszczyk, *Imagining Consumers: Design and Innovation from Wedgwood to Corning* (Baltimore: Johns Hopkins University Press, 2002); and Nelly Oudshoorn and Trevor Pinch, eds., *How Users Matter: The Co-construction of Users and Technology* (Cambridge, MA: MIT Press, 2003), texts that consider the efforts at, respectively, 'imagining' or 'configuring' users in different branches of design.

26. The story of the Helvetica typeface is particularly emblematic of this transition. It was designed in 1957 by Max Miedinger with Eduard Hoffmann, capitalising on the long modernist quest for a neutral typeface, before quickly becoming a corporate favourite and being used in a number of wordmarks. See Lars Müller and Victor Malsy, eds., *Helvetica Forever: Story of a Typeface* (Zurich: Lars Müller, 2007).

PART 4 INDUSTRIES

11 DESIGNING A NEW SOCIETY: A SOCIAL HISTORY OF ITALIAN CAR DESIGN

FEDERICO PAOLINI

Car design has been a powerful force in Italian industry and has also been immensely influential on global design culture. Cars designed and made in Italy have had a profound impact on society both in Italy and internationally, as Italian car designers have designed models for manufacturers all over the world. Rather than focusing on the practice and output of celebrated design consultancies, this chapter offers a social history of Italian car design, providing a survey of how Italian cars have transformed Italian society, from notions of freedom, prosperity and progress to more recent concerns over industrial decline and consumption.

FROM TRICYCLES TO ECONOMY CARS (1900–1953)

The automobile era in Italy is commonly said to have begun in 1894. It was in that year that the Società Motori Bernardi of Padua built the earliest examples of motor tricycles and quadricycles. Eleven years later, in 1905, the designation *autovetture* (motor cars) appeared for the first time in the official statistics: there were then 2,119 cars in circulation.[1] As is so often the case with new technology and small-scale production, the number of manufacturers in these early days was substantial: in the period 1894–1918 there were about forty carmakers based in major cities like Turin, Milan, Florence, Brescia, Ferrara, Genoa, Naples, Padua, Piacenza and Trieste. In addition, the budding car industry also counted a significant number of chassis-makers and over eighty coachbuilders. However, only six of the automobile manufacturers can be said to have operated on an industrial scale: Alfa (1910), Bianchi (1895), Fiat (1899), Isotta Fraschini (1900–1949), Itala (1904–1934) and Lancia (1906). At the turn of the century, no car manufacturer ran its own body workshops. Rather, that task was outsourced to external craftsmen whose skills—often acquired as manufacturers of horse-drawn carriages—brought the classic car to full maturity.

Fiat was the first major company to take a decisive step away from the pioneering craft phase of the automobile industry, soon making it the largest car manufacturer in Italy: between 1900 and 1918 it produced 25,143 cars and 53,426 commercial vehicles. In 1912 Fiat presented a vehicle revolutionary in its bodywork: the Zero, a so-called torpedo design, connecting in a single line the hood, the *coupe-vent* (wind deflector) and the chassis radiator, thus overcoming the traditional separation between the two bodies

of the hood and passenger compartment.[2] With about 2,000 units built in serial production plants (not yet a real assembly line), the Zero helped to popularise the car among the upper middle class, thanks to its price (8,000 lire in 1912 and 6,900 lire in 1913), which was about half the price of other cars of the same type.

Despite its relative affordability, the Fiat Zero was still a far cry from the contemporary Ford Model T in terms of production volume and price, and in Italy the car remained, at least to the end of the 1920s, an item of luxury and leisure. Nevertheless, the automobile secured a place in the public imagination long before mass car ownership, largely due to its spectacular use in competitive sports. It was futurism, however, that made the car a symbol of the incipient 'machine civilisation': the motor, the exaltation of speed and the power of the car became the myths of an industrial society. Think of poetic works such as the 'Canto dei motori' (1912) by Luciano Folgore and 'Zang tumb tuum' by Filippo Tommaso Marinetti (1914), or paintings such as *Velocità di automobile* (1912) by Giacomo Balla and *Dinamismo di un'automobile* by Luigi Russolo (1913).

While Italian cars asserted themselves in the world as artefacts symbolising sumptuousness and stylistic sophistication (for example, the Alfa Romeo RL, 6C 1500 and 8C 2900 A/B; the Isotta Fraschini Tipo 8; or the Lancia Lambda), the press began to call for the development of cars that were affordable for the urban middle classes. Until the first half of the 1920s, only Fiat produced cars that were accessible to a limited section of the middle classes (models 501 and 505 of 1919), fuelling expectations about the commercialisation of an economy car.

In the spring of 1925, the 509 entered production on the assembly line at the Lingotto factory, Fiat's state-of-the-art plant inaugurated two years earlier. The launch of the 509—a relatively small vehicle (3.70 by 1.42 metres, or 12.14 by 4.66 feet) with a three-speed gearbox and a 990 cc engine—marked the beginning of mass motorisation in Italy. In order to encourage sales, Fiat organised a national promotional tour and introduced a system of payment in instalments administered through a dedicated new company called Sava.

Following the recession triggered by the crash of the US stock exchange in 1929, car manufacture was further concentrated. In Italy there remained one large producer (Fiat) and two medium-sized manufacturers (Lancia and Alfa Romeo), besides a small manufacturer (Bianchi) and two luxury brands (Isotta-Fraschini and Maserati). Also in the 1930s, the structural characteristics of the motorisation process were established. At one end of the market stratum Fiat pursued the mass production of affordable, low-powered cars. The objective was to create a mass market for the car, and this was possible only by producing models at a relatively low retail price. At the other end of the market stratum, a group of car-body builders (Bertone, Pininfarina, Savio, Zagato) produced high-quality chassis in small series and established the pre-eminence of Italian car design (Figure 11.1).

At the Salone dell'Automobile di Milano (Milan Car Show) of 1932, Fiat presented an important vehicle in the move towards the democratisation of car ownership: the 508 Balilla. It was a low-cost vehicle (the ordinary version cost 9,900 lire) with low fuel

Fig. 11.1 An Alfa Romeo 8C, with body design by Carrozzeria Touring, at the 2006 Mille Miglia. Photograph by Federico Paolini.

consumption (eight litres per 100 kilometres, or about 29 miles per gallon) and good performance (it reached eighty to eighty-five kilometres per hour, or fifty to fifty-three miles per hour). With the 508 Balilla, Fiat was able to synthesise in an economy vehicle all the principal advancements of the time: an electrically welded all-metal body, noise reduction through the employment of deadening material fitted between the chassis and framework, hydraulic brakes and doors with wind-down windows.

The Balilla (of which about 113,000 units were produced) was still not the 5,000-lire people's car requested by Mussolini to enable private motoring among people in the lower-income segments, however.[3] This remained an unobtainable ideal, but what is commonly considered the first Italian 'people's car', the Fiat 500 A 'Topolino' (the nickname means 'little mouse', which was also the Italian name for Mickey Mouse), was launched in 1936 at a price of 8,900 lire and quickly established itself in the affections of many Italians. Marketed with the slogan 'I too have a car. Fiat 500, the great small vehicle!' it had a double seat (the narrow back seat could accommodate two children or a modest amount of luggage) and a 569 cc engine generating a maximum speed of eighty-five kilometres/hour (fifty-three miles/hour) using six litres of gasoline per 100 kilometres (39 miles per gallon). Designed by the Fiat design department, led by engineer Dante Giacosa, the Topolino was in fact the world's first mass-produced small car. The unique design included a daring technological solution enabling a passenger compartment within a span of scarcely two metres (6.5 feet): a rear engine and the replacement

of the frontal leaf springs (a spring made of a number of strips of metal curved slightly upward and clamped together one above the other) with one sole frontal semi-elliptical leaf spring (Figure 11.2).

Although the Topolino was a commercial success (with over half a million cars built by 1955), Italian automobility remained an elite phenomenon, as confirmed by data on family consumption, which show that the category 'transport and communications' remained essentially marginal for the first forty years of the twentieth century. At the beginning of the 1940s family expenditures were divided thus: 52.06 per cent for food, 12.66 per cent for clothing and footwear, 10.93 per cent for the dwelling, 7.63 per cent for various goods and services, 4.60 per cent for furnishings and kitchenware, 3.75 per cent for transport and communications, 3.37 per cent for tobacco, 3.01 per cent for hygiene and health and 1.99 per cent for fuel and electricity.[4]

With the Fiat 500 A, the car came within reach of the urban middle classes (in theory, at least): the yearly salary of a clerk was 8,538 lire, and that of an usher was 7,226; an attendant had to work eighteen months to save enough to buy a Topolino. The cost of living was not cheap; as a consequence, the car remained a luxury affordable only to a few. In addition to the purchase price, *owning* a car was expensive. A medium-to-small car required an annual expenditure of 3,200 lire for fixed costs (amortisation of capital, insurance premiums, road taxes, garage and parking expenses) and 3,400 lire for running costs (fuel, engine oil, tires, maintenance), for a total of 6,600 lire per year, which in 1936 equated to 77.3 per cent of the annual salary of a clerk and to 112 per cent of that

Fig. 11.2 An Italian soldier and his Fiat Topolino, first half of the 1940s. Image from the Paolini family archives.

of an attendant. Notwithstanding instalment payment plans and the growing second-hand market, the car continued to be an object to be admired in the showroom windows for most Italians.

Even after the Second World War, then, Italy was far from being a motorised country. The car density was still very low: in 1950 there was one vehicle for every 81.9 inhabitants in Italy compared to one car per 48.7 inhabitants in West Germany, per 17 inhabitants in France, per 15.2 inhabitants in Great Britain and per 3.1 inhabitants in the United States.

THE MIRACLE OF THE CAR (1953–1974)

At the beginning of the 1950s, the number of car models aimed at a broader public remained restricted. In fact, the choice was between two pre-war Fiat models in slightly updated versions: the 500 A and B Topolino and the larger 1100 E. A decade would pass before the car industry could offer genuinely new models in new designs—cars that became vehicles of mass motorisation and landmarks in the history of Italian industrial design.[5]

Several factors contributed to this achievement: further improvement of construction technology, especially the adoption of monocoque (single-shell) bodies; closer collaboration between the car industry and coach-building companies resulting from a decreasing market for their niche product: custom-built luxury cars; and, last but not least, the increasing importance of aesthetics in the design of mass-produced cars, creating a more conscious and coordinated identity for the new models. Car design was becoming a mark of social distinction, not just for the wealthy few, but for the masses.

The Fiat 1100/103 (not to be confused with the 1100 E mentioned above) was launched at the 1953 Geneva Motor Show specifically to satisfy the demands of the average Italian family. The 1100/103 featured an engine capable of remarkable performance considering its modest volume (1089 cc) and a compact, rational design characterised by a self-supporting structure with four doors hinged at the centre.

Two years later, also at the Geneva Motor Show, Fiat presented a truly remarkable design—a car that would conquer the Italian car market virtually overnight: the 600, a very small and economical car that nonetheless could accommodate four people, with a rear engine and drivetrain. The highly innovative 600, designed—like all Fiat models of the 1950s and 1960s—under the direction of chief engineer Dante Giacosa, sported a distinct two-volume body design (the first including the hood, spare wheel and a small trunk and the second consisting of the passenger compartment and the motor), a simple four-cylinder engine, independent suspension and no driveshaft (a rear engine and rear-wheel drive).

As if the 600 was not small enough, in 1957 Fiat introduced the Nuova 500. It was very similar to the 600 in many respects, with the significant difference that it was a two-seater, like the old 500 Topolino. Allegedly, Giacosa was inspired by microvehicles such as the Iso Isetta and the Glas Goggomobil (Figure 11.3).[6] At first, the Nuova 500

failed to convince aspiring car owners; it had a peculiar design with the rear roofline deliberately very low, as the car was to carry only two people. Fiat imagined the 500 as an alternative to the scooter rather than a competitor to the 600. The 500 was not that much cheaper than the 600, so many potential buyers decided to save up the little extra needed for the 600. Only in 1960, when Fiat decided to turn the smallest model into a proper car by fitting it with a back seat and upgrading its comfort, did the 500 (mark D) become a commercial success. For the last version (F), the 500 was given a facelift and featured new mechanics; it quickly became the best-selling car in Italy (2,272,092 units were built from 1965 to 1972) (Figure 11.4).

As for cars of a less pedestrian character, one of the most potent symbols of 'made in Italy' was undoubtedly the Alfa Romeo Giulietta (1955–1964). Nicknamed *la fidanzata d'Italia* (Italy's girlfriend), the Sprint version—designed by Franco Scaglione at Carrozzeria Bertone—was characterised by a captivating silhouette and renowned for its speed and handling. In 1963 Alfa Romeo launched the Giulia with the slogan 'designed by the wind'; it represented a new departure in Italian sports car design with its compact, streamlined body with rounded edges and a truncated tail. More surprisingly, perhaps, it also set a new standard in terms of safety. It was the first Italian car to be designed with a

Fig. 11.3 An Isetta (BMW version) at the 2006 Mille Miglia. Photograph by Federico Paolini.

Fig. 11.4 A boy playing with a Fiat Nuova 500, 1975. Image from the Paolini family archives.

view to passive safety; it featured a progressive impact zone, a reinforced passenger compartment, front seatbelts and a steering box that was moved back.

If Alfa Romeo catered to the market for sporty cars, a range of more luxurious models were offered by Lancia. The company's entry-level model, the Appia of 1953, was a direct competitor to the Fiat 1100 but was marketed to a more discerning clientele. Lancia's flagship, the Flaminia, debuted in 1957. Designed by chief engineer Antonio Fessia (the Berlina version) and coachbuilder-cum-design consultancy Pininfarina (the Coupe version), it was the most prestigious car made in Italy and the vehicle of choice of the president, Sophia Loren and Battista 'Pinin' Farina himself. Filling the segments between these models, Lancia introduced two innovative and commercially successful vehicles: the Flavia (1960) and the Fulvia (1963), both designed by Fessia and characterised by a nonconformist style (a square body with rounded edges, double headlights

and a trapezoidal grill) and innovative mechanics (the Flavia was the first Italian car with disc brakes).

But for most Italians, car ownership meant Fiat. As the 1960s drew to a close, the market was completely dominated by the minute models 500 and 600, built in massive quantities. When the Topolino and the Balilla were discontinued, only the 1100 held its own, whereas the new and slightly larger 850, introduced in 1965, quickly became a popular alternative to the smaller models.[7] Despite the predominance of its small vehicles, Fiat did develop a full-size family car: the 1300/1500 (1961/1964). However, in this market segment Fiat faced fierce competition from more sought-after models like the above-mentioned Alfa Romeo Giulietta and Giulia and the Lancia Appia, Fulvia and Flavia.

As these latter, less mundane cars remained the privilege of a wealthy minority, the trade press lamented that Italian car drivers had no real alternative to the small, economical Fiats. The car magazine *Quattroruote* laconically observed the 'unchanging choices of national car drivers'.[8] The magazine ran two questionnaires (in 1958 and 1960) on the topic of 'the ideal car', and based on the results car drivers appear to have been unhappy and dissatisfied with their small cars. The dream car was a five-seat sedan with four doors and a medium-sized engine (1200–1400 cc), fast and well equipped. Asked to indicate their preference for a model on the market, *Quattroruote*'s readers preferred the Citroen DS 19 (1955), designed by Flaminio Bertoni and André Lefèbvre, and the Fiat 1800 (1959), designed by Pininfarina, for the shape of their bodies, while the cars rated most attractive overall were the Fiat 1800 (again); the Alfa Romeo Giulietta Sprint (1954), designed by Franco Scaglione at Bertone; and the Alfa Romeo 2000 (1958), designed by Mario Boano. Whereas Italy was introduced to automobility via the Fiat 500 and 600, Italians aspired to driving larger, faster, more comfortable and prestigious cars.

The years around 1970 saw a radical innovation in the structure of Italian car design. In 1968 Italdesign was founded by designer Giorgetto Giugiaro with the aim of creating an independent specialised centre for car design optimised by the study of production systems and intended for the big manufacturers. The integral design process developed by Italdesign proved more effective than the methods used in the manufacturers' own design studios, and Italdesign soon made its mark on mass-production models. Until then, independent car design companies such as Bertone and Pininfarina had largely been concerned with niche models in small production runs. These structural changes to the design process made Italian car production more varied: from small, innovative mass-produced models such as the Fiat 127 (1971; designed by Pio Manzù, an alumnus of the Hochschule für Gestaltung Ulm, where he studied under tutors such as Tomás Maldonado), the Alfa Romeo Alfasud (Italdesign, 1971) and the Lancia Beta (Centro stile Fiat, 1972), via more moderate models with a more quotidian design, to 'dream cars' with a highly aestheticised design such as the Lamborghini Miura (Bertone, 1966) and Urraco (Bertone, 1973), the Maserati Indy (Vignale, 1969) and Merak (Italdesign, 1972) and the Ferrari 308 (Pininfarina, 1973).

The period of the 'economic miracle' can therefore just as well be called that of the 'car miracle': in 1974 there were 14,303,761 cars on the road in Italy, compared to 612,944 in 1958, amounting to a total growth of 2,234 per cent during this period.[9] In little more than twenty years Italy had closed the gap that separated its car consumption from that of other countries. In 1974 Italy had one car for every four people, equalling Great Britain and West Germany and not far behind France, Sweden, Australia, Canada and the United States.

From a design historical perspective, this massive increase in car ownership can be broken down to reveal a significant trait: its self-sufficiency in national terms. In 1970, 69.64 per cent of cars in Italy were made by Fiat and 13.78 per cent by other Italian manufacturers, whereas the remaining 16.58 per cent were imported. As late as 1974, despite the significant free trade agreements implemented by then, Italian manufacturers still held 63 per cent of the market. For cars with engine volumes between 500 and 1551 cc—representing 90 per cent of all sales—the quota rose to 76 per cent. Between 1959 and 1974 Italian manufacturers built a total of 20,227,409 cars, whereas imports added up to 3,292,881. In the car industry, then, domestic design and manufacture were booming along with the economy in this period.

Still, Italian automobility was, in many respects, inferior to that in other countries. The predominance of small cars has been noted: as late as 1974, 57.91 per cent of all cars had engine volumes smaller than 1000 cc, whereas most cars in other European countries had engine volumes between 1000 and 2000 cc. In addition, Italian cars were old: in 1974 only 27.34 per cent of automobiles had been registered within the past three years, whereas 29.09 per cent had been registered over five years earlier and 25.48 per cent more than ten years earlier.

In fact, cars did not become easily affordable for the majority of Italian families despite the consumption growth of the 'economic miracle'. In 1963 monthly expenditures on a Fiat 500 were estimated at 30,000 lire (49,400 lire for those buying a car in instalments), whereas the average salary was 27,000 lire. In 1973, when the average monthly salary was 84,000 lire, the monthly cost was 34,000 lire for a 500, 40,000 lire for a 600 and 57,000 lire for an 1100. From these data we may conclude that a considerable number of Italian families needed loans in order to acquire a car. In 1963 cars bought via instalment payment plans made up 23.19 per cent of total purchases in the south and 10.55 per cent in the centre and north of Italy. In 1967, 30 per cent of the newly registered cars were bought using instalment plans. At the beginning of the 1970s the sales phenomenon of instalment payment plans extended to 38 per cent of all new cars bought.

In the 1960s and early 1970s the car therefore remained a consumer good available chiefly to the Italian urban middle class. In an Italy transformed by the economic miracle, car ownership reached 44.04 per cent of the families of clerks and executives, 14.49 per cent of farmers and 13.02 per cent of factory workers and farm workers. Despite these modest rates, the car was becoming many families' best friend: a convenient means of transport for the work commute, a new way of organising free time and a facilitator of holidays and weekend outings to the countryside.

A COUNTRY ON FOUR WHEELS: INDUSTRIAL DECLINE
AND A CONSUMPTION EXPLOSION (1975–2000)

From around 1975, Italian car manufacturers began to lose their grip on the domestic market as foreign cars gained popularity. Once Lancia and Alfa Romeo became part of the Fiat Group, in 1969 and 1986, respectively, they lost their identities: their most popular models in this period were neither luxurious nor sporty but quite modest cars in size, performance and price, such as the Lancia Y (1985) and the Alfa Romeo 145 (1994). Fiat's decline was interrupted only by the success of the small Panda (1980), Uno (1983) and Punto (1993). These models marked Fiat's move away from relying exclusively on in-house design: they were all designed by Giugiaro's Italdesign. The Panda was characterised by a remarkably square body and was designed as a cheap, basic car that would be easy to maintain. The Uno, a massive hit in the 1980s, offered a flexible and comfortable interior containing the essentials and a number of innovative mechanical solutions. The Punto broke with the boxy shape of its predecessors to assume a softer silhouette. It featured a highly innovative rear with vertical headlights, a comfortable interior and extensive standard equipment (power steering, an anti-lock braking system, dual airbags, side impact bars, air conditioning, etc.).

As production processes were increasingly standardised from the 1980s onwards, to meet new regulations on safety and fuel consumption, the creative leeway of the designers arguably diminished. Concept cars and custom-built cars thus became an increasingly interesting playground, an arena where experiments in form could be conducted with fewer constraints. The plastic and daring shapes so typical of Italian car design were thus confined to prestigious and luxurious vehicles such as the Ferrari 456GT (1992, inspired by the Ferrari Mythos concept car by Pininfarina) and the Maserati 3200GT (1998, designed by Giugiaro).

All the Italian car manufacturers except Lamborghini were eventually acquired by the Fiat Group (Fiat, Lancia, Autobianchi, Abarth, Ferrari, Innocenti, Alfa Romeo, Maserati), and the Italian car industry appeared unable to compete with French and German manufacturers. Nor was it capable of adjusting its production technology to match that of Asian manufacturers, which were characterised by a flexible and agile production process designed to maximise the skills of each individual worker.[10] But although the number of cars made in Italy was declining steadily, Italian car consumption did not follow suit: the number of cars in use grew from 15,059,689 in 1975 to 32,583,815 in 2000 (an increase of 116 per cent). In 2000 no European country had more cars per capita than Italy: it had one car for every 1.72 inhabitants, compared to one car per 1.96 inhabitants in Germany, per 2.04 inhabitants in France, per 2.30 inhabitants in Spain and per 2.61 inhabitants in Britain. The notion of a car crisis, then, is unfounded. Rather, a structural depression occurred in the Italian car industry, exacerbated by the monopoly production of the Fiat Group, an anomaly quite unique in the world; among the car-producing countries, Italy is the only one where there is a monopolistic system.

Since the early 1990s, the Fiat Group has fallen into a deep crisis for two reasons: its inadequate approach to survival in a global marketplace characterised by ever more aggressive competition and the extra manufacturing diversification strategy that curtailed the development of the car industry at a time when Fiat's competitors undertook major acquisition campaigns.[11] The commercial failure of many Fiat models in the 1990s (for example, Duna, Palio, Marea, Bravo and Brava), along with the poor financial performance of Alfa Romeo and Lancia, only made things worse: the Fiat Group's domestic market share decreased from 56.78 per cent in 1989 to 35.50 per cent in 2000. As a result, Italian automobility has overcome its self-sufficiency: in 2000 for the first time the majority of the cars on Italian roads were of foreign manufacture. Italian car owners have become more 'European' in another sense as well: Italy's long-standing preference for smaller and less powerful cars than those driven elsewhere diminished so that by 2000 the majority (52.48 per cent) of cars in Italy had engine volumes between 1200 cc and 2000 cc.

CONCLUSION: MOTORISED MODERNISATION

In Italy the car has played a dual role: as a driving force of accelerated industrialisation and as an agent of social change. The rapid automobilisation of Italy from the 1950s to the 1970s is intimately linked to the modernisation of society at large and has proved to be of fundamental importance not only for the manufacturing industry and related service sectors but also for the entire Italian economy.[12] The car industry has also played a primary role in planning and in the transformation of the landscape, whether urban, suburban or rural. The large factories of Fiat, Lancia and Alfa Romeo in Turin and Milan attracted thousands of immigrants, who populated the great working-class neighbourhoods located in the suburbs of both of these cities, while the Alfa Sud factory in Pomigliano d'Arco was instrumental in the development of Naples.

In terms of social change, the car soon became a symbolic object not only for the middle classes but also for the working class, to whom it offered the chance to participate in the affluent society that Italians first encountered through Hollywood movies and, subsequently, via advertising slogans whose values were based on the American lifestyle propagated by the press and television.[13] The car provided a level of personal mobility never before known, and, consequently, the organisation of leisure time changed radically: the car provided easy access to the entertainment offered in the city, as well as allowing leisure trips further afield.[14] Reaching holiday resorts by car soon became commonplace: in August the transit on highways was more than double the annual average.

The car contributed to the unification of Italy: while television was breaking down language barriers, physical distances were shortened by the car, collapsing the geographical segregation of remote districts excluded from public transport networks. Domestic tourism flourished, as people looked beyond their *paese* (village) to visit major cities, small remote towns (which in turn became part of a larger network as a result of increased mobility) and the seaside, as well as mountains and lakes off the beaten track.

The car was also a tool of freedom for women, and the youth culture was catalysed by automobilisation, as the car allowed the young to break free from parental control.[15] The new mobility of the young meant they no longer met under the close supervision of adults but rather in discos or leisure resorts, where they made social connections that transcended the network of family or neighbourhood circles. All this represents a true generational watershed since social processes of change took similar paths in both the north and the south.

The car's popularity, therefore, appears closely linked to the fact that it became, in the collective perception, a symbol of prosperity and individual freedom, as opposed to the traditional values of an oppressive pre-war society. In addition, especially for the financially deprived, owning a car was a way of displaying to others the achievement of a higher economic and social status. Italians were convinced that the car was a requirement for a better life: they considered it an indispensable object not only for making personal movement easier but also for acquiring social prestige, which derived not so much from its possession as from the fact that it ensured a dynamic life and faster movement. Ultimately, the success of the car, both historically and in the present day, hinges on the fact that it is a dream machine.[16] Cars are bought not just for mobility but also for pleasure, in order to feel fulfilled and to signify status (Figure 11.5). These consumption processes are not unique to Italy, but there is no doubt that Italian design has contributed greatly to making the car a vehicle of dreams.

Fig. 11.5 Crowd admiring a Ferrari in Florence (Piazza della Signoria, 2006 Mille Miglia). Photograph by Federico Paolini.

NOTES

1. Ornella Sessa, Alessandro Bruni, Massimo Clarke and Federico Paolini, *L'automobile italiana: Tutti i modelli dalle origini ad oggi* (Florence: Giunti, 2006), 39–201; Federico Paolini, *Storia sociale dell'automobile in Italia* (Rome: Carocci, 2007),15–54; and Istat, *Annuario statistico italiano* (Rome: annual editions from 1938 to 1976).

2. See Sessa et al., *L'automobile italiana*, 75–76; and Vittorio Gregotti, *Il disegno del prodotto industriale: Italia 1860–1980* (Milan: Electa, 1982), 102.

3. Mussolini was very pleased with the fact that the Italian car industry had managed to produce a small car two years in advance of the Germans. In Germany the Volkswagen Type I, designed by Ferdinand Porsche, was put into production in 1938. The history of the Volkswagen Type I began in 1934 when Adolf Hitler, convinced that the car should not remain a privilege of the few, asked the German industry to put into production a 'people's car'. Hitler called for the creation of a car capable of carrying five people, or three soldiers and a machine gun. Cf. Alessandro Pasi, *Il Maggiolino: La storia mai raccontata della piccola Volkswagen, dalla Germania degli anni Trenta al Duemila* (Venice: Marsilio, 1996).

4. Cf. Istat, *Statistiche storiche dell'Italia 1861–1975* (Rome: Tipografia Failli, 1976); and Istat, *Sommario di statistiche storiche 1926–1985* (Rome: Grafiche Chicca, 1986). Italy remained a country of pedestrians: 65,484 vehicles were circulating in 1922 (one for every 583.7 inhabitants) and 149,344 in 1942 (one for every 299.2 inhabitants). The spread of the car became a socially relevant phenomenon only in the 'industrial triangle' (Liguria, Piedmont and Lombardy) and in some regional capitals. In 1946, 42.42 per cent of automobiles resided in the 'triangle'. Cf. Paolini, *Storia sociale dell'automobile*, 23–28.

5. Sessa et al., *L'automobile italiana*, 227–477; Gregotti, *Il disegno del prodotto industriale*; and Federico Paolini, *Un paese a quattro ruote: Automobili e società in Italia* (Venice: Marsilio, 2005), 111–187.

6. Cf. Romano Strizioli, *La 500: La piccola grande auto che ha aiutato gli italiani a crescere* (Albenga: Bacchetta Editore, 1990); and Enzo Altorio, *La Fiat Nuova 500* (Avezzano: Automitica, 1993).

7. Fiat produced 2,605,000 units of the 600 (1955–1969), 3,093,649 units of the Nuova 500 (1957–1972), 740,000 units of the 1100/103 (1953–1960), 557,067 units of the 1100 (1960–1963), 600,000 units of the 1300/1500 (1961–1967) and 2,203,380 units of the 850 (1964–1971). Cf. Associazione Nazionale fra Industrie Automobilistiche (Anfia; Italian Association of the Automotive Industry), *L'automobile in cifre* (Rome: annual editions from 1950 to 2004).

8. See 'L'automobilista italiano è costretto a usare vetture economiche', *Quattroruote* (1963); and Paolini, *Un paese a quattro ruote*, 118–128.

9. Anfia, *L'automobile in cifre*.

10. On the decline of the Italian car industry cf. Luciano Gallino, *La scomparsa dell'Italia industriale* (Turin: Einaudi, 2003), 79–94. On international car producers see James P. Womack,

Daniel T. Jones and Daniel Roos, *The Machine That Changed the World* (New York: Rawson, 1990); and Michel Freyssenet, Andrew Mair, Kiochi Shimizu and Giuseppe Volpato, *One Best Way? Trajectories and Industrial Models of the World's Automobile Producers* (Oxford: Oxford University Press, 1998).

11. During the 1990s, Fiat's strategy of increasing the volume of production and growing its global market was threefold: to expand production by opening new plants in different countries, to gain control of other leading car manufacturers and to establish solid joint ventures with some other important producers. Fiat has prioritised the first option over the other two, but in none has it reached its goal. For an in-depth analysis of the Fiat crisis see Gallino, *La scomparsa dell'Italia industriale*, 79–94. See also Valerio Castronovo, *Fiat: Una storia del capitalismo italiano* (Milan: Rizzoli, 2005).

12. Cf. Giuseppe Berta, 'La civiltà dell'auto', in *Vita civile degli italiani*, vol. 6, *Trasformazioni economiche, mutamenti sociali e nuovi miti collettivi* (Milan: Electa, 1991), 14–27; and Valerio Castronovo, *Storia economica d'Italia: Dall'Ottocento ai giorni nostri* (Turin: Einaudi, 2006).

13. On the car and social change see Raymond Flower, *One Hundred Years on the Road: A Social History of the Car* (New York: McGraw Hill, 1981); James J. Flink, *The Automobile Age* (Cambridge, MA: MIT Press, 1988); Tom McCarthy, *Auto Mania: Cars, Consumers and the Environment* (New Haven, CT: Yale University Press, 2007); and Brian Ladd, *Autophobia: Love and Hate in the Automotive Age* (Chicago: University of Chicago Press, 2008).

14. On utilitarian motivations, see Pierpaolo Luzzatto Fegiz, *Il volto sconosciuto dell'Italia: Dieci anni di sondaggi Doxa* (Milan: Giuffrè, 1956); Paolo Guidicini, *Lo studio dei movimenti pendolari come misura del perimetro dell'area metropolitana* (Bologna: Clueb, 1967); and Centro Studi sui Sistemi di Trasporto, *I comportamenti, gli atteggiamenti e le motivazioni del pubblico in relazione alla mobilità e ai trasporti nelle aree urbane* (Rome, 1971).

15. On women and cars see Luca Goldoni, *La donna e l'automobile* (Bologna: Edizioni Calderini, 1963); Luciano Palomba, *Consigli alle guidatrici* (Rome: Automobile Club d'Italia, 1968); Aldo Saponaro, 'Medicina e turismo: Donne al volante', *Le Vie d'Italia* (May 1958); 'All'università in automobile', *Donne al Volante* (May 1962); 'Anche la donna deve avere l'automobile', *Quattroruote* (July 1966); and Paolini, *Un paese a quattro ruote*, 160–170. See also Virginia Scharff, *Taking the Wheel: Women and the Coming of the Motor Age* (New York: Free Press, 1991); and Grace Lees-Maffei, 'Men, Motors, Markets and Women', in *Autopia: Cars and Culture*, ed. Peter Wollen and Joe Kerr (London: Reaktion Books, 2002), 363–370.

16. On consumption see Stephen Bayley, *Sex, Drink and Fast Cars: The Creation and Consumption of Images* (London: Faber and Faber, 1986); Ernest Dichter, *Handbook of Consumer Motivations* (New York: McGraw-Hill, 1964); Giampaolo Fabris, *Il comportamento del consumatore: Psicologia e sociologia dei consumi* (Milan: Angeli, 1970); Karin Sandqvist, *The Appeal of Automobiles: Human Desires and the Proliferation of Cars* (Stockholm: Kommunikationsforskningsberedningen, 1997); Roberta Sassatelli, *Consumo, cultura e società* (Bologna: Il Mulino, 2004); and Emanuela Scarpellini, *L'Italia dei consumi: Dalla Belle Époque al nuovo millennio* (Rome: Laterza, 2008).

12 ESPRESSO BY DESIGN: THE CREATION OF THE ITALIAN COFFEE MACHINE

JONATHAN MORRIS

The espresso coffee machine is one of the most Italian of products. The first machines were produced in Milan at the beginning of the twentieth century, and virtually every successive major development in the design of the machines has occurred within the country. A period of rapid innovation in both design and technology in the decades immediately following the Second World War ended in convergence on a format that has remained essentially unchanged since the 1970s. This has subsequently been adapted to respond to the advent of microchip technology and the explosion in international consumption of espresso-based coffees since the 1990s, enabling Italian companies to maintain a 70 per cent share of the worldwide market for professional espresso machines today.[1]

Sources for researching the history of espresso machines are disparate and require careful interpretation. Manufacturers have become more astute about exploiting their history as a marketing tool, with several privately publishing copiously illustrated volumes including contemporary photographs and operating brochures, while others have put up a wide variety of historical material on their websites. This information is usually unmediated (often undated), with any commentary confined to a hagiographic account of the firm, and frequently unclear about technical details and historical context.[2] There are no functional company archives, although some manufacturers allow access to their collections.[3] The private collector Enrico Maltoni has done the most to make material available to the public through his publications and virtual museum.[4] Much of this collection is now displayed in the Museo di Macchine per Caffè Espresso in Milan, opened by La Cimbali in 2012.

Espresso is best thought of as a preparation process by which coffee is brewed under pressure—with the water being forced or 'expressed' through the coffee—thereby resulting in a faster and more concentrated extraction than that obtained by using the drip and infusion processes exemplified by filter and *cafetière* ('French press') methods respectively. This is an 'express' process in that an espresso normally takes around twenty-five to thirty seconds to prepare, whereas a filter or cafetière coffee requires around four minutes. Consequently, customers can be offered a fresh single cup of coffee that is prepared 'expressly' for them rather than bulk-brewed in advance, thereby reducing freshness and wasting coffee. The speedier service and lower recurrent cost of coffee compensate proprietors for the high initial costs of espresso machines.

The essential elements that have to be combined into a machine are a boiler for heating the water, an operating mechanism for pressurising it and so-called groups into which the water is delivered, onto which the portafilters containing a filter basket of compressed ground coffee can be clamped and then removed. The lower part of the portafilter normally contains two spouts from which the coffee liquor will fall into cups resting on a drip stand. Most machines also incorporate at least one steam wand for preparing hot milk, as well as a direct hot water outlet. The task of the designer is to integrate these various elements within a form that best suits the various users of the machine.

For the operator—the so-called barista—the key requirement of a machine is probably that it fits well with his or her 'choreography' for preparing coffee. The controls need to be easily usable and accessible, preferably in such a way that a minimum of movement is required within the workspace to produce the beverage. For the bar customer, the machine should, at least subconsciously, contribute to the ambience and furnishings of the outlet. The aesthetics of the machine—its decoration and styling—may provide a focal point of attention within the space. Displaying the theatricality of the preparation process, however, is equally a way of catching the customer's eye and demonstrating the degree of attention that goes into the preparation of each beverage.

From the proprietor's perspective, the machine must work within the physical and economic constraints of the enterprise. Its physical footprint will play a considerable role in assessing its suitability for a particular location, while the machine's price will be related to technical quality, not just in terms of the coffee output, but also with regard to the proprietor's willingness to invest in training baristas to the level necessary to operate it.

The initial purchasers of most machines, however, are not the users mentioned above but distributors and roasters who provide and maintain coffee machines for bars, often as part of an exclusive coffee supply contract. Durability, reliability, the use of compatible components across a range of models and the provision of easy access to the machine's interior are all critical factors for these customers.

UPRIGHT BEGINNINGS

The first machine able to deliver coffee in accordance with all three elements of the espresso concept—a single cup swiftly brewed under pressure at the moment of ordering—was the La Pavoni Ideale, first manufactured in 1905 and exhibited at the Esposizione Universale di Milano (world's fair) of the following year.[5] (See Figure 12.1.) Water was heated in a large upright boiler that trapped steam at the top, building up pressure on the hot water underneath it. When a tube leading from the main body to the group was opened by the operator, the water was forced through the coffee held in the portafilter clamped to the group head. A second inlet tube in the top of the boiler could be opened to flush steam directly into the group head, supplying extra pressure, completing the extraction and 'drying' the spent coffee grounds, making it easier to clean out the filter. The operating instructions suggested that the steam control be activated after a third of the beverage had been delivered.[6] Delivery took around forty-five seconds under pressures of

around 1.5 bars, with the resultant beverage having the form and appearance of a more concentrated demitasse of filter coffee.

The Ideale was constructed from copper and brass and housed in a nickel-plated cylindrical dome with a bell-like base. The boiler was usually gas-fired (although electric models were also available) and came in four sizes with a boiler capacity from 12 to 50 litres (about 3 to 13 US gallons), with the standard 40-litre (10.5-gallon) model weighing in at an imposing 74 kilograms (164 pounds). There were two finishes—standard and luxury; the latter, shown in Figure 12.1, replaced the simple manufacturer's plate displayed on the casing with an embossed colour emblem of two peacocks (*pavoni* in Italian) and a combination of Greek fret and foliage decorations on the top of the dome. The machine was placed on the front counter of the bar with the emblem facing out into the room, the operating controls (including the pressure gauge and steam wands) facing towards the barman, and one group head extending from each side of the machine, enabling the customer to watch the coffee being delivered into the cup.[7]

The Ideale was based on two patents deposited by Luigi Bezzera, a Milanese engineer, in 1901 and 1902, the second of which he transferred to Desiderio Pavoni, proprietor

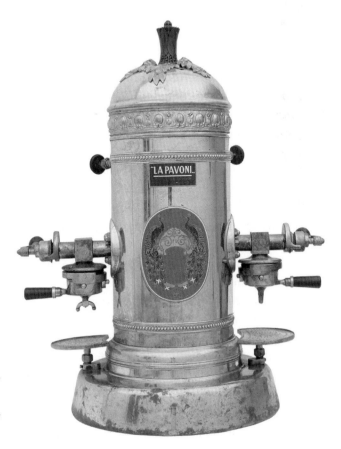

Fig. 12.1 La Pavoni Ideale, first manufactured in 1905; this model with a luxury finish is from circa 1910. Courtesy of Collezione Enrico Maltoni.

of several hospitality and leisure enterprises, including the Caffè Commercio, located in Milan's central square, Piazza Duomo.[8] Pavoni clearly realised the potential value of Bezzera's machine as both an operating tool and a decorative object within the new so-called American bars, which adopted a format that had evolved on the other side of the Atlantic, where barmen prepared and served beverages directly to customers standing on the other side of an enclosed counter. These were particularly popular among the business elite, whose prosperity had increased during the long era of economic growth experienced in Italy during the early twentieth century. By 1912 Pavoni had sold some 10,000 machines, while Bezzera also continued to produce machines based on his first patent.

Other manufacturers soon entered the market, with the number of patents filed for coffee-making devices in Italy tripling between 1911 and 1914. By 1930 sixteen companies listed themselves as manufacturers of coffee machines within the commercial guide to Milan and the surrounding area, with a further seven known to be in existence elsewhere in Italy.[9] Most were small workshops that combined the manufacture of coffee machines with the production of other items—for example, a catalogue for the Snider brothers, one of the Milan firms active in this era, included electric mixers, juicers, coffee grinders and toasters as well as coffee machines.[10] The exception was La Victoria Arduino of Turin, which employed around sixty workers in its factory in the mid 1920s, having developed an extensive international sales network. Beyond Italy, companies such as Reneka in France and WMF in Germany had also begun producing steam-based, pressure-brewing machines.[11]

As the fundamental form and functioning of the espresso machine remained similar throughout this era, the styling of the machines was the principal channel by which manufacturers communicated their individual identities. Sometimes this involved constructing subtle messages: for example, a figurine of a Venetian lion bestrode the domes of the San Marco 'Serenissima' range of machines, which were actually produced in Udine. Adopting the dominant aesthetic of the time was a simple way of suggesting modernity, so many manufacturers incorporated the statuary and foliage of the liberty era—the Italian variant on art nouveau—before adopting the cleaner lines and geometric patterns of art deco. During the 1930s at least three companies—Universal, Carimali and Rancilio—released models they dubbed 'Octagonale', featuring an eight-sided, flat-topped, geometric casing. Some, such as Arduino and Cimbali, took this one step further, launching so-called Littorio models that adopted the stark, militaristic Fascist aesthetic: the cylinder of the Rancilio Littorio model, for example, resembles a submarine conning tower.[12]

Fascism, however, held back the development of the espresso machine. The regime was ill-disposed to luxury imports such as coffee, and as early as 1926 it introduced a temporary ban on the installation of machines in order to improve the balance of payments. Consumption levels per capita declined steadily during the depression that followed the Wall Street crash of 1929, and several manufacturers went bankrupt.[13] Although there were some attempts to adapt to the needs of smaller premises (in terms of both physical

size and frequency of use) by manufacturers such as Snider and Eletta, who developed machines without integrated boilers, heating the water electrically for each shot and exploiting the pressure at which it was delivered from the main, many innovations were never pursued commercially as a result of the prevailing political and economic climate.[14] It was only well after the fall of the regime that a series of revolutions in espresso machine design could begin.

HORIZONTAL REVOLUTIONS

The first collaboration between a manufacturer and an external designer was initiated immediately after the end of the Second World War when La Pavoni turned to Gio Ponti. The division of responsibilities within the design process was made clear in a letter from Antonio Pavoni (presumably the son of Desiderio) to Ponti, which explained that a 'new machine is currently being worked on from a "technical" point of view. I shall therefore soon have the privilege of asking for your valuable contribution for its aesthetics'.[15] The connection between the two lasted for over a decade despite many indications of significant tension in the relationship stemming from the designer's almost dictatorial conduct—demanding that the company purchase exhibition space at the Milan Triennale of which Ponti was one of the organisers, denouncing Pavoni for 'disobedience' when elements were not produced to Ponti's exact specifications and warning that 'if you carry on this way, Cimbali will always beat you'.[16]

That Pavoni was prepared to tolerate Ponti's tantrums is testament to the quality of the work he produced, starting with the machine officially known as the D.P. 47—the number refers to the year the first prototype appeared—which entered into production in 1948 (Figure 12.2). The revolutionary idea at the heart of the design was to mount the boiler on its side so that it ran parallel to the countertop. It is not clear whether the idea of reorienting the boiler came from Pavoni or Ponti: indeed, Giuseppe Bambi of La Marzocco in Florence first registered a patent for a machine with a horizontal boiler in 1939, although again this never entered production.[17]

The beautiful sinuous styling of the gleaming, chromium-plated machine, lacking any external decoration except a stamped manufacturer's name, was clearly the result of Ponti's intervention, however. The group heads were positioned on the underside of arms attached to the top of the cylindrical casing and curving backward towards the operator, earning the machine the nickname 'La Cornuta'—'the horned one'. The cups were positioned underneath these on a rectilinear drip tray mounted on top of a box housing the controls, attached to which were steam wands projecting over the back of the countertop, allowing the barman to hold the pitcher in the space below them. The reorientation of the boiler meant that the height of the machine was only 49 centimetres (about 19 inches), making it easy to see over, while it fit easily onto a standard bar, with a depth of 32 centimetres (about 13 inches). The machine's length was determined by the overall capacity and number of groups—from 54 centimetres (about 21 inches) for the two-group Lilliput to 100 centimetres (about 39 inches) for the four-group Gigante.[18]

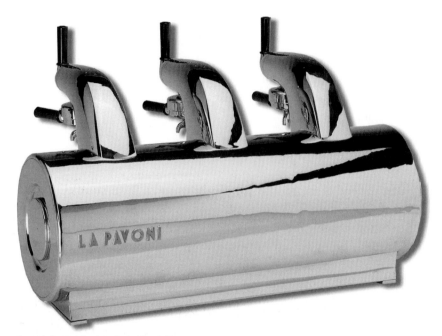

Fig. 12.2 La Pavoni D.P. 47, 1947, designed by Gio Ponti. Courtesy of Collezione Enrico Maltoni.

An unsigned piece in *Domus*, the design magazine edited by Ponti, extolled the sleek appearance of the machine, in which

> all the protruding and entangled devices have been hidden or eliminated, reducing the apparatus to three simple and distinct main elements—casing, central body, groups—which share the same perfect simplicity in their form as that achieved by certain wind musical instruments.[19]

Pavoni's publicity highlighted its practical advantages:

> We have achieved what we wanted and what you asked us for. By providing total visibility, we have been able to satisfy the desire of our clients to exercise complete control over the coffee making process. The form of the machine also permits the operator to see the customers without the necessity of moving from his working position.[20]

The D.P. 47 is often referred to as the most beautiful of all industrial espresso machines, as well as one of the most significant in design terms, yet it was not the most revolutionary machine to enter into production in 1948. That was the Gaggia Classica, the machine that transformed the very parameters of what was meant by espresso itself (Figure 12.3).

Achille Gaggia, like Pavoni before him, was a bar owner from Milan with a particular interest in coffee, who set out to resolve the problems of over-extraction that resulted from the use of steam to pressurise the hot water during delivery. Gaggia had already begun working on this prior to the war, purchasing a patent for a screw piston in 1938,

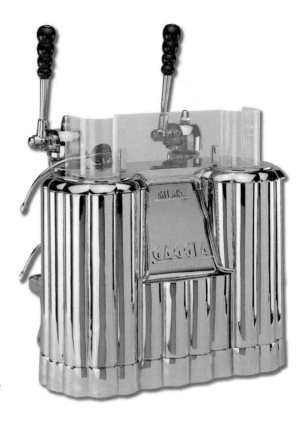

Fig. 12.3 Gaggia Classica, 1948. Courtesy of Collezione Enrico Maltoni.

to which he added a rotatable handle to produce a group that could be attached to the boilers on other machines. In 1947 he filed a new patent for a group that incorporated a coiled spring connected to the piston.[21] The barman depressed a lever, which raised the piston, allowing water from the boiler into the group. Upon release, the spring depressed the piston with considerable force, blasting the water through the coffee under much higher pressure (varying from three to twelve atmospheres over the course of the delivery). The resultant beverage was capped with a mousse or emulsion that became known as *crema*.

Crema is now considered to be the key visible characteristic of an espresso coffee. At the time, however, the beverage was such a departure from the previous incarnation of espresso that it was given a new name, *crema caffè*—literally, 'cream coffee'. By eliminating the use of steam, Gaggia was able to lower the brewing temperature and avoid burning the coffee. The taste in the cup was much more intense than previously, and the coffee was delivered in a shorter shot, while the original black, bitter brew was replaced by a hazelnut brown beverage with a creamy, full-bodied mouthfeel. Keen to highlight the crucial difference between his machine and those of his rivals, Gaggia adopted the advertising slogan 'Natural cream coffee—it works without steam', ensuring that all or part of this claim was visible on the machines themselves.

This was important, not least because the actual coffee-making process was now largely hidden from the view of the customer. The original Gaggia machines still contained upright boilers, albeit significantly reduced in size due to the smaller amounts of steam required (separate steam wands drawing directly from the top of the boiler were incorporated into the machine). The boilers were encased in pleated chrome 'moderne'-style casings, which perhaps invoked the theatrical curtains of the cinema, suggesting the spectacle that was taking place behind them.

Other manufacturers immediately realised the significance of Gaggia's reinvention of the espresso-brewing process. The first Pavoni model to offer the possibility of preparing crema caffè was the D.P. 51. The new model housed a horizontal boiler in an elevated box with the group heads positioned beneath it, over a drip tray on which were positioned the cups. Ponti explained to Pavoni that he had 'applied to it the invention I started mentioning to you a year ago: the possibility of transforming the look of the machine by changing the colour, ornamentation, decoration, light and branding in line with the client's wishes'.[22] He instructed Pavoni to produce interchangeable front panels for the machine of either anodised aluminium, with finishes in silver, colours or plated gold, or crystallised plate glass that could be coloured, mirrored, engraved or branded. As the publicity material for the D.P. 51 explained, this enabled 'every bar, café or restaurant to match the machine . . . to the character of the environment' in which it was placed.[23]

Ponti regarded designing coffee machines as emblematic of the challenges of creating an Italian aesthetic for the industrial era. In 1956 he persuaded Pavoni to collaborate with *Domus*, *Casabella* and *Stile Industria* to launch a 1 million lire competition for a new coffee machine to be manufactured by the company. The competition rubric articulated Ponti's conviction that 'in the coffee machine especially, the search for a new style often results in excessively decorative shapes, far from addressing the real, more serious and complete problems of the design of the machine'. These reflected the needs of serial manufacture and included the simple and rapid assembly of the components, fewer moulded parts, simpler joins between the essential elements, a reduction in costly finishings and the use of materials best suited to obtaining technical and aesthetic results that would evoke those principles of 'nobility and simplicity' that defined Italy's industrial design.[24] The rubric captured the way that industrial design was evolving into a holistic process, rather than the styling of a pre-existing prototype.

The winning design was by Bruno Munari and Enzo Mari. Its key feature was that the chassis was assembled from a variety of plates of stamped sheet metal that could be combined in various ways to create machines of different lengths and colour combinations.[25] Instead of a flat panel facing the customer, there were now prism-head projections accentuating the colourful geometric patterns formed on the front of the machine, resulting in the nickname given to the machine: the *diamante*, or diamond.

The need to produce spectacular machines that called attention to themselves within the bar environment led many other manufacturers to bring in external designers. Rancilio, for instance, began collaborating with Giovanni Travasa, with the first results

appearing in 1957 in the shape of the Alpina and Ducale, upright and horizontal machines respectively, whose angular front panelling featured the use of coloured plastics.[26] The Simonelli company, based in the Marche, turned to Paolo Castelli to design the Eureka, a horizontal machine with a decorative front panel in embossed copper and brass hand-milled by students in the School of Arts and Crafts in the factory's home town of Tolentino.[27]

Technological innovation also continued apace. The operation of Gaggia's spring-loaded piston required considerable physical effort on the part of the barista. Cimbali sought to address this by using a hydraulic system (harnessing the mains water pressure) to provide the motive power to operate the lever. The model usually associated with this is the 1956 Gran Luce, but other manufacturers soon developed similar approaches in machines such as Simonelli's 1957 Selene and, to judge from its handle, the curvaceous San Marco model—known as the 'Lollobrigida'—which featured an elevated cylinder that protruded at either end from a central curving decorated pillar, no doubt presenting customers with the striking profile that inspired the nickname.[28]

This rapid progress reflected broader developments in Italian society. During the 1950s, industry overtook agriculture as the largest sector of the Italian economy, resulting in a massive migration from the countryside to the city. This, in turn, resulted in a boom in the number of bars, which provided migrants with spaces to socialise outside their

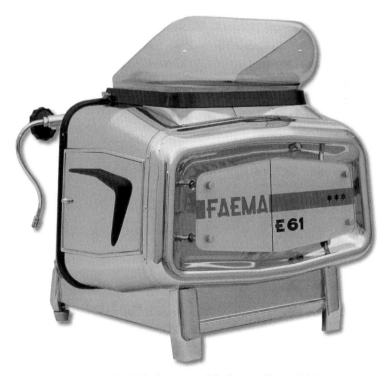

Fig. 12.4 Faema E-61, 1961. Courtesy of Collezione Enrico Maltoni.

overcrowded accommodations. Taking a coffee at the bar was popular for two reasons: first, it was one of the cheapest beverages on offer; second, crema caffè tasted significantly different from the coffee Italians prepared at home using the stovetop Moka pot. The Bialetti Moka was first produced in the 1930s and went on to become ubiquitous in post-war Italian kitchens, as the economic miracle resulted in a 1960s consumer boom and coffee consumption soared.[29] This may indeed have been another stimulus to the technological innovation within the bar-machine sector, given that the Moka pot effectively operated using the same steam-brewing techniques as the pre-war vertical espresso machines.

The cluster of leading manufacturers in the Milan area enjoyed easy access to the major design studios of the city, which resulted in a very fast process of knowledge exchange, as personnel moved from one company to another, while Italian patent law seemed unable to prevent competitors from quickly adopting and exploiting new developments. By the end of the 1950s nearly all of the manufacturers were producing horizontal machines capable of delivering crema caffè, increasingly incorporating a hydraulic lever. Yet these too became outmoded in 1961, when the Faema company released its E-61 model (Figure 12.4).

CONTINUOUS CONVERGENCE

Established by Carlo Valente in 1945, Faema produced a variety of domestic and light industrial electrical apparatuses and was contracted by Gaggia to manufacture his first machines. The arrangement continued until 1952, but Gaggia and Valente appear to have fallen out over the future direction of the product. Whereas Gaggia wanted to continue making an upmarket artisanal product, Valente wanted to create models that could be produced (and sold) in industrial quantities. Faema moved into independent production and over the decade began incorporating a variety of innovations into their machines—hydraulic levers, a thermostat regulating the water temperature, a heat exchanger and, in the case of the E-61, an electrical pump that enabled the barista to operate the machine with a simple on/off delivery switch. As the barista no longer supplied any element of the motive power for delivery, the machine was described as 'semi-automatic'.

The E-61 was also described as the first to offer so-called continuous erogation; that is to say, it enabled the brewing of coffee without interruptions. This was achieved by drawing the water supplying the group directly from the mains, pressurised by the pump; it then passed through the heat exchanger that was situated within the boiler (maintained at a regular temperature by the thermostat), before passing through the coffee into the cup, so there was no need to refill or reheat the boiler itself. Faema claimed that the E-61 could produce two coffees in twenty seconds, compared to the thirty-five seconds needed by a hydraulic lever machine, and the forty seconds of a manually operated one. Faema claimed the machine produced 'coffee with a new taste' by maintaining a constant nine bars of pressure and a temperature of ninety degrees Celsius (194 degrees Fahrenheit) throughout the delivery: parameters that remain standard for the production of espresso today.[30]

The machine featured a horizontal boiler mounted within an elongated casing, in editions with one to six groups, so that its overall length varied from 550 to 1600 millimetres

(about 21.5 to 63 inches). The depth on the counter was a mere 458 millimetres (about 18 inches), while the height was 565 millimetres (about 22 inches), making it easy to engage with customers over the top of the machine. The front panel facing the customer was finished with a simple coloured plastic frontispiece that gave the machine a some-what 'pop' look, anticipating the trends of the 1960s.

Espresso machine design also experienced a significant step forward in 1962 with the entry into production of the La Cimbali Pitagora, designed by Achille and Pier Giacomo Castiglioni, which won the Compasso d'Oro in that year.[31] (See Figure 12.5.) The ma-chine established a rational, mass-manufactured aesthetic form that continues to domi-nate the look of commercial espresso machines today. It was housed in an austere, boxy unit into which all the working elements were fully recessed, with a cup-warming tray mounted on the top. The casing was assembled from a combination of satin stainless steel and screen-printed coloured metal panels, produced in standard sizes that could be as-sembled into different model configurations depending on the number of groups desired.

The company's presentation of the model in the submission to the jury emphasised the way in which the design facilitated easy maintenance, and the close collaboration between the designers and the client throughout the design process:

> The main parts of the housing mechanisms can be dismantled easily for inspection or servicing: the body of the machine itself can be turned completely upside down or removed. At any time it is possible to have access to the working parts of the machine without switching it off (the technicians who service the machines are often called in when a bar is open to the public). The Castiglioni brothers now know every part of the espresso coffee machine and the way each is made.[32]

The machine was recognised by the jury, led by Battista 'Pinin' Farina, for its 'significant achievement . . . with regard to the responsibility for designing a product for collective consumption'.[33]

Over the next decade or so, commercial espresso machines converged towards the technical specifications introduced by the Faema E-61 and the design form established by the Pitagora, in much the same way as they had sought to combine Gaggia's tech-nological advances with Ponti's design innovations during the 1950s. Faema equipped

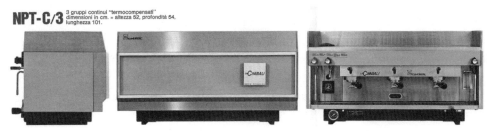

Fig. 12.5 La Cimbali Pitagora, 1962, designed by Achille and Pier Giacomo Castiglioni. Courtesy of Gruppo Cimbali.

its E-64 and E-66 Diplomatic models with recessed workspaces echoing that of the Pitagora, while La Cimbali collaborated with designer Rodolfo Bonetto on a series of machines, beginning with the M15 in 1970—an oblong machine with a red coral casing that incorporated the use of an electrical pump similar to Faema's. Rancilio too had begun using pumps in their machines by the later 1960s, and in 1971 turned to Marco Zanuso to design the Z8, another box-like industrial structure, this time protected by brightly coloured honeycombed durable plastic.[34]

ENDURING DESIGN

The essential form and function of the commercial espresso machine have remained largely unchanged since the 1970s. Most of the focus has been on simplifying the machines for serial manufacture, as with the creation of modular machines that can, in effect, be assembled by slotting self-contained cell-like structures next to each other. Early examples included the 1969 Faema Prestige and Metodo models designed by Osvaldo Carrara, featuring five different coloured casings made of Makrolon—a durable thermoplastic material developed by Bayer.[35] During the 1970s, however, the emphasis on attention-grabbing casings declined, as the machines themselves increasingly became simple tools positioned on the back counter, their flat front panels now facing into the wall. This allowed other potential items for purchase (for example, pastries) to be displayed on the bar and provided more room for customers to consume their coffee while standing there.

Subsequent technological modifications to the machines have essentially been aimed at refining, rather than rethinking, the brewing process. Although the advent of microchip technology led to the development of 'automatic' machines in which delivery is controlled by regulating the volume of water in the dose, it has mostly been used to hand back greater control of the brewing process to the barista by, for example, enabling him or her to set different temperatures at each group head. Over 90 per cent of the output of Italian manufacturers is still devoted to so-called traditional machines (semi-automatics and automatics), as opposed to the predominantly Swiss-made 'bean-to-cup machines' that integrate all aspects of beverage production from grinding beans to foaming milk.

With around 75 per cent of those Italian machines now being exported, however, some design refinements have had to be made. The height of the machines has been increased to enable the group heads to accommodate the larger cup sizes that are common in those markets outside Italy that prefer milk-based beverages such as cappuccino and caffè latte. This has necessitated the introduction of a pull-out shelf so that small espresso cups can still be positioned close enough to the spouts in the portafilter to avoid splashback and excessive cooling during the delivery descent. Cimbali's 1999 M32 Dosatron has a 'Tall Cups Version', for instance, that also features a turbosteam wand that foams large quantities of milk before cutting out automatically.[36]

The increase in height has reinforced the tendency to position the machine on the back counter, so the working area of the machine has now become more stylised with softer

curves to the casing and luminous electronic display strips enabling branding messages to be placed above the eye-level control panels. This enables customers to see the barista at work, thereby demonstrating that the coffee beverages are still being 'handmade' on a traditional machine. The machine no longer communicates visually with the customer— rather, it creates the stage in which the theatre of coffee preparation takes place.

By remaining attentive to the shifting requirements of users, both within Italy and beyond, manufacturers have successfully adapted the format of the traditional machine to fit the contemporary market. That they have been able to do so is testimony to the remarkable period of creativity between 1948 and 1962, when a confluence of ideas between engineers and designers resulted in a reimagination not just of the espresso machine but of Italy's iconic coffee beverage itself.

NOTES

1. This is the estimate most commonly cited within the industry. Email correspondence with Maurizio Giuli, marketing director, Nuova Simonelli, July 11, 2012.
2. The main examples used here are Franco Capponi, *La Victoria Arduino: 100 anni di caffè espresso nel mondo* (Belforte del Chienti: WIP Editoriale, 2005); Elena Locatelli, *La Pavoni: Dal 1905 macchine per il caffè* (Milan: Pavoni, 2005); Isabella Amaduzzi, *Rancilio e le sue macchine* (Parabiago: Rancilio, 2003); Decio Carugati, *La Cimbali* (Milan: Electa, 2005); Enrico Maltoni, *Faema Espresso 1945–2010* (Faenza: Collezione Enrico Maltoni, 2009); and Maurizio Giuli, ed., *Nuova Simonelli and Its Roots* (Belforte del Chienti: Srl, 2011).
3. Officina Rancilio 1926 in Parabiago (http://www.officinarancilio.com) was the nearest to a company museum open to the public until La Cimbali opened MUMAC.
4. Enrico Maltoni, *Espresso Made in Italy, 1901–1962* (Forlimpopoli: EM Edizioni, 2001). The virtual museum at http://www.espressomadeinitaly.com includes illustrations of many of the machines mentioned in this chapter.
5. Ian Bersten, *Coffee Floats, Tea Sinks: Through History and Technology to a Complete Understanding* (Sydney: Helian, 1993), 99–106, provides an introduction to the prehistory of the espresso machine. See also Capponi, *La Victoria Arduino*, 3–7.
6. The operating instructions are reproduced in Locatelli, *La Pavoni*, 44.
7. Locatelli, *La Pavoni*, 13–27.
8. Bersten, *Coffee Floats*, 261.
9. Franco Capponi, 'Espresso Coffee Machines and Their History', in Giuli, *Nuova Simonelli*, 256–258.
10. The catalogue is reproduced in Maltoni, *Espresso Made in Italy*, 35.
11. Bersten, *Coffee Floats*, 116.
12. Images of the machines or reproductions of the manufacturers' publicity are found in Maltoni, *Espresso Made in Italy*, 32–33, 46–47, 49. The Cimbali museum contains its Littorio model, while images of the Rancilio can be found in the 'La Collezione' file, Officina Rancilio, 1926.

13. Jonathan Morris, 'Making Italian Espresso, Making Espresso Italian', *Food and History* 8, no. 2 (2010): 152–155.

14. Maltoni, *Espresso Made in Italy*, 35–37, 43; see also Bersten, *Coffee Floats*, 111; and Capponi, 'Espresso Coffee Machines', 261.

15. Pavoni to Ponti, May 9, 1949, La Pavoni Museum, 'Historic Correspondence', image 8, http://www.lapavoni.it/museo.asp (accessed December 24, 2012).

16. Ponti to Pavoni, November 5, 1950, April 26, 1951, and December 12, 1950, La Pavoni Museum, 'Historic Correspondence', images 12, 17, 13.

17. Piero Bambi, *La Marzocco: Coffee Machines for Use in Bars* (Florence: Marzocco, 2001), 11.

18. Locatelli, *La Pavoni*, 69.

19. 'Forme', *Domus* 228 (September 1948): 50.

20. Pavoni D.P. 47 publicity pamphlet, in Maltoni, *Espresso Made in Italy*, 62.

21. Bersten, *Coffee Floats*, 115–118.

22. Quoted in Locatelli, *La Pavoni*, 82–84.

23. D.P. 51 publicity pamphlet, in Maltoni, *Espresso Made in Italy*, 72.

24. Advertisement, *Domus* 320 (July 1956): 63–64.

25. Giampiero Bosoni, 'Le macchine di caffè', in *Il disegno del prodotto industriale: Italia (1860–1980)*, ed. Vittorio Gregotti (Milan: Electa, 1982), 337.

26. Amaduzzi, *Rancilio*, 65–69.

27. Alessandro Feliziani, '1936–2011, Seventy Five Years "Expressed" with Passion', in Giuli, *Nuova Simonelli*, 160.

28. See Maltoni, *Espresso Made in Italy*, 92; Carugati, *Cimbali*, 46; and Feliziani, '1936–2011', 156–161.

29. Morris, 'Making Italian Espresso', 158–163, discusses the social factors behind the growth in coffee consumption between the 1950s and 1970s. On the Bialetti Moka Express see Jeffrey T. Schnapp, 'The Romance of Caffeine and Aluminium', *Critical Inquiry* 28, no. 1 (2001): 244–269.

30. Maltoni, *Faema*, 23–27, 222–245.

31. Carugati, *Cimbali*, 76–84, covers the Pitagora.

32. Ibid., 83.

33. Ibid.

34. Maltoni, *Faema*, 27, 248–257; Carugati, *Cimbali*, 96–105; and Amaduzzi, *Rancilio*, 106–117.

35. Maltoni, *Faema*, 27, 313–316.

36. Carugati, *Cimbali*, 122–123, 131–132. For more details on how the growth of the international market has affected machine design see Jonathan Morris, 'The Espresso Menu: An International History', in *Coffee: A Handbook*, ed. Robert Thurston, Jonathan Morris, and Shawn Steiman (Boulder, CO: Rowman and Littlefield, 2013).

13 ITALIAN FASHION: THE METAMORPHOSIS OF A CULTURAL INDUSTRY

SIMONA SEGRE REINACH

Italian fashion is generally given two birth dates: one in the 1950s, when Italy freed itself from Paris through the invention of the fashion boutique in Florence, and the other in the mid 1970s, with the invention in Milan of the Italian notion of fashion designers. It is difficult to go further back, unless it is to myths of the Renaissance and the associated 'craft workshop', to which the variety and wealth of Italian fashion are usually and indiscriminately traced. An in-depth look at the history of Italian fashion, though, reveals a development made up of continuities but also, and above all, of discontinuities.[1] Among the elements of stability we find the production of quality textiles, wools, velvets and silk, as well as craftwork competences, such as Tuscan and Pugliese embroidery or shoe manufacturing in the Marche, and the many variegated local traditions of production and transformation (processing). In the Italian case, fashion is also produced in the provinces; there, according to Elsa Danese, a competent fashion consumer culture is inevitably created.[2] The discontinuities in the history of fashion, on the other hand, show us specific cultures of fashion, real models for production and consumption characterising the vicissitudes of fashion from the early twentieth century till the present day.[3]

It is difficult to identify an Italian fashion in the first half of the twentieth century; French inspiration informed women's fashion, while British models prevailed for menswear. Elsa Schiaparelli and Mariano Fortuny are exceptions. The Spanish-born Fortuny's work was closer to art than to fashion, and Schiaparelli was an Italian designer who based her professional life in Paris.[4] For this reason, despite numerous points of excellence in various sectors, like the brands Ferragamo[5] and Gucci, until 1950 we may refer only to isolated episodes in the history of fashion in Italy, rather than to a coherent and continuous history of Italian fashion. The autarkic phase under Fascism had no repercussions either for the international perception of Italian fashion or for the promotion of the genuine development of the clothing sector, with the exception of research into synthetic fibres.[6]

Only from the early 1950s, therefore, did Italian fashion achieve international recognition.[7] With the 1951 fashion shows organised by Giovanbattista Giorgini in Florence, Italian fashion took its place on the European circuit, and above all in the United States. The result was Italian style, identified with the codes of aristocratic elegance but also with a simplicity of attitude, the recherché elegance of the fabrics and artisanal competences,

based on the unrealistic aims of the Fascist period. The 1950s were also a decade of growth for Italian industry.[8]

Florentine success created the basis for and developed opportunities that were fully realised only in the 1980s. Then, a new prêt-à-porter, or ready-to-wear fashion, emerged that was aesthetically attractive, stylistically and structurally independent of haute couture and of France, and completely different from both French *prêt-à-porter de luxe* and Florentine boutique fashion. Italy thus confirmed its engagement with fashion as a language of mass culture.[9]

The current period is taking shape as a realignment and redefinition of Italian and transnational production and stylistic potential, in a broader context created by the globalisation of markets and consumption. Milan's central role has been challenged on the one hand by the failing viability of the fashion designer system and on the other by the re-emergence of competences and experimentation in many other places in Italy, such as Puglia, Emilia Romagna and the Veneto. However, Milan is reasserting its status as a fashion city with research into and promotion of a different kind of fashion in Italy.[10]

THE 1950S: BOUTIQUE FASHION IN FLORENCE

In the period after the Second World War, closer relations between Italy and the United States (see Jeffrey T. Schnapp's contribution to this volume), which had made a decisive intervention in the war, also led to the relaunch of the Italian textile and clothing industry. Not only did the United States support economic recovery financially through the Marshall Plan, but a privileged relationship was also set up, together with a cultural interdependence between the two countries. The official date of birth of Italian fashion was February 12, 1951, when Giorgini organised a fashion show of Milanese and Roman couture houses in his home in Via dei Serragli (later events were held at the Palazzo Pitti). The press, the public and department store buyers attended, along with American journalists whom, thanks to his personal acquaintances and his already established business activity in the United States, Giorgini brought to Florence, taking advantage of their customary presence at the haute couture shows in Paris, with the purpose of enabling them to appreciate Italian national production.

After the Second World War, European and especially American consumers were ready for an offer less strict than haute couture. The quality of fabrics and manufacturing and the prices were the features that the United States appreciated in Italian production. These were presented within a frame of prestige that, although different from the French one, had many requisites of distinction, quality of manufacture or taste, all attributes demanded of fashion in that period. As Nicola White underlines, the protagonists of the Florentine fashion shows may be categorised into two types: on the one hand the couture houses that were heirs to the great Italian tradition of craftsmanship, such as the Fontana sisters, and on the other the members of the Italian aristocracy, who, out of necessity in the post-war years but above all due to a sensitivity to the new times, sought garments with a fashion and a style based on their new way of life.[11]

In Italy so-called boutique fashion competed with French deluxe prêt-à-porter and was indeed superior to the latter in many aspects. Parisian fashion was too expensive for the US market, and its models were difficult to reproduce, in that they were often technically complicated. Italian fashion cost much less, as is borne out by numerous articles in the press reporting on the fashion shows; also, above all, boutique fashion could be mass-produced. Compared with Paris, Florentine novelties included the presentation of menswear, from 1952, as a complement to womenswear. From 1963, with the collective presentations of menswear couturiers, the so-called continental look rivalled the output of British Savile Row tailors.

During the fashion shows Giorgini organised parties inspired by the Italian Renaissance. Photographic shoots were also arranged in 'monumental and artistic contexts', where the models posed amid the ruins of the Roman Forum and the excavations in ancient Ostia, against the background of the Colosseum or the Campidoglio, on the Appian Way or in front of Renaissance and baroque monuments and buildings.

Yet what enabled the success of Italian fashion was its liberation from a purely artisanal model and the affirmation of an organised financial hub that allowed the possibility of a dialogue between artisanal skills and the textile and clothing industry. Giorgini's aim was also to enhance the relationship between textiles and creativity, between industry and style. Apart from Florence, Americans loved Rome, a city in which it was possible to shoot films at affordable costs, such as *Quo Vadis* (1950), and that was also suitable as the subject for movies, like *Roman Holiday* (1953). Roman fashion was spectacular and linked to the cinema, from the first celebrated wedding gown created by the Fontana sisters for Linda Christian's wedding to Tyrone Power in 1949 to Valentino's creation for Jacqueline Kennedy's marriage to Aristotle Onassis in 1968. In the late 1960s Rome took over as the capital of Italian fashion: the last high-fashion shows in Florence were held in 1967, while the ready-to-wear shows remained there for a few more years. It was, however, not only the transfer of high fashion to Rome that hastened Florence's decline. Also decisive was the waning significance of the cultural codes of high fashion and the emergence of a new ready-to-wear fashion, which was increasingly able to blend aesthetic values and industrial reproducibility, to define the transformation of the forms, times and places of fashion.

Boutique fashion presented in Florence no longer kept pace with consumer demands emerging in the late 1970s, because Florence was no longer sufficiently connected to the textile industry. Walter Albini and Karl Lagerfeld, who in 1967 had already made early experiments in designs for the industrial manufacture of clothing in Florence, did not find the Tuscan capital a suitable place to develop their new idea of prêt-à-porter. It was at this point that Milan entered the game. In 1971 Albini, the creator of the Misterfox, Diamant, Escargot, Balle and Callaghan collections, considered the Florentine organisation inadequate and too rigid in its presentations; it also limited the number of proposals each designer could present. He therefore decided to leave Florence to show in Milan, where he presented five collections and 200 models. *Women's Wear Daily* (*WWD*)

headlined this trend as 'Putting It Together',[12] noting a new emphasis on coordination: the total look, in which accessories and details became almost more important than the garments themselves in the definition of style. After Albini, the Cadette and Krizia brands and many designers, including Ken Scott and Ottavio (Tai) and Rosita Missoni, left Florence and helped Milan to achieve a reputation as the place to create and promote the new fashion. These designers later became known as *stilisti*.

PRÊT-À-PORTER IN MILAN

The move from Florence to Milan attested to a further change of perspective in Italian fashion, from being the product of classical culture and of art, as the American gaze had preferred to interpret it, to becoming a practice of modernity. In the 1960s Milan was the driving force of the first Italian economic boom, which had started in the 1950s, and for many reasons, besides the presence of industry, it was the natural place in which to develop the new idea of prêt-à-porter that was then emerging. An atmosphere of openness, cosmopolitanism and experimentation characterised the city, which was home to many professionals in the field of contemporary art and culture. When Albini, together with other fashion creators, left Florence to show in Milan in 1972—twenty years after the historic first fashion show organised by Giorgini in Florence—the Lombard capital was already the home of much business trade in the fashion sector. Fabric manufacturers had been moving there since the mid-1950s, preferring to show their products in Milan instead of in Florence. In the 1960s the La Rinascente department store, a front-runner in the democratisation of luxury and highly sensitive to industrial design and the modernist movement in architecture (see Kjetil Fallan's contribution to this volume), was the first retailer to introduce designer-label garments by Pierre Cardin, identical to those sold in boutiques but at a lower price. With the Apem brand, La Rinascente produced ready-to-wear clothes from 1950 onwards and was one of the first companies to make use of an art director to organise and coordinate the company image. In the early 1950s La Rinascente entrusted to Bruno Munari the coordination of the store windows of Upim, a subsidiary department store chain, according to a standard 'inspired by geometric rigour, clarity and detailed information'.[13]

Milanovendemoda, an event organised by agents and commercial representatives in the clothing sector, launched in 1969, with the aim of intensifying relations with the many buyers already present in the city of Milan. Between 1967—when Elio Fiorucci's store opened in Galleria Passarella and the Missoni happening/show took place at the Solari swimming pool—and 1975—when ready-to-wear fashion definitively abandoned Florence—the leading textile associations were formed and strengthened. IdeaComo, the silk-textile union, was set up in 1974, and the following year the launch of Federtessile brought together ten textile associations in one single group.

Journalists and photographers—such as Maria Pezzi, Guido Vergani, Silvia Giacomoni, Adriana Mulassano, Anna Piaggi, Alfa Castaldi and Ugo Mulas—were all involved, in different ways, in Milan's cultural life and contributed to consolidating the

relationship between the intellectual world, the art world and fashion.[14] Moreover, Milan had been the city of design before becoming a fashion hub. Italian industrial design had already begun to make a name for itself in the early post-war years, spearheaded by designers such as Marco Zanuso, Vico Magistretti and Achille Castiglioni. Fashion design applied the same formula used in industrial design, of collaboration between a designer and a manufacturer, such as Zanuso's work with Arflex and Gio Ponti's with Cassina. Ready-to-wear fashion was therefore a product of the new Milanese culture, the result of an attentive reflection on the decline of French high fashion and the crisis of fashion in Rome.[15] It was the response of a group of designers who, like the Milanese designers of the 1960s, elaborated projects suited to mass production.[16]

The characterisation of Milan as the 'capital of international fashion' was achieved in a short, intense space of time from 1972, when the stilisti left Florence, to 1978, when Modit, the body regulating fashion shows, was founded by Beppe Modenese. Between 1970 and 1975 the future stilisti began to converge on Milan, attracted by the effervescence of the city. Having come from Piacenza to work as a window dresser in the fashion department of La Rinascente in the 1960s, Giorgio Armani met Nino Cerruti, who had been born in Biella but used a Parisian approach, having spent many years working in the Parisian fashion industry. From 1970 Armani worked for Cerruti's Hitman label, where, as a fashion designer, he perfected the celebrated unstructured jacket that was to make him famous. In 1976 he founded the Giorgio Armani company with Sergio Galeotti and in 1978 signed a contract with GFT—the Gruppo Finanziario Tessile, based in Turin[17]—which is today considered the starting point for Italian prêt-à-porter. Hailing from a tailoring family in Reggio Calabria, Gianni Versace moved to Milan in 1973 to work with the Genny (Girombelli Group) and Callaghan brands, before opening his own business with his brother Santo in 1976.

Milanese prêt-à-porter displays a series of hallmarks that may be summed up as follows: the entrepreneur-stilista—or in any case a close relationship between the fashion designer and a textile company's vertical production system (in other words, designers were connected to all textile-production stages from fabric to the end product)—and control of distribution. The association with an entrepreneurial figure gave the fashion designer the ability to manage the complexity that the new market demanded. Examples of entrepreneurs and designers who worked together include Valentino and Giancarlo Giammetti, Franco Mattioli and Gianfranco Ferré, Galeotti and Armani, Aldo Pinto and Krizia, Rosita and Ottavio (Tai) Missoni, Massimo and Alberta Ferretti, Tiziano Giusti and Franco Moschino, and Domenico Dolce and Stefano Gabbana. There is also an opposite trend: entrepreneurs who became fashion designers, such as Genny (Girombelli) and Alberta Ferretti, who started out as manufacturers and then designed their own lines.

The merger between the clothing industry and fashion design generated an industrial aesthetic in which Milan excelled. Four fashion designers in particular—Armani, Krizia, Missoni and Ferré—were often grouped together, as the journalist Maria Vittoria Carloni writes, 'for having elaborated that style so close to . . . industrial designing which

is the hallmark of Italian pret-à-porter'.[18] The products of Milanese prêt-à-porter have a high wearability and are readily marketable. In industrialising style, the ready-to-wear system includes the design, making up and communication of products. At all price levels and along the entire fashion pyramid, from Benetton to Max Mara and Armani, the period from the 1960s to the 1980s saw the achievement of a greater connection between production and distribution, which was advantageous for the construction of brand value as the foundation for quality and above all as a consumer guide. The success of Benetton, for example, developed from the 1960s with a product innovation, the so-called *tinto in capo*,[19] and with changes in distribution methods: self-service shops were introduced, ending the practice of counter sales in stores, which had made it necessary to call on the sales personnel, and allowing buyers to look at and touch the goods. And by 1984 a strong image was added, through the work of photographer Oliviero Toscani.

A particularly interesting relationship between design and fashion emerged in the 1980s. Memphis and radical architecture included fashion in their creative horizon. Architects like Alessandro Mendini and groups such as the Studio Alchimia proposed a soft design—close to fabrics and fashion—applied to furniture and objects in everyday use and to architecture itself. Monica Bolzoni's fashion as design (with the Bianca e Blu brand) and that of Nanni Strada are examples of this interesting hybridisation.

In the 1980s the fashion show was on stage in Italy and above all in Milan. Once the recession was over, stimulated by the fashion industry, the city of culture, publishing and journalism, of workers' struggles and industry, turned into 'Milano da bere', an affluent, dynamic city, rich in events to be consumed at will, all hallmarked by fashion, with the 'Quadrilatero della moda' fashion district and the world revolving around it, the fashion shows and the parties that became events. After the first generation of prêt-à-porter, it was the turn of Dolce & Gabbana, the collaboration of Domenico Dolce and Stefano Gabbana, who revisited Sicilian aesthetics, and Romeo Gigli, with his fairy-tale vision of women, in contrast to Armani's career girl and Versace's eroticism.

THE CRISIS OF THE 1990S

The 1990s were characterised by the formation of large luxury groups that brought to-gether various brands. They were created both to grasp new opportunities to increase the sales of luxury products and to cope with the difficulties arising from the internation-alisation of the markets. Two brands in particular, Prada and Gucci, prospered during this decade. Prada became successful with a minimalist, 'poor' interpretation of luxury, contrasting with the ostentatious culture of the previous decade, when fashion had de-veloped in a fairly uniform way, around the aesthetics of the career woman. Under the direction of the Texan Tom Ford and Domenico De Sole, the historic Gucci brand was relaunched as a blend of luxury and status.

The 1990s, however, also marked the beginning of a decline for prêt-à-porter and 'made in Italy'.[20] There were various reasons for prêt-à-porter's loss of hegemony. The growth in power of the luxury brands tended to obscure the work of the stilista-entrepreneur and

the ideal spread of fashion at all social levels. The role of Italian ready-to-wear in democratising luxury and overcoming a mainly middle-class vision of fashion was replaced by the culture of the major brands, which worked in the opposite direction to make dress, even casual dress, more luxurious. The total look of the 1980s, dressing entirely according to the prompts of a fashion designer, was replaced with a mix-and-match tendency to assemble garments in different styles, according to one's own personal logic and taste. Vintage, second-hand, fusion, limited-edition and recycled clothing were other trends stemming from the discarding of the model of following the latest collection.

Competition from countries with lower labour costs, above all China; the rise of fast fashion; and the presence of many fashions in the world that were equally attractive to and more experimental than Italian fashion (we may think of the success of radical fashion, from the Japanese revolution to the Belgian school) all impacted on the 'made in Italy' commercial model. Fashion presented a relationship that linked the individual to society and its codes. Until the 1990s, Italian fashion had represented the aesthetics of Western modernity. From the 1990s onwards it had to compete in a broader context.[21]

THE CURRENT CONTEXT

From the early years of the twenty-first century, handling retail at the international level was one of the primary objectives of fashion companies in general, given the growing importance assumed by the fashion store. Prada and Ferragamo were the two Italian brands included in the 2010 luxury charts, which listed companies with profits over €200 million and growing turnover. Ermenegildo Zegna is also a major group player at the international level. The leading brands of Italian fashion designers are very successfully sold in new markets such as China, Russia, Indonesia, Turkey and Brazil. Santo Versace states, 'We and the French each control 30% of the production of luxury worldwide. Behind us are the United States with 20% and Switzerland with 8–9%. The remaining share is divided between all the other countries, from Germany and Great Britain to Japan'.[22]

Compared with the 1980s, the characteristics of ready-to-wear—the vertically integrated production system, controlled at all stages from production to distribution; seasonal collections and fashion shows; product segmentation centred on the need for reach or market penetration and correlated to an equally complex and far-reaching licensing system; and communication based on lifestyles—are no longer dominant in fashion.[23] Even the character of the fashion designer has changed, and not only because many of the previous leading figures in fashion design have died, such as Enrico Coveri (1952–1990), Franco Moschino (1950–1994), Gianni Versace (1946–1997), Nicola Trussardi (1942–1999) and Gianfranco Ferré (1944–2007).[24] The new generation of designers and producers have a completely different professional and cultural background, and they prefer to call themselves fashion designers and not stilisti. Successful designers of the new generation are now presenting their collections internationally: the most interesting among them are Francesco Scognamiglio, Gabriele Colangelo, Sara Lanzi, Bianca Maria Gervasio, Marco De Vincenzo, Albino D'Amato, Tommaso Aquilano and

Roberto Rimondi, Pierluigi Fucci and Giambattista Valli, Andrea Incontri, Tommaso Anfossi and Francesco Ferrari, Fabio Sasso and Juan Caro.[25] They all base their creativity on the Italian sartorial background. These fashion designers relate explicitly to a conceptual approach to tailoring and a product construction that is closer to the 1950s fashion-boutique model; many of them explicitly claim to find their cultural roots in the boutiques rather than in the prêt-à-porter of the 1980s.[26]

With its swiftly changing stylistic proposals, fast fashion has created a marketing and communication system completely different from that of prêt-à-porter. Fast fashion is not based on a vertical, integrated production system; the garments may be made anywhere, from China to eastern or western Europe, or entirely in Italy, according to different company strategies. On the model of the Spain's Zara and Sweden's H&M, each thoroughly international, many fast fashion companies make up a considerable part of new Italian fashion, such as the Patrizia Pepe, Pinko, Celyn B, Carpisa and Liu-Jo brands.[27]

A distinction must still be made between 'made in Italy', Italian prêt-à-porter and the new Italian fashion springing up in relation to the changing sociocultural characteristics and market demands. Like many other international fashions, Italy seems to be swinging between these two opposites: the fast fashion logic (that is, speed and a wide range of products) and slowness, with the retrieval of traditions and craftsmanship, though in a technological key. Italian fashion today selectively retrieves a past of craftsmanship, the appreciation of beauty, and attention to product manufacture. Since incentives for young independent creatives are few, and fashion in Italy is still dominated by the leading brands, one of the risks is that those taking advantage of the creative excellence of Italian firms, where it exists, are the large international groups. This indeed enables Italy to be a centre of high-quality production—having abandoned competition on the middle to low levels to countries with low labour costs—but not a place for innovation, and in the long run this cannot but have repercussions for the future of Italian fashion. For example, the lack of a street style springing from youth creativity is often ascribed to the commercial dictatorship of the major Italian brands, concerned above all with selling rather than innovating. Ornella Kyra Pistilli writes on this subject:

> The street is the lymphatic system of fashion, sensitive and in continuous movement. It is the place of the gaze and desire, of the difference and dislike where restless visions of the future take the shape of clothing, accessories, make up, pose and colours becoming style and of the symbolic importance of differences exhibited by the style.[28]

While in other countries youthful styles blend with the mainstream of fashion, in Italy this is more difficult, for historical reasons, because the success of Italian fashion is based on the ability to make large-scale industrial production aesthetically important.[29] As Elsa Danese writes, 'The exclusive approach of *haute couture* was adapted to mass production, thus enabling the garment industry to enter the fashion circuit and its representation'.[30] In Kyra Pistilli's view, 'made in Italy' should rethink its style in this regard and respond to the challenge of change with research, creativity and innovation. *Fatto in Italia*, literally,

'made in Italy', is again becoming a value, but not so much for Italy (or perhaps not yet for young Italian creators) as for the leading luxury firms. Louis Vuitton, for example, has opened a shoe factory in the Veneto region, at Fiesso d'Artico near Venice:

> Savoir faire is a word we use almost like a mantra at Louis Vuitton. For each of the three main product categories for which we are famous in the world, we have selected the country and place possessing the best savoir-faire. For leather ware, we have Asnières in France; for watches, manufacture is centred at Le Chaux-de-Fonds in Switzerland, and for shoes, Italy, without a doubt. For this reason we have invested tens of millions at Fiesso d'Artico, where 200 persons are already working today, all hired locally, and their number will rise to 250 in a few months.[31]

'Made in Italy' is being replaced by an emphasis on regionalism within Italy, according to Chiara Colombi, who distinguishes between 'a generic craftwork ability' and 'a specific excellence know-how linked to diverse contexts and types of goods'.[32] She mentions Bottega Veneta in Veneto, Antonio Marras in Sardinia and accessories by Fontana Milano 1915. Bottega Veneta is part of the Gucci group; its chief designer is the German Tomas Mayer, who resides in the United States, but Bottega Veneta in fact produces its garments entirely in Italy. The small scale of the many Italian companies scattered across different Italian regions also enables flexibility; these small companies can accept projects that demand new manufacturing solutions that combine craft culture with an industrial set-up.[33]

Fig. 13.1 *The Secret Garden of Massimo Alba*. Giardino Botanico, Brera, Milan, June 2011. Courtesy of Massimo Alba.

This is the case with the sophisticated menswear and womenswear collections of the designer Massimo Alba, whose company is based in Milan (Figure 13.1). Brunello Cucinelli, a manufacturer of fine cashmere knitwear, is an interesting example of a company deeply embedded in the Umbria region (Borgo Solomeo) and listed in the stock exchange. Cucinelli praises real Italian craftmanship, not an empty 'made in Italy' label.

Furthermore, in Miuccia Prada's view, 'made in Italy' is an old concept. She welcomes the 'made in Italy' label when it corresponds to reality—and 85 per cent of Prada's production is in fact Italian—but if a product is made elsewhere, she believes its origin should be acknowledged, hence the idea of the 'Prada made in' project, in which the brand name is followed by the name of the country where the garment is produced. 'Mine is a political statement and it comes from a personal appreciation of originality', she says. 'You have to embrace the world if you want to live now'.[34]

Italy's great ability to produce fashion cannot be reduced purely to technical skill, which tends to become static unless it is accompanied by innovative design. The completely outdated nationalistic idea of a 'made in Italy' that protects geographical boundaries is flanked by new ways of considering an Italian product, as part of an international circuit where creative exchange may be the engine driving development. Unlike in the

Fig. 13.2 'Prenditi cura di te' (Take care of yourself): bags by Benedetta Bruzziches, 2012. Courtesy of Benedetta Bruzziches.

1980s, Italian creativity today may be exported to France: Antonio Marras is the creative director at Kenzo, Riccardo Tisci at Givenchy and Stefano Pilati at Yves Saint Laurent.

But signs of change in the world of young independent designers are also visible: Alessandro Manzi and Caterina Coccioli's brand Il sistema degli oggetti is entirely produced in Italy. The collection, sponsored by the Limonta textile firm, an Italian company founded in 1893, is inspired by the origins of American culture, workwear, the uniforms of youth contestation, and the films of Craig Stecyk and the photographs of Hugh Holland, documenting West Coast adolescence. With her Maison Happiness and L'F brands for unisex shoes, produced together with Francio Ferrari, Licia Florio produces entirely in Italy, placing a strong emphasis on design research. Benedetta Bruzziches, after having travelled and worked in India, Japan, Morocco, Brazil, China and the United States (Figure 13.2), makes wonderful bags that are completely handmade in Italy. Silvia Bisconti's Raptus and Rose reutilises existing garments retrieved from various parts of the world, reassembling them according to 'a sartorial work which comes from afar: an Italian

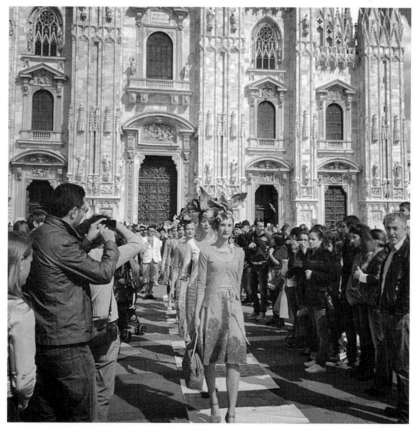

Fig. 13.3 'Segui i petali per le strade di Milano' (Follow the petals through the streets of Milan): a performance by Raptus and Rose during Milan Design Week, Piazza del Duomo, April 16–22, 2012. Courtesy of Silvia Bisconti.

tradition to wear in/take into the future/develop in the future'.[35] (See Figure 13.3.) These are just some examples of new interpretations of 'made in Italy', in which Italy is seen as a creative workshop and not a perpetuator of obsolete systems. Italian designers work in different ways. Some revise sartorial craftsmanship; others interact with the identity of a brand and its products, adapting them with their own personal vision; while other designers look for different ways to deal with the Italian textile and fashion industry.[36]

Fashion, as Emanuele Coccia writes, is the mechanism that allows men and women to change their appearance and therefore liberates them from presenting themselves in only one way.[37] For this reason every new fashion may arouse desire to the extent that it succeeds in communicating the promise of difference.

NOTES

1. See also Maria Giuseppina Muzzarelli, *Breve storia della moda in Italia* (Bologna: Il Mulino, 2011).

2. Elsa Danese, 'Moda, modernità e luoghi del made in Italy', in 'La cultura della moda italiana— Made in Italy', ed. Simona Segre Reinach, special issue, *ZoneModa Journal* 2 (2011): 32–39.

3. Simona Segre Reinach, 'La moda nella cultura italiana dai primi del Novecento a oggi', in *La cultura italiana*, vol. 4, *Cibo, gioco, festa, moda*, ed. Carlo Petrini and Ugo Volli (Turin: Utet, 2009), 603–661.

4. Valerie Steele, *Fashion, Italian Style* (New Haven, CT: Yale University Press, 2003).

5. Vittoria Caratozzolo, 'Enchanted Sandals: Italian Shoes and the Post-World War II International Scene', in *Accessorizing the Body*, ed. Cristina Giorcelli and Paula Rabinowitz (Minneapolis: University of Minnesota Press, 2011), 220–236.

6. Eugenia Paulicelli, *Fashion under Fascism* (Oxford: Berg, 2004).

7. Nicola White, *Reconstructing Italian Fashion* (Oxford: Berg, 2000).

8. Sofia Gnoli, *Un secolo di moda italiana 1900–2000* (Rome: Meltemi, 2005).

9. Patrizia Calefato, *Mass moda* (Genoa: Costa e Nolan, 1996).

10. Leopoldina Fortunati and Elsa Danese, *Il made in Italy* (Rome: Meltemi, 2005).

11. Guido Vergani, *La sala bianca: Nascita della moda italiana* (Milan: Electa, 1992).

12. See Simona Segre Reinach, 'Putting It Together', in *Walter Albini and His Time*, ed. Maria Luisa Frisa (Venice: Marsilio, 2010), 18–19.

13. Elena Papadia, *La Rinascente* (Bologna: Il Mulino, 2005), 130.

14. Minnie Gastel, *50 anni di moda italiana* (Milan: Vallardi, 1995).

15. Elena Puccinelli, ed., *Professione PR* (Milan: Skira, 2011).

16. Gloria Bianchino and Carlo Arturo Quintavalle, *Moda dalla fiaba al design. Italia 1945–1989* (Novara: De Agostini, 1989).

17. GFT was a textile and clothing company originally established in Turin in 1887 as Donato Levi e Figli, for the production of men's off-the-rack clothing. The company was purchased in 1925 by the Rivetti family, who formed Gruppo Finanziario Tessile in 1930. GFT was a cornerstone for the development of Italian prêt-à-porter in the 1970s. The company closed in

2003. 'Gruppo GFT', *Fashion Designer Encyclopedia*, http://www.fashionencyclopedia.com/Fr-Gu/Gruppo-Gft.html#ixzz1ssNz6yz6 (accessed May 8, 2012).

18. Maria Vittoria Carloni, 'Ferré', in *Dizionario della moda*, ed. Guido Vergani (Milan: Baldini Castoldi Dalai, 2003), 425–426.

19. *Tinto in capo* is the expression used for the dyeing of finished garments.

20. Simona Segre Reinach, 'Milan: The City of Prêt à Porter', in *Fashion's World Cities*, ed. Christopher Breward and David Gilbert (Oxford: Berg, 2006), 123–134.

21. Simona Segre Reinach, 'Fast Fashion vs Prêt à porter: Towards a New Culture of Fashion', *Fashion Theory* 9, no. 1 (2005): 1–12.

22. Quoted in Paola Jadeluca, 'Una star nella borsa', *Finanza e Investimenti Forum*, October 2, 2011.

23. Maria Luisa Frisa, *Una nuova moda italiana* (Venice: Marsilio, 2011).

24. Federica Muzzarelli, 'Volti del Made in Italy', *ZoneModa Journal* 2 (2011): 160–178.

25. I wish to thank Sabrina Damassa and Elisabetta Berla for their insights into the new Italian fashion scene.

26. Frisa, *Una nuova moda italiana*.

27. Enrico Cietta, *La rivoluzione del fast fashion* (Milan: Franco Angeli, 2009).

28. Ornella Kyra Pistilli, 'Debranding Italy', in Segre Reinach, 'La cultura della moda italiana', special issue, *ZoneModa Journal* 2 (2011): 40–47.

29. Emanuela Mora, *Fare Moda* (Milan: Franco Angeli, 2009).

30. Elsa Danese, 'Moda, modernità'.

31. Giulia Crivelli, 'La fabbrica globale è sul Brenta', Luxury 24 (June 2009), http://www.luxury24. ilsole24ore.com/ModaStili/2009/06/fabbrica-globale-brenta_1.php (accessed April 25, 2012).

32. Chiara Colombi, 'Made in What Italia?' in Segre Reinach, 'La cultura della moda italiana', special issue, *ZoneModa Journal* 2 (2011): 56–59.

33. Danese, 'Moda, modernità', 39.

34. Quoted in Suzy Menkes, 'Throwing down the Gauntlet', *The New York Times*, September 28, 2010.

35. According to the Raptus and Rose website, http://raptusandrose.com/ (accessed May 8, 2012).

36. Frisa, *Una nuova moda italiana*.

37. Emanuele Coccia, *La vita sensibile* (Bologna: Il Mulino, 2011), 178.

PART 5 MEDIATIONS

14 ANNUS MIRABILIS: 1954, ALBERTO ROSSELLI AND THE INSTITUTIONALISATION OF DESIGN MEDIATION

KJETIL FALLAN

The period from the mid 1950s to the mid 1960s represents an intriguing and eventful time in the history of Italian design. Marking the heyday of the nation's 'economic miracle', this is when the rationalist logic and socialist ambitions characterising the reconstruction efforts of the immediate post-war period slowly gave way to the more experimental attitudes and liberal aspirations that were to distinguish Italian design culture from that point on. In the midst of this ocean of change, like a captain and his ship navigating through strange waters, we find architect and designer Alberto Rosselli and his influential design magazine *Stile Industria.*

This chapter explores a series of events all of which unfolded at the beginning of this period, in what might be called modernism's happy moment: an instance in the mid-1950s when a sense of achievement and confidence settled in before soon developing into disillusionment and discomfort with the 'good design' cause. The account revolves around Rosselli as a key actor and three events closely identified with him: the launch of the magazine *Stile Industria*, the founding of the award Compasso d'Oro and the manifestation of the tenth edition of the Triennale di Milano. All taking place in 1954, these highly significant events converge to render this year an annus mirabilis in the history of Italian design and a turning point in the institutionalisation of design mediation in Italy.

ALBERTO ROSSELLI: MISSIONARY OF MODERNISM

Rosselli (Figure 14.1) was born in Palermo in 1921 and came from an upper-middle-class family. His father was an engineer, and the family moved frequently because of his professional assignments. Rosselli started engineering studies at the Politecnico di Milano, but his education was interrupted by the war, during which he stayed in Switzerland. There he came to know the Italian Jewish architect Ernesto Nathan Rogers, who also spent the war years in exile. Rogers inspired Rosselli's interest in industrial design, and the two would frequent the same environment for the rest of their careers. When the war was over, Rosselli returned to the Politecnico di Milano, where he earned a degree in architecture in 1947.[1]

After the war, Rosselli got to know, and later married, Giovanna Ponti, the daughter of another pioneer of Italian design, Gio Ponti. This connection helps to explain the close

relationship that subsequently developed between Rosselli and Ponti. However, it would also serve to complicate their professional links later on. Rosselli established a section devoted to industrial design in Ponti's architectural magazine *Domus* in 1949 and edited it until it expanded into the design magazine *Stile Industria* in 1954.

In 1950 Ponti and Rosselli, together with the engineer Antonio Fornaroli, established the Studio Ponti-Fornaroli-Rosselli. From 1967 Rosselli also collaborated with engineer and designer Isao Hosoe. In addition to his work as a designer and as editor/director of *Stile Industria*, Rosselli also embarked on numerous other projects within Italian industrial design circles. He contributed to the Triennali both as an exhibitor and as a committee member. He was among the prime movers for establishing Compasso d'Oro and served several times as a jury member for the award. Rosselli also became the first president of the Associazione per il Disegno Industriale (ADI) when this organisation was established in 1956. In 1963 he began teaching industrial design at the Politecnico di Milano. Rosselli also wrote two books on design theory.[2] He died in Milan in 1976, at only fifty-five years of age.

Even though Rosselli never entered politics, his political stance was quite clear. His socialism, like that of many designers of his generation, was reflected in his design ideology. He wanted to create the best possible material environment for all. Good design should be for all, not just for the elite.

Fig. 14.1 Alberto Rosselli. Photograph taken in December 1972 in Havana, Cuba, by Paolo Rosselli. Courtesy of Paolo Rosselli.

Alongside his prolific and various activities, Rosselli steadily worked as a practising designer, with much of his output being presented on the pages of *Stile Industria*. He designed furniture for Cassina, Saporiti and Arflex, among the most technologically advanced furniture manufacturers in Italy—and the world—at the time, as well as products for Kartell, a pioneering enterprise in the plastics industry. Like his father-in-law, Rosselli designed espresso machines for La Pavoni (a product category crucial to the history of Italian design, explored in Jonathan Morris's chapter in this volume). An example of design on a larger scale is the bus Meteor (a collaboration with Isao Hosoe) for Carrozzeria Renzo Orlandi, which was awarded the Compasso d'Oro in 1970.

After the closure of *Stile Industria* and the ideological 'crisis' that greatly affected the activities of the ADI in the 1960s, a disillusioned Rosselli largely retreated from organisational work to pour all his energy into his design practice and teaching. But teaching industrial design based on socialist but not revolutionary principles became increasingly challenging, and Rosselli's sustained interest in designing for an established industrial infrastructure made him a prime target of the 1968 student revolts at the Politecnico di Milano. The treatment he got was, according to Giovanni Klaus Koenig, comparable to that accorded to Trotsky by Stalin. Whereas Koenig therefore sees Rosselli's career as 'a history of the lost battle',[3] the present study focuses on the moment in which the fortunes of war were at their brightest.

STILE INDUSTRIA: MEDIATING MODERNISM

The architecture magazine *Domus*, founded in 1928 and edited by Ponti, showed, over the years, increasing interest in industrial design. In 1949 Rosselli began editing a section with articles related to industrial design, graphic design and packaging. The design section slowly increased in volume, and after five years of symbiosis, Rosselli separated it from *Domus* and founded his own magazine, *Stile Industria*. The editorial staff was small and included Franca Santi Gualteri (subeditor), Michele Provinciali (graphic designer), Luciana Foschi (secretary), Giancarlo Pozzi and Angelo Tito Anselmi—the last became quite a stablemate of Rosselli's in writing for the magazine.[4] The bonds to *Domus* were not severed, though: Ponti and Rosselli remained closely related both personally and professionally, and *Stile Industria* was published by Editoriale Domus, the parent magazine's publishing company.

For many years, *Stile Industria* was the only Italian magazine dedicated entirely to industrial design. Forty-one issues were published between 1954 and 1963: initially at quarterly intervals, then bimonthly. *Stile Industria* quickly became a prime arena for debate in the consolidating industrial design community, as well as an important mediating channel employing an impressive group of Italian design professionals. Moreover, *Stile Industria* was a significant object of design itself, featuring cover illustrations by graphic designers including Michele Provinciali, Bruno Munari, Albe Steiner, Enzo Mari, Max Huber, Pino Tovaglia, Bob Noorda and Roberto Sambonet (Figures 14.2–14.6, discussed further below). However, the new magazine never achieved the public and commercial

success of its parent publication, failing to bring in sufficient advertising revenue, and Editoriale Domus discontinued it in 1963. Nevertheless, *Stile Industria* provides an excellent barometer for assessing significant changes in Italian design culture during the turbulent decade in which it operated.

Presenting his new magazine, Rosselli underlined its purpose:

> Today, . . . the values of Italian design are affirmed around the world; STILE INDU-
> STRIA intends to promote among Italian industry, public and artists a concrete inter-
> est in the aesthetic values of the product, from the creation, through the presentation,
> to the propaganda, [of] values that constitute a unifying expression in the modern
> style of production.[5]

These words succinctly exemplify the optimism and eagerness of the strategic actors in Italian design in the mid 1950s. We can easily see a strongly felt notion among the prime movers of being part of something immensely important, and even though hard work lay ahead, the sky was the limit. In *Stile Industria*, the missionaries of modernism established an arena for professional debate and a channel for propaganda and information. Their intentions were explicitly expressed in the first editorial, symptomatically titled 'Disegno: Fattore di qualità' (Design: Quality factor):

> A new category of artists who direct their activity towards industrial production, who
> are familiar with new technology, who interpret its meaning and translate it into the
> most correct, most useful and most beautiful design of an object, can—together with
> the industry—lead to the synthesis which represents the highest level of the industrial
> culture.[6]

Stile Industria's mission was to promote design as a factor of quality, thereby elucidating the core competences of the new professional figure of the industrial designer. To Rosselli, obviously, quality meant rational, functional and beautiful design. This modernist ideology envisioned the pinnacle of industrial culture as a direct result of an improved relation between designers and industry.

Support for the emerging profession was just one of the ways in which Rosselli and *Stile Industria* constantly campaigned for the importance and value of good design. Other strategies included covering activities in the field, such as exhibitions, conferences, and so on, and reporting on foreign events and developments. As with most other design periodicals, the presentation of new design was a key feature of *Stile Industria*. However, *Stile Industria*'s policy on this matter was quite different from what can be seen in most design magazines, past or present. It covered the entire spectrum of industrial products, not only the usual suspects of 'designer goods'. In addition to furniture, lighting and cutlery, there are articles on milling machines, toilets, boats, cars, sewing machines and much more. This clearly shows that *Stile Industria*'s mission was to promote design in all fields of industrial production. To the editors, design was a matter of social responsibility and material culture, and certainly not confined to the realms of style and fashion.

COMPASSO D'ORO: MEDALS FOR MODERNISM

As noted above, 1954 was a remarkable year for Italian design culture: *Stile Industria* was launched, perhaps the most successful Triennale di Milano took place, and the design award Compasso d'Oro was established. Rosselli was deeply involved in all these ventures, which he also strategically 'cross-pollinated', for example by showcasing award-winning products in the magazine (Figure 14.2).

The department store chain La Rinascente played an important part in the setting up of the Compasso d'Oro award. Reopened after the war only in December 1950, La Rinascente was the leading chain of department stores in Italy, with branches in all the major cities. It carried a vast range of products, from toys to furniture, make-up to sports

Fig. 14.2 Cover of *Stile Industria* 9 (December 1956), showing the products awarded the Compasso d'Oro in 1956 with Alberto Rosselli on the jury. Cover design by Michele Provinciali. Courtesy of Editoriale Domus.

equipment. The firm therefore had a vested interest in the quality, functionality and aesthetics of the wide variety of goods on offer in its department stores.

A precursor to the prize can be found in an exhibition staged the previous year. In October 1953 the exhibition *L'estetica nel prodotto* could be seen at La Rinascente in Milan. The objects had been selected by Rosselli in collaboration with La Rinascente's technical staff.[7] Perhaps not surprisingly, Rosselli did not mention this fact when asking of the event, 'What does this exhibition mean, if not that among the thousands of products offered the public in a department store, only a few dozen, unfortunately, can be considered exemplary in their technical and aesthetic nature?' Although the state of the art was considered quite deplorable, Rosselli praised the initiative as a call to arms:

> We are grateful to La Rinascente for this initiative that we regard as an effective work
> of propaganda and at the same time an example of culture and industrial civility; but
> we are awaiting, from many industries, from many artisan complexes, from techni-
> cians and artists, from those responsible for these manufactures in general, a real
> understanding of the problem and an effort in this direction.[8]

The good reviews in *Domus*—which was anything but impartial—and other media, as well as the significant public attention achieved by staging a design exhibition in the 'secular' space of a department store, likely influenced La Rinascente's decision to patronise a design award. Having established contact with the design community, La Rinascente, fronted by senior executives Aldo Borletti and Cesare Brustio, thus gave life to an idea Carlo Pagani, Ponti, Rosselli and others had been playing with for a while. The department store's marketing impetus (and budget), combined with the modernist missionaries' ambition of promoting 'good design', prepared the ground for the Compasso d'Oro as a joint venture.

Given the wide range of its stock, La Rinascente possessed valuable knowledge about the state of Italian industrial production and was also an active importer of foreign goods. This led to another, and possibly more idealistic, motivation for its engagement: the desire for a national manufacturing industry capable of making better products and of competing more effectively with imported goods. Brustio especially was aware of the extent to which the industry's output severely conditioned the retailer's latitude in influencing the public's taste.[9]

The prize (with a graphic identity designed by Albe Steiner) was awarded to chosen products thus: the golden compass was given to the manufacturing company, and the silver compass, accompanied by 100,000 lire, to the designer. One year later, in 1955, two additional awards were established: the Gran Premio Nazionale and the Gran Premio Internazionale. These were not intended for products but for persons, companies or institutions that had contributed to the promotion of design in, respectively, the national and international contexts.[10]

But the award was not merely to be an instrument for promoting sales; the idealists who set it up had a more profound purpose in mind:

> With the Compasso d'Oro, one wishes to honour the merits of those industrialists,
> artisans and designers who in their work, through a new and particular artistic effort,
> give the products quality of form and of presentation, such as to give them a unitary
> expression of their technical, functional and aesthetic characteristics.[11]

As we can see from this quotation, commercial motives and professional interests merged in an ideological message that was utilised in both camps. The Compasso d'Oro became an important and public instrument of critique, and thus a strategic actor in the fostering of design culture by encouraging designers and companies to develop products that corresponded with the award stewards' modernist ideology.

In the beginning, the awards were restricted to the types of products sold in department stores. Although that allowed a fairly comprehensive scope—the first winners included a suitcase, a toy monkey and a hunting rifle—it was not until 1958, with the intervention of the ADI, that all types of products became eligible, giving, for example, the important car industry an opening. In 1962 La Rinascente withdrew completely from the award, leaving it in the presumably more capable hands of the ADI. This coincided with the change from yearly editions to longer intervals.[12]

As a current event of great significance to the contemporary design discourse, the establishment of the Compasso d'Oro naturally featured prominently in the very first issue of *Stile Industria*, published in June 1954. The initiative was praised and seen as a way of supplementing the magazine's own ambitions regarding the promotion of good design. This enthusiasm is hardly surprising, as Rosselli was on the award jury (along with Ponti) and thus had every interest in consolidating the efforts of the two new initiatives.[13]

As with the *L'estetica nel prodotto* exhibition, Rosselli's comments on the Compasso d'Oro centred on the industrial-political aspect of design:

> This award, in its program and statement, represents the very important affirmation
> of the most modern principles of production and constitutes the first manifestation
> to appreciate and articulate the problem of production not only as an economic fact,
> but also an aesthetic one, of culture and of custom.[14]

The staff of *Stile Industria* clearly saw the Compasso d'Oro as an auxiliary in the magazine's mission. Rosselli was eager to cast industrial production as a culturally integrated problem. He lamented the lack of promotional organisations in Italy equivalent to those found in other countries (such as the British Council of Industrial Design). The success of Italian design thus far was, according to the editor, more a result of 'the natural creative attitude of Italians and the special disposition of a few industrialists' than of 'precise propaganda and action' at the governmental or institutional level. He therefore considered the new award a positive development in the quest for a more concerted campaign of design reform.[15]

Important as this aspect was, the structuring of design reform was not the only agenda inscribed in the Compasso d'Oro. As with any design award, it was also a vehicle for the recognition of both individual designers and manufacturers, as well as of the emerging profession of industrial design.

X TRIENNALE DI MILANO: MARKETING MODERNISM

> Today, the tenth Triennale . . . aspires to be, not a merchandise fair nor an exhibition
> of masterpieces . . . but a battle for the house, for the city of this new, open, liberal,
> progressive humanity.[16]

This quotation from the communist newspaper *La Voce Comunista*'s review of the X Tri-
ennale in 1954, written by the philosopher Antonio Banfi, exemplifies the exhibition's
unifying character and the way it won the approval of those concerned with social tasks
and the battle for a more 'progressive humanity', something the VIII edition in 1947 had
also managed but that the IX edition in 1951 had completely failed to do. But Banfi's
comment simultaneously belies the event's considerable success at promoting modern
industrial design with all its commercial entanglements.

After the 'proletarian Triennale' of 1947, the 1951 IX Triennale was heavily criticised
for serving *borghese* values rather than addressing social issues and was considered a fail-
ure in terms of both public outreach and economic outcome. In his 'obituary' of the IX
Triennale, Ponti—who withdrew from the executive council of that event on grounds of
insufficient leeway[17]—stressed the importance of starting the planning of the X Triennale
immediately. In his optimistic manner, he hoped that an early start, improved coopera-
tion and experience would result in a 'perfect Triennale'.[18] Even though Ponti's call for
early planning was ignored (the executive council was appointed only a year before the
exhibition opened), the 1954 edition would clearly show that the Triennale di Milano
had matured considerably.

At the opening of the X Triennale on August 28, 1954, the president of the Triennale,
Ivan Matteo Lombardo, presented its programme and aspirations. The intention was to
accord industrial design increased attention, more so than at any other edition:

> It is in relation to this interpretation of art as something never arbitrary or merely
> decorative, but fundamental and necessary, that the program of this Decima Triennale
> pivots: 1) The unity, and hence the correlation, of the arts, and 2) the collaboration
> between the world of art and the world of industrial production.[19]

The first of the two points Lombardo refers to here, the unity and correlation of the arts,
was a vision that was often mentioned in the discussions on the Triennali's function. The
second point, the collaboration between the world of art and the world of industrial pro-
duction, illustrates how industrial design rose to the top of the agenda at the X Triennale—
as it did simultaneously with the establishment of *Stile Industria* and Compasso d'Oro.

Lombardo went on to proclaim that industrial design had reached a level of maturity
that warranted centre stage:

> We have arrived, not as one might think, at a sort of industrialization of art or
> 'aestheticization' of technology, but at that ideal place . . . where the product of
> technology, escaping from the shapeless accident, enters the sphere of art, while
> this latter—rejecting every unfounded attitude, abandoning every capricious and

proud personal whim—assumes a precise civil and social function. The experiences of the Decima Triennale must be understood in this sense and in this direction.[20]

Like the two previous Triennali, the X Triennale featured a separate exhibition dedicated to industrial design. But many of the other 1954 exhibitions also incorporated industrial design. La Mostra della Casa (the housing exhibition) focused on mass-produced furnishings and industrialised construction. Even traditional crafts and decorative art were subsumed within the overall focus on industrial design: ceramics, glass, fabrics, silver and gold, and so on were arranged within the collective exhibition Mostra Merceologica (the merchandise exhibition), the name of which is highly revealing of the governing sentiment towards even the most 'art-like' form of design.

Another mainstay of design-as-decorative-art—furniture—was also recast as industrial design at the X Triennale. La Mostra del Mobile Singolo (the individual furniture exhibition) conceptualised furniture as a group of utility articles, showing recent and forthcoming Italian serial production—including designs by Rosselli and Ponti for Cassina—alongside foreign examples, above all Scandinavian ones. The two following sections proposed how this furniture could be integrated in housing environments. La Mostra dello Standard (the standard exhibition) consisted of an apartment—unrealistically big, one might claim—demonstrating the 'possibilities opening up to those who use mass produced furniture in the house'.[21] La Mostra di Ambienti (the environment exhibition) suggested three complete apartments, more modest in dimensions (c. fifty square metres, or about 540 square feet). The contribution from Studio Ponti-Fornaroli-Rosselli was a studio apartment designed to include all facilities of modern life despite the limited space.[22]

Industrial design dominated the X Triennale to such an extent that even architecture was thought of exclusively in terms of industrialised construction and prefabrication. This view also characterised the structures mounted in the Parco Sempione (the park surrounding the main exhibition venue, the Palazzo dell'Arte). Alongside the two geodesic domes designed by R. Buckminster Fuller and brought to Italy by Roberto Mango (discussed in Jeffrey Schnapp's contribution to this volume) were several experimental houses, including the Casa Unifamiliare di Serie (single-family, serially produced house) designed by Studio Ponti-Fornaroli-Rosselli, 'constructed entirely from serially manufactured elements'.[23]

Given the status awarded industrial design at the X Triennale, the Mostra dell' Industrial Design (the industrial design exhibition) appropriately formed the main attraction. Organised by Rosselli in collaboration with other noted designers such as Marcello Nizzoli, Roberto Menghi, Achille Castiglioni and Pier Giacomo Castiglioni,[24] the exhibition emphasised industrial design as a commercial, social and moral undertaking in complete symbiosis with modern society. Underlining this view, Rosselli's discussion of the exhibition in *Stile Industria* included the argument that industrial design had matured

to the point of being able to domesticate technology and mitigate the shortcomings of earlier mass production, turning vices into virtues:

> The number, the series, the quantity no longer represent a discouraging prospect, an insecurity in the coming of our industrial epoch, but . . . they supply the vehicle for a new aesthetic experience, homogeneous and cohering to every manifestation of our life.[25]

The exhibitions at the X Triennale, Rosselli claimed, demonstrated how industrial design was able to join 'the values of quantity with those of quality' and how good products always resulted from 'a correct and happy relationship between technology and art, between functionality and fantasy'.[26] Whereas Rosselli thus conflated his exhibition work at the Triennale with his editorial work in *Stile Industria*—for example, by publishing magazine covers that could be mistaken for exhibition posters (Figure 14.3)—Ponti did

Fig. 14.3 Cover of *Stile Industria* 2 (October 1954), the issue dedicated to the X Triennale. Cover design by Bruno Munari. Courtesy of Editoriale Domus.

the same at *Domus*. Ponti hailed the X Triennale as a great triumph, declaring that the Triennale di Milano had become for design what the Biennale di Venezia was for art and—very telling of the conflation of roles on the part of Rosselli and himself—that he considered his own magazine to be 'a continuing Triennale'.[27]

CONGRESSO DELL'INDUSTRIAL DESIGN: CONVENING MODERNISM

Accentuating the emphasis on industrial design at the X Triennale, the Centro Studi Triennale organised the first-ever international conference on industrial design in Italy. During three days in October (28–30), the entire Italian design community and a cohort of foreign notabilities convened for extensive theoretical discussions on industrial design. Rosselli welcomed the event with great anticipation, stating that it 'responds to a national demand currently due, and connects unambiguously to the announced program of the X Triennale'.[28] Each of the three days had a specified agenda. The first day was dedicated to 'industrial design and culture' (chaired by Giulio Carlo Argan), the second day dealt with 'industrial design and production processes' (chaired by Konrad Wachsmann), and the third day considered 'industrial design in society' (chaired by Max Bill).

Under the heading 'industrial design and culture', Enzo Paci (professor of philosophy at the University of Pavia and chair of the organising committee) and Giulio Carlo Argan underlined the importance of incorporating design in the planning of all human activities, even at the most basic level, in order to keep design from serving capital. Drawing on linguistic philosophy Paci claimed that the designer held a position between art and society and was thus responsible for considering all aspects of the impact design has on humans and society.[29] This was yet another example of how design was commonly viewed as a way of improving society through material culture.

On the second day, the Americans Wachsmann and Walter Dorwin Teague talked about 'industrial design and production processes'. Although Italian and US design were separated by an ideological and conceptual ocean bigger than the Atlantic, the Italians were greatly impressed by the respect designers enjoyed in American industry and by the scale of their operations. On the other hand, the overtly commercial context of US design was met with significant scepticism, and the formal language dominating mainstream US design was downright despised.[30] Crucially, this ambivalence towards US design was not restricted to Italy—the sentiment was remarkably coherent throughout Europe.[31]

In his relation on 'industrial design and society' on the conference's last day, Bill firmly disagreed with the Americans' views on design. This was hardly surprising, considering the social commitment underpinning the recently established Hochschule für Gestaltung Ulm, which he had co-founded and directed (an institution that would later be the subject of a special issue of *Stile Industria*) (Figure 14.4). Bill refused to see industrial design as a marketing tool for the industry. What was important, according to Bill, was the relation between object and human, object and society: 'Every object has to be at man's service, and because the sum of men forms the human society, these objects have to fulfil a function in human and social life'.[32]

Fig. 14.4 Cover of *Stile Industria* 21 (March 1959), an issue dedicated to the Hochschule für Gestaltung Ulm. Cover design by Albe Steiner. Courtesy of Editoriale Domus.

As he so often did, Rosselli assumed a middle ground and took it on himself to act as a mediator. He argued that industrial design defended its position in the production process and free market economy. But he was no less critical of seeing design *solely* as a means to increase sales and profit than were Bill and others. Rosselli also questioned the relevance of processes and practices developed in the context of American mass production to the very different structure of Italian industry. Rather, Italian design had to be based on the characteristics of the nation and its people, meaning traditions of art, culture, invention and technology. Even the success of Italian design in the United States was not entirely positive, warned Rosselli. He feared that it was merely an 'antidote for the monotony of the standard, a style imported for the sake of sales'.[33]

The international conference on industrial design was welcomed with enthusiasm and provoked a vivid debate on the nature and function of design as a professional activity and a cultural phenomenon. It might be argued that the outcome was something close to a common consciousness within the Italian design environment regarding its own aims and purposes. The most important part of this result can be seen as the emergence of an 'Italian way' that would guide the development of Italian design—at least for the brief remainder of modernism's 'happy moment'.

CODA: ADI, ORGANISING MODERNISM

The ADI was formally founded at a constitutional assembly on April 6, 1956, at the Museo della Scienza e della Tecnica in Milan. An organising committee led by Rosselli

Fig. 14.5 Cover of *Stile Industria* 36 (February 1962), the second of two issues presenting the results of a comprehensive enquiry amongst leading European designers. Cover design by Enzo Mari. Courtesy of Editoriale Domus.

and Giulio Castelli had prepared the ground, and it was no surprise that Rosselli was elected president. The organisation numbered ninety members even before the official founding, so the establishment of the ADI must be seen as a formalisation of an already existing network and institutional infrastructure—of which the events discussed in this chapter were part and parcel.

The ADI represented simultaneously a professionalisation and a de-ideologisation of the industrial design community. More than any other initiative it forged bonds with the sphere of industry and commerce, effectively dissociating design discourse from the socialist ideology so prevalent in the early post-war period (and, albeit in very different

Fig. 14.6 Cover of *Stile Industria* 28 (August 1960), the issue containing Alberto Rosselli's report from the World Design Conference in Tokyo, which he attended as the president of the Associazione per il Disegno Industriale. Cover design by Max Huber. Courtesy of Editoriale Domus.

forums and forms, in times to come). The activities of the ADI consolidated the in-
dustrial design profession at home, while becoming the primary mediator between the
national and international communities (Figure 14.5). As president of the ADI, Rosselli
visited the American Society of Industrial Designers and the Aspen conferences. The
ADI also contributed to an exhibition of Italian design in Paris and to the founding of
the International Council of Societies of Industrial Design, and it sent delegates to the
World Design Conference in Tokyo (Figure 14.6).[34]

As was his habit, Rosselli conflated his roles as journalistic subject and object here as
well. His vision for the ADI, presented in a *Stile Industria* editorial, was that it should
become an arena unifying all parties involved in the sphere of industrial design, acting as a
mediator between the spheres of design, production and the market. As he saw it, 'the in-
sufficiency does not lie in the means at our disposal, but in the principles directing them'.[35]

Rosselli's key role in establishing the ADI thus conforms to, and adds to, his reputa-
tion as the chief architect of the institutionalisation of design mediation in Italy, which
peaked with the events of 1954 discussed in this chapter. Neither a conservative rational-
ist nor a freewheeling expressionist, Rosselli played the part of the negotiator, moderator
and mediator in what he described a decade later, in the very last issue of *Stile Industria*,
with appropriate resignation, as the 'debate between the interests of production and
those of culture, which still remain very distant'.[36]

NOTES

1. The biographical information in this section is chiefly based on an interview with Alberto
 Rosselli's son, Paolo Rosselli, conducted in April 2000.
2. Alberto Rosselli, *Lo spazio aperto: Ricerca e progettazione tra design e architettura* (Milan: Pizzi,
 1974); and Alberto Rosselli, *I metodi del design* (Milan: Clup, 1973).
3. Giovanni Klaus Koenig, 'Saggio introduttivo', in *Stile Industria: Alberto Rosselli*, ed. Amalia
 Fracassi and Simona Riva (Parma: Università di Parma, 1981), 13–14.
4. Franca Santi Gualteri, A *Trip through Italian Design: From* Stile Industria *Magazine to* Abitare
 (Bologna: Corraini, 2003), 6.
5. Alberto Rosselli, 'Stile Industria', *Domus* 292 (March 1954): 82.
6. Alberto Rosselli, 'Disegno: Fattore di qualità', *Stile Industria* 1 (June 1954): 1.
7. Anty Pansera, *Storia del disegno industriale italiano* (Bari: Laterza, 1993), 124.
8. Alberto Rosselli, 'L'estetica del [*sic*] prodotto alla Rinascente', *Domus* 290 (January 1954): 64.
9. Alfonso Grassi and Anty Pansera, *Atlante del design italiano 1940/1980* (Milan: Fabbri, 1984), 32.
10. The jury's decision to withhold the Gran Premio Nazionale in 1959 spurred a heated debate
 on the question of whether Italian design was in a state of crisis: Kjetil Fallan, 'Heresy and
 Heroics: The Debate on the Alleged "Crisis" in Italian Industrial Design around 1960', *Mod-
 ern Italy* 14, no. 3 (2009): 257–274.
11. From the award regulations, published in *Stile Industria* 1 (June 1954): 6.
12. Pansera, *Storia del disegno*, 161.

13. Roberto Rizzi, Anna Steiner and Franco Origoni, eds., *Compasso d'Oro ADI: Design italiano* (Milan: Associazione per il Disegno Industriale, 1998), 162.

14. Editorial [Alberto Rosselli], 'Un premio per l'estetica del prodotto', *Stile Industria* 1 (June 1954): 6.

15. Ibid.

16. Antonio Banfi, 'Discutiamo della Triennale come di una nostra battaglia', *La Voce Comunista*, September 15, 1954.

17. Anty Pansera, *Storia e cronaca della Triennale* (Milan: Longanesi, 1978), 70.

18. Gio Ponti, 'Dalla IX alla X Triennale', *Domus* 264–265 (December 1951): 1–2.

19. Ivan Matteo Lombardo, 'Proposti e realtá della Decima Triennale: Estratto dal discorso di presentazione della X Triennale', in *Catalogo della Decima Triennale*, ed. Ivan Matteo Lombardo (Milan: Centro Studi Triennale, 1954), 22–23.

20. Ibid.

21. Lombardo, *Catalogo*, 105.

22. Ibid., 111–114.

23. Ibid., 421.

24. Ibid., 129.

25. Alberto Rosselli, 'L'oggetto d'uso alla Triennale', *Stile Industria* 2 (October 1954): 1.

26. Alberto Rosselli, ' "Industrial Design" alla X Triennale', *Stile Industria* 2 (October 1954): 2.

27. Gio Ponti, 'La X Triennale é in corso', *Domus* 299 (October 1954): 1.

28. Alberto Rosselli, 'Notiziario della X Triennale—Il Congresso dell'Industrial Design', *Stile Industria* 2 (October 1954): 22.

29. Mario Labò, 'Il Congresso dell'Industrial Design alla X Triennale', *Casabella-Continuità* 203 (November–December 1954). For more on Paci's address, see Giovanni Anceschi, 'Introduction to Enzo Paci's Presentation at the 10th Triennial', *Design Issues* 18, no. 4 (2002): 48–50; and the address itself: Enzo Paci, 'Presentation at the 10th Triennial', *Design Issues* 18, no. 4 (2002): 51–53.

30. Carlo Santi, 'Il I Congresso Internazionale di Industrial Design alla X Triennale', *Stile Industria* 3 (January 1955): 45.

31. Max Bill, quoted in Pansera, *Storia e cronaca*, 78.

32. Alberto Rosselli, 'Incontro alla realtá', *Stile Industria* 3 (January 1955): 1–2.

33. 'Attività dell'ADI', *Stile Industria* 8 (October 1956): 21.

34. Alberto Rosselli, 'A Parigi il disegno industriale italiano', *Stile Industria* 12 (June 1957): 1; and Rosselli, 'World Design Conference 1960—Tokyo', *Stile Industria* 28 (August 1960): XI–XXIV.

35. Alberto Rosselli, 'L'Associazione per il Disegno Industriale in Italia', *Stile Industria* 7 (June 1956): 1.

36. Alberto Rosselli, 'Commiato', *Stile Industria* 41 (February 1963): 1.

15 A VEHICLE FOR 'GOOD ITALIANS': USER DESIGN AND THE VESPA CLUBS IN ITALY

THOMAS BRANDT

Some design objects evoke particular national symbolic meanings. The processes by which mass-produced consumer goods become tied to a particular national identity vary from the highly contingent to the strictly planned. National identities may be inventions or constructions, but people still hold them to be important. Both national pride and producers of strong brands may be strengthened by being associated with each other.

Italy is one of the countries in which ideas of national identity have been tied to consumer goods in distinctive ways. There are certain products and machines that are embedded in a notion of Italy. Fashion, furniture and foodstuffs are different realms where certain aesthetics, lifestyles and symbols make Italy a brand in itself.[1]

This chapter highlights one product that has contributed to and benefited from a notion of 'italianicity', to use Roland Barthes's term.[2] The Vespa motor scooter is an expression of Italy and is one of the landmarks of post-war Italian design. But what does it mean when the Vespa is said to be Italian? What values, practices and ideas does this entail? The historical processes that made the Vespa 'Italian' are manifold. Everything from bureaucratic decisions about traffic regulations to Hollywood cinematography contributed to the symbolic construction of the Italian Vespa.[3]

The question of who designed the Vespa could be answered straightforwardly by stating that it was the work of the aviation engineer Corradino D'Ascanio and his collaborators at the Piaggio Company.[4] It would be more satisfactory, however, to complicate matters a bit, for neither D'Ascanio nor the Piaggio Company can really be credited with turning this vehicle into a 'twentieth-century icon', to paraphrase a Vespa exhibition held in London in 1999.

Kjetil Fallan argues for a design history that puts 'greater emphasis on the relational and reciprocal dynamics of idea and object, mind and matter, ideology and practice'.[5] Fallan's call is part of a trend away from the celebration of canonical design objects and the sometimes hagiographic accounts of individual designer geniuses that long remained predominant in design historiography. Instead, design history should be more mindful of the co-construction of designed artefacts by a multitude of actor groups. Designers are of course important, but so are engineers, marketers, mediating agents and users. In his seminal dossier on Italian scooter history, Dick Hebdige sketches an approach to design history that includes production, mediation and use as equally important 'moments' in

the history of the making of the scooter.[6] More recently, design historian Grace Lees-Maffei has identified the emergence of a 'production-consumption-mediation' paradigm over the last two decades within design historiography.[7] One may argue that the emphasis on mediation and consumption runs the risk of belittling the role of the designers. Yet D'Ascanio, the man behind the original Vespa design, was conscious of the importance of users within the design process. To his mind, the product trials of an industrial manufacturer could never emulate the experiences of customers.[8] User responses did more than simply provide feedback to inform incremental technical touch-ups. A well-crafted, innovatively designed object was the basis of the Vespa's success, but it was the people dreaming of a Vespa, buying it and driving it who brought the scooter into post-war popular culture. In other words, the role of Italian consumers in creating Italian design was key.

Students of the history of design, technology and consumer culture are now well aware of the importance of taking into account users as active participants in the making of material commodities. Still, as Fallan also rightly points out, there are many methodological challenges to the study of how users have mattered. Individual consumers rarely leave substantial traces in archives or other available sources; their thoughts and actions most often elude the historian. One means of better understanding the importance of users in the development of design and technology may be to look for the imagined or represented users, Fallan suggests.[9] In the case of the Vespa, there exists a welcome opportunity to study a particular group of users. Sometimes communities of users become organised, not around one kind of technology, but around a specific brand of a product. These are called brand communities, or 'subcultures of consumption', which can be defined as groups in society that self-select on the basis of a shared commitment to a particular product class, brand or consumption activity.[10] This chapter brings to attention the ways in which the Italian Vespa Club, as what would today be termed a brand community, contributed to the making of the Vespa as an Italian product. The Italian Vespa Club represented an important interface for the exchange of values, modes of representation and norms of practice between Vespa users and the Piaggio Company in the 1950s and 1960s.

THE COMPANY TAKEOVER OF THE CLUB SYSTEM

The Vespa was introduced in Italy in 1946, and by the end of the decade the 125 cc motor vehicle had become a mass phenomenon in northern Italy and in major cities elsewhere, while also attracting attention from abroad.[11] For foreign observers, like the Danish journalist Carsten Nielsen writing in 1949, in the midst of the post–Second World War recovery, the noise of the omnipresent Vespas in Rome was a 'fanfare for Italy, which through hard work is recapturing her right to live'.[12] Not everyone was as tolerant towards the Vespa as Nielsen. Paul Hoffman of the *New York Times* thought scooters were worse than the mosquitoes in Rome:

> The engine of the popular Italian motor scooter has been described as a technical marvel combining the smallest volume with the greatest noise. This is not correct.

The engine purrs discreetly when it leaves the factory. The new *scuterista*, as the proud owner is called, at once starts tampering with it until it produces those ear-splitting roars and explosions that boost his ego with a feeling of power.[13]

As users of Vespas and other scooters grew in number, alongside increasing automobile usage, the congestion of the inadequate Italian roads became a source of heated discussion. Scooters were facing, on the one hand, noise-abatement campaigns in the cities and, on the other, national lawmakers wanting to regulate traffic by introducing driver's licences and requiring driver health examinations even for vehicles such as scooters. The Piaggio Company—a traditional naval and aviation firm with no prior experience with mass-produced consumer goods like the Vespa—experienced difficulty in communicating the virtues of its product and arguing against these accusations and cries for regulation.[14] But it tried, with good help from its allies—among them the Vespa Clubs.

The Italian Vespa Club was established in 1949, only three years after the introduction of the Vespa. Local initiatives had sprung up in different parts of the country, where groups of Vespa owners had sought to establish a national organisation of 'Vespisti', as they were known. There were probably many reasons for wanting to establish a brand community in the form of a club. Both motorcyclists and automobile owners already had national clubs and federations with traditions dating back to the early twentieth century.[15] Although not brand specific they could testify to the benefits of an organisation devoted to motoring, both for competitions and for tourism, as well as for joining forces in the cause of automobility. However, Vespa drivers seem to have felt a need to distinguish themselves from car owners and traditional motorcyclists, even if the relationship to the motorcyclists' organisations in general was good.[16] Automobiles were often seen as upper class, even aristocratic, while motorbikes represented a working-class masculine culture. The Vespa may in this sense be regarded as a 'gentrified' form of two-wheeler in 1950s Italy.[17]

The managers of the Piaggio Company witnessed the growth of Vespa groups with enthusiasm. As early as 1949 they started to promote the idea of gathering all the local initiatives under a national umbrella. In their corporate magazine, *Rivista Piaggio*, they argued that the clubs would benefit from 'more homogeneous and more efficient organization' that could unify the norms, and discipline the activities, of the Vespa clubs. In the view of the *Rivista Piaggio* editorial, there were several problems facing Vespa drivers that could be tackled only by joining forces. The problems in question were mostly bureaucratic impediments and regulations, as well as taxes and fuel prices.[18] Innocenti, producer of the competing brand Lambretta, followed a similar strategy, establishing their own club system in order to promote brand loyalty and maintain their market share.[19]

Renato Tassinari was editor in chief for the *Rivista Piaggio* and apparently influential, therefore, in how the Vespa was promoted in the early years. Tassinari was, however, only a mouthpiece for the powerful Enrico Piaggio, who personally controlled every part of the Piaggio operation. In the summer of 1949 the presidents of the different Vespa clubs

met to formally establish an Italian union of Vespa drivers. At this point it seemed that the organisation was in the hands of the Vespa users themselves. But at the national convention in Viareggio in October, things changed: the congregation of delegates elected Tassinari president of the Vespa Club of Italy, along with other Piaggio managers as members of the board and counsellors. The vote for leaving the organisation and management to the directors of the company producing the Vespa can be explained partly by the fact that some of the delegates were not only local representatives of Vespa clubs but also sales agents for Piaggio.[20]

There is no reason to believe that this was a hostile takeover in the eyes of ordinary members and local Vespa leaders. Their club was now taken care of both financially and organisationally by a large professional industry. Sports and tourist activities would now benefit from a direct connection with the manufacturer of the product that formed the nexus of the club community.[21] The Piaggio dominance of the club regime did, however, imply that the company's management could exercise some control over the members' activities. Enrico Piaggio, for instance, did not hesitate to sack the local club president in Naples after being informed that he had been observed on a Lambretta—the fierce contender for leadership of the worldwide scooter market.[22]

Piaggio regarded the Vespa Club system as an important tool for forging the image of Vespa-riding in Italy and encouraged the licensed producers in Great Britain, France, Germany and Spain to establish national Vespa clubs—which they did, albeit with less strictness than in Italy. In particular, Enrico Piaggio was unimpressed by O.J. Hoffman, the licensed producer in Germany, located in Augsburg, which he felt sabotaged the international coordination of Vespa Club activities.[23] Hoffmann was eventually replaced by Messerschmidt as the licensed producer of Vespas in West Germany.

Even though the Vespa was immensely popular in Italy, it was also contested. During the 1950s one could almost speak of a 'moral panic' about scootering as deaths and injuries due to traffic accidents soared.[24] Lightweight vehicles like scooters were the dominant form of private transportation, with more than 1.2 million small two-wheelers in circulation in 1952, a number that more than doubled over the following decade. Vespa was the largest scooter brand, with Innocenti's Lambretta chasing behind.[25] No wonder, then, that Piaggio felt alarmed by the accusations levelled against its product and its users' reckless behaviour.

A MOVEMENT BASED EXCLUSIVELY ON VIRTUE

Although they represented only a small percentage of the total Vespa users in Italy, the Vespa Club members were useful allies in resisting these allegations.[26] Piaggio saw the Vespa clubs as a way to project the ideal Vespa user onto Italian society (Figure 15.1) by nurturing the myth of the Italians as essentially *brava gente*, or 'decent and good-hearted folk', to use the words of Donald Sassoon. This stereotype had been activated partly as 'a form of self-justification of those who felt left out by the dominant story of heroic Resistance', Sassoon says.[27] When Piaggio promoted Vespa drivers as, ideally, well-behaved,

gentle and disciplined citizens, it invoked a stereotype that was useful not only for battling accusations of reckless speeding and noisy driving but also as an attempt to counter the widening ideological gaps in Italian society. Anyone could be part of the Vespa family as long as they behaved according to the Piaggio ideals. This is the general idea expressed in a quote by Tassinari, from his speech at the tenth annual convention of the Vespa Club d'Italia:

> As you well know, we are a movement based exclusively on virtue, with none of the poison of political hatred, none of the rigidity of hazy or unreachable idealism; a movement that comes about, expresses itself and breeds to the beat of small engines and hearts serene and free in seeking far-off beautiful countryside and brotherly friendship.[28]

This was said in 1959, at a time when the Vespa Club was approaching a peak in membership and the number of local chapters. It was also a time when ideological conflict between the left and the right was relentless in Italy and in many other parts of the world. Outside the Piaggio factory gates, workers would soon protest against Enrico Piaggio's

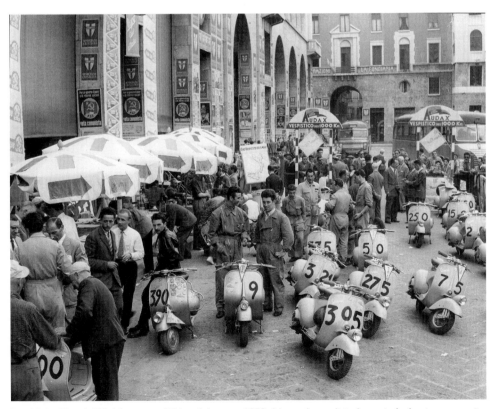

Fig. 15.1 The 1,000-kilometre (621-mile) race, 1953. Note the political parties' election campaign posters. Courtesy of the Piaggio Archive, Pontedera, Italy.

conspicuous consumption while they were paid the minimum wage.[29] One could argue that Tassinari's bid for an apolitical sphere was in itself an expression of a specific ideological stance: both conformism and familism can be traced in his discourse, which was directly linked to the dominating centre-right political hegemony in Italy at the time.[30] Tassinari's outlook was shared throughout the Vespa Club organisation. For instance, in 1956 a newly elected club president would be impressed by how friendly and efficient the club leaders were in organising their activities; he hoped God would ensure that Italy itself was governed with the same sincere, friendly, brotherly spirit as the national Vespa Club congress.[31]

During the 1950s, the Vespa clubs were engaged in a series of activities linked to promoting Vespa-riding as a good way for Italians to pass their time. In early winter they entered the city squares to participate in the Epiphany tradition, which under Fascism had come to involve donations of gifts to civil servants, like the *vigili urbani*— the traffic officers in charge of urban traffic management. Vespa Club members gave cakes and other presents to the officers, with the intention of ending the assumption that scooter drivers were 'bedevilled rebels' pitted against the traffic officer as an 'unyielding Cerberus'.[32] Piaggio would often cover these events in its magazine as if it

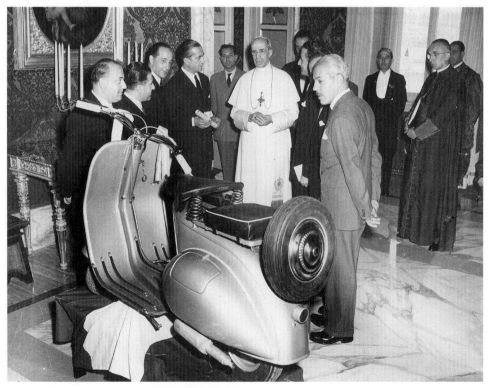

Fig. 15.2 Leaders of the Vespa Club in Italy at an audience with Pope Pius XII, 1949. Courtesy of the Piaggio Archive, Pontedera, Italy.

had been the sole observer of this ritual. From other sources, like the film news service *Settimana Incomm*, it is evident that Vespa drivers were only one of many groups involved in the ritual.[33]

The Epiphany tradition was one way of demonstrating that Vespa Club members were good Catholics. This was also underlined on several other occasions, including, notably, a papal audience in 1949 (Figure 15.2). In the article following this event, the Piaggio magazine was euphoric in its description of the scene in which 500 Vespa drivers received papal blessings outside Castel Gandolfo: 'On their knees beside their shimmering steel horses each of them seemed like a knight on a new crusade: for civility, for labour and for good taste'. The Piaggio management was given a private audience afterwards, a sign of the power structures that were in operation.[34]

HERALDS OF MODERNITY

Vespa Club members were, in other words, on a heroic mission under the guidance of both the pontifex maximus and Piaggio & Co.[35] They were to be good Italians but also *modern* Italians. An important part of the activities was races and competitions. The so-called Giro dei Tre Mari—a tour of the three seas of southern Italy—was part of a strategy to promote scootering in the less developed parts of the country. The event was represented as a contrast between the traditional rural life in the south and the fast-paced modernity of the urban north. In 1955 a newspaper headline would term the Vespa drivers as 'heralds of progress'. Piaggio hastened to emphasise, however, that the 'modern' Vespas did not 'suffocate tradition and enthusiasm'.[36]

In the 1950s the Vespa clubs in Italy were also involved in different events where national unity was invoked as a virtue. The idea of Italy as a nation has been questioned by many over the years. Patriotic sentiments have of course been present in various ideological projects since the nineteenth century, but national identity has often been downplayed in favour of *il campanilismo*, belonging to one's native local community.[37]

The Vespa Club decided that it wanted to celebrate the national character of Vespa-riding. In 1951 it orchestrated rallies all over the peninsula, with simultaneous gatherings in twelve major cities. The Minister of Labour, Achille Marazza, gave a radio speech addressing Vespa riders throughout the country. He spoke of the Vespa as a 'jewel in the service of utility transportation' and the result of an 'ingenious understanding of the economic possibilities in our country'. Even if Italy had few natural resources, a vehicle like the Vespa had created work for many people, he said. Thus, once again, the Vespa was evoked as a national symbol indicating progress and prosperity.[38]

CROSSING BORDERS

Progress and prosperity were indeed virtues upheld by many in post-war Italy, even though the capacity to take part in the new freedoms of modern life was restricted for most. Those lucky enough to own a Vespa could use it to go on excursions—what in Marino Livolsi's words was a national 'rite of "exorcising" economic hardship, and a

symbol of the possible entry into a much wider world than that of Italy's towns and country hamlets' (Figure 15.3).[39]

The Piaggio magazine and the Vespa Club newspaper presented excursions as something to be done under the auspices of the Vespa clubs. Those venturing on long trips on their own were seen as fairly foolhardy, and coverage of such trips focused on the bravery needed and the accidents that had to be expected.[40] Even shorter trips abroad, for instance an organised trip to Klagenfurt in Austria in 1949, could be demanding for the average Italian. Practicalities like obtaining passports for crossing the border, arranging hotels and restaurants, organising motorcars to follow the participants and of course dealing with the language: all these things were taken care of by the Vespa Club system. Tassinari seemed moved when he later wrote about the excursion to Klagenfurt: 'it was a real sight for the eye' as loudspeakers announced the parting of each member from Udine, with Miss Italy brought in to wave goodbye.[41] When Vespa drivers crossed borders like this, they represented Italy and Italians abroad as orderly, well-behaved and friendly folk.

Borders could, however, evoke quite different emotions from a sense of transnational belonging. One of the cities involved in the Vespa Day in 1951 was Trieste. This city held

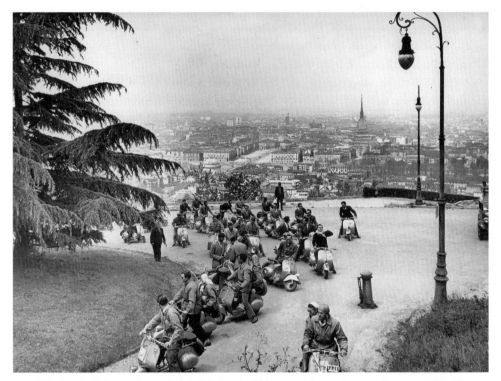

Fig. 15.3 Vespa Club members rally outside Turin, 1950s, exact date unknown. Courtesy of the Piaggio Archive, Pontedera, Italy.

a special meaning for many Italians in the period after the Second World War. Trieste and the region of Venezia Giulia had been fought over by Italy and the Slavs, and after the Second World War Yugoslavia got hold of parts of this area, while Trieste's destiny was undecided. Only in 1954 did Trieste become part of Italy. This event was celebrated in Italy and throughout the Western world. Mainly due to its economic prosperity, the north-eastern part of Italy had a large scootering population. This meant that the celebrations in Trieste in October 1954 were, to some extent, characterised by groups of Vespa Club members. Entering Trieste in their regular cohort and waving the *tricolore*, the Vespa riders managed to attract the attention of some observers, most notably *Life Magazine*.[42] (Figure 15.4.)

For Piaggio this was valuable publicity. The coverage of the Trieste events in the company's own magazine gave the impression that the Vespa clubs had 'conquered' Trieste. Looking at other sources, this image becomes less evident. First of all, it seems quite unlikely that Vespa riders in any way dominated the masses gathered in Trieste to welcome the Italian soldiers taking over the city.[43] Second, some reports in the news media indicate that Vespa drivers could have been involved in less heroic and less good-humoured forms of celebration. The *New York Times* told of episodes where scooter riders from Italy had provoked the inhabitants of a nearby Slavic village by hanging the Italian flag on a wall. This led to several skirmishes, and the police had to intervene.[44]

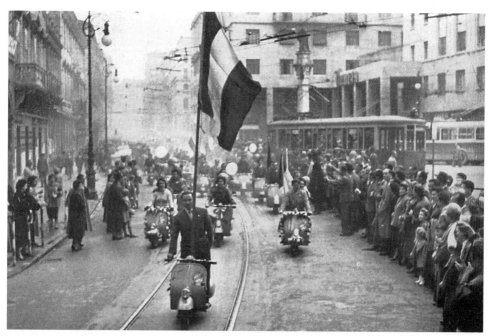

Fig. 15.4 Vespa drivers enter Trieste, October 24, 1954. *Life Magazine* published a similar picture in its October 18 issue. Courtesy of the Piaggio Archive, Pontedera, Italy.

WOMEN IN THE VESPA FAMILY

The preceding are just a few examples of how the Vespa Club members in Italy were involved in the construction of the Vespa scooter as Italian in a particular sense. The 'italianicity' of the Vespa was to be seen as well behaved, familial, patriotic and progressive.

Modernity and tradition were both at play in the ways women were included in the Vespa clubs. Female members were welcome to participate alongside men, even in competitions. Special women-only rallies were arranged as early as 1949 (Figure 15.5). As Piaggio's own journalist stated at the time, 'They [now] have the right to vote, why not the right to scoot?'[45]

Still, as in a traditional patriarchal extended family, women had little formal say in the running of the clubs. A tradition of electing Miss Vespa meant that women had to endure being scrutinised as objects by the male gaze—a tradition Stephen Gundle has shown existed across the ideological spectrum in post-war Italy.[46] It is only in recent years that women have made their way into important positions in the Vespa Club system. On the occasion of the fiftieth anniversary of the Vespa Club in Italy, Christa Solbach, a former president of the Federation Internationale des Vespa Clubs, and Annalisa Manfrè, president of the Vespa Club Bovolone, recounted some of the frustrations experienced by young women in the club regime: 'Too often we were considered only as representative figures, while we had the spirit of initiative and the will to take charge'.[47]

Fig. 15.5 Female Vespa Club member preparing for an excursion in Switzerland, 1949. Courtesy of the Piaggio Archive, Pontedera, Italy.

For several reasons, Vespa-riding diminished during the 1960s. Fiat cars had taken over as the objects of desire in Italy (see Federico Paolini's contribution to this volume). The battle against regulation for scooters was lost. Piaggio had to think about new products designed for the budding youth cultures.[48] With the death of Enrico Piaggio in 1965 the Vespa clubs lost their patron. Piaggio no longer wanted to spend money on club activities, and gradually the membership declined.

Besides, the new users of Vespas were no longer interested in joining a relatively hierarchical and old-fashioned organisation like the Vespa Club. Finally, some critical voices could be heard speaking against the club leadership. Someone writing under the moniker *Il pettegoliere* ('The tattler') started claiming in the club newspaper that the leaders had grown too old, that they followed the rallies and excursions in their big cars and that no serious steps had been taken to recruit new members.[49] Il pettegoliere was probably right, but no one would listen. Thus the movement that once had filled the squares and streets of Italian cities and towns with their imposing ranks of well-behaved, happy and orderly Vespa riders slowly waned.

CONCLUSION

During the first post-war decades Piaggio's Vespa scooter became one of the symbols of Italy's prosperity as a modern, democratic nation. Piaggio had introduced the Vespa in 1946 as a utility vehicle for a recovering Italian society in the wake of a return to normality in the aviation industry. It was as unprepared as anyone for the immense success of its vehicle.[50] While the Vespa's technical qualities and product design were lauded in public opinion within Italy and abroad, the construction of the Vespa as a symbol of post-war liberty and affluence also resulted from its use and the ways in which it was mediated. Italian Vespa Club members represented only a tiny fraction of the consumers, but due to their strong ties to the producing company they became instrumental in imbuing the Vespa with ideas, values and modes of action linked to perceived positive notions about modern Italy.

Even though the Piaggio Company exercised more control over its brand community in Italy than abroad, it was not able to fully harness the Vespa's intended use. As Hebdige has shown for British scooter clubs, the members in Italy would also most often find their own meaningful ways of engaging with their vehicles. Club members in Italy nevertheless helped develop a cultural repertoire surrounding the Vespa. Through their rallies and excursions they produced a critical mass for conveying an idea of the Vespa not only as a convenient commodity but also as a token of belonging within an urban modernity to which many Italians aspired.[51] In this sense, the Italian Vespa Club was an instance of consumption as mediation and an example of how Italian consumers have been actively involved in the shaping of Italian design products.

NOTES

1. Omar Calabrese, 'Introduction', in *Italian Style: Forms of Creativity*, ed. Omar Calabrese (Milan: Skira, 1998), 1–3. Italian emigrant entrepreneurs and diaspora communities

throughout the world have probably contributed to this notion. An issue of the Italian journal *Memoria e Ricerca* (vol. 18, January–April 2005) deals with this topic ('Da emigranti ad imprenditori: Gli italiani all'estero nel secondo dopoguerra', ed. Saverio Battente). See in particular the contributions by Dominic Candeloro, ' "Gente che conosce davvero la propria cucina": L'imprenditorialità tra gli italiani a Chicago dal 1850 a oggi', 41–60; Saverio Battente, 'Le capacità imprenditoriali degli italiani emigrati in Germania nel secondo dopoguerra: Un caso deviante', 123–134; and Stefano Luconi, 'Dalla nicchia al mercato: L'imprenditoria italo-americana a Providence, Rhode Island', 21–40.

2. Roland Barthes, 'The Rhetoric of the Image', in *Image, Music, Text*, ed. and trans. Stephen Heath (London: Fontana, 1977), 32–51.

3. For a well-documented, company-commissioned coffee-table history, see Davide Mazzanti, ed., *Vespa: Italian Style for the World* (Florence: Giunti/Piaggio, 2003).

4. Sandro Marinacci, *Il volo della Vespa: Corradino D'Ascanio, dal sogno dell'elicottero allo scooter che ha motorizzato L'Italia* (L'Aquila: Textus, 2006); and Mazzanti, *Vespa*, 34.

5. Kjetil Fallan, *Design History: Understanding Theory and Method* (Oxford: Berg, 2010), viii.

6. Dick Hebdige, 'Object as Image: The Italian Scooter Cycle', in *Hiding in the Light: On Images and Things* (London: Routledge, 1988), 77–115.

7. Grace Lees-Maffei, 'The Production-Consumption-Mediation Paradigm', *Journal of Design History* 22, no. 4 (2009): 351–376, doi:10.1093/jdh/epp031 (accessed December 12, 2011).

8. Corradino D'Ascanio, 'Come é nata la "Vespa" ', *Rivista Piaggio* 1 (1949): 4. For the technical design development of Vespa models during 1945–2003, see Ornella Sessa, 'The Fifteen Models', in Mazzanti, *Vespa*, 44, 50, 94, 100, 106, 150, 156, 162, 208, 214, 220, 258, 264, 302, 308.

9. Fallan, *Design History*, 98.

10. John W. Schouten and James H. Alexander, 'Subcultures of Consumption: An Ethnography of the New Bikers', *Journal of Consumer Research* 22, no. 1 (1995): 43–61; Albert M. Muniz Jr. and Thomas C. O'Guinn, 'Brand Community', *Journal of Consumer Research* 27, no. 4 (2001): 412–432; Bernard Cova, 'Community and Consumption: Towards a Definition of the "Linking Value" of Product or Services', *European Journal of Marketing* 31, nos. 3–4 (1997): 297–316; and Adam Arvidsson, *Brands: Meaning and Value in Media Culture* (London: Routledge, 2006), 5.

11. See also Thomas Brandt, 'La Vespa negli Stati Uniti: Il trasporto culturale di una merce italiana', *Memoria e Ricerca* 3 (September–December 2006): 129–140.

12. Carsten Nielsen, 'La 'Vespa' nell' opinione estera', *Rivista Piaggio* 2 (1949): 6.

13. Paul Hoffman, 'Anti-noise Drive', *New York Times*, April 24, 1955.

14. In 1953 Piaggio launched a campaign warning its Vespa customers that tampering with the construction would result in the loss of warranty rights. The campaign ad was also run in the Vespa Club newspaper, an indication that Piaggio had little faith in the virtues of the club members in this respect. *Vespa Club d'Italia*, March 15, 1953. For the auto industry's battle

against hot-rodding, see David Gartman, *Auto Opium: A Social History of American Automobile Design* (London: Routledge, 1994), 171. See also Karin Bijsterveld, *Mechanical Sound: Technology, Culture, and Public Problems of Noise in the Twentieth Century* (Cambridge, MA: MIT Press, 2008).

15. The Federazione Motociclistica Italiana was established in 1904. The Automobile Club d'Italia was founded in 1905.

16. 'La costituzione in tutta Italia dei gruppi "Vespisti" ', *Rivista Piaggio* 1 (1949): 12.

17. Lars Lagergren, *Svensk motorcykelkultur* (Stockholm: Symposion, 1999). See also Christopher T. Potter, 'Motorcycle Clubs in Britain during the Interwar Period 1919–1939: Their Social and Cultural Importance', *Journal of Motorcycle Studies* 1, no. 1 (2005); and Karen Bettez Halnon and Saundra Cohen, 'Muscles, Motorcycles and Tattoos—Gentrification in a New Frontier', *Journal of Consumer Culture* 6, no. 1 (2006): 33–56.

18. Renato Tassinari, 'Un ponte tra lavoro e clientele', *Rivista Piaggio* 1 (1949): 1–2. Debates on vehicle regulations and taxation were recurrent in the Italian motoring press in general. For instance, see Gino Magnani, 'Si profila all'orizzonte un grave conflitto d'ordine sociale', *Motociclismo* 28 (1952): 15.

19. Vittorio Tessera, *Innocenti Lambretta: The Definitive History* (Vimodrone: Giorgio Nada Editori, 1999), 26.

20. For instance, Robert Sieghel of Trento. See 'Attività del Vespa Club d'Italia: Il Congresso di Viareggio', *Rivista Piaggio* 6 (1949): 12; and 'Agenti all'ordine del giorno! Bruno Sighel', *Vespa Servizio*, March 1, 1959, 1–2.

21. Club membership would also give access to several discounts and members-only benefits, as well as a reduced subscription rate for the *Rivista Piaggio* and the club newspaper *Vespa Club d'Italia.*

22. Enrico Piaggio to Mario Revetria, July 1, 1953, Archivio Storico A.B. Piaggio (ASP), fondo Direzione Generale, box 1, folder 1.

23. Enrico Piaggio to O.J. Hoffmann, February 27, 1954, ASP, fondo Direzione Generale, box 18, folder 1.

24. The accusations against scooterists could be fierce in the press. In November 1952 the magazine *Epoca* launched an investigation into the causes of traffic accidents and put much of the blame on 'scooterism'—a special mentality allegedly predominant among some road users. Furio Fasolo, '1. Perché la strada uccide? Sangue sull'asfalto', *Epoca* 112 (1952): 24–27; '2. Sangue sull'asfalto: Esame di maturità per tutti I guidatori', *Epoca* 113 (1952): 60–64; and '3. Perché la strada uccide? Troppi "pericoli pubblici" alla guida di auto veloci', *Epoca* 114 (1952): 42–45. See also Mildred Adams, 'Now Europe, Too, Runs into a Traffic Jam', *New York Times*, August 4, 1957.

25. For Innocenti's Lambretta, see Tessera, *Innocenti Lambretta.*

26. Based on available statistics I have found that between 5 and 7 per cent of registered Vespa owners were club members: Automobile Club d'Italia, *Statistiche automobilistiche 1955*

(Rome: Centro Meccanografico dell'Ufficio Statistiche dell'ACI, 1959); *La Moto*, March 30, 1956; *La Moto* 6 and 23 (1959); ASP, fondo Lanzara, box 220 and box 119, folder 2; and *Vespa Servizio*, May 1, 1961. Data from 1949 to 1955 are unreliable, because no statistics separating production, sales and exports exist.

27. Donald Sassoon, 'Italy after Fascism: The Predicament of Dominant Narratives', in *Life after Death: Approaches to a Cultural and Social History of Europe during the 1940s and 1950s*, ed. Richard Bessel and Dirk Schumann (Cambridge: Cambridge University Press, 2003), 274.

28. Quoted in Mazzanti, *Vespa*, 76.

29. Paola Casagrande, 'Piaggio—Il padrone, la fabbrica, gli operai', *Lavoro*, May 24, 1962.

30. For the different political cultures in Italy, see Sandro Bellassai, *La morale communista: Pubblica e privato nella representazione del PCI (1947–1956)* (Rome: Carocci, 2000); and Guido Crainz, *Storia del miracolo italiano: Culture, identità, trasformazioni fra anni 50 e 60* (Rome: Donzelli, 2003).

31. 'Impressioni di un Presidente novellino', *Vespa Club d'Italia*, March 15, 1956, 3.

32. 'In tutta Italia i Vespisti per il Natale dei Vigili del traffico', *Rivista Piaggio* 13 (1951): 5.

33. 'La Befana per i vigili al traffico', *Repertorio Incom*, January 1952, part of *Settimana Incom* 703–704, Archivio Luce, Rome, http://www.archivioluce.com (accessed December 14, 2011).

34. Umberto Piccini, 'Il Pontefice riceve e benedice cinquecento Vespisti a Castel Gandolfo', *Rivista Piaggio* 7 (1949): 4.

35. The clubs were not always eager to follow the general directives. Vice president Manlio Riva wrote in the club newspaper warning against failing to accommodate the wishes of the club leadership and 'our associates' (i.e. Piaggio), threatening neglectful local leaders with withdrawal of funding and support for their activities. 'In Margine al Congresso di Sorrento', *Vespa Club d'Italia*, March 15, 1956, 3.

36. Quoted in Guido De Rossi, *Uomini in Vespa da un mare all'altro: La storia del Giro dei Tre Mari* (Pontedera: CLD, 2000), 32. *Rivista Piaggio* also printed a photo from the event, with the caption: 'In Benevento where "the modern" does not suffocate enthusiasm and tradition'. *Rivista Piaggio* 35 (1955): 10.

37. Luigi Manconi, 'Campanilismo', in *L'identità degli italiani*, ed. Giorgio Calcagno (Rome: Laterza, 1993), 36–42.

38. 'Ai Vespisti d'Italia', in 'Giornata della Vespa', special issue, *Rivista Piaggio* (July 1951): 1.

39. Marino Livolsi, 'Behind the Myth of the Vespa', in Calabrese, *Italian Style*, 20.

40. 'Un "a solo" del vespista Mantellini attraverso l'Italia', *Rivista Piaggio* 5 (1949): 6.

41. Renato Tassinari, 'Coi Vespisti in Austria', *Rivista Piaggio* 5 (1949): 3.

42. 'Trieste Celebrates End of Old Dispute', *Life Magazine*, October 18, 1954, 36–37.

43. For images and memories surrounding the October 1954 celebrations in Trieste, see http://www.triesteitaliana.it (accessed December 15, 2011).

44. Arnaldo Cortesi, 'Trieste Acclaims Italian General as He Arrives to Assume Control', *New York Times*, October 7, 1954; and Michael L. Hoffman, 'Triestines Rejoice as Allies End 9 Years of Occupation', *New York Times*, October 26, 1954.

45. Dino Falconi, 'Venere a motore', *Rivista Piaggio* 6 (1949): 20.

46. Stephen Gundle, 'Feminine Beauty, National Identity and Political Conflict in Postwar Italy, 1945–1954', *Contemporary European History* 8, no. 3 (1999): 359–378.

47. Quoted in Roberto Leardi, *Cinquant'anni di Vespa Club d'Italia—la storia dell'Associazione nata con la Vespa* (Rome: CLD, 1999), 47.

48. Adam Arvidsson, 'From Counterculture to Consumer Culture: Vespa and the Italian Youth Market, 1958–78', *Journal of Consumer Culture* 1, no. 1 (2001): 47–71.

49. Il pettegoliere (The tattler), 'Un dialogo difficile ai margini del 18. Congresso', *Vespa Club d'Italia*, May 1967.

50. Andrea Rapini, 'Il romanzo della Vespa', *Italia Contemporanea* 244 (2006): 385–407.

51. Arvidsson, *Brands*, 4.

16 'MADE' IN ENGLAND? THE MEDIATION OF ALESSI S.P.A.

GRACE LEES-MAFFEI

The discourse surrounding Italian design often invokes the notion, myth or unofficial brand of 'made in Italy' as shorthand for indicating the quality and specialness of Italian design. This chapter examines 'made in Italy' more closely. It challenges the production emphasis of 'made' with an understanding that products are as much made through their consumption and mediation as they are through their manufacture. The chapter also replaces a focus on that which occurs 'in Italy' with a case study analysis of what happens outside Italy (in England in this example) for a better understanding of the significance of Italian design. It does this through analysis of a variety of discourses, including vanity publishing and press releases; interviews with designers, manufacturers, retailers, commentators and consumers; and statistical information about sales and magazine circulation.

INTRODUCTION: QUESTIONING 'MADE IN ITALY'

What does 'made in Italy' mean? It refers to the special nature of Italian design based, variously, on the architectural training of many Italian designers, the input of sympathetic manufacturers, the concentration of local centres of specialisation, the fusion of craft heritage with experimentation with new materials, and tight networks based on family, proximity and a number of key institutional initiatives such as the Salone del Mobile. 'Made in Italy' clearly prioritises production—'made'—an emphasis reflected in the historiography of Italian design, which has dwelt on ideation and manufacture at the expense of consumption and mediation, as Maddalena Dalla Mura and Carlo Vinti note in chapter one of this volume. Yet it is possible to question the extent to which goods 'made in Italy' are actually *made* in Italy, in several ways.

An example of the importance of Italian production is shown in the case of the northern Italian household goods company Alessi, founded in 1920 to manufacture metal parts such as bedsprings and pressed trays. Alessi maintains an image as the quintessential Italian 'design factory' by insisting on the Italian manufacture of its products. According to co–managing director Alberto Alessi, the 'many medium-size and small-size specialised companies' around Milan are

> flexible, risk-taking and produce things of high quality. In the Fifties, there was the
> miracle of the young architects coming out of Italy who formed the basis for lots

of modern design. We are entrepreneurs, and creativity is in our DNA. Since the workshops of the Renaissance, we have had this expertise combining industry and handcrafted products.[1]

Alberto Alessi has said of the manufacturers he groups under the banner 'Italian Design Factories' that 'they believe, even in their orientation towards design for production and sales, that they are *mediators* in a new artistic field, that of design'. Their roles are 'very close to the activity of a gallery or museum curator, or a conductor, or even a film maker. The Italian Design Factories are essentially artistic mediators in the field (or rather a number of fields) of industrial production'.[2] Even this emphasis on mediation is presented as a characteristic feature of Italian industrial production. Just as a film-maker is a producer as much as a mediator, so an industrialist or manufacturer is more accurately understood as occupying a pivotal role in *production* even though she or he may work in a mediating role with designers and production teams. Of course, as an industrialist, entrepreneur and design manager himself, Alberto Alessi would tend to advance the creative input of those occupying his role. The Triennale Design Museum exhibition and accompanying book in which he made these claims each promote the figure of Alberto Alessi himself, as a cartoon image and through the eponymous custom-designed 'Alb script' font based on his handwriting.[3]

Alessi's claim to Italian nationality hinges entirely on its products being *made* in Italy in the face of the internationalism of its designers, materials (Alessi imports some of the metals from which its goods are made) and market.[4] From the aptly named Bombe tea service (1945), designed by Carlo Alessi, via Richard Sapper's 9090 espresso coffee maker (1979), awarded the Compasso d'Oro and displayed at New York's Museum of Modern Art, to Michael Graves's whistling bird kettle (1985) and the Panda Alessi collaboration with Fiat (2006), Alessi has undergone a remarkable transformation to become a global design-led brand with a reputation for the innovation, wit and style that are seen as epitomising Italian design. Alessi has worked extensively with an international group of architects, in projects ranging from the trenchantly international Tea and Coffee Piazza (1983) produced in sterling silver (and aimed at the museum market, due to its cost)[5] to more recent projects such as the Spring/Summer 2012 launch of (Un)Forbidden City, a range of eight trays by leading Chinese architects, designed to promote Alessi in the world's biggest market. As well as forming part of a wider group of Italian manufacturers that is able to attract international design talent into Italy, Alessi enjoys a global market along with other global brands, from Armani to Zanussi, that have bases in Italy which are instrumental in determining their nationality.

Why is production accorded such a decisive role in determining national design output? Informed by twentieth-century advances in semiotics, structuralism and post-structuralism, and feminist and postmodern theoretical approaches, a range of fields in the humanities and social sciences, from design history to cultural studies, have increasingly demonstrated the importance of looking beyond production to consider the roles

of mediation and consumption in determining the meaning and significance of design.[6] Within this context, 'made in Italy' functions as an unofficial brand to communicate on one level that Italian goods are well designed and well made, and on a metalevel that they conform to a broader *notion* of being well designed and well made, as the mediation of Italian manufacturers, designers and brands has led us to expect. 'Made in Italy' therefore refers to the self-fulfilling *reputation* of Italian design and manufacture as much as it does to the facts of production. Using and displaying such goods is a way of buying into and basking in the reflected glory of the superiority, in both design and manufacture, of Italian goods. So if 'made in Italy' refers to narratives as well as goods, are those narratives also made in Italy? This chapter provides one answer to this question by examining Alessi as a case study, as it is mediated in England.

WHAT IS 'MADE' AND WHERE IS 'ITALY?'

As well as goods being 'made in Italy', the narratives surrounding them stem in part from marketing campaigns 'made in Italy' by in-house marketing staff within manufacturing companies, such as that at Diesel, or by hired marketing and public relations companies, such as Di Palma Associati. Alessi uses both strategies for 'official' narratives composed during the design process and through post-project reflections 'made in Italy' at the Alessi headquarters and disseminated internationally via press releases, catalogues, annual reports and vanity publishing.

Alessi's self-published books shape retailers', mediators' and consumers' perceptions of the stable of three brands (Alessi, Officina Alessi and A di Alessi) by adding value to the products and cultivating the company's design history. For example, typically beginning 'since time immemorial the Alessi family has been firmly established on Lake Orta', the successive editions of Alberto Alessi's book *The Dream Factory: Alessi since 1921* contextualise Alessi's twenty-first-century projects, which have extended the company's range beyond small household goods into consumer durables, including bathroom fittings—Il Bagno Alessi One, designed by Stefano Giovannoni, of 2002, and Il Bagno Alessi Dot by Dutch designer and architect Wiel Arets, of 2007—within a quintessentially Italian genesis and heritage.[7] Notwithstanding their limited distribution,[8] Alessi books provide narratives that inform media coverage of the company.

Alessi's official history is further disseminated through press releases intended to shape the mediation of their subjects as directly as possible, by giving journalists (or, these days, bloggers) the information (and remarkably attractive publicity shots) necessary to compile a notice about a new product or event. The similarity between press releases and the editorial publicity for those products is not surprising, because one aim of the press releases is to direct media coverage.[9] This is achieved not only through rich prose and imagery but also through gifts: 'Alessi sent a specially packaged coffee spoon when they launched their Sottsass cutlery. What design magazine publisher can resist using such seductive and generously bestowed material?'[10] The Italian design world is bilingual; just as *Domus*

and *Casabella* today contain text in Italian and English, Italian companies promote their products through press releases in English as well as Italian. Therefore, the international English-language publicity surrounding Alessi goods is as likely to have derived from company press releases 'made in Italy' as is the Italian mediation of the products.

Alessi's mysqueeze lemon squeezer is a case in point, where the official discourse made in Italy worked effectively to carry one version of events above competing narratives (Figure 16.1). In 2007 lastminute.com founder Brent Hoberman launched the online interiors website and retailer mydeco.com, with seed funding from Philippe Starck among others.[11] In 2009 mydeco design board member Starck and British designer, retailer and restaurateur Sir Terence Conran judged Romanian/German design student Roland Kreiter the winner of mydeco's 'Pure Creativity' competition. Using three-dimensional rapid prototyping, Kreiter's mysqueeze lemon squeezer reinterpreted the traditional wood or ceramic citrus reamer in stainless steel:

> Not only did Starck give Kreiter a prestigious internship working at the designer's Paris studio, he also picked up the phone to Alberto Alessi and told him he'd found his next iconic juicer. The mysqueeze forms part of Alessi's 2010 Object Bijou collection. Alberto Alessi says, 'This seemed to me like a worthy tribute to "Juicy Salif" (1990), the most controversial Citrus-squeezer of the twentieth century'.[12]

Although the name 'mysqueeze' references mydeco, Alessi's 2010 launch publicity touts the product as 'the new icon, heir to the "Juicy Salif" designed by Philippe Starck, the

Fig. 16.1 Designers Roland Kreiter and Philippe Starck with Kreiter's mysqueeze lemon reamer for Alessi, 2010. Courtesy of mydeco.com.

citrus squeezer produced by Alessi which went on to become one of the most renowned icons of contemporary life in all four corners of the globe'.[13] Yet while mysqueeze seems in retrospect to be an obvious candidate for inclusion in Alessi's catalogue, the young student designer Kreiter could not have anticipated that his design would be produced by Alessi. Rather, the tribute notion was elaborated after Starck had brought the product to Alessi's attention and is therefore a result of its *mediation* as much as its production. Thus, mysqueeze is 'made in Italy' as a part of Alessi's catalogue that pays tribute to another item from its catalogue.[14] There is a pattern: just as the mysqueeze of 2010 pays tribute to the Juicy Salif of 1990, so the Tea and Coffee Towers of 2003 reprise the Tea and Coffee Piazza of 1983; in each case the tribute appears after exactly two decades.

The marketing of mysqueeze needs to be understood within the context of a reflexive manufacturer concerned with heritage, history, legacy and family; not only is Alessi one of Italy's many family firms, but it treats its designers as part of an extended 'family', and products are developed in 'families'.[15] Alessi is one of several Italian companies with relatively long histories that market their heritage and design history more widely. For example, Olivetti's long-standing investment in curatorial practice is echoed in the Alessi museum. Cassina's reproductions of Le Corbusier's furniture find a corollary in Alessi's reproductions of Marianne Brandt ashtrays and other classics.[16] Alessi goes further, indeed, in using design history in a referential, if not reverential, cycle of invention and reinvention. For instance, the Christy bowl (1993) reinterprets a design by British industrial designer Christopher Dresser (1834–1904) in brightly coloured plastic and therefore extends beyond mere reproduction into something new.

Alessi's vanity publishing and marketing activities are, like its products, 'made in Italy'. But where, precisely, is 'Italy'? The mysqueeze juicer demonstrates how digital technology facilitates global design, production and mediation processes. Kreiter is a Romanian-born designer, educated in Germany. He entered a competition hosted by an English online retailer, which was judged by a French designer, who contacted an Italian manufacturer to produce the winning design, which is now being sold as Italian on the assumption that it is, quite literally, *made* in Italy. That electronic communication has globalised culture is news to no one, but the way in which mediating discourses can *make* a mythical national identity should give pause for thought to those seduced by 'made in Italy'.[17]

'MADE IN ITALY' AND 'DESIGNER' CULTURE IN BRITAIN

While the international influence of mediating discourses 'made in Italy' is clear, they need to be considered in tandem with localised examples if the significance of Italian design beyond the domestic market is to be understood. Just as the period from 1980 to 1995, following Alberto Alessi's promotion to general manager in 1979, was a watershed at Alessi, from the Tea and Coffee Piazza of 1983 to Family Follows Fiction (FFF) of 1993, the same period witnessed a significant change in the popular reception of design in Britain. Thatcherism fostered acquisitiveness among a wider proportion of the British

market. Working-class people were actively encouraged to become homeowners through the right-to-buy scheme that depleted Britain's social housing infrastructure, and a (doomed) property boom rewarded existing owner-occupiers. Even the ensuing slump in the property market meant that people focused on improving their current homes and that leisure became more home-centred. While the 1980s were popularly referred to as the 'designer decade' in Britain, the 1990s consolidated popular interest in design.

How do we know this? Sales data (see below) are one way to establish the truth of generalisations about the extent to which interest in design increased during the 1980s, but interest is not exemplified only through purchases. Consumption of the discourses through which design is mediated can also reveal insights into popular interest in design. Anthropologist Grant McCracken has noted:

> The viewer/possessor must have been given prior acquaintance with new meanings so that he or she can identify the cultural significance of the physical properties of the new object. In short, the designer relies on the journalist at the beginning and then at the end of the meaning-transferring process. The journalist supplies new meaning to the designer as well as to the recipient of the designer's work.[18]

If magazines disseminate meaningful narratives about design, then magazine circulation data can be analysed retrospectively to identify historical trends.[19]

The mass-market mediation of design through consumer magazines grew significantly between 1980 and 1995 in the United Kingdom (Figure 16.2). In addition to the introduction of several new titles, circulation figures for existing titles grew. Both *What's New in Interiors* and *House Beautiful* reached circulation highs in 1993, while *Homes and Gardens* and *Home Improvements Journal* fell victim to increased competition. These data support the notion that consumer interest in interior design and decoration increased in the period 1980–1995. Figure 16.3 shows the UK circulation data for design, do-it-yourself (DIY) and decorating trade and consumer journals. In 1980 a separate 'Design' category was introduced into British Rate and Data magazine circulation reporting. The titles that migrated from the 'Architecture and Building' section, *Design* and *Designer*, were soon joined by *Creative Review*, launched in 1981; *Blueprint*, in 1983; and *Designer's Journal*, in 1985 (*Design Selection*, not shown in the table, also launched in 1985). Established in 1949, *Design* suffered from the competition of the new launches in the 1980s. *Blueprint* and *Creative Review* peaked in 1991, and *Designer's Journal* folded in 1993. Magazine circulation data therefore evidence a boom period for interest in design between 1986 and 1992, and these magazines were central in mediating design, including, notably, Italian design, to British consumers and design professionals.

Magazine circulation data also show interest in dedicated DIY titles subsiding into the 1990s: *Practical Householder* and *Do It Yourself* lost almost 100,000 and 80,000 readers respectively. Simultaneously, the trade publications *Interior Design* and *Kitchens and Bathrooms* increased their circulations by around 50 per cent, shifting the emphasis from a dated design ideal promoted in existing amateur DIY titles to a more professionalised

Year/Title	Homes and Gardens	House and Garden	Ideal Home	Home Improvements Journal	World of Interiors	What's New in Interiors	Period Home	Period Living & Traditional Homes	House Beautiful
1980	225,132	142,330	218,888	–	–	–	–	–	–
1981	219,537	139,871	221,864	–	–	Uncert.	–	–	–
1982	190,392	113,215	207,558	41,933	43,436	9,790	Launched	–	–
1983	190,731	116,874	195,316	35,182	50,571	9,842	Uncert.	–	–
1984	209,709	124,537	212,394	"	54,111	10,280	Uncert.	–	–
1985	212,711	141,307	204,107	34,803	58,513	10,685	Uncert.	–	–
1986	194,048	136,458	191,556	26,060	61,975	10,823	Uncert.	–	–
1987	187,049	133,030	197,572	29,481	65,546	13,012	18,990	–	–
1988	204,432	140,768	267,003	25,563	70,983	"	32,331	–	–
1989	231,145	148,721	286,809	Uncert.	69,182	11,451	35,277	–	–
1990	"	145,335	293,917	Uncert.	70,431	11,280	32,303	40,398	215,815
1991	213,903	144,888	251,024	Uncert.	68,462	11,136	–	"	238,193
1992	206,328	142,512	230,841	Uncert.	–	–	–	32,133	306,377
1993	190,021	142,851	254,758	Uncert.	–	18,684	–	45,309	344,466
1994	189,911	150,627	253,318	–	61,903	16,999	–	50,014	320,396
1995	179,233	151,869	245,708	–	63,341	–	–	–	–

Fig. 16.2 Circulation of selected interiors consumer publications in Britain, 1980–1995. Compiled by the author from the British Rate and Data (BRAD) Archive.

Fig. 16.3 Circulation of selected design and practical and trade journals in Britain, 1980–1995. Compiled by the author from British Rate and Data (BRAD) Archive.

Year/Title	Design Journals					Practical & Trade Publications			
	Design	Creative Review	Blueprint	Designer's Journal	Design Week	Practical House-holder	Do It Yourself	Interior Design	Kitchens and Bathrooms
1980	17,301	–	–	–	–	108,810	115,521	6,067	6,680
1981	16,867	Uncert.	–	–	–	95,171	89,701	6,076	6,624
1982	"	10,764	–	–	–	76,778	81,302	5,796	6,648
1983	12,248	10,708	–	–	–	70,137	73,264	6,920	6,667
1984	12,236	11,687	Uncert.	–	–	57,429	56,845	9,764	6,685
1985	13,209	12,218	Uncert.	Uncert.	–	52,469	55,919	"	10,176
1986	13,142	14,990	8,500	Uncert.	11,562	"	61,741	9,820	–
1987	14,036	16,712	Uncert.	Uncert.	11,889	47,358	"	9,545	10,593
1988	13,990	17,336	8,029	15,282	10,227	43,478	60,668	"	10,544
1989	13,241	18,831	9,111	14,909	"	45,544	49,640	9,564	–
1990	11,416	19,130	9,406	12,133	10,406	46,325	42,418	9,436	–
1991	11,085	19,327	9,790	11,749	"	39,017	–	–	–
1992	10,696	18,629	7,512	10,763	10,042	28,352	–	–	–
1993	11,363	17,046	7,122	–	8,702	–	–	–	–
1994	–	15,718	6,334	–	7,876	–	–	–	–
1995	–	14,019	–	–	–	Uncert.	–	–	–

approach to interior design and decoration. However, the gain in circulation for these latter two titles is dwarfed by the loss of circulation for the DIY titles, so that the group as a whole declined. We may extrapolate from this that interest in interiors was increasingly aesthetic, rather than practical, between 1980 and 1995.[20]

From 1980 to 1995, British consumers more and more embraced a self-consciously styled, attention-seeking and increasingly *knowing* design aesthetic. This context opened the (kitchen) door to Alessi's quintessential 'designer' goods. McCracken has written persuasively about the ways in which our ideals are separated from daily life either geographically—we hanker for the culture of another country or region—or temporally, as we seek solace in the past or the future.[21] In Britain 'made in Italy' has fulfilled the former function for at least seventy-five years, if not hundreds more. Italian design carries with it associations of La Bella Figura. Britons perceive style, beauty and living well as being valued more highly, and pursued with greater vigour and excellence, in Italy than they are at home. British appreciation of Italian culture is evidenced not only by tourist travel to that country but also through the enthusiastic consumption of Italian food, wine, beer, coffee, films, cars, fashion and product design. The popularity of Italian design and Italian culture more broadly shows no signs of abating.

In May 2010 London's Design Museum hosted a series of talks entitled 'Made in Italy: The Influence of Italian Design', initiated and sponsored by the Italian beer brand Peroni Nastro Azzuro, which had collaborated the previous year with Alessi on the Peroni Blue Ribbon Design Awards for new design talent. As well as reinforcing the 'made in Italy' mythology in Britain, the series exemplified a sustained interest in Italian design: 'Understanding the nature of contemporary Italy is an essential part of the Design Museum's programme', its director Deyan Sudjic said at the time.[22] In Britain, to know design is to know Italian design.

THE BOTTOM LINE: FROM FAMILY FOLLOWS FICTION TO A DI ALESSI

In 1990 Alessi launched the Centro Studi Alessi, headed by Laura Polinoro, to institute collaborations with new designers. Workshops hosted by the centre applied semiotics and anthropological perspectives to design practice. Alessi's book *Family Follows Fiction Workshop 1991/1993* records a Centro Studi Alessi project that resulted in the 1993 launch of a range of plastic products that, following initial set-up costs, could be produced, and therefore sold, more cheaply than the main Alessi line. However, rather than admitting that the new plastic products were cheaper, the official discourse of Alessi's vanity publishing instead presented the range as being as rich, philosophically, as Alessi's stainless steel and silver output. As Polinoro explains, 'The authoritativeness, lucidity, and impact of the products that had been made until then did not quite satisfy our most delicate, tender, intimate and affective demands. We needed new sensorial experiences, and new materials to represent our new thoughts'.[23] This is reflected in the range name: Family Follows Fiction overturns Louis Sullivan's dictum 'Form follows function', replacing utility with lineage and affect. FFF necessitated new ways of mediating Alessi's

output to customers, both on the part of the company itself and on the part of retailers. The FFF book uses Franco Fornari's work on affective codes and the work of developmental psychologist D. W. Winnicott on transitional objects to explain the playful plastic items and thereby provide design mediators with a ready-made story.[24]

But how does that story translate across cultures? In Italy Alessi is not perceived as symbolic of Italian design: Alessi's barware is ubiquitous, and Alessi goods are sold everywhere, from mom-and-pop hardware stores to leading department stores such as La Rinascente. As Alessandro Mendini put it, speaking about Alessi at his studio in Milan, 'Here it is our reality'.[25] In Britain, however, Alessi's output has long been perceived as relatively expensive designer merchandise. This view of Alessi was particularly pronounced during the 1980s and early 1990s, the period leading up to the FFF launch. A retrospective report of June 2000 by the market researchers Mintel noted the added value of 'Alessi styling':

> The designer influence has affected the premium end with products as simple as a lemon squeezer selling for £30 or more if in a suitably stylish design, such as the Philippe Starck chrome alien-like product sold in the more exclusive kitchen shops. The distinctive Alessi designs featuring bright colours and fun shapes have spread from kitchen appliances to gadgets such as timers, corkscrews etc.[26]

While this characterisation of Alessi clearly includes the FFF products—'bright colours and fun shapes'—Mintel underlines the fact that Alessi goods are sold at a premium price point, rather than distinguishing between the main Alessi line and the cheaper FFF plastics.

Two years after the launch of FFF, an article in the Christmas 1995 edition of the UK magazine *Kitchens, Bedrooms and Bathrooms* (Figure 16.4) reported the relatively recent additions to the Alessi range as aspirational and elite. The title, 'The House of Alessi', aligns Alessi with a Parisian haute couture atelier, while Amanda Waggott's text praises Alessi's 'collection of beautiful and witty designs for living' as 'tomorrow's antiques': 'these Italian made household products add the finishing touch, the icing or the cream, to stylish kitchens, bedrooms or bathrooms'.[27] The spread shows the more outré FFF items— Biagio Cisotti's Diabolix, Guido Venturini's 'bizarre' phallic Firebird gas lighter and Stefano Giovannoni's 'wacky' Merdolino toilet brush—alongside Alessi classics including Bombé and the Graves kettle, plus an item from the less well-known Twergi wooden line. Placing FFF within the context of the company's heritage, this article, like Mintel's report and the 'made in Italy' narrative, avoids the message that FFF is simply *cheaper*.

Speaking in 1995, retailer Caroline Elphick—whose Caz Systems lighting showroom stocks design-conscious household items in the seaside town of Brighton on the south coast of England—was clear that Alessi 'made people realise that design is important, especially in this country'. She noted, 'They've seen it in a museum and now they see it in the shop. . . . A lot of people say "We've just seen this in the museum." So that's how you know'.[28] So successful was the association of Alessi with high design and designer

Left: Merdolino is a wacky toilet brush and holder designed by Stefano Giovannoni for the Family Follows Fiction range (around £44.50)

Left & Right: The Girotondo series was designed for Alessi by King Kong Production, and is characterised by cut out shapes of little men. Seen here as part of the range are a pair of egg cups (around £40) and a bowl (£34)

Left: These Diabolix bottle openers are part of the Family Follows Fiction collection and come in green, red, purple and black (priced around £11). They were designed by Biagio Cisotti in 1994

The House of Alessi

Alessi has taken the homes of the design conscious by storm – Amanda Waggott explains why

Left: Part of a collection of wooden objects by Alessi, the Twigi leaning pepper mill is made from Kawringo- and ash. Designed by Massimo Iosa-Ghini in 1989, it costs around £100

Left: This stylish teapot costs £220 and is part of the Bombè tea and coffee service designed by Carlo Alessi Anghini in 1945. A timeless design, Bombè is still in production today

Left: Designed in 1985 by Michael Graves, the kettle with the bird shaped whistle is functional as well as novel. Shown here in black with an orange bird, the kettle costs around £86.50

Left: Memory containers were developed as a result of several research projects conducted by the Centro Studi Alessi. This 'Ovo' model was designed by Joanna Lyle in 1994. The wild 'Rhubarb and Custard' style handles come in pink as shown here, or green, orange and purple (around £57 per jar)

Left: Scappo bottle openers by Massimo Morozzi, designed in 1993. Looking like children's dummies in blue and pink, they are part of the Family Follows Fiction collection (at around £12)

Left: This bizarre object is actually a rather novel gas lighter. Called the Firebird, it was designed by Guido Venturini in 1993 and costs around £40

A
lessi has been described as a fun factory, with Alberto Alessi as the Circus Master. When you look at the products that have come out of this company, particularly in the 1980s and 1990s, you can understand why. From Michael Graves' jaunty kettle with the bird whistle to Joanna Lyle's Memory Container, these Italian made household products add the finishing touch, the king of the cream to stylish kitchens, bedrooms or bathrooms. Founded by Giovanni Alessi in 1921, the company originally made trays and coffee makers, and some of these original designs are still on sale today. To anyone familiar with the House of Alessi, it's not just a name but a collection of beautiful and witty designs for living. Alessi products are tomorrow's antiques – they are a specific reflection of the period they were designed for.

ADDRESSES

OGGETTI'S ALESSI SHOP
143 Fulham Road, London SW3 6SD
(0171 584 9808)

A selection of Alessi products can be found in Harrods, Liberty's, The Conran Shop London, and most major department stores nationwide

culture that British purchasers of Alessi in the mid 1990s perceived Alessi as a designer rather than a manufacturer, were unable to name any designers who had worked for Alessi ('Now . . . does Mendini . . . What *does* Mendini do?')[29] and, notwithstanding the extraordinarily diverse group of Alessi designers, homogenised the Alessi catalogue into a single signature style: 'You know an Alessi piece when you see it'.[30] For these consumers, Alessi represented a generalised *idea* of design.

However, Alessi's official 'made in Italy' narrative about psychologised postmodern playfulness did not entirely succeed in conditioning the response to FFF. In talking about the stock in her shop, Elphick described FFF as 'cheap things': 'They come in a box and they are Alessi. So they are great. But you see "Diabolix", £9.95, that's a really good bottle opener. It's ergonomic, it's funny, it's clever. That's great'.[31] While Alessi headquarters avoided the value proposition of FFF, perhaps feeling that it might have damaged the Alessi brand, price was certainly emphasised by some retailers in their sales patter to potential FFF customers. This is not just a difference between published and spoken discourses but rather one between the discourses 'made in Italy' for dissemination nationally and internationally and the discourses surrounding Italian design (in this case, Alessi) in foreign markets. Although the competing 'cheap things' narrative was 'made in England', retailers in other countries would of course have used price in selling Alessi's plastic goods. However, Alessi's reputation as expensive was more pronounced in the United Kingdom than it was elsewhere, particularly Italy. Price played a part in the mediation of FFF in England precisely because Alessi was sold there at a premium.[32]

Between 1984 and 1994—the period directly following the launch of the Tea and Coffee Piazza and ending just after the launch of FFF—Alessi's worldwide annual turnover quadrupled.[33] Simultaneously, domestic sales and sales in the Americas, Africa and Asia all dropped as a proportion of total sales, while sales in Oceania (principally Australia) grew from 0.18 per cent to 0.69 per cent of total sales, and European sales outside Italy nearly doubled, rising from 22.85 per cent to 41.73 per cent of total sales, primarily due to a leap in Germany from 3.9 per cent to 18.48 per cent of worldwide sales and small increases in Austria, Portugal and Spain. UK sales dropped slightly from 1.2 per cent of global sales in 1984 to 1.06 per cent in 1994. The preceding year, the United States commanded 1.2 per cent of worldwide Alessi sales.[34] These data show that anglophone markets for Alessi were limited, which has implications for the relatively marginal status of anglophone discourses on Alessi.

FFF epitomised a wider trend within mid-1990s product design for colourful plastics for the home. Reflecting on ten years of design retailing, from 1985, the year the Graves kettle was introduced, through to the development, launch and first two years of sales of FFF, Elphick recalls:

> When we first opened everything was black and silver, there wasn't a colour in here and there was hardly any plastic. What has happened to plastic in the last ten years is

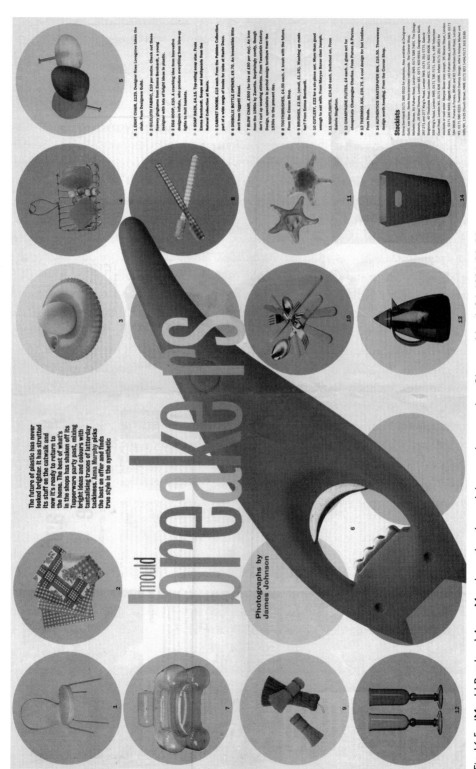

Fig. 16.5 'Mould Breakers', Anna Murphy, author, James Johnson, photographer, *Observer*, March 24, 1996, 38–39.

absolutely amazing. Just look around, you've got 'Bookworm,' Alessi-Philips, 'Fruit Mama'—wonderful combination[s] of plastic and stainless steel.[35]

She refers to Ron Arad's 1994 PVC Bookworm bookshelves for Kartell, the Philips-Alessi bulbous pastel-coloured kitchen appliances (1992–1994)[36] and Stefano Giovannoni's first design for Alessi (1993), the Fruit Mama fruit bowl, one of the earliest FFF items. This trend was mediated to the consuming public in articles such as 'Mould Breakers' (Figure 16.5), a 1996 double-page spread in the *Observer*'s colour supplement showing Alessi's Diabolix bottle opener as the central grinning element in a group of plastic goods that, we are told, mix 'bright ideas and colours with tantalising traces of latterday tackiness'.[37]

Promoting FFF as inexpensive will have helped sales, and yet, along with an aesthetic shift towards cute, whimsical references moulded in cheap and cheerful, colourful plastics, it risked tarnishing the brand. It also risked alienating a self-conscious strand of the design cognoscenti that was attracted to the 1980s limited-edition projects such as the Tea and Coffee Piazza and that perceived the catalogue from the mid 1990s, when FFF launched, as vulgar and déclassé. Alessi's most pronounced shift into character-led design occurred just at the time that the core clientele it attracted in the 1980s was in thrall to minimalism. This story is not found in Alessi's vanity publishing and public relations channels, but it is admitted by retailers and some commentators. Design critic Stephen Bayley complained, 'You know Alessi does seem to have a malign influence on otherwise sensible people. You know Richard Sapper used to be quite a lateral designer; as soon as he goes to work for Alessi he goes silly'.[38] However, Alessi's plastics enabled another group of consumers newly interested in design to engage with the Alessi catalogue and formed a kitsch alternative to the company's aspirational metalware for some existing consumers. Alessi's 'made in Italy' provenance helped to rescue FFF from being despised as cheap and tacky in Britain; to the design cognoscenti, its playful approach was aligned with Italy's particularly creative approach to design and its history of innovation in plastics.[39]

The Centro Studi Alessi closed in 1998; its workshop method was adopted at Alessi, and Polinoro continued as a consultant to the company. The FFF items that remain in the Alessi catalogue are now incorporated into Alessi's diffusion line A di Alessi, with the slogan 'Top design, pop price'. Alessi's official discourse failed to obscure competing messages about its plastic goods in foreign markets such as the United Kingdom; furthermore, Alessi's authorised marketing discourse, 'made in Italy', has been overwritten to reflect the discourse on the (English) shop floor.

CONCLUSION: 'MADE IN ITALY' AS MADE IN ENGLAND

Of course, 'made in Italy' does represent Italy to Italians, to some extent, but it is only by examining what it means outside Italy that we can fully understand its implications. This chapter has shown that by challenging the production emphasis of 'made in Italy' we can see it as a result of mediation, too: narratives as well as goods are made in Italy. In addition, digital culture necessitates a more fluid international geography than the one denoted by a

production-focused understanding of 'made in Italy'. By placing its goods within a histori-cal trajectory, and within a canon, Alessi has also placed them within a narrative discourse. While the mediating discourses made in Italy often prevail, they are sometimes undercut by variant narratives, for example ones in which Alessi is seen as cheap and vulgar. Yet by enabling UK consumers to access *Italianità*, Alessi's cheaper FFF products democratised the aestheticisation of everyday life. Writing in 2001, British design journalist Dominic Lutyens recognised that 'Alessi divides opinion down the middle: people see its creations as joyously witty or annoyingly jaunty. Take the second view, however, and you'd be dis-missing a huge and influential chunk of Italian design history'.[40] 'Made in Italy' is, at least partly, made in England, made in Britain and made around the world.

NOTES

1. Alberto Alessi, quoted in Rosie Millard, 'Interview with Alberto Alessi', *The Telegraph*, Prop-erty section, March 15, 2012, 3.

2. Alberto Alessi, *Le fabbriche dei sogni* (Milan: La Triennale di Milano, Triennale Design Museum/Mondadori Electa, 2011), 123.

3. Ibid.; and Alberto Alessi, 'Le fabbriche dei sogni: Uomini, idée, imprese e paradossi delle fabbriche de design italiano', Triennale Design Museum, fourth edition, Milan, April 5, 2011, to February 26, 2012.

4. Grace Lees-Maffei, '*Italianità* and Internationalism: Production, Design and Mediation at Alessi, 1976–96', *Modern Italy* 7, no. 1 (2002): 37–57.

5. Alberto Alessi, interview with the author, Alessi, Crusinallo, March 19, 1996. The V&A's Registered Papers contain a letter from New York agent Max Protetch (now subsumed by Meulensteen) to the Tate Gallery, London, offering examples of Alessi's Tea and Coffee Piazza for purchase. The V&A bought the versions by European architects plus Yamashita in 'the most expensive purchase of twentieth century metalwork this museum has made'. Curator Richard Edgecumbe to Alberto Alessi, December 22, 1987, V&A Registered Papers.

6. See Grace Lees-Maffei, 'The Production-Consumption-Mediation Paradigm', *Journal of Design History* 22, no. 4 (2009): 351–376; and Emanuela Scarpellini, *Material Nation: A Consumer's History of Modern Italy*, trans. Daphne Hughes and Andrew Newton (Oxford: Oxford University Press, 2011).

7. Alberto Alessi, *The Dream Factory: Alessi since 1921* (Milan: Electa and Alessi/Fratelli Alessi Omegna, 2002), 5. This title was published annually between 1998 and 2002.

8. Laura Polinoro, interview with the author, Centro Studi Alessi, Milan, March 22, 1996: 'Who reads them? I don't know. Some designers, many students . . . some design theorists. . . . I don't know because they are not distributed through bookshops. . . . Where you can buy the Alessi objects, it is not so easy to find the books'.

9. For example, 'Exhibition of Alessi Household Objects Explores Unique Design Collaborations', press release for *Alessi: Ethical and Radical* exhibition, Philadelphia Art Museum, October 4, 2010, http://www.philamuseum.org/press/releases/2010/845.html (accessed May 29, 2013).

10. Anna Griffiths, 'Agenti segreti in buona causa', *Design World* 24 (1992): 58.

11. 'About Us', mydeco.com, http://mydeco.com/the-magazine/style/mydeco-about-us (accessed May 25, 2012).

12. 'Alessi mysqueeze Citrus Juicer', mydeco.com, http://mydeco.com/p/mysqueeze-citrus -juicer-by-roland-kreiter-for-alessimydeco/GB00000012E68CC644B92DC0FE1C75E07 4CFA8DD/ (accessed May 25, 2012).

13. 'RK01—mysqueeze, Citrus-Squeezer', Alessi, http://www.alessi.com/en/2/4916/kitchen -accessories/rk01-mysqueeze-citrus-squeezer (accessed December 11, 2012). See also Grace Lees-Maffei, 'Juicy Salif, Italy (Philippe Starck, 1990)', in *Iconic Designs: 50 Stories about 50 Things*, ed. Grace Lees-Maffei (London: Bloomsbury, 2014).

14. Alberto Alessi states, 'It is a fact that half the successful products from the Italian Design Factories are based on internal briefs and the other half on unsolicited proposals by our designers. A direct consequence of the artistic nature of our products is that good projects cannot be commissioned at will'. Alessi, *Le fabbriche*, 320.

15. Lees-Maffei, '*Italianità* and Internationalism', 52–54.

16. Grace Lees, 'The Process of Meaning: Alessi in Britain 1980–1995' (master's thesis, Royal College of Art, London, 1996), 24.

17. Following Benedict Anderson's idea of nations as 'imagined communities', John Dickie has suggested that Italy is a 'social fiction'. See Benedict Anderson, *Imagined Communities: Reflections on the Origin and Spread of Nationalism* (London: Verso, 1983); and John Dickie, 'Imagined Italies', in *Italian Cultural Studies: An Introduction*, ed. David Forgacs and Robert Lumley (Oxford: Oxford University Press, 1996), 19–33.

18. Grant McCracken, *Culture and Consumption: New Approaches to the Symbolic Character of Consumer Goods and Activities* (Bloomington: Indiana University Press, 1990), 82.

19. Figures 16.2 and 16.3 use data collated from the British Rate and Data (BRAD) archive. BRAD records are based on annual or biannual averages; I used April as a sample month.

20. Penny Sparke makes a similar point about design magazine publishing in Italy in the 1960s in '"A Home for Everybody?" Design, Ideology and the Culture of the Home in Italy, 1945–1972', in *Modernism in Design*, ed. Paul Greenhalgh (London: Reaktion, 1990), 194–195.

21. McCracken, *Culture and Consumption*, 107–108.

22. 'Peroni Nastro Azzurro, in Partnership with the Design Museum, Launch *"Made In Italy— The Influence of Italian Design"*', Design Museum press release, [n.d., March 2010?] http:// designmuseum.org/media/item/76045/2499/Influence-of-Italian-Design-FINAL.pdf (accessed May 21, 2012). The quotation is reproduced in an advertising promotion 'Made in Italy', Style section, *Sunday Times*, May 2, 2010, 48.

23. Laura Polinoro, 'Introduction to the Metaproject F.F.F. for the Workshop: Centro Studi Alessi 1991/1993', in *Family Follows Fiction Workshop 1991/1993*, ed. Giampaolo Guerini and Laura Locatelli (Crusinallo: Fratelli Alessi Omegna, 1993), 14.

24. Alberto Alessi discussed Winnicott, Fornari and the Family Follows Fiction project in 'The Design Factories: Europe's Industrial Future?', lecture hosted by the Design Museum and Pentagram at the Royal Geographical Society, London, June 1993, which later appeared as a chapter of the same name in *Alessi: The Design Factory*, ed. Meret Gabra-Liddell (London: Academy Editions, 1994), 9–15. These texts, in turn, form the basis for Alessi, *Le fabbriche*.

25. Alessandro Mendini, interview with the author, Atelier Mendini, Milan, March 21, 1996.

26. The UK kitchen gadgets market grew by 21 per cent between 1995 and 1999 to £129 million. Mintel International Group, 'Kitchen Gadgets' (London: Mintel, June 20, 2000), n.p.

27. Amanda Waggott, 'The House of Alessi', *Kitchens, Bedrooms and Bathrooms* 36 (December–January 1995–1996): 39.

28. Caroline Elphick, manager, Caz Systems, Brighton, interview with the author, October 16, 1995.

29. Ms. A.B., Alessi customer, interview with the author, November 27, 1995.

30. Mr. C.P., Alessi customer, interview with the author, November 27, 1995.

31. Elphick, interview.

32. Alessi's leadership of the British housewares market was based on design values, not sales. Elphick, interview; and Craig Allen, buyer for the Conran Shop, London, interview with the author, October 25, 1995.

33. Michele Alessi, co–managing director (finance) at Alessi, interview with the author, Royal College of Art, London, October 5, 1995.

34. Unpublished data supplied to the author by Michele Alessi, co–managing director (finance) at Alessi S.p.A.

35. Elphick, interview. With a retailer's pragmatism, she adds, 'But of course it's a nightmare for stocking things, because people always want blue and you have only got red and yellow or whatever it is'.

36. Philips-Alessi was commemorated with a trilingual brochure reviewing the history of household appliances.

37. Anna Murphy, 'Mould Breakers', *Observer*, March 24, 1996, 38–39.

38. Stephen Bayley, interview with the author at his office, Chelsea Embankment, London, October 31, 1995.

39. Italy established a plastics industry in the 1930s. It was boosted by Giulio Natta's invention of polypropylene in 1954 at the Politecnico di Milano and its commercial application from 1957 by Montecatini. Kartell is just one among several manufacturers to have targeted the possibilities of plastic for furniture. Peter Dormer, *Design since 1945* (London: Thames and Hudson, 1993), 166–168.

40. Dominic Lutyens, 'Alessi Is More: From Frog-Eyed Bottle Stoppers to Spring-Loaded Ashtrays and Day-Glo Loo Brushes, Alessi Caught the Mood of the 90s. So How Will the Italian Firm's Designers Define This Decade?' *Observer*, March 11, 2001, 52.

CONTRIBUTORS

Thomas Brandt is associate professor of history at the Norwegian University of Science and Technology in Trondheim. Brandt earned his PhD with a thesis on the cultural production, mediation and use of the Italian Vespa scooter in post-war Italy. His scholarly interests lie in the intersection between cultural history and the history of technology and science. His most recent publication is a history of the Norwegian University of Science and Technology (Pax, 2010).

Maddalena Dalla Mura is a freelance researcher and editor. She graduated from the Università di Udine in 2000 with a degree in conservation of the cultural heritage and in 2010 received her PhD in design sciences from the Università Iuav di Venezia. Her research interests concentrate on design history, graphic design and museum studies. She is the co-editor, together with Giorgio Camuffo, of the publication *Graphic Design Worlds/Words*, released on the occasion of the exhibition *Graphic Design Worlds* (Triennale Design Museum, 2011). In 2012–2013 she conducted research at the Free University of Bozen-Bolzano.

Elena Dellapiana is associate professor in the Department of Architecture and Design at the Politecnico di Torino. She is a scholar of architectural, town and design history of the nineteenth century, with several papers and books on Italian and European architects and on the transmission of architectural culture in art academies, applied arts museums, the discussion about historical sources and historicism. She is one of the authors of *Storia dell'architettura italiana: L'Ottocento*, edited by Amerigo Restucci (Electa, 2005) and a member of several research groups. She has recently authored *Il design della ceramica in Italia (1850–2000)* (Electa, 2010).

Kjetil Fallan is associate professor of design history at the University of Oslo's Department of Philosophy, Classics, History of Art and Ideas. He is the author of *Design History: Understanding Theory and Method* (Berg, 2010) and the editor of *Scandinavian Design: Alternative Histories* (Berg, 2012) and has written numerous book chapters and journal articles, for example in the *Journal of Design History, Design Issues, Design and Culture, History and Technology, Architectural Theory Review, Modern Italy* and *Enterprise and Society*. Fallan is an editor of the *Journal of Design History*.

Imma Forino (MA PHD) is associate professor of interior architecture in the Scuola di Architettura e Società at the Politecnico di Milano, where she is also member of the PhD board in interior architecture and design. She is also on the international PhD board in philosophy of interior architecture at the Università degli Studi di Napoli and the Universidad Autónoma de Aguascalientes, Mexico. Her main publications are *Uffici: Interni arredi oggetti* (Einaudi, 2011), *George Nelson: Thinking* (Testo&immagine, 2004), *Eames: Design totale* (Testo&immagine, 2002) and *L'interno nell'interno: Una fenomeno- logia dell'arredamento* (Alinea, 2001). She is co-editor of *Places and Themes of Interiors* (Franco Angeli, 2008) and of *Interior Wor(l)ds** (Allemandi, 2010).

Lisa Hockemeyer (BA Hons UCL, MA RCA) is a historian specialising in twentieth- century Italian art, design and material culture and their relationships. She is adjunct lecturer in design history at the Politecnico di Milano and visiting research fellow at Kingston University, where she earned a PhD with a thesis on early post-war Italian ceramics. Hockemeyer curated the exhibition *Terra Incognita: Italy's Ceramic Revival* at London's Estorick Collection of Modern Italian Art (2009) and edited and co- authored with Gillo Dorfles *The Hockemeyer Collection: 20th Century Italian Ceramic Art* (Hirmer, 2009). She is an active member of the Italian Association of Design Historians.

Grace Lees-Maffei (PhD, MA RCA FHEA) is reader in design history and TVAD (Theorising Visual Art and Design) Research Group coordinator at the University of Hertfordshire and managing editor of the *Journal of Design History* (Oxford University Press). Her publications include *Design at Home: Domestic Advice Books in Britain and the USA since 1945* (Routledge, 2013); the edited books *Writing Design: Words and Ob- jects* (Berg, 2011) and *The Design History Reader*, co-edited with Rebecca Houze (Berg, 2010); chapters in *Must Read: Rediscovering the American Bestseller* (Continuum, 2012), *Performance, Fashion and the Modern Interior* (Berg, 2011) and *Autopia* (Reaktion Books, 2002); and articles in the *Journal of Design History*, *Modern Italy*, *Women's History Review* and *Arts and Humanities in Higher Education*. Lees-Maffei is an advisory board member for the *Poster*.

Jonathan Morris is professor of modern European history at the University of Hert- fordshire in the United Kingdom. A specialist in modern Italian history, he directed the research project 'The Cappuccino Conquests: The Transnational History of Italian Cof- fee', with outputs including 'Made in Italy: Consumi e identità collettive nel secondo dopoguerra', co-edited with Claudia Baldoli, special issue, *Memoria e Ricerca* 23 (2006); 'Making Italian Espresso, Making Espresso Italian', *Food and History* 8, no. 2 (2010); and *Coffee: A Handbook*, co-edited with Robert Thurston and Shawn Steiman (Rowman and Littlefield, 2013). He is currently completing *Coffee: A Global History* for Reaktion Books.

Gabriele Oropallo is a design historian and curator based at the University of Oslo, Norway. His current research project looks at the design history of sustainability in late Modernism. Educated in Naples, Düsseldorf, and London, he held a Marie Curie EST fellowship for research on social commitment and design at University College London, where he also taught design history and in 2010–2011 curated a series of public symposia on design ethics. His recent publications include catalogue essays for exhibitions held at Milan's Triennale or São Paulo's SESC and chapters in books such as *Writing Design: Words and Objects* (Berg, 2011) and *Iconic Designs: 50 Stories about 50 Things* (Bloomsbury, 2014).

Federico Paolini is a researcher and adjunct professor of contemporary history in the Faculty of Arts of the Seconda Università degli Studi di Napoli. His research interests focus on environmental history, mass-consumption history and the social history of transport. He is a member of the American Society for Environmental History and the European Society for Environmental History. His main monographs are *Storia del Sindacato ferrovieri italiani 1943–1958* (Marsilio, 1998), *L'esperienza politica di Oliviero Zuccarini* (Marsilio, 2003), *Un paese a quattro ruote: Automobili e società in Italia* (Marsilio, 2005), *Storia sociale dell'automobile in Italia* (Carocci, 2007) and *Breve storia dell'ambiente nel novecento* (Carocci, 2009).

Daniela N. Prina is a postdoctoral research fellow of the Fond de la Recherche Scientifique at the University of Liège. She has lectured in the architecture and design history courses at the University Study Abroad Consortium and at the Politecnico di Torino. Her research interests focus on the training of architects and engineers, as well as architecture and design in the nineteenth and twentieth centuries in Belgium and Italy. She regularly presents her research at international conferences, and she has published in national and international journals, including the *Journal of Design History* and the *Journal of the History of Collections*.

Raimonda Riccini is associate professor and coordinator of the Ph.D. program in Design Sciences at the Iuav University of Venice (Italy), where she heads the Museology of Design Research Unit. She is co-founder of the Italian Association of Design Historians and editor of the online magazine *AIS/Design. History and Research*. Active as a theoretician and historian, she has published books, articles and chapters on the history of design (recently *Pensare la tecnica, progettare le cose. Storie dal design italiano*, Archetipolibri, 2012) and has organised international conferences and exhibitions, such as Copyright Italia: Brevetti, marchi, prodotti 1948–1970, Archivio Centrale dello Stato, Rome, 2011.

Vanessa Rocco is assistant professor in the Department of Humanities and Fine Arts at Southern New Hampshire University and co-editor of *The New Woman International: Representations in Photography and Film 1870s–1960s* (University of Michigan Press,

2011). She was assistant curator at the International Center of Photography in New York for exhibitions including *Expanding Vision: Laszlo Moholy-Nagy's Experiments of the 1920s* (2004). She served as curatorial advisor for the exhibition *Universal Archive* at the Museu d'Art Contemporani de Barcelona (2008) and contributed an analysis of architectonic photography in Italian Fascist exhibitions to the catalogue *Public Photographic Spaces* (Museu d'Art Contemporani de Barcelona, 2008). Her publications on photography and exhibitions have appeared in the journals *History of Photography*, *SF Camerawork* and *Afterimage*.

Catharine Rossi is senior lecturer in design history in the School of Art and Design History at Kingston University, London. In 2011 she completed an AHRC (Arts Humanities Research Council) Collaborative Doctoral Award at the Royal College of Art/ Victoria and Albert Museum, entitled 'Crafting Design in Italy, from Post-war to Postmodernism'. Her research areas span twentieth- and twenty-first-century craft and design, with a particular interest in post-war Italy. Her publications include articles in the *Journal of Design History* and the *Journal of Modern Craft*, a chapter on Memphis in the Victoria and Albert Museum exhibition catalogue *Postmodernism: Style & Subversion 1970–1990* (2011) and a book, *The Italian Avant-Garde: 1968–1976*, co-edited with Alex Coles (Berlin: Sternberg Press, 2013).

Jeffrey T. Schnapp is the faculty director of metaLAB at Harvard University and co-director of the Berkman Center for Internet and Society. A cultural historian with interests extending from antiquity to the present, his recent books include *Speed Limits* (Skira, 2009), *The Electric Information Age Book* (Princeton Architectural Press, 2012) and *Digital_Humanities* (MIT Press, 2012). His pioneering work in the domains of digital art and the humanities as well as curatorial practice has included collaborations with the Triennale di Milano, the Iris and Gerald Cantor Center for the Visual Arts, the Wolfsonian and the Canadian Centre for Architecture.

Simona Segre Reinach is a cultural anthropologist and adjunct professor of Fashion Studies at Bologna University. She has written on fashion from a global perspective in the books *Berg Encyclopedia of World Dress and Fashion* (2010) and *The Fashion History Reader* (2010), and in the journals *Fashion Theory, Fashion Practice, Business and Economic History*, and *Critical Studies in Fashion and Beauty*. Segre Reinach conducted fieldwork in China (2002–2010) on Sino-Italian joint-ventures within a collaborative project. She is a founding partner of Misa, Associazione Italiana Studi di Moda. Segre Reinach's latest book is *Un Mondo di mode* (Laterza 2011). She recently guest edited a special issue of *Zonemoda Journal* on Italian fashion.

Penny Sparke is pro vice-chancellor (research and enterprise) at Kingston University. Awarded her doctorate in 1975, she has taught history of design at Brighton Polytechnic

(1972–1982) and the Royal College of Art (1982–1999). She has published widely in the field of design history with an emphasis, since the mid-1990s, on design, gender and the interior. Her books include *As Long as It's Pink: The Sexual Politics of Taste* (Pandora, 1995), *An Introduction to Design and Culture: 1900 to the Present* (Routledge, 2004), *Elsie de Wolfe: The Birth of Modern Interior Decoration* (Acanthus, 2005) and *The Modern Interior* (Reaktion, 2008).

Carlo Vinti is a research assistant professor in the School of Architecture and Design at the Università degli Studi di Camerino. He received a PhD in arts theory and history (School of Advanced Studies in Venice, 2006) and has been adjunct professor and research fellow at the Università Iuav di Venezia. Among his publications: *Gli Anni dello Stile Industriale 1948–1965* (Marsilio, 2007) and *Comunicare l'Impresa* (coedited with Giorgio Bigatti, Guerini e Associati, 2010). In 2012 he co-curated with Giorgio Camuffo and Mario Piazza the fifth edition of the Triennale Design Museum (*TDM5: Grafica Italiana*).

SELECT BIBLIOGRAPHY

Accame, Giovanni M., and Carlo Guenzi, eds. *Avanguardie e cultura popolare*. Bologna: Galleria d'Arte Moderna, 1975.

Adamson, Glenn. *Thinking through Craft*. Oxford: Berg, 2007.

Alessi, Alberto. *The Dream Factory: Alessi since 1921*. Milan: Electa and Alessi/Fratelli Alessi Omegna, 2002.

Alessi, Alberto. *Le fabbriche dei sogni*. Milan: La Triennale di Milano, Triennale Design Museum/ Mondadori Electa, 2011.

Alfieri, Dino, and Luigi Freddi. *Guida alla Mostra della Rivoluzione Fascista*. Bergamo: Italian Institute of Graphic Arts, 1933. Reprint, Milan: Candido Nuovo, 1982.

Amatori, Franco. *Proprietà e direzione: La Rinascente 1917–1969*. Milan: Franco Angeli, 1989.

Ambasz, Emilio, ed. *Italy: The New Domestic Landscape: Achievements and Problems of Italian Design*. New York: Museum of Modern Art, 1972. An exhibition catalogue.

Anceschi, Giovanni. 'Il campo della grafica italiana: Storia e problemi'. *Rassegna* 3, no. 6 (1981): 5–19.

Anceschi, Giovanni, ed. *Prima biennale della grafica: Propaganda e cultura*. Milan: Mondadori, 1984.

Anceschi, Giovanni, Giovanni Baule and Gianfranco Torri. 'Charter of Graphic Design: Proposal for a Debate on Visual Communication Design'. *Design Issues* 8, no. 1 (1991): 67–73.

Anderson, Benedict. *Imagined Communities: Reflections on the Origin and Spread of Nationalism*. London: Verso, 1983.

Arvidsson, Adam. *Brands: Meaning and Value in Media Culture*. London: Routledge, 2006.

Arvidsson, Adam. 'From Counterculture to Consumer Culture: Vespa and the Italian Youth Market, 1958–78'. *Journal of Consumer Culture* 1, no. 1 (2001): 47–71.

Bassi, Alberto, and Raimonda Riccini, eds. *Design in Triennale 1947–1968: Percorsi fra Milano e Brianza*. Cinisello Balsamo: Silvana, 2004.

Bauer, Riccardo. *La Società Umanitaria: Fondazione M. P. Loria, 1892–1963*. Milan: Bertolotti, 1964.

Baule, Giovanni, and Valeria Bucchetti. 'Le mutazioni del design della comunicazione'. In *La cultura italiana*. Vol. 9, *Musica, spettacolo, fotografia, design*, edited by Ugo Volli. Turin: Utet, (2009): 598–633.

Bellati, Nally. *New Italian Design*. New York: Rizzoli, 1990.

Bersten, Ian. *Coffee Floats, Tea Sinks: Through History and Technology to a Complete Understanding*. Sydney: Helian, 1993.

Bianchino, Gloria, Grazietta Butazzi, Alessandra Mottola Molfino and Carlo Arturo Quintavalle, eds. *La moda italiana*. Vol. 1, *Le Origini dell'Alta Moda e la Maglieria*; vol. 2, *Dall'Antimoda allo Stilismo*. Milan: Electa, 1987.

Bosoni, Giampiero. *Italian Design.* With an introduction by Paola Antonelli. MoMA Design Series. New York: Museum of Modern Art and 5 Continents, 2008.

Bosoni, Giampiero, ed. *Made in Cassina.* Milan: Skira, 2008.

Bosoni, Giampiero, and Irene de Guttry. *Il Modo Italiano: Italian Design and Avant-Garde in the 20th Century.* Milan: Skira, 2006.

Bossaglia, Rossana, ed., *L'ISIA a Monza: Una scuola d'arte europea.* Cinisello Balsamo: Silvana Editoriale, 1986.

Brandt, Thomas. 'La Vespa negli Stati Uniti: Il trasporto culturale di una merce italiana'. *Memoria e Ricerca* 23 (September–December 2006): 129–140.

Branzi, Andrea. *The Hot House: Italian New Wave Design.* Translated by C. H. Evans. London: Thames and Hudson, 1984.

Branzi, Andrea. *Introduzione al design italiano: Una modernità incompleta.* Milan: Baldini e Castoldi, 1999; rev. ed. 2008.

Braun, Emily. *Mario Sironi and Italian Modernism: Art and Politics under Fascism.* Cambridge: Cambridge University Press, 2000.

Buck, Alex, and Matthias Vogt, eds. *Michele de Lucchi.* Berlin: Ernsy & Sohn, 1993.

Carpenter, Wava J. 'Designing Freedom and Prosperity: The Emergence of Italian Design in Postwar America'. Master's thesis, Cooper-Hewitt, National Design Museum, Smithsonian Institution and Parsons the New School for Design, 2006. http://hdl.handle.net/10088/8788 (accessed January 10, 2012).

Cassanelli, Roberto, Ugo Collu and Ornella Selvafolta, eds. *Nivola, Fancello, Pintori: Percorsi del moderno.* Milan: Jaca Book, 2003.

Castelli, Giulio, Paola Antonelli and Francesca Picchi, eds. *La fabbrica del design: Conversazioni con i protagonisti del design italiano.* Milan: Skira, 2007.

Castronovo, Valerio. *L'industria italiana dall'Ottocento a oggi.* Milan: Mondadori, 1980.

Cimoli, Anna Chiara. *Musei effimeri: Allestimenti di mostre in Italia, 1949–1963.* Milan: Il Saggiatore, 2007.

Clarke, Alison J. 'The Anthropological Object in Design: From Victor Papanek to Superstudio'. In *Design Anthropology: Object Culture in the 21st Century*, edited by Alison J. Clarke, 74–87. Vienna: Springer, 2011.

Colaiacomo, Paolo. *Fatto in Italia: La cultura del Made in Italy (1960–2000).* Rome: Meltemi, 2006.

De Fusco, Renato. *Made in Italy: Storia del design italiano.* Rome-Bari: Laterza, 2007.

della Campa, Massimo, and Claudio A. Colombo, eds. *Spazio ai caratteri: L'Umanitaria e la Scuola del Libro.* Cinisello Balsamo: Silvana, 2005.

Dickie, John. 'Imagined Italies'. In *Italian Cultural Studies: An Introduction*, edited by David Forgacs and Robert Lumley, 19–33. Oxford: Oxford University Press, 1996.

Dorfles, Gillo. 'Ceramic Art in Italy Today'. *The Studio* 142, no. 732 (1954): 83–87.

Dorfles, Gillo. *Il disegno industriale e sua estetica.* Bologna: Cappelli, 1965.

Eco, Umberto. *The Open Work.* Cambridge, MA: Harvard University Press, 1989. Originally published in Italian in 1962.

Escot, Laura. *Tomás Maldonado: Itinerario de un intelectual técnico.* Buenos Aires: Rizzo Patricia Editora, 2007.

Falasca-Zamponi, Simonetta. *Fascist Spectacle: The Aesthetics of Power in Mussolini's Italy.* Berkeley: University of California Press, 1997.

Fallan, Kjetil. *Design History: Understanding Theory and Method.* Oxford: Berg, 2010.

Fallan, Kjetil. 'Heresy and Heroics: The Debate on the Alleged "Crisis" in Italian Industrial Design around 1960'. *Modern Italy* 14, no. 3 (2009): 257–274.

Fossati, Paolo. *Il design in Italia, 1945–1972.* Turin: Einaudi, 1972.

Fracassi, Amalia, and Simona Riva, eds. *Stile Industria: Alberto Rosselli.* Parma: Università di Parma, 1981.

Frateili, Enzo. *Continuità e trasformazione: Una storia del disegno industriale italiano.* Milan: Alberto Greco, 1989.

Frisa, Maria Luisa. *Una nuova moda italiana.* Venice: Marsilio, 2011.

Gabra-Liddell, Meret, ed. *Alessi: The Design Factory.* London: Academy Editions, 1994.

Galindo, Michelle. *Italian Interior Design.* Salenstein: Braun, 2010.

Gallino, Luciano. *La scomparsa dell'Italia industriale.* Turin: Einaudi, 2003.

Ginex, Giovanna. 'La Galleria delle Arti Grafiche alla IV Triennale di Monza'. In *Sironi: La grande decorazione*, edited by Andrea Sironi, 193–194. Milan: Electa, 2004.

Gnoli, Sofia. *Un secolo di moda italiana 1900–2000.* Rome: Meltemi, 2005.

Golan, Romy. *Muralnomad: The Paradox of Wall Painting, Europe 1927–1957.* New Haven, CT: Yale University Press, 2009.

Gradowczyk, Mario H., ed. *Tomás Maldonado: Un moderno en acción: Ensayos sobre su obra.* Caseros, Brazil: Eduntref, 2008.

Grassi, Alfonso, and Anty Pansera. *Atlante del design italiano 1940/1980.* Milan: Fabbri, 1984.

Gregotti, Vittorio, ed. 'Design'. Special issue, *Edilizia Moderna* 85 (1965).

Gregotti, Vittorio. *Il disegno del prodotto industriale: Italia (1860–1980).* Milan: Electa, 1982.

Gualteri, Franca Santi. *A Trip through Italian Design: From* Stile Industria *Magazine to* Abitare. Bologna: Corraini, 2003.

Guida, Ermanno. *Roberto Mango: Progetti, realizzazioni, ricerche.* Naples: Electa Napoli, 2006.

Hebdige, Dick. 'Object as Image: The Italian Scooter Cycle'. *Block* 5 (1981): 44–64. Reprinted in *Hiding in the Light: On Images and Things*, 77–115. London: Routledge, 1988.

Hockemeyer, Lisa. *The Hockemeyer Collection: 20th Century Italian Ceramic Art.* Munich: Hirmer, 2009.

Hockemeyer, Lisa. 'Italian Ceramics 1945–1958: A Synthesis of Avant-Garde Ideals, Craft Traditions and Popular Culture'. PhD diss., Kingston University, 2008.

Horn, Richard. *Memphis.* New York: Columbus Books, 1986.

Iliprandi, Giancarlo, Franco Origoni, Alberto Marangoni and Anty Pansera, eds. *Visual design: 50 anni di produzione in Italia.* Milan: Idealibri, 1984.

Italian Institute for Foreign Trade (Istituto Nazionale per il Commercio Estero [ICE]), Handicrafts and Small Industries Agency (Ente Nazionale Artigianato e Piccole Industrie [ENAPI]). *Italian Ceramics.* Milan: Amilcare Pizzi, n.d., c. 1954.

Lang, Peter, and William Menking. *Superstudio: Life without Objects.* Milan: Skira; New York: Rizzoli, 2003.

Leardi, Roberto. *Cinquant'anni di Vespa Club d'Italia—la storia dell'Associazione nata con la Vespa.* Rome: CLD, 1999.

Lees-Maffei, Grace. '*Italianità* and Internationalism: Production, Design and Mediation at Alessi, 1976–96'. *Modern Italy* 7, no. 1 (2002): 37–57.

Lees-Maffei, Grace. 'The Production-Consumption-Mediation Paradigm'. *Journal of Design History* 22, no. 4 (2009): 351–376.

Lindinger, Herbert, ed. *La Scuola di Ulm: Una nuova cultura del progetto.* Genoa: Costa & Nolan, 1988.

Lombardo, Ivan Matteo, ed. *Catalogo della Decima Triennale.* Milan: Centro Studi Triennale, 1954.

Lupi, Italo, and Federico Tranfa. 'Goodbye to Milan's Subway'. *Abitare* 490 (2009): 34–37.

Maltoni, Enrico. *Espresso Made in Italy, 1901–1962.* Forlimpopoli: EM Edizioni, 2001.

Maltoni, Enrico. *Faema Espresso 1945–2010.* Faenza: Collezione Enrico Maltoni, 2009.

Marinacci, Sandro. *Il volo della Vespa: Corradino D'Ascanio, dal sogno dell'elicottero allo scooter che ha motorizzato l'Italia.* L'Aquila: Textus, 2006.

Mazzanti, Davide, ed. *Vespa: Italian Style for the World.* Florence: Giunti/Piaggio, 2003.

McCracken, Grant. *Culture and Consumption: New Approaches to the Symbolic Character of Consumer Goods and Activities.* Bloomington: Indiana University Press, 1990.

Mendini, Alessandro. *Paesaggio casalingo: Lo produzione Alessi nell'industria dei casalinghi dal 1921 al 1980.* Milan: Editoriale Domus, 1979.

Morris, Jonathan. 'The Espresso Menu: An International History'. In *Coffee: A Handbook*, edited by Robert Thurston, Jonathan Morris and Shawn Steiman. Boulder, CO: Rowman and Littlefield, 2013.

Morris, Jonathan. 'Making Italian Espresso, Making Espresso Italian'. *Food and History* 8, no. 2 (2010): 155–184.

Muzzarelli, Maria Giuseppina. *Breve storia della moda in Italia.* Bologna: Il Mulino, 2011.

Nicolin, Paola. 'Protest by Design: Giancarlo De Carlo and the 14th Milan Triennale'. In *Cold War Modern: Design 1945–1970*, edited by David Crowley and Jane Pavitt, 228–233. London: V&A Publishing, 2008.

Paci, Enzo. 'Presentation at the 10th Triennial'. *Design Issues* 18, no. 4 (2002): 51–53.

Pagano, Giuseppe. 'Parliamo un pò di esposizioni'. *Casabella-Costruzioni* 159–160 (March–April 1941): n.p.

Pansera, Anty. *Storia del disegno industriale italiano.* Rome-Bari: Laterza, 1993.

Pansera, Anty. *Storia e cronaca della Triennale.* Milan: Longanesi, 1978.

Pansera, Anty, and Mariateresa Chirico, eds. *1923–1930: Monza verso l'unità delle arti: Oggetti d'eccezione dalle esposizioni internazionali di arti decorative.* Cinisello Balsamo: Silvana, 2004.

Pansera, Anty, Anna Venturelli and Antonio C. Mastrobuono. 'The Triennale of Milan: Past, Present, and Future'. *Design Issues* 2, no. 1 (1985): 23–32.

Paolini, Federico. *Un paese a quattro ruote: Automobili e società in Italia.* Venice: Marsilio, 2005.

Paolini, Federico. *Storia sociale dell'automobile in Italia.* Rome: Carocci, 2007.

Pasca, Vanni, and Francesco Trabucco, eds. *Design storia e storiografia.* Bologna: Progetto Leonardo, 1995.

Paulicelli, Eugenia. *Fashion under Fascism.* Oxford: Berg, 2004.

Pesando, Annalisa B., and Daniela N. Prina. 'To Educate Taste with the Hand and the Mind: Design Reform in Post-unification Italy (1884–1908)'. *Journal of Design History* 25, no. 1 (2012): 32–54.

Pica, Agnoldomenico. *Storia della Triennale 1918–1957.* Milan: Edizioni del Milione, 1957.

Piccione, Paolo. *Gio Ponti: Le Navi: Il progetto degli interni navali*. Milan: Idearte, 2007.

Pivato, Marco. *Il miracolo scippato: Le quattro occasioni sprecate della scienza italiana*. Rome: Donzelli, 2011.

Poggioli, Renato. *The Oaten Flute: Essays on Pastoral Poetry and the Pastoral Ideal*. Cambridge, MA: Harvard University Press, 1975.

Poli, Alessandro. 'Nearing the Moon to the Earth'. In *Other Space Odysseys*, edited by Giovanna Borasi and Mirko Zardini, 109–115. Montreal, Québec: Canadian Centre for Architecture; Baden: Lars Müller, 2010.

Rapini, Andrea. 'Il romanzo della Vespa'. *Italia Contemporanea* 244 (2006): 385–407.

Rauch, Andrea, and Gianni Sinni, eds. *Disegnare le città: Grafica per le pubbliche istituzioni in Italia*. Florence: Lcd, 2009.

Ribalta, Jorge, ed. *Public Photographic Spaces: Exhibitions of Propaganda from Pressa to The Family of Man*. Barcelona: Museu d'Art Contemporani de Barcelona, 2008.

Riccini, Raimonda. 'Un'impresa aperta al mondo: Conversazione con Tomás Maldonado'. In *Comunicare l'impresa: Cultura e strategia dell'immagine nell'industria italiana (1945–1970)*, edited by Giorgio Bigatti and Carlo Vinti, 135–152. Milan: Guerini e Associati, 2010.

Rossi, Catharine. 'Furniture, Feminism and the Feminine: Women Designers in Post-war Italy, 1945 to 1970'. *Journal of Design History* 22, no. 3 (2009): 243–257.

Sabatino, Michelangelo. 'Ghosts and Barbarians: The Vernacular in Italian Modern Architecture and Design'. *Journal of Design History* 21, no. 4 (2008): 335–358.

Salaris, Claudia. *La Quadriennale: Storia della rassegna d'arte italiana dagli anni Trenta a oggi*. Venice: Marsilio, 2004.

Sassatelli, Roberta. *Consumo, cultura e società*. Bologna: Il Mulino, 2004.

Scarpellini, Emanuela. *L'Italia dei consumi: Dalla Belle Époque al nuovo millennio*. Rome-Bari: Laterza, 2008.

Scarpellini, Emanuela. *Material Nation: A Consumer's History of Modern Italy*. Translated by Daphne Hughes and Andrew Newton. Oxford: Oxford University Press, 2011.

Schnapp, Jeffrey. 'The Romance of Caffeine and Aluminium'. *Critical Inquiry* 28, no. 1 (2001): 244–269.

Segre Reinach, Simona, ed. 'La cultura della moda italiana—Made in Italy'. Special issue, *ZoneModa Journal* 2 (2011).

Segre Reinach, Simona. 'Milan: The City of Prêt à Porter'. In *Fashion's World Cities*, edited by Christopher Breward and David Gilbert, 123–127. Oxford: Berg, 2006.

Sessa, Ornella, Alessandro Bruni, Massimo Clarke and Federico Paolini. *L'automobile italiana: Tutti i modelli dalle origini a oggi*. Florence: Giunti, 2006.

Shaw, Paul. *Helvetica and the New York City Subway System: The True (Maybe) Story*. Cambridge, MA: MIT Press, 2011.

Sparke, Penny. *Ettore Sottsass Jnr*. London: Design Council, 1982.

Sparke, Penny. '"A Home for Everybody?" Design, Ideology and the Culture of the Home in Italy, 1945–1972'. In *Modernism in Design*, edited by Paul Greenhalgh, 185–202. London: Reaktion, 1990.

Sparke, Penny. *Italian Design 1870 to the Present*. London: Thames and Hudson, 1988.

Sparke, Penny. 'Nature, Craft, Domesticity, and the Culture of Consumption: The Feminine Face of Design in Italy, 1945–70'. *Modern Italy* 4, no. 1 (1999): 59–78.

Sparke, Penny. 'The Straw Donkey: Tourist Kitsch or Proto-design? Craft and Design in Italy, 1945–1960'. *Journal of Design History* 11, no. 1 (1998): 59–69.

Steele, Valerie. *Fashion, Italian Style*. New Haven, CT: Yale University Press, 2003.

Steiner, Albe. *Il mestiere di grafico*. Turin: Einaudi, 1978.

Stone, Marla. *Patron State: Culture and Politics in Fascist Italy*. Princeton, NJ: Princeton University Press, 1998.

Tarozzi, Fiorenza. *La Società Cooperativa Ceramica di Imola—Un'esperienza ultracentenaria*. Edited by Piero Giussami. Milan: Silvana, 1998.

Tessera, Vittorio. *Innocenti Lambretta: The Definitive History*. Vimodrone: Giorgio Nada Editori, 1999.

Triennale di Milano. *La memoria e il futuro: Il Congresso Internazionale di Industrial Design: X Triennale di Milano 1954*. Conference Proceedings. Milan: Skira, 2001.

Triennale di Milano. *Tomás Maldonado*. Milan: Skira, 2009.

Ulmer Museum/HfG-Archiv. *Ulmer Modelle—Modelle nach Ulm: Hochschule für Gestaltung Ulm 1953–1968*. Ostfildern: Hatje Cantz, 2003.

Vinti, Carlo. *Gli anni dello stile industriale 1948–1965: Immagine e politica culturale nella grande impresa italiana*. Venice: Marsilio, 2007.

White, Nicola. *Reconstructing Italian Fashion*. Oxford: Berg, 2000.

Williams, Raymond. *The Country and the City*. New York: Oxford University Press, 1973.

Zorzi, Renzo. 'Civiltá delle macchine, Civiltà delle forme'. In *Civiltà delle Macchine: Tecnologie, prodotti, progetti, dell'industria meccanica italiana dalla ricostruzione all'Europa*, edited by Valerio Castronovo and Giulio Sapelli, 141–149. Milan: Fabbri, 1990.

INDEX